Further praise for *Gi*

"Captivating. . . . A powerful sal .
liams, antebellum America's demure symbol of human freedom.
Highly recommended." *—Library Journal*, starred review

"Morgan-Owens has located a fascinating story and tells it with verve,
adding a new dimension to the much-studied struggle against slavery in
America." *—Publishers Weekly*

"A valuable contribution to abolitionist history." *—Kirkus Reviews*

"In a tour de force of historical recovery, *Girl in Black and White* com-
bines a compelling, meticulously researched biography of the slave child
abolitionists adored (and exploited) with a fascinating history of pho-
tography and visual culture. At the same time, Morgan-Owens's care-
ful inquiry into the complexities of so-called white slavery provides a
disturbing look at the limits of social sympathy that relies on simi-
larity. This beautifully written book challenges sentimental notions of
national progress and offers new ways to patch together the true story
of America's racial past."
—Carla Kaplan, author of *Miss Anne in Harlem:
The White Women of the Black Renaissance*

"*Girl in Black and White* tells a mesmerizing story made vivid by the
author's keen eye for detail. This is a riveting story of an individual's
life, an important biography of an era, and a phenomenal contribution
to discussions about the meaning of race in America."
—Emily Bernard, author of *Black Is the Body* and editor of
Remember Me to Harlem

GIRL IN BLACK
AND WHITE

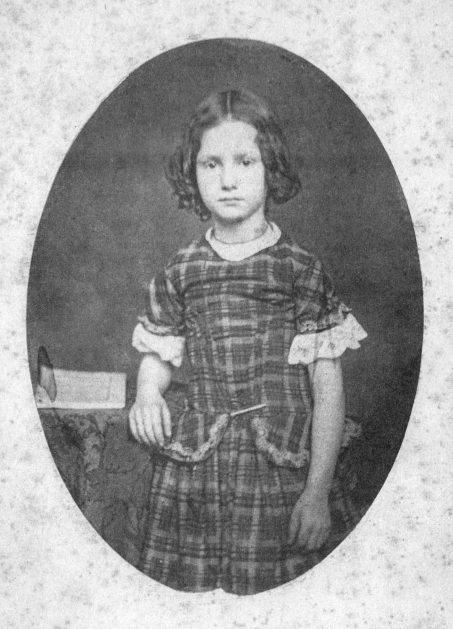

Mary Mildred Williams, crystalotype (card photograph),
found in a copy of Richard Hildreth's *White Slave* (1852).

GIRL IN BLACK AND WHITE

The Story of
Mary Mildred Williams
and the
Abolition Movement

Jessie Morgan-Owens

W. W. NORTON & COMPANY
Independent Publishers Since 1923

For information about permission to reproduce selections from this book, write to
Permissions, W. W. Norton & Company, Inc., 500 Fifth Avenue, New York, NY 10110

For information about special discounts for bulk purchases, please contact
W. W. Norton Special Sales at specialsales@wwnorton.com or 800-233-4830

Manufacturing by LSC Communications, Harrisonburg
Book design by Ellen Cipriano
Production manager: Lauren Abbate

Library of Congress Cataloging-in-Publication Data

Names: Morgan-Owens, Jessie, author.
Title: Girl in black and white : the story of Mary Mildred Williams and the
abolition movement / Jessie Morgan-Owens.
Description: First edition. | New York : W.W. Norton & Company, [2019] |
Includes bibliographical references and index.
Identifiers: LCCN 2018053655 | ISBN 9780393609240 (hardcover)
Subjects: LCSH: Williams, Mary Mildred, 1847–1921. | Williams, Mary Mildred,
1847–1921.—Family. | Child slaves—United States—Biography. | Slaves—
United States—Biography. | Photographs—Political aspects—United States—History—
19th century. | Colorism—United States. | Antislavery movements—United States—
History—19th century. | Racism—United States—History—19th century. |
United States—Race relations—History—19th century.
Classification: LCC E444.W746 M67 2019 | DDC 306.3/62092 [B] —dc23
LC record available at https://lccn.loc.gov/2018053655

ISBN 978-0-393-35827-8 pbk.

W. W. Norton & Company, Inc., 500 Fifth Avenue, New York, N.Y. 10110
www.wwnorton.com

W. W. Norton & Company Ltd., 15 Carlisle Street, London W1D 3BS

1 2 3 4 5 6 7 8 9 0

*For my mother
and grandmother*

Every photograph is in fact a means of testing, confirming, and constructing a total view of reality. Hence the crucial role of photography in ideological struggle. Hence the necessity of our understanding a weapon which we can use and which can be used against us.

—JOHN BERGER, *UNDERSTANDING A PHOTOGRAPH*, 1968

It is the picture of life contrasted with the fact of life, the ideal contrasted with the real, which makes criticism possible. Where there is no criticism there is no progress—for the want of progress is not felt where such want is not made visible by criticism. . . . Poets, prophets, and reformers are all picture-makers—and this ability is the secret of their power and of their achievements. They see what ought to be by the reflection of what is, and endeavor to remove the contradiction.

—FREDERICK DOUGLASS, "PICTURES AND PROGRESS," 1861

CONTENTS

◆

PART FOUR: SENSATION

PART FIVE: PRIVATE PASSAGES

GIRL IN BLACK AND WHITE

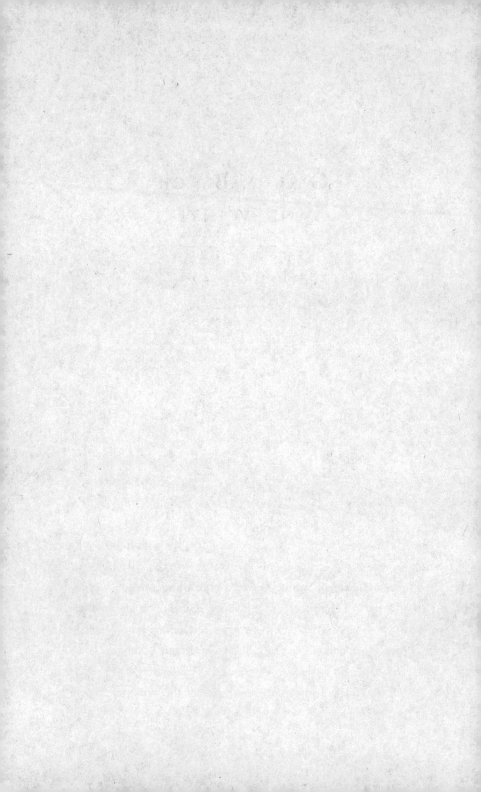

PROLOGUE

Boston, March 29, 1855

Charles Sumner, the young senator from Massachusetts, rose to address his supporters. Not one more person could have fit into Boston's Tremont Temple, because the organizer, Dr. James Stone, had purposely sold more tickets than there were seats. Spectators thronged the aisles. Dr. Stone had provided a pool of journalists with front-row desks and inkwells, and at this moment, they busily recorded the governor's introduction. Senator Sumner leaned over to whisper to a little girl who sat on stage in a chair too big for her. She smiled up at him, placed her hands on her lap, and stilled her swinging feet. Pulling at his brocade vest as he took the podium, Sumner delivered his lecture in subdued tone.

"First, I begin with the <u>necessity</u> of the Anti-Slavery Enterprise; this necessity is apparent in a simple statement of the wrong of Slavery, <u>as defined by existing laws</u>. A wrong so grievous and unquestionable should not be allowed to continue. For the honor of human nature and for the

good of all concerned, it should at once cease to exist. On this proposition, as a cornerstone, I found the necessity of the Anti-Slavery Enterprise."[1]

Supporters sent up a hurrah.

"I do not dwell on the many tales which come from the house of bondage; or the bitter sorrow there endured; or the flesh galled by the manacle or spurting blood under the lash; or the human form mutilated by the knife or seared by red hot iron; or the ferocious scent of blood-hounds in chase of human prey; or the sale of fathers and mothers, of husbands and wives, of infants, brothers and sisters at the auction block; or the prostration of all rights, all ties and even all hopes . . ."

Sumner paused in his delivery of this bloody catalog to return to the key principle, that slavery was an abomination that ought to be immediately redressed. He gave lectures, not speeches.

He turned to Anthony Burns, the twenty-year-old redeemed captive seated on the platform next to the little girl. A stowaway who escaped from slavery, Burns had been recaptured on the streets of Boston at the direction of his Virginia master on May 28, 1854. His court hearing had been interrupted by unsuccessful efforts to free Burns by force. The president had sent in the Marines. Despite the public outcry, federal officers marched Burns, in shackles, back to slavery on June 2, 1854.

Antebellum Boston made a rapid response. On the summer morning when Justice Edward G. Loring, in adherence to the Fugitive Slave Law, condemned Anthony Burns to return to slavery—only five days after he was first arrested—an estimated fifty thousand protesters lined the streets in witness and outrage. Bostonians draped buildings in funereal black bunting and flew flags upside down. Crowds yelled "Shame! Shame!" and "Kidnappers!" at the column of two thousand troops that marched the captive from the courthouse to the water-front. A coffin painted black with the word LIBERTY in white hung above State Street.

When the troops marched below the offices of the Boston *Commonwealth* newspaper, they were showered with cayenne pepper from

Citizens of Boston protest the rendition of Anthony Burns to slavery in 1854,
engraving by E. Benjamin Andrews, 1895.

several stories up, and a bottle of sulfuric acid crashed into the rear section. But such attempts to disrupt the formation failed. Protesters met the soldiers at Long Wharf, crammed onto the wharves and vessels in the harbor, until Boston's waterways were as crowded as the streets had been. They delayed the departure of the steamship *John Taylor,* with Anthony Burns chained below, but did not prevent it.[2] In a single day, Reverend Leonard Grimes of Boston's Twelfth Baptist Church raised $1,300 for Burns's redemption and retrieval to a free life. In this first real test of the Fugitive Slave Law, Burns became at once a symbol of abolition's collective might and also its relative powerlessness. He was not the first man to be recaptured under this law, but he was the first fugitive whose re-enslavement abolitionists could not prevent either by legal means or by force.

Acting quickly, Stone and his committee organized these activists and crowds into audiences for lectures. Moderate white Bostonians

found that their position on the "slavery question" had been tested by the Fugitive Slave Law, and they wanted further education in the movement. Stone presented a lecture series on the slavery question at Tremont Temple—and it was Boston's most successful to date. Tickets sold out for speakers such as William Lloyd Garrison, Ralph Waldo Emerson, and Wendell Phillips.

Senator Sumner had been slated to appear first in the series, but illness postponed his appearance until the spring of 1855, when he would appear last. This delay, as he wrote to Stone, might have been serendipitous, for in the interim, he had met a "bright and intelligent" girl, and "her presence among us [in Boston] will be a great deal more effective than any speech I could make."[3]

Now on stage, he turned to look at her, sitting next to Burns, then turned back to the crowd. ". . . Or the deadly injury to morals, in substituting concubinage for marriage and changing the whole land of slavery into a by-word of shame . . ." Sumner risked censure by uttering this last impropriety. Sexual slavery was not openly spoken of in antebellum Boston.

Sumner gestured to the girl to join him at the podium. She hopped down from her seat and walked across the platform to stand alongside his knee. She nodded up at him, then turned with a still face to the audience. The girl needed no introduction. The assembled crowd knew her as the "white slave," or "Little Ida May." According to the newspapers, she and her family had been enslaved in Virginia. Now, thanks to Sumner, she was free. To the sound of applause, Mary Mildred Williams retook her seat.

◆

This moment was the culmination of a publicity campaign around Mary that used photography to question the construct of race in the context of slavery. Mary was seven years old when antislavery activists had her photographed and exhibited as evidence that slavery was not racially bound.

When she first met Senator Sumner, in Washington in the spring of 1855, she reminded him of the kidnapped heroine in an antislavery novel called *Ida May: A Story of Things Actual and Possible*, published three months earlier. In the novel, five-year-old Ida May, a white child from Pennsylvania, is stolen, beaten unconscious, and sold across state lines. She is raised as a slave in South Carolina until her identity is recovered eight years later. The plot of *Ida May* was like Solomon Northup's *Twelve Years a Slave*, told from a girl's perspective, and it fictionalized a national fear: that under the Fugitive Slave Law, free children would be kidnapped and sold into slavery, just as Solomon Northup had been. Trouble was, not everyone believed such a thing was possible—which was why Sumner introduced Mary to the American public.

"Meanwhile, I send this picture," Sumner had written to Dr. Stone on February 19, "thinking that you will be glad to exhibit it among the Legislature, as an illustration of slavery. Let a hard-hearted Hunker look at it and be softened." Stone agreed. He forwarded Sumner's letter to the editor of the *Boston Telegraph*, Richard Hildreth, who published it in full the following Tuesday.[4] A daguerreotype of Mary, from the same seating as the portrait on the cover of this book, was placed at the Boston State House for public viewing. In her daguerreotype, Mary looked like a middle-class white girl, and her appearance challenged deeply held beliefs about race and class that maintained the slave economy.

Mary's daguerreotype was one of the first images of photographic propaganda and one of the first portraits made solely to prove a political point. It marks a forgotten moment in media history: when photography, introduced to the United States in 1839, first began to make its tenacious claim on our sympathies *and* on our political points of view. When a politician states, without equivocation, that a picture of a person has a purpose—when it is disseminated as a rhetorical tool to effect legislative change, to raise funds, or to create awareness—the subject of the portrait becomes appropriated as an object. The complexity of an individual life is flattened into a universal message. Sumner knew

his white audience in a way that seems, in retrospect, to be both empa-
thetically and politically astute, when he joked that Mary could convert
white Boston to antislavery by her presence alone. Sympathy, he knew,
works through resemblance.

◆

The majority of photographs made in antebellum America were Daguer-
rean portraits. Each one was unique: the image was imprinted on a
reflective mirror, typically in a compact size that was easily held, and
protected by a case of brocade and brass. The Massachusetts Historical
Society calls its daguerreotype of Mary, "Unidentified Girl, 1855." She
would have been lost among the images of children in their files but for
a handwritten note enclosed in the box along with the daguerreotype,
offering a clue to her identity: "slave child."[5]

Taboo and obfuscation had trapped Mary in the archives. Unlike
the title character from *Ida May*, Mary was not captured and bound
into slavery. She was born into the slave system, which condoned and
promoted rape as economic gain. Mary's skin color indicted at least
four generations of white American rapists, men who used their status
in the master class to coerce enslaved women into bearing their chil-
dren. Many of Mary's ancestors and relations were so light in complex-
ion as "to be taken to be white."

Complicated linguistic and legal codes arose to cover over the fact
of sexual slavery in the United States. In ancient times, slavery had been
a consequence of war, not passed on to the next generation. In Ameri-
can slavery, rape and pillage were ongoing modes of control and profit.
Although sexual violence was a fact of American slave experience, it was
not talked about openly and not written into historical records, which
is why Mary's story has remained untold for so long.

◆

At Tremont Temple, Sumner, with Mary behind him, closed his lecture with an exhortation that we ought to follow: "The first essential requisite is that the question shall be frankly & openly confronted. Do not put it aside. Do not blink it out of sight. Approach it. Contemplate it. Study it. Deal with it."[6]

White audiences in 1855 sympathized with Mary because of selective solidarity, or because she resembled them in color and manner. That easy sympathy, the sympathy of like to like, did not necessarily result in action on behalf of black and brown children. I write this frank truth as a white woman, the seventh generation on my father's side born in rural Louisiana. Those white abolitionists in 1855 who promoted Mary to public attention made slavery white in order to make its hardships legible to other white men, who could vote but who did not always recognize the full humanity of those who could not. In so doing, abolitionists perpetuated the racial hierarchy that made slavery possible in the first place. I am also writing my way into the house of slavery from a photograph of one of its whitest inhabitants, in an attempt to name, and correct, these myopic failures of white sympathy.

Sumner's audience in 1855 perceived this girl as both black and white, a person and a person's property, a real girl and a fictional heroine, an orphan and a loving daughter. How comfortably did all these contrasting identities rest on Mary's narrow shoulders? Without a doubt, wearing the mantle of these many identities would suggest she was quite the performer. But in all the documents where Mary, or "Little Ida May," is said to have made an appearance, only one faint, and perhaps false, echo hints at her reaction to what was happening around her. Here it is: the Boston correspondent for the *Worcester Daily Spy* mentioned that "her eyes sparkled just like those of any other little girl" at the incongruity of the golden codfish hanging in the Boston State House.[7] Though her contemporaries tirelessly discussed her appearance, these three words, "her eyes sparkled," are all that remains of her interior life.

Walt Whitman, in an 1846 gallery review, wrote in the *Brooklyn*

Eagle of the tragedy of photographic silence: "Ah! What tales might those pictures tell if their mute lips had the power of speech! How romance then, would be infinitely outdone by fact." Mary, her mother Elizabeth A. Williams, and her grandmother Prudence Bell are mute protagonists in the archive and in this book. History is constructed from documents, and documents are selectively archived. Not a single word from these women appears to have been written down and preserved in archival sources. If the voices of men—Charles Sumner, John Albion Andrew, Henry David Thoreau, Thomas Wentworth Higginson, and Frederick Douglass—sound more loudly across these pages, it is because they left a paper trail that was preserved and made available to the public. Mary's racial history began with her grandmother Prudence's bondage, and so this book is, both by design and by historical necessity, a matrilineal history. To set the story in motion, I must begin this narrative with Conney Cornwell, the white woman who purchased Mary's grandmother Prudence and great-grandmother Letty. Though the Cornwell women were illiterate, they were litigious and left good records.

Out of Mary's silence, I have constructed a composite portrait from information in other sources, arranged radially around my unknown subject. This book takes its form from the "Life and Letters" biographies of the nineteenth century, which featured passages from the archival record held together with the adhesive of narration. Sentences in quotation marks are the words of historical actors derived from letters, diaries, depositions, or other manuscript sources. When archival documents best do the work of storytelling, I copy the archive directly into these chapters. I commit these transcripts to paper in an act of trust that you, dear reader, will exhibit more human tolerance and equanimity than some of their authors did.

PART ONE

BONDAGE

———————◆———————

1

Constance Cornwell

◆

Prince William County, Virginia, 1805

Constance Calvert Cornwell saw the carriage coming up the road toward New Market Tavern. She knew her husband was not inside, although it was his carriage, his horses. His daughters, too, were now gathering around her. His slaves were gathering in the yard. She hadn't found the right time to tell them that Jesse was dead, and now she regretted that. The drive was short; the man was already stepping from the carriage. The horses were sweating profusely, and out of habit, she worried after them in the cold. Her hand gestured, as if on its own, both in greeting and as a direction to stable the horses before they cooled.

Francis Jackson climbed down from Jesse's carriage, alone, and walked with his hat in hand to the front step. He paused there, with one leg up and one on frosted dirt. The five children stood stock-still, lined up on the porch, gaping at the empty carriage.

In Jesse's carriage and pair, Jackson had brought home news of Jesse Cornwell's death.[1] That winter Jesse had been in North Carolina on pleasure and business: to visit his cousins and to see about a tract of land he had purchased. He arrived at Jackson's Christmas Eve party and was just getting down from the carriage when his horse spooked. He reached for the reins and was dragged under. Jackson hesitated to relay the details to his widow and children: the wheel crossed Jesse's abdomen, placing the whole weight of carriage, luggage, and tack on him, then crossed and recrossed that awful track twice more until he looked as if he would burst.

When Christmas morning dawned, twelve hours later, Jesse was still alive. He asked for a pen, ink, and paper and wrote a simple will, drawn up and witnessed by his cousins. Jesse Cornwell was in his prime, but no one could have survived that accident. His injuries got the better of him later that day, and he was buried with his relations in Rockingham.

A remorseful Jackson had brought Jesse's team home from North Carolina himself, a trip of three weeks, to deliver the will in person. Jesse had left five horses and seven slaves to his wife Conney. She had been Jesse's wife since she was just a child herself, barely older than her eldest daughter Caty. Everything she saw had been his.[2] It was now hers as long as she stayed single.

Principally and first of all I give and recommend my Soul into the hand of Almighty God, and my body I recommend to the Earth, to be buried in decent burial at the discretion of my Executors, nothing doubting but at the general Resurrection I shall receive the same again by the power of God. And as touching such worldly Estate as it has pleased God to bless me with in this life, I give, surmise, and dispose of the Same in the following manner and form:

I give and bequeath Conney, my dearly beloved wife, the whole of my Estate, wholy during the term she may remain my widow—but if she should marry again, then the whole of my Estate to be divided equally

among my children after all my just debts is paid, or if she should die
whilst my widow, then, the Estate to be equally divided as before men-
tioned. And lastly, I constitute and ordain my dearly beloved wife Con-
ney and my loving son Augustine Cornwell the sole executors of this my
last will and testament.

—*Jesse Cornwell's will, December 25, 1804*[3]

A look at the Prince William County personal property tax lists shows that the Cornwells and the Calverts were among that county's prominent families. Starting with the state's first collections in 1782 and for years thereafter, these two surnames predominate in family size and wealth. Conney's father, Humphrey Calvert, appears on county lists that date back to the first year recorded after statehood. The Cornwells had lived on the banks of Potomac Creek since at least 1741.

Cornwell family genealogists have determined that Jesse was the illegitimate son of Lidia Cornwell, daughter of Charles H. Cornwell and an unknown father, perhaps one who shared her last name. In early 1760 Lidia was summoned before a jury on presentment, or suspicion, that she had committed the crime of fornication. Her pregnant body would have presented conclusive evidence against her, so she did not show in person, opting instead to pay a fine, not to the state, but to the church: "The defendant failing to appear, judgment is granted the Churchwardens of Dettingen Parish against her for 50 shillings current money or 500 pounds of tobacco for the use of the poor of the said parish, with a lawyer's fee."[4]

Jesse Cornwell took his mother's name. He appears on Prince William County tax lists first in 1783, as a white male over twenty-one with one horse and three cows. In 1788, he acquired his first slave. When Jesse was in his thirties, he and Conney left their rented one hundred acres to become the proprietors of the New Market "ordinary" at Sudley Road and Balls Ford Road, which remains a thriving commercial interchange to this day.[5] Jesse applied for an "ordinary license"

or the right to serve alcohol at his tavern on May 7, 1796. The tavern opened about fifteen miles south down what is now Route 234 from his tobacco lease. Stagecoaches stopped there to change horses; Jesse kept five in the stables at the ready. He also kept a stud horse at the farm and ran a side business in horse breeding. Locals came by the New Market tavern for news; subscriptions to the *Republican Journal* and the *Dumfries Weekly Advertiser* were sold there. The Cornwells' tavern served as a hub in the community's public life.[6] Travelers stayed for the meals and political commentary.

◆

Conney's son, Augustine, died only a few years after Jesse, in 1807 or 1808, at about twenty years of age. With no white male to be the head of household, Conney and her four daughters became self-governing. Conney, in her early thirties, could have remarried but chose not to. She had paid off Jesse's debts of ninety-odd pounds that winter he died, by her industry and the sale of three young horses, two of them four-year-old bays.[7] As *feme sole*, or a widow who chose not to remarry, Conney regained the legal rights of property—to buy and sell land, to negotiate contracts, and to manage a household of slaves—that she had formerly lost by the coverture laws that governed married women. Like many "middling women," or women of moderate means, they worked alongside their enslaved people to scratch out a living in tobacco and horses on the hundred-acre lot. Their annual rent on the farm was a thousand pounds of crop tobacco.[8]

In the fall of 1808, Conney's second daughter, Kitty, fell pregnant by Juba (or Juber), an enslaved man in his fifties, who was the backbone of their tobacco farm. Here is what can be ascertained from the open secret of her pregnancy. By the rights of property, Juba was at Kitty's beck and call. Fifteen-year-old Kitty—fierce, poor, and isolated—may have ordered him to meet her. Juba may have welcomed the invitation,

or initiated it, but sex cannot be truly consensual when one partner enslaves the other. Juba may have forced himself on her, losing himself in a momentary power. By having relations with a white woman in Virginia in 1808, Juba also manifested a death wish.[9]

The baby who was born in June 1809 was black like his father, Juba, and a bastard like his grandfather Jesse.[10] The midwife took the baby to the kitchens to be washed and swaddled. When she returned the child to his mother's breast to latch, Kitty's eyes fastened on the ceiling. Conney named the boy John Cornwell and handed him over to be raised in the slave quarters.

Conney couldn't sell Juba because she needed him for fieldwork. So Juba, Kitty, and baby John remained on the farm, confined together in a tense state of impending crisis. Both Kitty and Juba were now in vulnerable circumstances. If John's parentage was found out, Juba faced death by hanging and Kitty would be "ruined" at sixteen, unmarriageable in a time when a woman's marital status determined her livelihood.

According to the legal doctrine *partus sequitur ventrem,* or "that which is brought forth follows the womb," the status of a child followed from that of the mother. The condition of slavery passed from one generation to the next along the matrilineal line. This convention-turned-legal-doctrine was put in place in the British colonies, and later the United States, to protect and enlarge property. Enslaved women with "abroad husbands," or men outside their plantations, would increase, through their children, the wealth of her master. Men who sexually assaulted their female slaves profited from the children of these unions, who were born into slavery. While *partus sequitur ventrem* did not guarantee the freedom of children born to free women, in John's case, it did have that effect. Kitty was a free white woman, so her child John was born free. But like all free black youths in Virginia, he was vulnerable to becoming enslaved. He was evidence of Kitty and Juba's crime. His grandmother Conney could have sold John off as the son of Juba and a light-skinned slave woman without much pretense and to her daughter's relief.

◆

About this time, Conney's father Humphrey Calvert offered her a deal on two slaves, a young woman and her mother. Humphrey's neighbor had owed him $110 and had put Prudence, or "Prue," up for security.[11] Prudence's mother, Lettice, or "Letty," came along with the deal. They had been working for Humphrey at Conney's brother's place. What did Conney need with two more women? She had four daughters living at home. Why would she support four female servants, one for each of them? She already kept Betsey, a young girl, and Hannah, the nurse.

Conney looked over these securities. This would be her first purchase in slaves. She appraised the women carefully, fingering their soft curls. Even with the midday sun streaming in, cutting across their skin, she couldn't see them as Negroes. Letty's hands gripped her last remaining daughter's shoulders. Though Conney was not in any position to take on people, she took the deal. The women could sew and help at the tobacco harvest. She had brought Juba along, as the carriage driver, and two hundred dollars she had saved. Her sister-in-law Nancy remembered that Conney counted "every cent of the purchase money of Prue . . . in my presence." Juba drove them home.

Prudence—who would be Mary's grandmother—was about eighteen years old when she came with her mother Letty to serve Conney. John was darker than Prue, but he was not a slave. Who would have the harder row? John's freedom to leave one day would count for so much.

◆

On September 1, 1810, Conney purchased 54 and a quarter acres on the banks of Powell's Run for $250, a sum she raised by selling the fine carriage and pair that had killed her husband.[12] And now that Conney could afford to lose the help, she sold Juba. Whether she intended to

preserve his life or his value as property, she saved Juba by selling him out of town.[13]

Today Powell's Run flows beneath clusters of cul-de-sacs of low-rent townhouses in Woodbridge, a suburb twenty-five miles southwest of Washington, D.C. If it were still standing, Conney's house would be visible from I-95. She had bought prime land, near Rippon Landing, where tobacco was once shipped via the Potomac to points north and east. When Conney was a child, Dumfries, the county seat just a few miles to the south, had been a busy seaport, situated on Quantico Creek near the Potomac. After the Revolutionary War, the port at Alexandria stole the trade along that waterway. Nonetheless, to be within a few hours' ride of both town and sea made all the difference to Conney. More important, the location would introduce her daughters to a new society, so that what had happened to Kitty wouldn't also damn the others.

On September 10, 1810, not two weeks after she moved her family to Powell's Run, Conney married her eldest daughter, nineteen-year-old Caty, to Eli Petty, a man twenty years her senior. As an advance on Caty's share of the inheritance from her father, Conney gave Eli a dowry worth $575: one cow and calf, one bed, one horse, and a man named Abram, who had been owned by Jesse since boyhood. Eli sold Abram and bought a $300 tract of land close to Powell's Run.[14] Out of courtesy, he signed a release stating that he had received his wife's full share of her father's estate.[15]

Eli and Caty had two daughters before Eli died at the age of forty-four on January 2, 1815. Less than five years into her marriage, Caty was a widow with a farm to run and daughters to raise, just like her mother.

Unlike her mother, Caty owned no enslaved people to increase her property's worth. Caty and her daughters faced want and dire circumstance. She had no property of her own to offer a second husband, and her first husband had signed off on any future inheritance. In her mother's files, Caty found the release on Jesse's property that Eli had

signed, and she threw it in the fire.[16] Destroying this record would make her eligible for a greater inheritance if Conney's wealth continued to increase. Betsey, now serving as Conney's cook, had brought two daughters, Mahala and Jane, into the family. Caty needed whatever help might come her way.

In 1816, when she was twenty-three, Kitty married William King, a miller and a gambler. Billy saw jail time for disturbing the peace, and so did Kitty. Records show they had one son, "J. W." King. Time after time Constance supported them, giving them $25 outright one year, loaning them $18 the next. Kitty took back her maiden name. From 1833 to 1837, she lived alone with her younger son and her mother's enslaved woman Hannah in nearby Centreville, Fairfax County. After 1837, her husband Billy King appears in the Fairfax County tax records only sporadically.[17]

In his teenage years, Kitty's son John Cornwell frequently shows up on the local registries—on the books at the courthouse and the town center in Dumfries, and on the county's account books—as a young man who did odd jobs. He captured rogue pigeons, scalped ravens, and surveyed roads. He tamed horses and sold them. To society, John was black, and both white and black society treated him accordingly.

Prue served the family for sixteen years, caring for John as he grew up, as Conney's children married into farms of their own. Prue married James Bell, a freedman some years older than her. He ran a small restaurant for longshoremen in Washington.[18]

◆

When Conney was in her late forties, her health suddenly declined. On September 14, 1825, she wrote a will that she hoped would prevent her four daughters from selling Prue and ensure that they cared for her sixteen-year-old grandson, John. Conney called upon her neighbor Captain Thomas Nelson to serve as her executor. He was the county

surveyor, with some legal knowledge from his own extensive holdings in both people and property. Perhaps Nelson had assured Conney that he would make sure everything and everyone would be safe in his hands, as if they were his own.

They *were* his own: Nelson had fathered Prudence's children, Albert, born in 1820, and Elizabeth, born in January 1822.

Conney intended to do well by both Prue and John. She wanted to provide for John. But she did not want John to profit one day from Prue's continued service or to be deceived by greed into a dishonorable sale. She did not write her will carelessly, and it was entirely to form, but a proviso would later catch Prue and her children in a legal bind. (Conney had taken to calling Prue "Princy.")

In the name of God, Amen. I Constance Cornwell of the county of Prince William and state of Virginia, being sick and weak of body but of sound mind and memory and being sensible of the uncertainty of human life do make and ordain this to be and contain my last will and testament, that is to say, it is my will and desire to be decently buried at the discretion of my executor hereafter mentioned and as to what worldly estate it hath pleased God to bless me with, I give and bequeath the same in the following manner, viz.

It is my will and desire that all my just debt be first paid and for that purpose all debts that due me I wish collected and applied so far as it will go and should that prove insufficient it's my desire that so much of my stock should be sold as will be sufficient to pay the balance.

Item. I give and bequeath to my Grandson John Cornwell the oldest son of my daughter Catherine [Kitty] the following slaves, viz, Letty, Princy, and her two children, Elizabeth and Albert them and the increase of the females forever, also my horse. It's my will and desire that my Grandson Jn. Cornwell shall not sell any of the slaves nor their future increase and should he attempt so to do they shall be free.

Item. Should any money be left after paying my just debts out of the

sale of my stock, it's my will and desire that it should remain in the hands of my executor hereafter named and by him applied to the use of my slaves until my Grandson comes to the age of twenty one years at which time they are to be given up by my executor.

Item. I give and bequeath to my four daughters all my household and kitchen furniture and all other of my estate both real and personal to be sold by my executor and equally divided amongst them. But should any of my four daughters claim any thing of my estate for what I may have sold and used of my deceased husband's property they forfeit all interest in my estate. And lastly I do hereby constitute and appoint Thomas Nelson Executor of this my last will and testament hereby revoking all other or former will or wills and testaments by me before made. It is my desire that my executor before named shall not be required to give any security in testimony whereof I have hereunto set my hand on this 14th day of September 1825.

Constance Cornwell (her mark)

—Last Will and Testament, September 1825

When sixteen-year-old John inherited thirty-four-year-old Prue and her two young children Elizabeth and Albert, he also inherited "the increase of the females forever," which would one day include Prue's four additional children as well as her future grandchildren, Mary, Oscar, and Adelaide. Conney knew that Prue and her family might be too expensive for John to keep, so she instructed Captain Nelson to sell off her stock certificates to pay her debts and to support them until John's twenty-first birthday. On that day in June 1830, Nelson was to deliver the family to John and divide the remainder of Conney's estate among her four daughters and two sons-in-law.

Conney knew firsthand the power of wills to write the future. The limitation preventing John from selling Prue and her children would protect them from the dangers of the open market should John's moral compass falter. If he was allowed to sell Prue and her family, they would be sold as concubines. The slave economy traded in light-skinned "fan-

cies," or children whose value on the auction block rose with their sexual desirability to the white planter class. But Conney did not choose Prue over John by giving her liberty outright. If she freed Prue, Conney knew, Prue would leave that very day, leaving John with nothing.

These women and children were the only wealth Conney had. Her sister-in-law had heard Conney say, at different times, that "Prue was her own property and that she would do with her what she pleased." Kitty (left destitute and hardened by her marriage to Billy) and Caty (recently remarried but still penniless) would take whatever they could get their hands on from Jesse's estate. Jesse's hurriedly composed will, drawn up that gory Christmas Eve twenty years earlier, had set the course for the rest of Conney's life, as Jesse no doubt intended it would.

That will had bound Conney to solitude, as she would now bind Prue to service.

◆

On the day Conney died in December 1825, her property was increased. Prue was in labor with her third child, another daughter, born on the day of her mistress's death. This child was named Evelina.

Days after Conney's body left its wake in the parlor for its place in the ground, her neighbors rushed to get as much property off of her land and onto theirs as they could. Caty, thinking back to that time twenty years later, remembered it as a "scramble" to take things from Powell's Run.[19] On December 12, 1825, everything went in a "crying sale." Captain Nelson carefully tallied the accounts as Conney's possessions went out the door.

Conney's eldest daughter Caty, the first entry on this list, acquired a meal sifter, worth 25 cents, and shortly afterward a lot of pewter dishes and eleven spoons worth $2. Charles Cornwell took one bed and bolster, worth $12, and Caty took the other, worth $11. Kitty did not come, and neither did her youngest sister, Lydia. Conney's third daugh-

ter, Nancy, won Conney's $4 embroidered counterpane, while Caty took the cotton one from the spare room. Her neighbors, the Lynn family, began a foray in the kitchens, taking a coffee mill, a clay pot, and thirty-one green dishes. Moses Lynn took a bridle and much more, while his wife took the loom. Constable Tansill took a couple of jugs. A Mr. Russell took the cowbell, while John Cornwell took the cow.

John Cornwell, at sixteen, was accustomed to hard work, which accounts for the practicality of his choices. He took tools: cotton wheels and cards, two axes worth nothing and a saw worth $1.25. He took two tubs, a cupboard, a piggin—a small wooden pail with a tall handle sticking up from one side—and five barrels.

The total worth of Conney's nonhuman possessions at her death was $150.96. From that sum was subtracted $5.50, to pay for her coffin.[20]

In preparation for this neighborly scramble for Conney's property, the Prince William County Court had requested an estate list on December 6, 1825. The two-page appraisers' list contains no niceties— no books, no art, no musical instruments, and no silver. The items on the first page are a succinct inventory of the sturdy goods required to run a small subsistence homestead in the early nineteenth century. Conney had two beds, a well-outfitted kitchen, and a full suite of tools for cloth and clothes making. She had one cow, one bull, one heifer, and a horse.

On the second page of the list, the appraisers listed Prue, her three children, and her mother, between the entries for the three cows.[21]

- *1 Cow and Bull $8*
- *# Pruey, Elizabeth and Albert and one Infant, $450.00.*
- *Lettice [Letty] $10.00*
- *1 Heifer $5, old cupboard $1.00, and 2 tubs 25 cents.*

A generous reading of this list would offer the conjecture that this family of five lived in a small slave cabin on the property near the field and paddock, or in a lean-to attached to the barn. Thus the list follows

the logic of the appraisers' tour: they started in the bedroom (beds, sheets, quilts, counterpanes, pillows), then moved to the kitchen (scales and weights, clay pot, stone pot, tinware, coffee mill, meal sifter, jug, earthen and pewter dishes, oven, griddle), then went out to the barn, where they might have come across Prue and her small children.

The appraisers would have spoken to them to learn their names, asking property to name itself. Perhaps they spoke kindly to the children and asked them for their ages, as adults have always done to knee-high children. Albert and Elizabeth—the girl who would one day be Mary's mother—were now five and three, respectively. Evelina was an infant, only days old, her mother still recovering from childbirth. Maybe the "old cupboard and two tubs" were found in Prue's home. Maybe the heifer was under Prue's care.

It was more likely, however, that the appraisers inspected these chattel property as no different from cattle and cupboards. They might have stripped the women to examine their backs for scars and examined their limbs for lameness. Prue's childbearing capacity was evidenced by the children around her. She was past her prime value; prices fetched for enslaved women peaked at age twenty-two.

Prue's mother Letty earned a low price. In his slave narrative, the abolitionist Henry Bibb describes a test that had likely been performed on her: "As it is hard to tell the ages of slaves, they look in their mouths at their teeth and prick up the skin on the back of their hands, and if the person is very far advanced in life, when the skin is pricked up, the pucker will stand for so many seconds on the back of the hand."[22] The small children, Elizabeth and Albert, now past the dangerous ages of infant mortality, were priced as a percentage of their future potential worth. Tests were made to determine their mental acuity. Questions would be asked concerning Prue and Letty's skills as domestics, seamstresses, nurses, and cooks. The appraisers conversed back and forth. A low price was settled upon: $450. Then they moved on, to inspect the heifer.

A quick computation in the margins subtracted Prue's worth from

Conney's property. With Prue and her children valued at $450, her mother Letty at $10, and Conney's horse worth $38.05, the clerk of court highlighted that Kitty's son, John Cornwell, received the lion's share of the family inheritance.[23]

At Jesse's death, Conney's human property had included Juba (who was sold in 1810) and Abram (who was given to Caty at her wedding, and sold right away). Conney's younger daughters had also received slaves from Jesse's estate for their weddings: Nancy got Jerry, who shortly afterward "ran away and never was got," and Lydia got a young man called Martin.[24]

When Conney died, her property consisted of four women, Hannah, Betsey, Letty, and Prue; five small children, Albert, Elizabeth, the infant Evelina, Mahala, and Jane; and a young field hand named Frank, who was twenty-two, cross-eyed, and known for his singing voice. Most of this property belonged not to Conney herself but to her husband's estate: Betsey and her daughters, Mahala and Jane, were appraised at $400, and Frank, at $325. The total worth of Jesse and Conney's human possessions at her death: $1,185.

Kitty did not receive her equal share. Conney had said she did not regard Kitty's husband, Billy, fit to inherit Jesse's property. Conney lent Betsey or Mahala to Kitty, but Kitty would have to knit her mother a pair of stockings or pay her a pound of wool per year in exchange for the hire of these women. Conney feared that if she gave Kitty property outright, Billy would sell these women at the first opportunity. Once Conney died, this arrangement of stockings for servants ended.

The death of a mistress was a pregnant moment in slave life. The sites and rules of work and family life were certain to change. As Conney's neighbors and relations dismantled the place that had been their home for fifteen years, the enslaved people at Powell's Run speculated about which daughter's home would offer them the safest place to see their babies grow.[25] Family separation through sale threatened with every visit from lawyers, clerks, and appraisers. Which sister would

GIRL IN BLACK AND WHITE 25

expect the most reasonable labor? What work would fill their future days? They knew Kitty was in the habit of hiring or borrowing slaves from her family members and not returning them. Any promises the mistress had made, death had broken. Any goods and small comforts they had accumulated were taken back for Conney's crying sale. Alliances that grew in the close quarters of domestic servitude were easily dissolved. Benefits and favors—Sundays off, Saturday visits from their husbands, the right to keep a cow or a garden, a steady supply of scraps for quilts, or opportunities to weave new fabric on the loom in the hall—these privileges went with Conney to her grave.

◆

Kitty kept Hannah at her home in Centreville, and when she was pressed to bring Hannah to court to be included in an inventory and assessment of Conney's property, Kitty refused. One of the three appraisers who had been called in to assess the estate, remembered that he did not see Hannah that day. "I have some recollection of something being said by Caty" about Kitty, "finding fault for her not being brought to the appraisement." When it came to Hannah, Kitty was "unwilling to give her up." Hannah had had two children, but both had died. Kitty "lamented the loss of them."[26] Anyway, another appraiser, John Tansill, thought Hannah was not worth "one cent," saying "I would not have owned her as a free gift."[27] Kitty's neighbor remembered Hannah as "not worth more than her victuals and clothes."[28] After her mother's estate was settled, Kitty complained that the childless Hannah was an insufficient inheritance.

Kitty embarked on what would become a nearly continuous war with her sisters and her mother's executor Capt. Thomas Nelson over what remained of her father's estate. In December 1829, June 1835, January 1836, and June 1844, Kitty Cornwell attempted to force arbitration, in the hopes of disposing property in her favor.[29] Year after year Caty and Kitty fought over Jesse's and Conney's wills, until they were

both old women. Their younger sisters, Lydia and Nancy, had their husbands sign agreements with Nelson to distribute what shares of property he could and call it finished. But Caty and Kitty depended on what property they might yet inherit and could not let it go.

The first case recalled a drunken night in 1823, when Kitty's husband, Billy King, was jailed for disturbing the peace. John Appleby, Caty's fiancé, had put up Billy's bail, but with no property of his own, Appleby was not "strong enough to become security to the commonwealth for Billy King's keeping the peace."[30] This had been Billy's second arrest in a year. Kitty had signed a recognizance for Betsey "and her increase" over to John Appleby, so that it would appear to the courts that Appleby had sufficient funds to stand as security for Billy King. Betsey was held in the county jail until the matter could be settled.

Billy was found not guilty and released. Betsey was also released, to John Appleby. When Kitty came for Betsey, John showed her that in her time of need, Kitty had signed not a recognizance—as she believed—but a bill of sale, giving Betsey over to him.

February 27th, 1823, then Received of John Appleby three hundred Dollars, Virginia money, it being in full fare for a negro Girl called and known by the name of Betsey, about the age of Twenty-two years of age of a yellow complexion, which Said negro I have bargained and sold and delivered up to the Said John Appleby and do further convert and defend the right will to say in him and his heirs and assigns forever, the Said John Appleby and no one else, as witnessed by my hand and seal this day and date above written.

 Kitty Cornwell [seal]

Signed sealed and acknowledged in the Presence of Isaac Lynn
 —Bill of sale for Betsey, May 17, 1823[31]

Kitty could not read. When her attorney read aloud to her the above bill of sale in 1825, Kitty refused to acknowledge that she had signed it,

insisting that she did not intend to sign any such paper or instrument. She demanded that John Appleby show how he paid for Betsey, to prove that the bill of sale was valid. Where was the $300 he said he had paid for this childbearing woman in her prime?

Furious, Kitty and her friend Eliza Gosling went to Caty's home, intending to retrieve Betsey, but they found no one to confront. To settle the score, she took the eldest of Betsey's daughters, Mahala, but left unsatisfied.[32] Kitty sued, but the court found in John Appleby's favor.

Ten years later, in 1835, Caty and John Appleby sold Betsey and her children (by then she had four) south. Caty's attorney told the court in March 1836, that Caty "sold the Slaves for Fifteen hundred dollars, and she considers she had a right to do so, or to make any other disposition of them as she pleased."[33] It is unclear which sister retaliated first, but in the summer of 1835, Frank, who had been hired out by Kitty, had also disappeared. When she was confronted about Frank, outside the Brentsville courthouse, Kitty said, "I did not sell him, but I received the money." When asked how much she had got for him, she equivocated: "I got the money for him." Frank worked at Grigsby's tavern and was well known in Centreville. He was thought to have sold for a thousand dollars. One witness reported he was headed south in a coffle.[34]

Any amity between Kitty and her sisters left with Frank. The Cornwell women knew what dire circumstances met Frank, Betsey, Mahala, Jane, and the two younger children, whom they had known all of their lives, when they sold them south. The domestic slave trade was at its height in northern Virginia, as the voracious slave markets of the Deep South pulled living trains of fifty or more people chained at the feet and arms onto the seven-week-long march way away from all they knew and all who knew them. What happened to Frank and Betsey after they were sold south? Their records end here, with Caty holding a banknote for $1,500, and Kitty pretending not to. As white women of limited means, they could not be depended on for their constancy.

2

Prudence Nelson Bell

───────────◆───────────

In January 1826, Prue was sent to live at Captain Thomas Nelson's plantation and mill. She was thirty-four years old and married to James Bell, the free man residing in Washington. (Nelson was forty-three and unmarried.) With her came her son Albert, and her two daughters by Nelson, Elizabeth and the infant Evelina. Her mother, Letty, came along, as well as her young master, John Cornwell.[1]

Prue Bell was to live with Thomas Nelson for five years, until John Cornwell came into his majority. During this interval, if she sustained her alliances and did not get hired out, she could raise her young children. But then on September 12, 1826, two days shy of the anniversary of Conney's will, John sold the horse his grandmother had bequeathed him and moved out on his own. Nine months later, shortly after his eighteenth birthday in June 1827, John traveled south, "to parts and

places unknown." Like his grandfather Jesse Cornwell, John left for North Carolina and did not come back.

The law forbade him to return. Following Denmark Vesey's Rebellion in 1822, a free black who left the state of Virginia, for any reason, could not return. The laws of North Carolina criminalized John's arrival: the North Carolina Migration Law of 1826 forbade free blacks to enter the state. Violators would be penalized with a fine of $500 or ten years of enslaved labor. Free blacks were permitted to travel through Maryland, but only if their stay lasted less than two weeks. After two weeks, they would be charged $10 per week, and should the emigrant not pay that fine, he or she would be liable to imprisonment and reenslavement. A citizen of Maryland who "hired, employed, or harbored" a free black would be fined $5 for each day the emigrant was hired (sailors excepted).[2] Born illegitimate, John Cornwell was now stateless and in danger of enslavement by law or by kidnapping.

Soon afterward his mother, Kitty, concluded that "John Cornwell was dead, or gone where I never should see or hear from him again." And as his next of kin, Kitty asserted that she had "a right to [his] negroes."[3] After John had been "absent for seven or eight years," Kitty sued to retrieve Prue from Nelson. In the suit, Caty acknowledged that their mother, Conney, had not had the right to give Prue to John. Instead Prue and her children should be considered a part of the larger estate belonging to their father, Jesse Cornwell, which should now be distributed to his surviving children according to his will.

Prue lived in fear of separation and sale to the South. She had learned that should she or her children become Kitty or Caty's property, these women were likely to sell her, too.

Year after year Captain Nelson fought to uphold an arbitration agreement the sisters had signed before their mother died, an agreement to leave things as they were. John's whereabouts were unknown, a fact that Nelson used to his advantage. Any new arbitration would

be invalid, he said, because John was not around to defend his rightful property. And since John could not participate in a new arbitration, it could not be enforced.

Kitty demanded "several times" that Prue be given to her, but Captain Nelson always replied that he "would not deliver the negroes to [her], or any other person, until Cornwell returned and demanded them. They were there and ready for him."[4]

◆

Nelson had engineered Prudence's residence with him, and he maintained this arrangement against the wishes of the Cornwell sisters. This could be taken both as a legal act of sexual exploitation and as a sign of an alliance—sex for safety. Either way, Prue kept her family together on a knife's edge. Her husband, James Bell, died in 1835, and at some point during this period, her mother, Letty, also died. She looked around for protection and took Nelson's name, becoming Prudence Nelson Bell.

The first ten years Prue spent living in bondage with Nelson could have been measured in trimesters. She bore Nelson three more surviving children who were given the last name Bell Nelson: Jesse in 1828, Ludwell in 1833, and Catherine in 1835, born when Prue was forty-four years old. She made the devil's bargain, pleasing the master in the hope that John would return, weighing her hopes for freedom against the danger of passing year after year in bondage and under threat of sale.

As an enslaved woman, Prue had little agency to refuse or resist his advances. In May 1830, Nelson married Eliza Jane Weedon, who had been born on Christmas Eve in 1801. She was ten years younger than Prue, but the bride was no young fool. Her groom was a middle-aged bachelor living with a woman who shared his family's name and color but not status. I do not know how his new wife negotiated this common situation. She could have bitterly resented Prue, felt her presence as a raw exposed wound, and sought to exact domestic punishments. Or

she could have compartmentalized, looked the other way, and accepted her husband's infidelity and her rival's pregnancies as a mode of economic growth.

Eliza Jane had married late and was pregnant within the year. She went into labor with her firstborn son, Edwin, on Independence Day 1831. Like Prue, Eliza Jane would have three sons and three daughters. Her youngest son, Horatio Nelson, was born in 1845, when she was forty-four years old and her husband was sixty-two.

◆

Nelson visited both women's beds openly, from the first day of his marriage to the last. Court documents note that "Pruey herself was a light mulatto [*sic*], and her children were very light mulattoes, some of them showing scarce a trace of negro blood; and it seemed that the children were the children of Nelson."[5] This exploitation was an open secret, openly disclosed. This arrangement of sexual slavery, so common to that time and place, was carried on with the hubris of permanence and inevitability common to patriarchal systems of oppression. When he left Prue's bed, Nelson likely stepped over a pallet of sleeping white children on his way back to his wife.

In 1840 or 1841 John Cornwell resurfaced in Georgetown. When the news reached the family, Caty Appleby asked Nelson, "Why has John Cornwell not come to get his slaves?"

Nelson replied, "Oh, he *has* demanded them of me, but he is not in a situation to receive them at this time." John could have freed Prue and her family at any point after 1830, when he came into his majority, but he did not. Instead, he asked Nelson to act as his agent and bind Prue's two elder sons out for work—Albert to learn the trade of blacksmith, and Jesse that of a wheelwright. Nelson agreed.

Sometime afterward Caty asked Nelson about how Albert and Jesse fared in their training. Nelson had not followed through on his agree-

ment with John, and he had never sent them out. "I asked him why he did not bound out these slaves, as requested by John," Caty later said, "and he said, 'I have a reason for it.' So, I asked him, 'What was your reason?'

"Nelson replied, 'Because they are my children and if I were to hire them out and they should get bad homes I could not take them away.'"

A bond usually was made for the entire calendar year, from January to January, during which time the lessee could treat and train hires according to whim, as his or her own property. Hiring out was like auctioning off, only it happened annually.

In her record of this exchange, Caty did not comment on Nelson's admission that "they are my children." She must have already known. She did not seem surprised that Nelson expressed fatherly concern toward the fortunes of these enslaved young men. Instead, she asked Nelson if he had "any persons in view, with whom he intended to put them?"[6]

Nelson had another option: "he could have them learn a trade without the bonding out, then if they were ill treated he could remove them to another place." Twelve-year-old Jesse went to work at Chapman's Mill, to learn to be a millwright, and twenty-year-old Albert apprenticed with W. Chapman, its blacksmith. Chapman's Mill was a much larger operation than the little mill on Nelson's property. It had been the preeminent mill of the neighborhood for one hundred years, a technological marvel still standing seven stories over Broad Run, a stone's throw from the Fauquier County line, along the thoroughfare through the Shenandoah Valley that would become Interstate 66.[7]

The children's placements made good sense. Nelson followed the spirit of his agreement with John, while training his sons in profitable careers with the best in the neighborhood. A millwright builds and maintains mills. With this training, Jesse could one day run the mill on his father's property. Every working farm in Virginia needed a blacksmith, so Albert could likewise be a valuable asset to his father's plan-

tation. Their training enriched property that they could never inherit. Their skills increased their value as slaves when they became men. Nelson clearly did not plan to give them up.

Nelson did not mention that these boys, and their sisters, had also learned to read and write. The law prohibited empowering slaves with literacy. Prue's children must have learned in secret alliances: with their half brothers and sisters, with their father, or while out on apprenticeships. Conney, her daughters, and their husbands signed their names with a "mark" rather than a signature. In court documents, a justice of the peace transcribed Caty's and Kitty's depositions and signed an affidavit that he had read the documents back to them. The master class was illiterate, but Prue's children by Nelson could read and write. This skill brought a tactical and strategic advantage: these children could forge their way to freedom and pass into white society.

Thomas Nelson showed great care in keeping his sons safe from harm and close at hand. He did not own Albert and Jesse. They were another man's inheritance, and John Cornwell wanted them hired out. Nelson could protect his children from the vicissitudes of enslavement only if he kept them physically close. His only claim on their safety was proximity.

Another detail suggests tenderness. Billy King was responsible for the maintenance of the mill on Nelson's property, and at Nelson's request, he kept separate accounts: one for the meal that Prue used to feed herself and her family, one for himself, and one for everyone else. Wheat and grain were the primary cash crop of northern Virginia in the early nineteenth century, so King would not have taken exception to Nelson's demand for careful accounting.

Later in court, an attorney asked King, "Did Nelson tell you to keep an account of the meal that slave Prue used out of the mill?"

"Prue was in the habit of getting meal for her self and children," King explained. He hastened to add: "I put down what I get out of the mill as well, at Nelson's request."

In the document where King's deposition is recorded, the attorney for John Cornwell has crossed the next line out: "Nelson would not let Prue have meal from his home, but from the mill." That is, Prue is not to get her weekly ration of meal from the house, like the other people on the place. Here is evidence of an affair. She is singled out to collect her family's weekly ration directly from the mill, where she is unlikely to bump into the mistress. Perhaps Nelson wanted to hide his growing number of children with Prue from his wife's accounting. Prue may have lived apart from the house or from Nelson's other slaves. Perhaps she and her children lived independently in a quiet cabin, out of the way.

Nor did Prue receive her weekly peck in rationed whole kernels, handed out to the enslaved people on the place on Saturday, for them to grind, laboriously, in a hand mill or between two rocks on Sunday. Rather, her meal arrived stone-ground from the mill. Even though her portions were carefully recorded, she took what she wanted. Her meal was measured and tallied by the miller King, as if she were a white customer patronizing the neighborhood mill.

Entries in a miller's ledger are scant traces to rely upon, to infer a life from. What evidence remains of tenderness? What evidence remains of cruelty?

◆

Thomas Nelson died intestate in 1845. It was an inexcusable lapse in judgment for a sixty-three-year-old father and landowner to neglect to leave a will, for he died a wealthy man, with a great deal of property and children, both free and enslaved, to protect. Census data from 1840 shows that he held thirty male slaves, eight of whom were field hands, and seven were boys under the age of ten. Jesse and Albert are listed as "1 male slave manufacturer/trade" and "1 male slave learned profession." He held thirteen females: six women under the age of sixty-five,

including Prue (who was fifty-four at the time of Nelson's death), Elizabeth (twenty-three) and Evelina (nineteen), and five girls under the age of ten.

Nelson's widow Eliza Jane, inherited $6,000 worth of personal property, as well as the plantation and mill, on 600 acres that were worth another $5,000. One hundred fifty of those acres were under cultivation. That year Eliza Jane's daughter, the five-year-old Elizabeth Nelson, also died. Eliza Jane's other five children survived, including the infant Horatio, and they inherited a vast property in slaves.

As a widow with significant wealth, Eliza Jane was free to punish her rival Prue as she saw fit. Eliza Jane's brother, John Catesby Weedon, was named the executor of Nelson's estate. Known as J. C., Weedon was also, legally speaking, the administrator *de bonis non* of Constance Cornwell's remaining estate. In other words, he was now responsible for goods not administered by the previous executor, Nelson, who had died without finishing the work of administering the Cornwell estate. The Cornwell sisters—Caty, Kitty, Nancy, and Lydia—were cut out completely.

Prue, her children, and her children's children—Prue's "increase"— were sent to Brentsville to serve J. C. Weedon, who had made his wealth by selling children and hiring out their parents. He took possession of Prue and her family and put them out to work for him, betting that John Cornwell's race would bar him from taking Weedon to court. Allegedly, Weedon planned to have Prue and her children "sent off to the south" through a slave trader named John Cooper within the year.

◆

How much money would Weedon's late brother-in-law's children, these unclaimed nieces and nephews, bring him? An affidavit attesting to the probable worth of Prue and her children had been submitted to the court six years earlier, at Kitty's request. Seymour H. Storke, Captain

Nelson's neighbor, had hired the thirteen-year-old Evelina from time to time and had been responsible for setting the price of Prue and her family for the court.

Are you or are you not acquainted with a Family of Slaves, living with Thomas Nelson in Prince William County, consisting of a woman named Prue and her children; if yea, please state what you know and think, as to their description, health, and value?

I do know that family of Slaves. I have been some years living within about a mile of Captain Nelson's Plantation and Mill. I know them severally except the youngest, a girl called Catherine about 4 years old. The children of Prue are more nearly approaching to white than any Slaves I ever saw. At a few paces they would be taken for white persons, both as to Colour and appearance, except Evelina and Ludwell, who are a degree whiter than a bright and fair mulatto and I'm told that the youngest is a shade darker than Elizabeth, or the others of white complexion. From what I've understood, Prue is a delicate woman, she is a mulatto. Elizabeth would be taken to be a white woman and is so to all appearance— She is very delicate and sickly from all that I learn and know of her. Albert is only tolerably well grown, hearty and serviceable, he is not quite as white as Elizabeth. I suppose from exposure to the sun. Evelina is tolerably well grown, a hearty, fine woman, she lived with me. Jesse seems to be a hearty good looking boy, very fair, I should take to be a white boy. Ludwell is a bright and fair mulatto, very delicate and badly grown, though sprightly. Catherine I have seen, but don't recollect, I'm told she is a very bright mulatto, near about as fair as Elizabeth. She is healthy and as well grown as usual, I believe. I would not buy any of them, at anything approaching the usual prices of Slaves at the same ages, excepting Evelina, owing to their being so fair Complexioned, nor do I believe that any of them, except Evelina and Ludwell, would sell at near the usual prices in the Slave market, for the same reason. To Elizabeth and Ludwell apply the additional objection of delicate health. Prue might

make another exception, but she is rather old and delicate to appearance. For myself, if I had means to buy slaves, I would not purchase any such as they are, except Evelina, and She would be objectionable as to Colour in a family of slaves.

The following are the names and to the best of my knowledge and belief, respective ages, market value of said Slaves, viz.

1. Prue—about 42 years old—value say, $150.00
2. Elizabeth, 20, very white and infirm, $100.
3. Albert, 15, very white, $400.
4. Evelina, 13, not so white, $600.
5. Jesse, 9, very white, $200.
6. Ludwell, 6, mulatto, small, $150.
7. Catherine, 4, very white, $120.
Total= $1720

I think the said slaves would be considerably indebted after offsetting the hires or annual value of those who are serviceable. I consider Evelina and Albert, as the only ones of them of annual value, Albert say for 5 years worth about $75.00, and Evelina, for say 3 years, about $30, together about $105.00. I think they have been chargeable since 1826 say 13 years, at the rate including incidental expenses (Doctors and Midwife's fees) of say $50.00 per annum. I think Elizabeth has a charge from what I have known and heard of her health.

— Seymour H. Storke, October 11, 1839[8]

Storke had most of the ages wrong. Holding the common opinion that white slaves were weak workers, he thought only Albert and Evelina worth hiring out. He used the euphemism "delicate" to refer to Prue's family, thereby communicating what he saw as their unfitness for work, their womanly refinement, and his own polygenetic belief that the mixing of races resulted in ill health. They were "chargeable" at

fifty dollars per year, by which he meant that it cost Nelson that much to keep Prue and her children in health and home.

Storke would not buy any of them, not even his favored Evelina, because he believed the other slaves on his plantation would reject her because she was white, or because he would find it objectionable. Regardless, he set her purchase price hundreds of dollars higher than her sisters and brothers. Why?

Historian Walter Johnson, who has extensively studied the domestic slave trade, explains that "according to the ideology of slaveholders' racial economy, which associated blackness and physical bulk with vitality," enslaved women who were "light-skinned and slender" embodied the opposite: "their whiteness unfitted them for labor." They represented a different economy: "for slave-buyers, near-white enslaved women symbolized the luxury of being able to pay for service, often sexual, that had no material utility—they were 'fancies,' projections of the slaveholders' own imagined identities as white men and slave masters." Edward Baptist in *The Half Has Never Been Told* reminds us that the word "fancy" has two relevant meanings: as decoration and desire.[9] Storke carefully noted the children's color—"very white," "not so white," "mulatto"—because it affected their value in complex ways. Elizabeth was "sickly" and "infirm," but her younger sister "Evelina [was] tolerably well grown, a hearty, fine woman, she lived with me." Evelina suited his prurient desire: she was not too white, not too dark. Though he called her a "fine woman," Evelina was then only thirteen years old.

A month later, in rebuttal, the neighborhood slave trader was called in to comment on Prue and her children's worth on the slave market. The court document notes that the "servants" were "all present" for John Cooper's appraisal.

I have directly and indirectly been engaged in buying and selling ~~Slaves~~
for 17 years and still buy and sell. I <u>minutely</u> viewed Prue and her chil-

*dren and am at a great loss to say as to the value. They are all so white
as to put it out of the question of taking to any foreign Market for they
would not sell on account of colour for some of them <u>has</u> not a vestige in
appearance of negro blood, not even a <u>hair</u> that inclines to Curl. Some
others appear to bear a slight shade of <u>mulatto</u> with straight hair, another
objection still stronger in some of them is the visible appearance of disease,
viz. Elizabeth and Evelina, the latter is [missing word] with a sunken
breast and totally unfit for any kind of labour. Taking probable charges I
would say Prue is worth One Hundred Dollars, Elizabeth One hundred
Dollars, Albert Two hundred and fifty dollars, Evelina One Hundred,
Jesse Two hundred, Ludwell One hundred and Twenty five dollars, and
Catherine Seventy five Dollars.*

—John Cooper, November 1839[10]

Applying his seventeen years of experience as a slave trader, "and
making a minute calculation," Cooper stated that Prue and her chil-
dren would sell for $950. It would be out of the question to take them
to a foreign market to sell—by which he meant outside the county—
because they were white enough to arouse suspicions of kidnapping.
Cooper, for the defense, did not value Evelina as highly as Storke: for
Prue, Elizabeth, and Evelina, he set the price at $100 each. If they were
kept in Brentsville and hired out to neighboring farms, Cooper believed
that after four years, the income brought by their labor would break
even against the expenses of keeping them by only $64.

A second neighborhood slave trader, William Carter, was brought
in to corroborate Cooper's assessment. Carter nudged their purchase
price up to $1,000, stating that he would offer $50 higher for Albert,
but it was "doubtful whether Evelina was worth anything or not."

Prue was appraised—in this "minute" and derogatory fashion—at
least seven times in twenty years: when Conney first bought her, when
Conney died, and for the courts by Seymour Storke, John Cooper, Wil-
liam Carter, and John Tansill. Tansill appraised her twice, once in 1825

for Conney's crying sale and again in 1844. He gave Prue and her children a high value in spite of their color, in 1844: "I consider them (as they are of very light complexion) to be worth about Eighteen hundred Dollars, but were they black negros and mine, I would not take less than Twenty-five Hundred Dollars."[11]

Caty's husband, John Appleby, who had been asked to set the value of Prue and her children in 1850, made the seventh and final assessment of Prue's value on the slave market. By this time, he had known Prue for thirty years, and his estimate was by far the highest, perhaps due to their personal connection. Caty had known Prue from childhood, and John Appleby added, "I have seen some of them within the last two weeks." John and Caty valued Prue and her family at $5,250, or double the highest price yet given.

◆

While the Virginia courts debated Elizabeth's and Evelina's poor health as a function of color, the Northern popular imagination would have cast them as heroines. Prue's older daughter, Elizabeth, was of lighter complexion than her mother or sister, and though she was beautiful, she was of "delicate" health. Archival sources construe her as the quintessential nineteenth-century "tragic mulatta," living most of her life subject to the caprices of a master who was also her father, and destined for an early grave. Elizabeth could have walked out of any number of antislavery novels.

In the 1840s and 1850s, stories of enslaved women who to all appearances presented as white were tremendously popular. The women whom Southern speculators denounced as unfit to work, Northern audiences regarded as paragons of mysterious beauty. Prurient fascination followed near-white enslaved women, and the lighter they appeared, the more sexualized their past was perceived to be.

Abolitionists accused young gentlemen in the Southern states of running brothels, not farms.

The highest social life is often the most vile in its secret history. A young man at the age of twenty-one takes possession of the paternal estate, erects a house upon it, where he retires and establishes a household for himself. He secures what means of gratification his taste can select, and thus lives, sometimes ten or fifteen years, if no heiress or beauty cross his path of sufficient attractions to induce him to add her as an ornamental appendage to his establishment.

Meanwhile, his human 'property' steadily increases, both in numbers and value; for the lighter the mulatto the more desirable among the fastidious; and rare beauty is often the result of a second intermingling of the same aristocratic blood with the offspring of a former passion. From time to time, friends come to visit this bachelor hall, and in due season the master is repaid for his hospitality to them by a valuable addition to his stock of human chattels.

*A South Carolina woman, Mrs. Douglass, is quoted: "Southern wives know that their husbands come to them * * * from the arms of their tawny mistresses. Father and son seek the same sources of excitement, * * * scarcely blushing when detected, and recklessly defying every command of God and every tie of morality and human affection."*

—Mrs. Louisa Jane Whiting Barker, "Influence of Slavery upon the White Population" (pamphlet distributed by the American Anti-Slavery Society), New York, 1855.

This abolitionist propaganda hits its mark, accurately reflecting Prue's experience on Thomas Nelson's plantation. Nelson began gratifying himself with Prue when he was in his late thirties and she was the slave of a neighboring farm.

Given their circumstances, Prue—and likely her daughters, too—

suffered these "outrages" during their enslavement at Nelson's and then Weedon's plantations. Elizabeth was born on Powell's Run on January 12, 1822. She would spend two-thirds of her thirty-year enslavement in the service of Thomas Nelson, her father, followed by nine years with J. C. Weedon (her father's legal wife's brother).

In her early twenties, Elizabeth married Seth Botts, a charismatic young black man who served at the tavern at Bellefair Mills in nearby Stafford County. Seth, whose master was also his father, descended from a distinguished line of Virginia politicians and was known for his easy smile.

Given the upheaval that attended Nelson's death, we cannot know if Seth Botts or a white man was the father of Elizabeth's children. We do know that Seth's father was his white master and that Letty, Prue, and Elizabeth suffered decades of bondage to men who were known to force themselves on their slaves. By the genetic calculus of the time, Elizabeth was an "octoroon," or seven-eighths white. All who recorded meeting Elizabeth assumed her to be white. ·

Seth and Elizabeth's oldest child together, Oscar, was born the year Nelson died, in 1845. Oscar shared his father, Seth's, dark complexion. The following year Elizabeth was sent with her mother and siblings to live with J. C. Weedon. Mary Mildred, antislavery's future poster child, was born two years later, in 1847. Their third child, Adelaide Rebecca, was born in 1849. Elizabeth named this child after Seth's half-sister, Adelaide Payne, a free woman of color who lived in Washington in the service of a congressional clerk, John William DeKrafft.[12] Seth called all three children his. To all who noted their appearance, both daughters were white.

3

Jesse and Albert Bell Nelson

◆

J. C. Weedon waited a little over a year before he began to sell off Prue's sons. In the January hiring season of 1847, Albert, twenty-six, and Jesse, eighteen, were not hired out to a local as expected but were transported to an Alexandria slave trader for auction.

When she learned of the sale the following day, Caty Appleby—Conney Cornwell's eldest daughter, who had lost all claim to Prue's children—traveled from Dumfries to Weedon's plantation in Brentsville to confront Weedon in person. The conversation went poorly, as she recalled in an 1854 deposition: "By what authority have you sold Albert and Jesse?"

To which Weedon callously replied, "Because I wanted the money."

Caty persisted, "But you sold property belonging to John Cornwell, and not to you or Nelson."

"If it is the property of John Cornwell, then he will have to show it."

Weedon did not expect to see Cornwell, but should he come, Weedon would welcome the opportunity to have him locked up as a returning free black. He told Caty to convey a threat: John Cornwell must claim Albert and Jesse in person, if he wanted his property returned.[1]

It was a Saturday, and the sale had been made the day before. Caty knew that Prue's sons might still be nearby, and if so, she had the rest of the day and Sunday to find them. By Monday morning, these two young men would likely be in a coffle headed south. She could not bear to see her mother's wealth marched away, the proceeds lining another man's pockets.

Caty traveled by steamboat to Alexandria and began her search for Jesse and Albert in the "establishment kept by Mr. Bruin" at 1707 Duke Street, in the town's West End. Joseph Bruin and his partner Henry Hill used this federal-style building (today private offices, across the street from a Whole Foods Market) as a holding facility for slaves awaiting sale to the South. These men were slave traders, and from 1844 to 1861, they did a brisk traffic shipping thousands of enslaved people from Virginia, Maryland, and Washington to the booming auction houses of New Orleans.[2] Bruin and Hill used the adjacent lot as an exercise yard for imprisoned slaves (most notably the sisters Mary and Emily Edmundson). The National Park Service has transformed this two acre yard, which now covers underground parking, into a small plaza and monument to the people held there.

Harriet Beecher Stowe's *Key to Uncle Tom's Cabin* refers to Joseph Bruin and his "large slave warehouse" twenty times, as the setting for scenes in *Uncle Tom's Cabin*. Bruin considered himself a cultured Christian man, whose every interaction with the public was conducted with impeccable manners.[3] Bruin, Stowe wrote, was a "man of very different character from many in his trade." He lived on the premises, with his wife and two young daughters.

At Bruin and Hill, Caty learned that she had just missed Albert and Jesse. They had been held at Bruin only overnight, then were marched

down to the Potomac and into Washington for auction. Caty informed Bruin that the men that he had held the night before were not the property of J. C. Weedon. Bruin was helpful. He told her that if she went to Williams Jail right away, she would find them there.

Caty followed Jesse and Albert to Washington.

◆

William H. Williams's "private" slave jail, known as the Yellow House, was located on the National Mall, with an adjacent yard surrounded by a twelve-foot-high wall. The Yellow House is no longer standing, and its precise location is hard to determine, as federal buildings now cover the area that was once Eighth Street and Independence Avenue. Most researchers place the Yellow House site at 600 Independence Avenue S.W., in what is now the Federal Aviation Administration building.[4]

Jesse and Albert Nelson were kept in a damp, moldy basement that admitted no light, in a barred cell with only a low bench for comfort. In that dark place, stories ended. Marriages ended. Identities were changed and lost. Children were held there for weeks after their parents had been sold, to "fatten" before sale.[5] As the property of new masters, children and adults alike were renamed when sold. The shackled men, women, and children who emerged from this dark tomb suffered a terrible rebirth.

In 1841, six years earlier, Solomon Northup had awoken in that dark place, still groggy from the drug slipped to him by his kidnappers. When he regained consciousness, as he remembered in *Twelve Years a Slave*, he was in total darkness, alone, in chains. Then the door that barred his cell "swung back upon its hinges, admitting a flood of light, and two men entered and stood before me." One was the prison's turnkey, Ebenezer Radburn, and the other was James H. Burch, a slave trader whose next act would be to beat Solomon into submission. Northup and his ghostwriter, David Wilson, chose to pause the fear-

ful narrative here, with these men standing in the doorway, to take the opportunity to describe the Yellow House from the perspective of one of its prisoners.

The pain in my head had subsided in a measure, but I was very faint and weak. I was sitting upon a low bench, made of rough boards, and without coat or hat. I was hand cuffed. Around my ankles also were a pair of heavy fetters. One end of a chain was fastened to a large ring in the floor, the other to the fetter on my ankles. I tried in vain to stand upon my feet. Waking from such a painful trance, it was some time before I could collect my thoughts. Where was I? What was the meaning of these chains? . . . What had I done to deserve imprisonment in such a dungeon? I could not comprehend . . .

The light admitted through the open door enabled me to observe the room in which I was confined. It was about twelve feet square—the walls of solid masonry. The floor was of heavy plank. There was one small window, crossed with great iron bars, with an outside shutter, securely fastened. An iron bound door led into an adjoining cell, or vault, wholly destitute of windows, or any means of admitting light. The furniture of the room in which I was, consisted of the wooden bench on which I sat, an old-fashioned, dirty box stove, and besides these, in either cell, there was neither bed, nor blanket, nor any other thing whatever. The door, through which Burch and Radburn entered, led through a small passage, up a flight of steps into a yard, surrounded by a brick wall of ten or twelve feet high, immediately in rear of a building of the same width as itself. The yard extended rearward from the house about thirty feet. In one part of the wall there was a strongly ironed door, opening into a narrow covered passage, leading along one side of the house into the street. The doom of the colored man, upon whom the door leading out of that narrow passage closed, was sealed. The top of the wall supported one end of a roof, which ascended inwards, forming a kind of open shed. Underneath the roof there was a crazy loft all around, where slaves, if so

disposed, might sleep at night, or in inclement weather seek shelter from
the storm. It was like a farmer's barnyard in most respects, save it was so
constructed that the outside world could never see the human cattle that
were herded there.

—*Solomon Northup,* Twelve Years a Slave[6]

This place of terror and woe, Northup reminds the reader, was "within plain sight" of the U.S. Capitol. "The voices of patriotic representatives boasting of freedom and equality, and the rattling of the poor slave's chains almost commingled. A slave pen within the very shadow of the Capitol!"

Seen from the outside, the Yellow House would have appeared like a private residence on a major thoroughfare. Not all passersby knew of the people chained inside. On auction days, prisoners would be brought from their fettered dungeons to the yard for sale. Sunday was not an auction day. Caty would have to return to the Yellow House the following morning.

Jesse and Albert spent two nights locked in the dungeon. When the turnkey led them into the light admitted by the prison door, up the stairs to the yard and through the covered passage to the iron gate, they found a middle-aged woman from their hometown, the eldest daughter of their mother's former mistress. Caty Appleby had come to redeem them. When she saw Jesse and Albert, she later recalled, she clasped their hands in her own. She spoke to them. She offered them hope.

Returning to the offices arranged for business, Caty gave the same story she had told Joseph Bruin to William H. Williams. Williams made it clear that he would not release them without paperwork to support her story, and even if her story proved true, he would not release the men without a promise of reimbursement from Weedon. Williams would proceed with the auctioning of this property unless their rightful owner came to claim them. Caty ran against time and propriety, but this once, she proved strong in that run.

◆

John Cornwell had lived and worked at a hardware store in George-town since 1840. He was in the employ of Otho Z. Muncaster, who ran Muncaster & Dodge Hardware on the south side of Bridge Street at number 123, between Congress and High streets. Georgetown streets were renamed at the end of the nineteenth century (Bridge Street is now M Street, and the hardware store was between 31st Street and Wisconsin Avenue), but the stately row of brick shop fronts remains unchanged to this day. John Cornwell had a family, and he had found steady work. By all accounts given to the courts, he was established in Georgetown "permanently."[7] Caty and Kitty both met with him in 1840 or 1841.[8]

John went to work on Jesse and Albert's behalf immediately, since they could be taken beyond reach in a matter of hours, on any given day. Williams owned two ships, the *Tribune* and the *Uncas*, both outfitted for the express purpose of transporting slaves to New Orleans. Williams boasted that he had six agents working the countryside around Washington, bringing in hundreds of people from the homes and fields of Virginia and Maryland to be transported to Louisiana's auction houses.

John's first step was to secure a replevin bond in the amount of $2,000, which was raised by his friends John Davidson and Henry B. Walter. These men were likely abolitionists—that is to say, political operatives who could leverage the slave market in a slave's favor. This initial legal step took six months. A replevin bond, worth twice the appraisal price for Albert and Jesse, should have redeemed Albert and Jesse before the courts had decided the outcome in John's suit. Albert and Jesse were appraised by "four good and lawful men of my bailiwick, duly summoned and sworn for that purpose." These four men found the value of the property in question to be $1,050, for "one negro man named Albert—$550.00" and "one mulatto boy named Jesse $500.00."

Williams of the Yellow House was summoned, on June 12, but did not appear. Albert and Jesse remained imprisoned.

◆

Albert and Jesse's predicament catalyzed John. On June 21, 1847, he instituted a suit in the Circuit Court of Prince William County against Weedon, to recover Prue and her children, twenty-one and a half years after he had inherited them. Though he did not know it, John Cornwell's suit would one day allow him to free Mary, who was a newborn baby when *Cornwell v. Weedon* began.

In the two decades that had passed since his inheritance, John had not avoided responsibility. As his counsel, Judge Christopher Neale, told the court, John had "often requested" these people from Captain Thomas Nelson, who "sometimes pretended one thing, at another time another thing, down to the time of his death."[9] For reasons that he did not disclose (but that we can well guess), Nelson did not want Prue and the family to leave with John. But John Cornwell had not sued Nelson for Prue, perhaps because John thought Prue was better off at Nelson's plantation, given his own poor circumstances. Or perhaps John, in his community of free people, did not wish to bring down upon his family the ignominy of slave ownership. Prue's preference can only be speculated upon. The will had simply dictated that John could not sell Prue as he had sold the horse. The interpersonal relationships between the properties in question, the estate's executors, and the heir cannot be read in the neat resolution of Nelson's ledger.

In 1847, the possibility that his grandmother's legacy could be sold without his permission or gain incensed John to action. If he did not claim Prue and her children now, he would soon find them sold and separated, a terrible but common fate. John had limited choices, limited mobility, and a family to support. Other sources imply that he might have been in poor health and his handwriting was all wavers, tremors, and blots. Prue's children were grown and well trained workers. John returned to the idea that he could hire them out, now without Captain Nelson's interference. He could pass along the expense of their

board, and no one in his community would need to know the source of the profits. Albert, an experienced blacksmith, was worth at least $75 a year. Prue's youngest son, Ludwell, brought $50 to $70 a year to Weedon's coffers. John could collect between $400 and $500 a year from their combined labor, whereas his own income was likely less than $100 a year.

John Cornwell submitted to the court that Constance Cornwell's will stated that Prue and her children were to be delivered to him when he attained his majority in 1830. That they had not been, he laid at Nelson's feet: Nelson had taken possession of Prue and failed to deliver her and her family to him, their rightful owner. Nelson had died without doing so. John could not prove that Nelson had ever intended to convey them to him.

John did not know whether all the slaves belonging to him—Prue's children and grandchildren—were still in Weedon's possession. He demanded an account of their whereabouts, names, and ages. He asked that Prue and her children be delivered to him immediately. He wanted to know his property's market value, from 1830 to the present, and in damages, he demanded restitution of any profits that had been made from hiring them out.

In October 1847, acting under court mandate, William H. Williams of the Yellow House allowed Albert and Jesse to leave with John Cornwell. They had spent ten months imprisoned at the Yellow House. Weedon had had to refund the purchase money to Williams, and the replevin bond was dissolved.

John hired both men out to Washington merchants in the next hiring season.

◆

A year later, on October 18, 1848, Weedon responded to John Cornwell's suit with an eight-page demurrer, or objection.[10] The court turned

him down, and the suit went forward. Predictably, one of the key claims in Weedon's objection was John's race: Weedon's attorney, Daniel Jaspar, argued that John Cornwell had "no right to maintain any action at law or in equity for the purpose of recovering or otherwise acquiring permanent ownership of any slave, in any of the courts of the State of Virginia." This referenced a March 1832 act that prohibited free blacks from acquiring ownership of slaves in the state of Virginia. Christopher Neale, John's counsel, countered that Constance Cornwell's will from 1825 predated this prohibition. Furthermore, since John was a free black resident of Georgetown, Weedon's team claimed that abolitionists had likely aided him—a damning claim in Virginia's courts.

Weedon's team pleaded a statute of limitations; the plaintiff, John Cornwell, had slept upon his rights for more than twenty years, and many of the witnesses to his claim were now dead. They called for proof that these slaves had ever been Conney Cornwell's to give away. Weedon, allegedly, had never heard of any claim on these slaves until January 1847, when Caty had turned up at the Yellow House to claim Jesse and Albert.

Sixty-three white Virginians were called to testify. The court summarized:

> A number of witnesses were introduced by the plaintiff, who testified as to the purchase of Pruey, then a girl of ten or twelve years of age, by Constance Cornwell; and that she and her children were always claimed by her and considered as her own property. Some of them also testified to the admissions of Nelson, up to a short period before his death, that the slaves were the property of John Cornwell; and that he held them for him. The credibility of some of these witnesses was assailed by the defendant; and witnesses were introduced by both parties, whose opinions as to their character for veracity differed.[11]

Caty Appleby was called as John's first witness: she came in person to Neale's office in Alexandria to give her deposition in July 1848. In

retaliation, Daniel Jaspar called five men from the neighborhood to try to discredit Caty Appleby and her testimony. She was present to hear her neighbors say, "Her character for veracity, from what I have heard, and what I believe, is not good" and "I would not believe her on her oath in any case."[12] Two respondents for John Cornwell countered under oath that Caty was "a woman of truth."

These men were also asked to testify on John's race: "Do you, or not, know John Cornwell, the Plaintiff in this suit, if so, state where or not he is a free negro or mulatto." On this point, there was general agreement. One witness, John Davis, testified: "[John] is a Mulatto Man, and near my age, we were raised in the same neighborhood—I have always understood that he is the son of Kitty Cornwell, a White woman, and his father was a slave named Jubar, belonging to her father, on his estate—and he has always passed as such in my neighborhood." Seymour Lynn agreed: "He has always passed as a free negro, and I have never heard it contradicted to this day."

In May 1849, in her initial deposition, Kitty had neglected to mention that she was John Cornwell's mother. Four months later, she was called back to Neale's office to address the accusation. She told the truth, the best form of containment. Judge Neale asked only three questions of her.

[Christopher Neale] Question 1st. Are you acquainted with the Complainant in this cause?

[Kitty King] Answer—Yes.

Question 2nd. Is he or is he not your Son?

Answer—Yes, he is.

Question 3rd. State if you can, or as near as you can, when he was twenty one years old.

Answer—In June 1830.

—Kitty Cornwell, September 14, 1849[13]

For the duration of the trial, Weedon could not legally sell any member of Prue's family or send them from Virginia; nor could John free them. John Cornwell, fearing that Prue and her family would "be secretly sent from Prince William County, Virginia, to the jail house of said Williams, for the purpose of being transported to the South, and there sold," filed a complaint. On June 5, 1849, the court said the state of Virginia would take over administration of the "estate of Constance Cornwell." It ordered Prue and her family to be delivered into the hands of the Prince William County sheriff's office in Brentsville for safekeeping.

When Prue and her family were delivered to the sheriff's office, the court ordered that the office notify John's lawyer in Alexandria. But the Brentsville sheriff, James B. J. Thornton, ignored the order, as did the deputy sheriff, Edwin Nelson—Eliza Jane's son and J. C. Weedon's nephew. Four months passed. The court issued a subpoena against the sheriff's office for not protecting Prue and her family. In September 1849 Cornwell's suit was amended to include Sheriff Thornton as a party, becoming *John Cornwell v. John C. Weedon and James B. J. Thornton.*

It was unclear where Prue, Evelina, Ludwell, Elizabeth, and Elizabeth's two small children, Oscar and Mary, were living during this time. Did they remain at Weedon's plantation? According to county records, they could not have been housed at the Brentsville jail, as it had been determined to be too populated to board enslaved families.

"Where are the slaves?" John's counsel Judge Neale demanded of Sheriff Thornton. "Who has them in possession?" He received no answer.

4

Henry Williams

◆

Boston, 1850

I t was Elizabeth's fifth year as J. C. Weedon's slave. Though she had survived her pregnancies, she was in poor health, and her husband, Seth, could see from her labored breathing that she might not be with him always. He might torment himself with the thought of Weedon, or one of his overseers, forcing himself on her. Her sister Evelina no longer had use of her hands, so hard had the tyrant worked her in the laundry. For all she knew, her brothers Jesse and Albert had been auctioned off, since neither brother had come back to Brentsville after January 1847. Withholding information was one way slaveholders like Weedon inflicted emotional cruelty and extended their control beyond slaves' physical reach. The information he gave John Cornwell and his counsel, Christopher Neale, was as incomplete and sporadic as rumor; even less information reached Prue.

Soon after Adelaide Rebecca was born in 1849, Seth had decided

that he could no longer wait for the court to decide their destiny. Why would he trust a court of slaveholders to move quickly to secure this baby's future? The courts did not even know his daughters' names: Mary and Adelaide were listed in the lawyers' files as "*also two infant slaves, whose names are not known.*"

Elizabeth's husband, Seth, was owned by James Folson, who was "the proprietor of the Bellefair Mills," in Stafford County, Virginia.[1] Bellefair has vanished, lost in the wilderness located on what is now CIA property at Quantico Station. Folson was a wealthy man, free of debt, and hard-working. According to his master, who was also his father, Seth had earned Folson's trust, his "love and affection."[2]

Seth studied the banks of the Potomac for creeks that led deep into the swampy backcountry north of Folson's place. He saw the mouth of the Occoquan, the river that Elizabeth had grown up along, and the marshes to the south. He located Powell's Run, Quantico Creek, and Rippon Landing—all were too busy for the business of running away. He had heard of others who had found passage by makeshift skiff in these interconnected waterways. He listened at the tavern for scraps of information—when the steamships and trains ran, which roads were muddy and unused, which creeks were silted in, whose horse was loose—anything he could use to piece into a plan. He was looking for an opportunity to betray Folson's trust and leave forever.

His half-sister Adelaide Payne could keep Elizabeth and the children close if and when John Cornwell and his lawyer got them to Washington. She could be their surrogate protector if he escaped.

He did not know how many years of labor awaited him in the North, should he make it there. He could not know how many years the courts would take to render a decision. He risked never seeing Elizabeth again. Walking the dirt track back to Bellefair from Brentsville, he trained his mind to look for visions of his journey north in the blank spaces of bondage.

◆

In September 1850, Seth made his move. His journey likely began in his friend Henry Williams's room in Washington, above the hotel restaurant where Henry worked. This night they met formally, as if it were noon on a Sunday, and honored the solemnity of Seth becoming *fugitive*. The word sounded like a leaping off; it made the floor grow uneven. Henry Williams carefully copied his own free papers and gave the forgery to Seth, who waited until the night watch ended at ten, then another two hours to be certain.

Seth never told how he got from bondage in Virginia to Samuel Snowden's May Street Church in Boston, but given the state he arrived in, he appears to have traveled much of the way on foot. Customarily fugitives did not recount how they got to Boston, as making a route public risked its exposure to slave catchers.[3] But if he followed the Underground Railroad, he might have run for 37 miles along the railway through Maryland, then stayed low during the daytime at a collecting place, run another 40 miles the following night, slept wherever daylight found him, crossed the Susquehanna River into Pennsylvania, and then walked the remaining miles into a border town where he could find a Quaker safe house, and transport on to Boston. The water traffic on the Chesapeake and the railway system offered more direct routes out, if he could secure or steal passage. Either way, the first forty hours out of Washington made all the difference.

When he arrived in Boston, he introduced himself as Henry Williams and procured a new shirt to replace his torn one. He lodged with other fugitives at the home of Isabella Holmes, the daughter of a Methodist minister, Reverend Samuel Snowden, who had also escaped slavery. Known to abolitionists and theologians alike, Father Snowden preached antislavery at the May Street Church and welcomed run-

aways, particularly those who came by sea. Hundreds of fugitives had blessed his front door as the threshold to a new life.

The day Father Snowden died, October 8, 1850, thirteen men arrived at his door, not knowing that they would find grief and succor in equal measures.[4] Seth might well have been one of them.

Seth appears to have discarded the name of his ancestor, the eighteenth-century planter Seth Botts, when he got to Boston. The Bottses of Virginia were a powerful family, with business in the North. John Minor Botts, who had served in the U.S. House of Representatives, was often in the press for his Unionist, or anti-secession, pro-compromise views. People in Boston would recognize the name, and that recognition could get Seth taken back to Stafford County. He chose to risk using it only in his correspondence with that place.

In becoming Henry Williams, he took a ubiquitous name, the kind that gives historians headaches. Only two Seth Bottses appear in early American historical records: our man, and his English ancestor who settled in Virginia in the early 1700s. But nineteenth-century Boston knew hundreds of Henry Williamses. In slavery, names are changed without consent. Because Seth became Henry of his own accord, from this point I will use "Henry Williams" to refer to the man, Mary's father, who bore the name Seth Botts in slavery.

◆

Henry Williams arrived in Boston to find a thriving African-American community on the northern slope of Beacon Hill. According to census data, by the 1850s, black families constituted 2 percent of Boston's population, or about 2,500 residents, and 70 percent lived in Ward 6. The residences and boardinghouses most often mentioned in this history can be found on Belknap Street (later Joy Street), Smith Court, Southac Street (now Phillips), May Street (now Revere), Robinson Lane, Gib-

bon Court, Fish Street, and Botolph Street. People moved from one address to another within these few blocks. The Underground Railroad ran directly down Joy Street in the 1850s.[5]

At 20 Hancock Street, one block over from Joy Street, the newly elected Senator Sumner was packing up his Boston residence for his first term in the Capitol.

In September 1850, Congress passed the Fugitive Slave Act, which catalyzed this community, already committed to antislavery activism through fugitive assistance and aid. The federal act prohibited people like Isabella Holmes from aiding fugitives. By offering food and shelter to the thirteen refugees who arrived at Father Snowden's doorstep on the night of his wake, Isabella Holmes was committing a federal crime punishable by a fine of $1,000 (several years of a man's wages) and potential jail time. The Fugitive Slave Law deputized the entire North to apprehend people of color as potential fugitives. It mustered a legion of slave catchers, bands of kidnappers who operated under federal commission. These policemen were paid tax dollars to track down fugitives and return them to slaveholders.

In response, some residents of Boston's black community chose to answer the call offered by colonization and separatist movements and left the country, to begin new lives in Haiti or on the eastern coast of Africa. Others saw the early integration of Cambridge's school system as a sign that these whites might welcome black children; they moved out of the crosshairs of Black Boston into smaller, scattered communities across the Charles River. A few, including community leaders William Cooper Nell, Dr. John Sweat Rock, Lewis Hayden, and Charles Redmond, stayed in Boston to continue the fight for integrated schools and to protect people of color by demanding their full rights as citizens of Boston. Black militia groups such as the Massasoit Guards and Liberty Guard were organized and armed. Corner lookouts watched key thoroughfares for man-hunters. Outposts were

established in the countryside. The community gathered itself together in defiance of this law.

Resolved, That God willed us free; man willed us slaves. We will as God wills; God's will be done.

Resolved, That our oft repeated determination to resist oppression is the same now as ever, and we pledge ourselves, at all hazards, to resist unto death any attempt upon our liberties.

Resolved, That as South Carolina seizes and imprisons colored seamen from the North, under the plea that it is to prevent insurrection and rebellion among her colored population, the authorities of this State, and city in particular, be requested to lay hold of, and put in prison, immediately, any and all fugitive slave-hunters who may be found among us, upon the same ground, and for similar reasons.

—Congregation of Belknap Street Church, October 25, 1850[6]

◆

Frederick "Shadrach" Minkins, a waiter at Cornhill Coffeehouse, was the first member of the Boston community to be arrested under the Fugitive Slave Law. The coffeehouse, near Boston's State House, at Court Square, was owned by its former bartender, George Young, who had bought it when its founders retired. By 1850 Young presided over one of the most popular power lunches in Boston, and his private rooms hosted lavish dinners for governmental committees, private men's clubs, and fundraisers. Young was also known for employing and supporting fugitives from slavery.

On Saturday, February 15, 1851, two federally commissioned slave catchers entered the coffeehouse posing as customers. At the height of breakfast service, they seized Shadrach Minkins, a "stout, copper-

colored" man with carefully combed hair. Minkins fought his arrest with the fierceness of a man twice his size. He was taken to the nearby courthouse. Robert Morris, Richard Henry Dana, Jr., Ellis Gray Loring, and Samuel E. Sewell, members of the Vigilance Committee and among the leading black and white lawyers in the state, immediately arranged counsel for Minkins and filed a petition for writ of habeas corpus.

The chief justice of the Supreme Judicial Court of Massachusetts, Judge Lemuel Shaw (Herman Melville's father-in-law), refused to honor the defense's petition. A brief hearing began that very day, on February 15, before Judge George T. Curtis, a Daniel Webster supporter who had led a rally in support of the Fugitive Slave law. Minkins was not to be afforded a trial by jury.

The return of alleged fugitives, according to section four of the Fugitive Slave Law, could be decided by commissioners in concert with the Superior and Circuit courts of Massachusetts.[7] These courts had the authority to "take and remove such fugitives . . . to the State or Territory from which such persons may have escaped or fled" upon the evidence of 'satisfactory proof being made.'"[8] The court concerned itself only with whether Minkins was the man wanted by his master, not with whether he ought to have a master. "Satisfactory proof" was established by a certificate from the claimant (the master) who stated under oath that this person was his property. This affidavit could be easily obtained, or indeed, falsified.

Minkins could not speak on his own behalf. Section six of the Fugitive Slave Law stated: "In no trial or hearing under this act shall the testimony of such alleged fugitive be admitted in evidence." This was unsurprising, given that black testimony was not permitted in the South.

Section eight added a financial incentive, which propelled the law into infamy, by awarding the commissioner ten dollars should the judge find in the claimant's favor, but only five dollars should the judge find in the fugitive's favor.

Minkins's hearing was scheduled for February 18, giving him and his lawyers three days to strategize. Meanwhile a crowd of two hundred antislavery activists gathered in the hallways and stairwells of the courthouse, easily outnumbering and overwhelming the guards. Officer Calvin Hutchins, who had been assigned to the courtroom door, cautiously unbolted the lock at around two o'clock, to allow the attorneys to leave. The door was forced, and twenty black men stormed the courtroom. They carried Minkins off upon their shoulders, leaving choice words for Judge Curtis. Black abolitionists Lewis Hayden and John J. Smith hid Minkins in town for a few days, then secreted him out of Boston by way of Concord, where he hid at the home of Mary Brooks, Henry David Thoreau's neighbor. He later settled safely in Montreal.

President Millard Fillmore responded forcefully, announcing that the nine black and white abolitionists and lawyers identified as planning and aiding in Minkins's escape would be prosecuted and fined for violating the Fugitive Slave Law. The secretary of state (and former Massachusetts senator) Daniel Webster accused his neighbors of treason for this show of defiance to a federal law. Henry Clay wrote a bill to lend strength to the Fugitive Slave Law in cases such as this one, to settle the question of "whether the government of white men is to be yielded to a government of blacks."[9]

The nine rescuers were ultimately acquitted, but Boston's abolitionist community was put on notice.

◆

One man's capture was another's lucky break. In March, after six months without steady work, Henry Williams learned that George Young was short a waiter. He applied for Shadrach Minkins's place at the coffeehouse and got it.

At the Cornhill Coffeehouse, a standard bill of fare in the 1850s included a first course of oysters, then a soup course, usually mock turtle

or tomato, followed by a roast course that offered a choice of "Mongrel Goose, Wild Turkey, or Partridges." This was followed by a game course and dessert. When Williams served there, the game menu offered a choice of "Black Ducks, Brant, Blue-bill Widgeons, Red Heads, Teal, Woodcocks, Partridges, Quail, Plover, Winter Yellow-legs, Snipes, and English Black Cock." Meals lasted hours, and diners came to know their waiters.[10]

On the last day of September 1851, when Henry Williams came in for service, his fellow-waiters and Mr. Young informed him that the police—led by the same Frederick Byrnes who had captured Minkins—had called at Cornhill again. This time they did not bother to pose as diners. They presented writs for two men by the name of Williams, claiming both were runaway slaves under the Fugitive Slave Law. Williams prepared to flee. Young sent for Vigilance Committee member Joseph Lovejoy.

Henry Williams had in his possession a letter of introduction that had been given to him by famed abolitionist William Lloyd Garrison. Garrison frequently gave out these endorsements to recommend fugitives to friends in securing work and safe housing. When Lovejoy arrived at the coffeehouse, he added his own endorsement to that letter, then sent Williams into hiding in the countryside, at the home of Vigilance Committee member Henry David Thoreau.

The journey to Concord took six anxious hours, and it was dark when Williams arrived at the side entrance of 255 Main Street. In Boston it was said of Thoreau that though he no longer lived in his cabin in the woods, he dressed and groomed as though he might return at any moment. In any case, the house was new and nearly bare. Williams was shown to a room near the back fireplace. Food was brought in, with beer and water. Thoreau and his sister Sophia wanted to know all about Williams: his life in Boston, his wife and children, and the man who had owned him without calling him son. They cheerfully created

the atmosphere of a country holiday, not the criminal act of aiding a fugitive.

While Thoreau chatted, he set a pan of hot water before Williams. As if it were the most ordinary of acts, Thoreau began to perform the ablution he provided fugitives who came his way: he took first one shoe and then the other from the fugitive and set the blistered feet in the water.[11]

The next morning Thoreau collected what funds he could from his neighbors, including fifty cents from Ralph Waldo Emerson. In his journal on October 1, 1851, Thoreau noted that Williams had raised "only" $500 of the $600 that his father Folson had demanded for man-umission, "by months of toil and begging and the aid of friends has raised the money for his freedom."[12] A man of New England, Thoreau did not recognize the bargain: a man of Williams's health and ability would have fetched much more on the auction block.

They spent the late morning talking, while Thoreau looked for the right opportunity to put Williams on a northbound train. The train to Burlington, Vermont, from Concord was a well-known track for fugitives to Canada, so the men decided to try for the train to Fitchburg, in northern Massachusetts, from where a transfer to the cars headed north into Vermont would go unnoticed. He had sent others safely north on this route before.

From the back of Thoreau's home, the train platform was a two-minute dash across School Street. Thoreau had previously walked Shadrach Minkins to the station and put him on the train moments before it pulled away. But now Thoreau spotted a policeman and decided this underground station seemed rather exposed just now. He and Williams turned and walked back toward Main Street. The policeman did not follow.

They would try again in the late afternoon, which left the day free for conversation. The men were the same age, thirty-four, and could

speak as equals. Thoreau asked Williams how he had guided himself from Virginia to Massachusetts without a map or a track.

Oct. 1, 5 P.M. Just put a fugitive slave, who has taken the name of Henry Williams, into the cars for Canada. He escaped from Stafford County, Virginia, to Boston last October; he has been in Shadrach's place at the Cornhill Coffee-House; had been corresponding through an agent with his master—who is his father, about buying—himself—his master asking $600, but he having been able to raise only $500. Heard that there were writs out for two Williamses, fugitives, and was informed by his fellow-servants and employer that Auger-hole Burns and others of the police had called for him when he was out. Accordingly fled to Concord last night on foot, bringing a letter to our family from Mr. Lovejoy of Cambridge and another which Garrison had formerly given him on another occasion. He lodged with us, and waited in the house till funds were collected with which to forward him. Intended to dispatch him at noon through to Burlington, but when I went to buy his ticket, saw one at the depot who looked and behaved so much like a Boston policeman that I did not venture that time. An intelligent and very well-behaved man, a mulatto.

There is an art to be used, not only in selecting wood for a withe, but in using it. Birch withes are twisted, I suppose in order that the fibers may be less abruptly bent; or is it only by accident that they are twisted?

The slave said he could guide himself by many other stars than the north star, whose rising and setting he knew. They steered from the north star even when it had got round and appeared to them to be in the south. They frequently followed the telegraph when there was no railroad. The slaves bring many superstitions from Africa. The fugitives sometimes superstitiously carry a turf in their hats, thinking that their success depends on it.

—Henry David Thoreau, October 1, 1851[13]

Henry Williams knew it would take more than dirt to guide himself to freedom.

Once Williams was safely on the evening train, Thoreau took his customary walk in the woods and recorded it in his journal. He did not write of what it would be like to be a fugitive tearing through Delaware or New Jersey or Massachusetts, his wife and children left behind in bondage. He wrote instead of the autumnal coolness gathering beneath his bare feet, and how the crickets seemed as far away as the passing season. He wrote that twilight blackened the earth to "an unvaried and indistinguishable black" while the departing sun set the sky alight, "as if you were walking in night up to your chin."

PART TWO

MANUMISSION

5

John Albion Andrew

◆

Henry Williams did not stay in Canada, as Thoreau and the Vigilance Committee had intended. Unlike Shadrach Minkins, who had placed advertisements seeking work as soon as he arrived in Montreal, Williams headed back to Boston, arriving by the end of the year. But before he could show his face again at the Cornhill Coffeehouse, he had to make arrangements with his former master James Folson. He planned to request an advance on his free papers with the $500 he had raised so far. Only that document could protect him against the affidavits of a federally commissioned bounty hunter like Frederick Byrnes.

Among the regular diners at Cornhill Coffeehouse was John Albion Andrew, a young lawyer who kept an office with his partner Theophilus P. Chandler at 4 Court Street, steps from the restaurant. He was a member of the Saturday Club, which met monthly for dinner and discussion of Free Soil politics. He lived on the other side of Beacon Hill

at 110 Charles Street, near Pinckney Street. (His home was replaced by a commercial structure by the end of the nineteenth century.)

Andrew was a frequent figure in both the annuals of the North Slope and on the dinner party circuit. Working in alliance with the Reverend Leonard Grimes of the Twelfth Baptist Church, he provided what assistance he could to his neighbors. He founded the Home for Aged Women of Color with the help of the Reverend James F. Clarke and his wife. Every Sunday Andrew visited the prisons. He took on women's divorce cases at a time when many lawyers chose not to. He opposed the death penalty. When he became the wartime governor of Massachusetts, he opened the ranks of the Commonwealth to regiments of men of color.

No modern biography has yet taken the measure of this man, so it is hard to get a sense of him. A turn-of-the-century biography by Henry Greenleaf Pearson opens with this sinking observation: "It is hard to imagine a man of more transparent nature than John A. Andrew. Yet, for all that his character lies open to the understanding, there was about him a quality which compels one to recognize at the outset the impossibility of presenting him fully to the reader."[1]

Photographs show a portly man with curls framing his face. He liked to talk. He suffered debilitating headaches. He chose square spectacles. He loved the work of Byron. He considered himself a dreamer, lazy to a fault. "The truth is," Andrew wrote to his dear friend Cyrus Woodman in 1847, "I am a terrible procrastinator; I am, by nature, averse to labor, always thinking of something else; I am forever dreaming about doing."

John Albion Andrew's *carte de visite*, 1859–70.

He was most at ease in the immediacy of the courtroom, where in his perseverance could be found "a dash of old-fashioned but manly temper" that won him his legal and political career.

While he was a sophomore at Bowdoin, Andrew had twice heard the British abolitionist George Thompson speak, and he considered lines from those speeches to be forever "adhered to his memory." One of his classmates remembers that "Andrew would stand in the college grounds or in his room with the window thrown open and give us the recitation of the lecture almost verbatim; and to one listening with averted face, it was generally agreed that the redelivery of the lecture was scarcely a whit inferior to the original presentation in its rhetorical finish."[2] Twenty-five years later, when he was governor of Massachusetts, he would recite from memory this sentence from a Thompson lecture he had heard at nineteen:

"I hesitate not to say that in Christian America, a land of Sabbath schools, of religious privileges, of temperance societies and revivals, there exists the worst institution in the world. There is not an institution which the sun in the heaven shines upon, so fraught with woe to man as American slavery."[3]

Andrew's opportunity to join the ranks of antislavery agitators came in the summer of 1846, when he was three years past the bar but in his first year of practice. The brig *Ottoman*, which was owned in Boston, had unknowingly picked up a stowaway in New Orleans. When discovered, the fugitive, an unnamed man, was isolated on an uninhabited island in Boston Harbor. The captain intended to pick him up on his return trip to New Orleans. Somehow antislavery activists caught word of it and sent out a steamer to rescue him. The *Ottoman*'s captain got there first and carried him back to bondage.

Failure instigates meetings. Three days later at Henry Ingersoll Bowditch's home, a committee was formed, with Dr. Samuel G. Howe as chairman and Andrew as secretary, to collect testimony against the

Ottoman's Boston-based owners. Ten days later they presented the case to the public at Faneuil Hall, with former president John Quincy Adams presiding. Howe recited the facts, Andrew called for a series of resolutions, and Charles Sumner, Stephen C. Phillips, Theodore Parker, Wendell Phillips, and others delivered speeches. Before the night was through, a resolution was passed to form a "Vigilance Committee" comprised of forty members, with the intent to move more quickly to aid fugitives in future.

The Vigilance Committee provided legal aid, shelter, and financial support for fugitives in Boston. Reverend Theodore Parker served as chairman, and its clandestine meetings took place in his study. Similar groups sprang up in New York, in Philadelphia, and along the Underground Railroad, working in tandem with existing networks. Following the Fugitive Slave Law, Boston's Vigilance Committee swelled to more than one hundred members—including thirty lawyers—with the express purpose of preventing the return of fugitives to their masters, either by force or by law. Senator Charles Sumner was among those who provided legal counsel.

Vigilance Committee member Thomas Wentworth Higginson wrote in his journal that it took effort for this community to coalesce and "to educate the mind to the attitude of revolution. It is so strange to find one's self outside of the established institutions; to be obliged to lower one's voice and conceal one's purposes; to see law and order, police and military, on the wrong side."[4] Many Vigilance Committee members occupied positions of privilege and power in their communities. They were used to upholding the law and the institutions they inhabited, not circumventing them. So, these members devised every *legal* means necessary to frustrate slave catchers. Placards were posted with descriptions of known slave catchers, who if found, were followed, harassed, and even arrested. In the last week of October 1850, "two prowling villains" from Macon, Georgia, were arrested three times,

charged with slander (against a fugitive) and conspiracy to abduct (a fugitive), and forced to post more than $30,000 in bail.[5]

A more radical group, the Boston Anti-Man-Hunting League, met every other Wednesday to train themselves in extra-legal tactics to stop fugitive kidnappings by abducting the slave catchers first. It trained its members to physically restrain and deport "man-stealers," plotting complex maneuvers in hotel lobbies and train stations.

Andrew organized actions for both groups, both in public and in secret. At the time he met Henry Williams, Andrew was chairman of Finance for the Vigilance Committee. His mandate was "to spare no rightful effort to secure every human being upon the soil of Massachusetts, in his right to liberty," and to secure "the aid and support of firm and watchful friends."[6] His poor health and headaches kept him from participating in the wilder antics of the Boston Anti-Man-Hunting League (such as kidnapping and piracy), so he fundraised: for the league's boat (the *Moby Dick*), for billy clubs, and for regional expansion. Moreover he came to know most of the fugitives in Boston personally; his "Budget for Destitute Fugitives" supported four hundred families in the 1850s.

When Henry Williams came back to Boston, he decided to entrust his story to Andrew. He explained how, born as Seth Botts, slave, he had escaped to Boston, how close he had come to restitution last fall, and how much his freedom would mean to his family. He gave a scant summary of Prue's case, stalled in appeals, and asked Andrew to help him secure his deed of emancipation from James Folson.

Andrew accepted Williams's case on behalf of the Vigilance Committee. Williams would need a liaison between himself and his master's lawyer. In legal matters, a fugitive required the intercession of the rare lawyer who could be trusted to keep close any details that might give him or her up. On January 22, 1852, Andrew wrote a fellow member of the Vigilance Committee, Senator Charles Sumner, who, now that

he lived in Washington, could be of assistance in this case. Andrew enclosed in his letter a description of Henry Williams that referred to him by his Southern name, Seth Botts.

Seth Botts—owned by James Folson, proprietor of Bellefair Mills, Stafford County, Virginia—Seth is about 31 yrs of age, Stout + well made, 5 feet + 11 inches in height, erect in form, copper complexioned, with thick bushy hair, mild expression of countenance, shows his teeth and smiles often when speaking, has a slight scar on the brow over his left eye, and another slight scar over the left side of his upper lip.

—John A. Andrew to Charles Sumner, January 22, 1852[7]

Andrew's admiration and friendship for Williams is readable between the lines. Phrases like "mild expression of countenance" and "shows his teeth and smiles often when speaking" are not often found in descriptions of enslaved men in American archives. Henry Williams's smile resonates across time.

Along with the January 22 letter, Andrew forwarded Sumner a banknote for the $500 that Williams had raised. Sumner was to hand the banknote over to another intermediary, Mr. John Clark of Bellefair Mills, who would call in person on behalf of James Folson by the end of the month. Andrew told Sumner that he would recognize Clark as "a clergyman who writes in the tone and style of a gentleman" and added, "I have had quite an agreeable correspondence with Clark." Andrew hoped this would interest Sumner, newly in Washington and open to friendships across the divide: "I hope the matter may not be burdensome; that Mr. Clark may be to you an agreeable acquaintance." Clark was pro-slavery on religious and Unionist grounds, yet somehow Andrew was correct in his matchmaking: Clark and Sumner would correspond for a decade, well after Williams's liberty had been secured.[8]

"Will you take the trouble to see that the deed is in proper form and fully secures the object of Seth's emancipation?" Andrew requested. "I am acting, as a matter of charity, to the poor fellow."

Sumner and Andrew had been friends since 1846, when Sumner also held an office at No. 4 Court Street and both men became anti-slavery activists. Andrew and Samuel G. Howe had been the first to urge the uncompromising Sumner into politics, putting Sumner's name forward before he accepted the idea of a public life.

Andrew closed, "My letter is already too long; and without stopping to add anything upon matters of more general and political intent, I will only detain you for the assurance of my heartiest sympathy in the labor and trials of your new position and my prayers for your success and prosperity; not only for the sake of the 'good old cause,' but, for your own sake and that of your friends."

Nearly two weeks later, on February 4, Sumner sent Andrew and Williams good news. The exchange had been made: Williams had bought his freedom. The manumission document was enclosed. Furthermore, Sumner confirmed from Clark that James Folson was a "man of considerable means, and free from debt," so the deed of manumission he signed for Seth Botts was "entirely valid." Folson's prosperity made him generous: Folson wrote that for "the consideration of love and affection" he felt for Seth, he agreed to leave two further years for him to raise the remaining sum. Folson's love did not extend so far as to waive the remaining $100, and during the intervening two years, Williams remained at risk: this agreement "would not suffice against creditors," should Folson be called to account. As Williams's lawyer, Andrew noted that the "provision that Seth is to pay $100 more in two years" must not be a "condition" of this agreement, for "if accident should befall" Folson, "it would work a forfeiture." All involved knew not to trust a master's promise, which could unravel quickly in death or debt.

Williams made the remaining payment of one hundred dollars "by the hand of the Hon. Charles Sumner" in a document dated July 28, 1854. Sumner enclosed the updated manumission papers in a letter to Andrew and Williams, with a pun on the deed of manumission, enclosed: "I rejoice that this good <u>deed</u> has been done."

6

Elizabeth Williams

———————— ✦ ————————

W hile Henry Williams stood in John Andrew's office negotiating his future freedom, back in Virginia, his brother-in-law Ludwell stood outside the Brentsville courthouse with another year's labor ahead of him. Inside, J. C. Weedon was renewing an annual hire for "Lundy."

———————————————————————————

We bind ourselves our heirs, executors, administrators jointly and severally to pay or cause to be paid to J. C. Weedon administrator of Thomas Nelson dec'd his heirs or assigns the full and just sum of Fifty Dollars on or before the 1st day of January 1853 for the hire of the slave Lundy [Ludwell] for the present year 1852 and to furnish said Slave with two pair of summer pantaloons two shirts a twilled yarn fustian coat pantaloon and vest, shoes and socks, hat and blanket and not to employ him in

fishing shore or long boats nor on any public works nor underhire him to be so employed and return him on the 1st day of January 1853.

Given under our hands and seals this 1st day of January 1852

J. C. Goods

P. D. Lipscomb

—*J. C. Weedon and P. D. Lipscomb,*
slave contract, January 1, 1852[1]

Hiring out Prue's children was the only way Weedon could make money off of them until *Cornwell v. Weedon* was decided. At $50 a year, Ludwell's labor, from 1846 through 1853, would have brought in $350, far more than the cost of providing him with food and pantaloons. This document's provision that he not be seen on the shore or in public works suggests that Weedon took seriously the possibility that Ludwell might find ways to escape or communicate with his brothers.

Ludwell was hired by Phillip D. Lipscomb, the Prince William County clerk, which put him in tantalizing proximity to the very documents that tracked and adjudicated who owned him, and whether John Cornwell should be able to free him. Ludwell, like his brothers and sisters, could read, though he had to do so without being noticed. While at the courthouse, he had opportunity to access information vital to his family and the progress of their suit. It was a small building, with a jail adjacent, where the family might have been held. If he had been in prior service to Lipscomb, he might well have heard depositions hosted there.

The day this bond of service was signed, January 1, 1852, was also the last day that counsel for *Cornwell v. Weedon* could submit new evidence. Thereafter the case would be moved to the Circuit Court of Spotsylvania County at Fredericksburg, to be heard on appeal, on May 29, 1852.

◆

In August 1852, Andrew asked Sumner to gather information about the progress of *Cornwell v. Weedon*, since it concerned the family of Henry Williams.[2]

My dear Sumner,

I wish to obtain your friendly aid, a little further, in behalf of Seth Botts, the col'd man, for whose deed of manumission I negotiated through you, some months ago.—

Seth's wife's mother—Prue Bell—was the slave of a Mrs. Constance Cornwell of Prince William Co. Va. Mrs C. died, leaving a will—years ago, Prue then had two children. Since then—four more. One of these children is Seth's wife—who is nearly white.—and Seth and wife have three children of their own (grand-children of Prue).

The will of Mrs. Cornwell made some provision for the ultimate, or contingent emancipation of Prue;—but what, and on which, I don't know;—Prue and some, or all of her children—& grandchildren came, some born, into the hands of a Capt. Nelson of Prince William, who is now dead. By him, & his administration, they have been held as slaves. But, a suit has been brought by one of the Cornwell family, which was decided, at Fredericksburg, and very favorably to Cornwell; but now, which decision, perhaps, an appeal may have been taken to the Court of Appeals.—Seth says that Cornwell sued for the purpose of [word illegible] the rights of Prue and her descendants under the will of his mother Constance Cornwell; and that if he is successful, they will set free.

He says that Cornwell's counsel is "Judge O'Neill" of Alexandria, who is a judge of the Orphan's court.—As the information of Seth is imperfect and indistinct, I wrote lately to the Judge asking him to inform me all about the case—in order that Seth might know what the position and prospects of his family are; and with a mind, also, to learn what, if anything, can be done for them, by raising money to compromise claims, or buy off claimants, could be done for them.—As I don't know his Christian name and I am not sure of the correct spelling of his sur-

name, perhaps my letter may never have reached him. If anything is to
be done—or can be done—Seth wishes to begin now; & to understand
the case as fully as may be. To this end, to secure information, I wish you
would find out for me—who this Judge O Neill is—his full name &
etc.—&, with the thought that perhaps you might get an opportunity to
see him, I have written you these facts, so that you might converse with
him, and learn the state of matters for our benefit. Will you please, at any
rate, find out the address of that gentleman and write me?

Seth says that the Plaintiff Cornwell is in the employ of Muncaster &
Dodge Hardware dealer, in Georgetown . . .

—*John A. Andrew to Charles Sumner, August 3, 1852*[3]

While the case was in appeal, Andrew had "tried to get the litigating parties to agree to allow a sum of money to be placed at stake, allowing the wife and children to depart." Andrew approached Weedon with $800 to redeem Elizabeth, Oscar, Mary, and Adelaide Rebecca. Elizabeth's purchase price would be fixed at her value at twenty-six, her age when the case began. In exchange, Weedon would let them go immediately and forgo their labor or future wages if hired out. Weedon at first consented, then changed his mind, "in view of the rising price of slave property, and of the increasing value of these children, to whom time was adding only strength, beauty, and intellect." That is, he reversed his position because Oscar, Mary, and Adelaide might one day make him a tidy profit.[4]

Andrew then turned to John Cornwell and his lawyer Christopher Neale with another deal. Should the case be decided in John's favor, Andrew urged him to pledge that the price of Elizabeth and the children's redemption would be $800, regardless of their assessed value at that time. Neale and Cornwell would promise to free the family for that amount as soon as the case was decided.[5] Constance Cornwell's will guaranteed that if John had tried to sell them, they would be free. But no impediment appeared to exist that would keep

John from making money in the act of securing their freedom. The
deal was made.

◆

Cornwell v. Weedon was heard in the circuit court, then in the Virginia
Supreme Court. In October 1854, the supreme court found Prue to
belong without condition to John Cornwell.

But in January 1855, despite the supreme court's ruling, the family
still had not come out of slavery. What obstacles were keeping Prue and
her family in Prince William County? Andrew asked Charles Inger-
soll, a young Boston lawyer visiting Washington, to pay a call on Judge
Christopher Neale at his home at the corner of King and Washington
Streets in Alexandria, Virginia.

Neale, a former mayor of Alexandria, was a well-respected man of
considerable social pull. He was a federally appointed judge, serving
the orphan's court for the city since Daniel Webster appointed him in
1826. In 1855, Neale was the richest man in Alexandria.

Given his wealth and social standing in a slave society, Neale's
sympathy to a slave's plight is surprising. According to their correspon-
dence, Sumner and Andrew did not know how to take the measure of
this man, this Southern judge who donated his time to a slave's cause.
Neale's name appears as a witness on several manumission documents;
I have found four, from as early as 1828. Was he an antislavery activ-
ist or a judicious bystander? How had he come to be John Cornwell's
counsel? It was providential for Prue and her family that John Cornwell
found such an influential and, as it turned out, persistent attorney.

In their conversation, Judge Neale must have reassured Ingersoll
that John had no interest in keeping Elizabeth and her children in slav-
ery. Ingersoll reported back to Andrew that Neale planned to go down
to Prince William County himself the following Friday, January 19,
1855, and bring Elizabeth and the children back with him.

True to his word, the following weekend Neale traveled to Brentsville. Weedon was expecting him and let the entire family go without a fuss. Prue, her children, and her grandchildren were now redeemed, but they were not yet free. Only John Cornwell could manumit them.

They took the steamboat up Potomac Creek to Alexandria, to meet with Cornwell in Neale's office. Five days passed before Cornwell could get there, arriving on January 24. He signed the deeds of manumission for Elizabeth, "a very bright Mulatto, and rather above the middle height," and her children: "Oscar, about ten—very [likely] Boy—Mary Mildred, about seven—very fair—and [Adelaide] Rebecca . . . light mulatto, about six years of age." All were now free.

On January 22, Andrew forwarded three valuable documents to speed their way: a bank draft in the amount of $800, from the Tremont Bank of Boston on the Chemical Bank of Washington; $25 in banknotes from the account of Henry Williams; and a description of Elizabeth, her children, and her friends.

Charles Ingersoll, who went from here some 10 days ago, called for me on Judge Neale, of Alexandria last week, in regard to the wife and three children of my client, Seth Botts, and he wrote to me that Mr Neale then intended going down to Prince William County Friday last, in the expectation of bringing wife Elizabeth and the children with him. I have been at a loss to understand—how the delay has been caused, in bringing this matter to its conclusion. The decree in favor of Judge Neale's client was rendered, I think, two months ago. And, perhaps, there maybe some more delay, still. But, in order not to be at all behind my own duty, I have enclosed a draft for $800 payable to your order, which is the sum to be paid to Mr. Neale, for Elizabeth and her three children, on receiving duly executed free papers from John Cornwell of Georgetown, the client of Mr Neale, and receiving delivery of the people. I sent it, on the supposition that he will apprise you, as soon as he is ready to deliver these people their papers . . .

If Elizabeth wishes to come on immediately, I presume that among her friends in Washington, she can find the means of making all useful arrangements; but, if she wishes to stop there with some of her friends, until Seth can come for her, she may do so, and he will start, on my being telegraphed that she is waiting for him.

As there is some legal restriction—such as requiring bonds, or the like—which prevent the free movement of colored people from the District of Columbia, I must stipulate that Judge Neale, or his client, shall make that all right and remove all such impediments.

Whatever expenses may be incident to the carrying of the four persons from their residence hitherto up to Washington, or will on the expenses of their journey from W. to Boston, I am to provide for; and Seth has the money ready. I have put $25, in this letter for store on the expenses. And you will please notify me of any deficiency, which can be made good at once. In fact, if as I suppose, Elizabeth will want Seth to go on to Washington for her, he will arrive with means enough to cover all reasonable contingencies.

In case you have not heard from Judge Neale—(his address is Hon. Christopher Neale, Alexandria)—before receiving this, will you be kind enough to drop him a line notifying him that his funds are awaiting his movement, in your hands?—

Please advise me of the receipt herein, and its contents, and pardon me, for the sake of the cause, for all the trouble I am giving you, and believe me, as ever,

Faithfully yours,

J A Andrew

4 Court Square

1. Elizabeth Botts (wife of Seth)—abt 30 yrs old, light-complexion + straight hair—wd pass for White.
2. Oscar—oldest child (boy)—about 10 yrs old
3. Mary Millburn [sic]—about 7 yrs
4. Adelaide Rebecca—about 6 yrs.

The boy is abt Seth's own complexion—but, the two girls are lighter, especially, the older of the two.

Persons who can identify the above are

- *Mrs. Caroline Wood—cook at the President's house.*
- *Jack Moore—[barrister] formerly a slave of, and emancipated by Euphemia Daniel of Stafford Co. Va.—*
- *Adelaide Paine -1/2 sister of Seth Botts -*
- *Milly Mason—living at service.*
- *Henry Williams—a hotel waiter -*

all of whom live in Washington can identify Seth's wife and children, and She will know how to find some or all of them

—John A. Andrew to Charles Sumner, January 22, 1855[6]

Elizabeth and her children's free papers had been dated and signed on Wednesday, but by Saturday the family had not yet arrived in Washington. Instead of their looked-for arrival, a letter from Judge Neale was hand-delivered by a "Major Thomas" to Sumner on Saturday, January 27. Neale requested an additional $47.25 to cover the expenses incurred "in recovering and bringing the Slaves to the City." Perhaps Neale was the wealthiest man in Alexandria because he did not leave a penny unaccounted for. This sum was equivalent to $1,200 today. Elizabeth could not cover these expenses, not on the first day that she legally became able to incur them.

Andrew wrote Sumner, two days after sending $825, that more money was forthcoming.

My dear Sumner,

I wrote to you by 3 o'clock mail yesterday, covering a draft of the Tremont Bank of B. on the Chemical Bk of DC for $800, and also $25, in bank notes, to be used for afc. of Seth Botts.

Today I have just rec'd a letter from Judge Neale—(which I here send you, and which please return to me again)—by which it appears that more money will be needed, i.e. $847.25 in all to be pd to Judge Neale; which must be added expenses of board & etc. in Washington and cost of a ticket through to Boston. In order that you have funds enough I have just got from Adams & Co. a letter of credit to the amount of $75, on their agent in Washington, so that he will advance you with that amt, whether more may be needed, than I sent you 800 toward the a/c. to me. This will make the whole amount placed with you = $900. If it is not enough [I will] cover for the bal. at sight.

I presume you will have heard from Judge Neale before receiving this. If not, please communicate with him and have the woman and children sent forward as soon as possible, Seth is very anxious to see them safely here. On account of the absence from him of his employer, Mr. Young, who wished him not to leave during his absence, Seth will adopt Elizabeth's suggestion that she can come on alone, and will await her arrival here; but would like to be informed through me, of the time of her probable arrival.

My purpose in writing to you yesterday about the means of identifying the family in question was simply, as a measure of extreme caution, to put you in the way of making sure that no wrong persons were put off upon us. But I do not in it slightest [. . .] doubt that Judge Neale is all right. He probably never saw the people before he went for them to Prince William last week . . .

—John Andrew to Charles Sumner, January 24, 1855[7]

Andrew urges Sumner to trust Neale, but just in case, he has provided references—to certify that these people are the family that Henry Williams is anxiously waiting for.

Neale wrote Sumner, "Whenever you are ready," by which he meant that when he had received this additional sum of $47.25, "I will go up to Washington, and deliver you the colored people, according to

contract, for their freedom." At that time "all necessary papers, duly authenticated, will be delivered you." His messenger waited on Sumner for a reply.[8]

The remaining expenses were collected from Sumner in the antechamber of the Senate, and he received, in exchange, the manumission papers for Elizabeth, Oscar, Mary, and Adelaide, duly signed. Though the manumission documents show a nominal amount of $1, they were accompanied by a bank draft for $800 made out to John Cornwell, in exchange for his signature, and $47.25 for Judge Neale's expenses. Andrew chose to think of this money more as the price "for the expenses of a suit for freedom than as the price of slaves." Besides, he added, "I am too thankful for the result to think of the money."

Once Elizabeth, Oscar, Mary, and Adelaide crossed the Potomac River as free people that January, Virginia law forbade their return. They left behind family, uncertain as to whether they would ever see them again. But a tantalizing offer was included in the packet: freedom papers drawn up for Evelina and Prue, left unsigned. John's signature would cost another two hundred dollars.

Sometime before the end of the case, traces of Elizabeth's youngest sister, Catherine Nelson, disappear. There is no mention of funds required for her manumission. Possibly Weedon followed through on his threat to sell her downriver to New Orleans, though surely that would have made it into the legal papers. Some accident or illness might have befallen her. The last mention of her name was in the family's 1850 appraisals, when around the age of fifteen, she was valued at five hundred dollars by Caty and John Appleby.

7

Evelina Bell

◆

C harles Sumner saved everything. He instructed his secretaries to paste not only such scraps of life as train tickets and calling cards but also 18,500 pieces of incoming correspondence into scrapbooks, in chronological order. Unlike many nineteenth-century letters—cross-written to cram a week's worth of news onto one folio—his letters show that he sprawled his hand across pages and left wide margins. Sumner dashed off dozens of letters a day, but unfortunately, he kept careless records of his outgoing correspondence.[1]

It had taken nearly two weeks of a three-way correspondence between Sumner in Washington, Andrew in Boston, and Neale in Alexandria, on the Williams family's behalf, to obtain Evelina and Prue's freedom.[2] These letters, which often crossed each other, had the air of settling in for a lengthy negotiation.

Neale opened his first letter with a price. "In meeting with my cli-

ent John Cornwell last week, to secure these papers, the matter arose as
to what he intends for the other members of Elizabeth's family and her
mother, Prue. With respect to Evelina, her fair quota, or proportion,
would be $400 for her, and her mother, but I succeeded in reducing
the amount to $200."[3] Sumner and Andrew had already corresponded.
Andrew felt that John Cornwell made "so honorable and excellent an
offer that it must not be suffered to slip." Though Andrew had over-
drawn subscriptions for the Williams family, "it being the beginning of
a new year," Andrew felt he would be able to advance the $200 himself.[4]

"Mr. Cornwell's generosity ought to be acted upon before it is with-
drawn."[5] Should anything happen to John Cornwell, or to his creditors,
Judge Neale warned, the chance would be lost. "In similar cases, the
limitation on Mr. Cornwell to not sell the family, in his grandmother's
will, may be considered, in legal terms, 'repugnant to the grant' should
the family be sold on the open market. Any limitation binding Mr.
Cornwell would be rendered void for their next owner."[6]

Judge Neale cited the case of *Williams v. Ash*, in which James Ash
had defended his freedom against William H. Williams of the Yellow
House in 1842.[7] William H. Williams had purchased James Ash to sell
him at auction, but Ash and his friends filed a petition for freedom at
the Circuit Court of Washington County, claiming that Ash was enti-
tled to the freedom promised him nearly twenty years earlier, in 1824,
by his mistress's will. Ash had been inherited by Gerard T. Greenfield,
the nephew of Maria Ann T. Greenfield, James Ash's first owner, whose
will stipulated that "he shall not carry them out of the state of Mary-
land, or sell them to any one; in either of which events, I will and desire
the said negroes to be free for life." It was a conditional limitation of
freedom, which would take effect the moment Ash was sold. Ash was
found "held in custody and confined in the private jail of William H.
Williams," that is, he was chained to the basement of the Yellow House.
Williams could not find a way to legally sell Ash until the matter of his

ownership was settled. A jury found in favor of James Ash, and the U.S. Supreme Court upheld his petition.

Chief Justice Roger B. Taney (author of the *Dred Scott* decision) wrote a curious judgment in which he demonstrated, once again, his infamous disregard for the rights of enslaved people when in conflict with the rights of property. Taney wrote for the majority, "We think that the bequest in the will was a conditional limitation of freedom to the petitioner, and that it took effect the moment he was sold" to Williams. However, Taney added a caveat, that this condition had to have been met within the lifetime of Gerard T. Greenfield. Had Greenfield died without selling James Ash, the stipulation in the will would have been null, and Ash would have remained a slave for life, as the property of Greenfield's heirs. The heirs, as a third party, could do what they wished with property they had inherited. Conditions placed upon one party did not pass to the next generation. Taney established a precedent of "a conditional limitation of freedom."

Sumner and Andrew wrote to Neale for his legal opinion. "You believe the slave laws of Virginia will prove consistent with this precedent from Maryland?" Prue's legal situation mirrored several key aspects of this case. Neale replied, "Yes, it is my opinion that *Williams v. Ash* will prevail, in part because I feel it precisely illustrates the bind we find ourselves in. We should assume that the limitation applies to Mr. Cornwell alone. Should he die before these proceedings are complete, that is, while he still owns Prue, the legal precedent would be for Prue and her children to remain enslaved to his heirs, without limitation, forever, after Mr. Cornwell's life ends."[8]

Given that John Cornwell was only a few years older than Senator Sumner, it seems noteworthy that they discussed John's imminent death in such a matter-of-fact way. Poor health may have explained John Cornwell's avarice as urgency.

Neale dodged the question of Cornwell's health. "Evelina's <u>general</u>

health, on the other hand, is excellent. She is young, very smart, and intelligent, and it is said that she is an elegant, first rate seamstress."

Was Neale selling Evelina to abolitionists? He let slip an affecting detail. He had noticed her hands, cramped and gnarled as if with age, when he met her in Brentsville. "They have become crippled. Such local afflictions are very common, with laboring people, and easily cured—they are produced by the sudden, and indiscreet, application, of extreme heat and cold—an especial plight among washerwomen. The proper application of a galvanic battery would, no doubt, restore the muscles of her hand to their original elasticity. Strange as you may think it, let her hands be cured, and she is worth, and would readily sell for $1000 cash, and her Mother, at least $300. Both of whom John proposes to free for $200. I am willing to extend a short credit, while the money is raised."[9]

Neale aimed this last volley to arouse Sumner's sympathies, but he needn't have bothered. Andrew had already written the check.

Sumner wrote few parting words to the worthy opponent he had unexpectedly found in Judge Neale. "I will take the matter into consideration."

Neale ignored the senator's dismissal. "Those poor creatures ought not to be separated from Prue, for they are really trustworthy, and faithful, and under all the circumstances, she ought to be free." He urged Sumner to act quickly: "Give me your note" for two hundred dollars, and he will "forthwith execute the deed of emancipation, and deliver it to you—that is—her owner shall."

Neale made Sumner a promise, which he signed and underlined for effect: "We share the same object, sir. I have promised these people their freedom, and they shall have it."

◆

The next morning's post brought Sumner another nudge to act quickly: a promissory note for $200 signed by John Andrew on January 31, to

come due in ninety days. With Sumner's endorsement, it would be considered as good as cash. And "in the meantime—having 90 days before us—we shall, I doubt not, be able to raise the necessary funds." Andrew underlined the next sentence with a strong hand: "<u>And, at all events, I will put you in funds, sufficient, before the lapse of the 90 days.</u>" Confident that the money could be quickly raised, Andrew offered to be the guarantor on the loan, ready to "pay down the $200" from his personal account on sight. "I wish you would let me know as soon as may be, what Judge Neale says. We shall raise the $200 easily if need be, I have already $150 subscribed."

Andrew's generosity came with one stipulation: that "Pruey and Evelina <u>immediately</u> come to Boston." To remain in Washington was to court detention as free people of color, and to be at the mercy of kidnappers and bondsmen, should John Cornwell's credit come into question. Andrew insisted that these women must not remain in Washington, even if Neale accepted the ninety-day loan. Wait three months, and the whole process could be undone.

In the last line of his letter from January 31, he made clear his commitment to the family, closing, as Neale had the day before, "They <u>must</u> be free."[10]

But Sumner sat on the promissory note for eighteen days. Both Andrew and Williams were "daily expecting to hear" from him "in regard to Evelina and the old Mother," Andrew wrote Sumner, "You have never told me what the Judge has decided on." Andrew wondered if the delay had to do with money and overstepped boundaries, so he sent his assurances by frequent post: "If need be, you can draw on me, at sight, for the $200, for their free papers, so as to let them come on with Elizabeth and the children, this week." Andrew's letters appeared to be written with increasing passion or haste. His handwriting became larger, the underlined words are more frequent, and his tone more forceful and effective.

Andrew offered nothing but solicitude for John Cornwell, who

had endured a "painful and arduous" legal battle to maintain his prop-
erty. *Cornwell v. Weedon*—resolved "in the Tribunal of last resort,"
that is the Virginia Supreme Court—had lasted "as long as the siege of
Troy—9 yrs"! Andrew felt that Cornwell had accepted this undertak-
ing because he hoped "to maintain the will, for the good, certainly, in
part, of the people in question." When the case resolved in his favor,
Cornwell assumed it would be for his own good as well. Andrew felt
that the sum of one thousand dollars for Prue, Evelina, Elizabeth, and
the children was fair "in view of his trouble."[11]

This thousand dollars, paid to John Cornwell in January 1855
(approximately $27,000 in today's dollars), was a windfall for a clerk at
a hardware store. Sumner was right; Cornwell had been lucky to secure
any price. He had not lived with Prue since they shared his grandmoth-
er's roof thirty years earlier. He might have even welcomed release from
the duty of supporting her into her old age.

Without any fanfare, Sumner forwarded Andrew's two-hundred-
dollar banknote to Neale and received in receipt a final letter from the
judge: "I am much gratified to find that Evelina, and her poor old Mother,
have found such kind and liberal friends."[12] Neale left a door open to
Sumner's friendship: "It will give me, great pleasure to call on you, when
the weather settles, and equally happy shall I be, to have you under our
Roof, promising you, plain Virginia fare, and a cordial and affectionate
welcome." There is no evidence that Sumner took the judge up on his offer.

In the last week of February 1855, Evelina, twenty-nine, and her
mother, Prue, sixty-four, were freed by John Cornwell's signature.

◆

More weeks passed without word from Sumner, and without the fam-
ily's expected reunion in Boston. Sumner's letter to Andrew of January
30, three days after he met Elizabeth, is lost, but Andrew's cautioning
reply is not. Sumner indicated that he was in no rush to send the family

on. Andrew responded, "I hope Elizabeth and all the family will leave much sooner than . . . indicated if possible." Andrew underlined: "They must not be allowed to continue slaves."[13]

It is unclear where the family stayed while in Washington. They had family, friends, and a former master nearby, but these people mostly lived in service to other families, so a party of six women and children would not have been welcomed. In one letter, Andrew asked Sumner to "send" an enclosed letter from Seth to Elizabeth, suggesting that they were not staying at Sumner's residence on H Street: "I enclose a letter for Seth, which please send to Elizabeth. He wants her to write to him, and feels disappointed that she has not already done so, since her stay has been prolonged."[14]

There is much discussion of payment of board, but to stay at a hotel unattended would have put the family at no small risk. The women and girls could pass for white, but Oscar could not, so their options were limited. They could not be seen out of doors after ten o'clock at night. All free persons of color were required to register, annually, in the district and to carry on their persons at all times "satisfactory evidence of their freedom." A free person of color could be called upon at any time "to establish their title to freedom," and if found without papers, they could be "committed to jail as absconding slaves."[15]

Andrew did not receive a reply. Twice more he wrote to request that Elizabeth and the children make their way to Boston "immediately."

The following Monday morning Sumner let Andrew know that the family was fine. Andrew replied that he was "much pleased" but added, "I hope to see Elizabeth and the children as soon as possible." Though Andrew had never met the family before, he expressed personal satisfaction and a "natural" curiosity to meet the people who had been his concern for nearly four years.

Andrew's curiosity was nothing compared to Williams's yearning to see his family: "Seth awaits their arrival with the natural anxiety and impatience of a husband and father." Andrew told Sumner that he had

shared his letters with Williams, who enjoyed "your letter's description of his children—he heard it with much delight."

Why did Andrew feel the need to remind Sumner—who was never a father—of Williams's emotional claim to Elizabeth, Oscar, Mary, and Adelaide? His daughters' light skin color raised doubt about his paternity, notwithstanding his tireless efforts to recover all three of his children. Andrew took this opportunity to remind Sumner that Williams's relationship to his wife and children was "natural"—in the context of the slave system—and that his anxiety and impatience to be reunited with them ought to be afforded respect.

Meanwhile, Sumner had decided that this family could stand as a compelling claim against race-based enslavement, as he intimated in his letter of January 29. Andrew reminded Sumner that Williams's emotional claim on his family superseded Sumner's political plans to exhibit them in Washington and elsewhere. It was difficult, after four years separation, to be expected to wait for a reunion that seemed so near.

Henry Williams was ready to take matters into his own hands if he did not see his family soon. Nearly every day in February, as he awaited news of his family's arrival, he stopped in Andrew's office on Court Square to solicit news. Every other day, Andrew passed those solicitations on to Sumner in Washington. Andrew repeatedly apologized for the favors he asked of Sumner, but his letters suggest no such timidity in Williams's demands. Even when ventriloquized by his lawyer, as Williams was in these letters, his presence was commanding and sure: he wanted to hear from Sumner "at once," he "reminded" Sumner of his failure to report on the entire family, and his word was his bond, as "friends here will take the word of Seth" as credit for hundreds of dollars.

According to Andrew, Williams "<u>was</u> intending, when we rec'd your letter, to leave for <u>Washington</u> himself, and accompany the family in person." And why not? His own free papers were not in question. He could travel freely to Washington, and his wife could freely travel out.

But his employer, George Young, had requested that Williams remain at his position until Young returned from a trip abroad. Williams would wait until Mr. Young returned.

◆

Prue complicated the delay. Her three sons—Albert, Jesse, and Ludwell—remained enslaved to John Cornwell and hired out in Washington for the year 1855. Prue refused to leave Washington without them. Williams knew she meant what she said, and that her choice to remain behind might also be Elizabeth's choice. So Williams applied the full force of his charisma toward securing the freedom of his brother-in-law, Ludwell. He expanded the scope of his efforts to include the emancipation of his wife's entire family.

Andrew conveyed a message from Williams to Sumner: "Seth wishes me to remind you that we have never heard, whether Judge Neale has fixed on any terms in regard to Jesse, Albert, and Ludwell.— He is very desirous to get Ludwell—the youngest boy. And he wants to know, at once, if you can tell, what Sum will buy him. He thinks the money can be got from friends here who will take the word of Seth that he and Ludwell will earn and repay the amount." Andrew added his endorsement, though he had never met Ludwell: "Ludwell can work out his freedom. Seth speaks of him with a good deal of affection and confidence in his character and capacity."

Should Judge Neale or John Cornwell be "unreasonable with the three men—the sons of Pruey," Andrew warned, they ought to drop the "confidence in this Judge and his client which I now feel" and initiate legal proceedings.

But Neale had already begun negotiations with Ludwell's hiring manager, "a Washington Merchant," to buy out the remaining nine months on his 1855 hire, offered in exchange for Ludwell's immedi-

ate release. John Cornwell signed the free papers for $300, plus $10 for Neale's expenses, "for preparing the deed, &etc. &etc."

Please make the best bargain you can with the Judge; & I will pay $300—(to be in full for expenses if at all possible)—the very day I may be called upon. Of course, I should like to have the draft as long, as may be; but, I will consent that you should draw on anytime, however short—even three days, I will advance the money, myself if need be.

Thank you for your letter of March 1st, covering the information, on which my proposed action herein is based. The work is already commenced of raising the $300 for Ludwell. Have him on my heart a good deal—because I felt the pathos of Elizabeth's letter to Seth, in which she speaks of her mother's unhappiness at the ~~thought~~ idea of leaving her youngest born in slavery, and with the thought that she might see him no more.—He is the Benjamin of her flock. I rely on you to bring him with the rest of the family, when they come.—

Albert and Jesse have no need, I should think, to remain slaves. When John Cornwell dies they will be much harder to buy. Can't they make any arrangement, which would secure to them freedom? Can we not aid them, in any way?

Yours Faithfully,
J. A. Andrew

—John Andrew to Charles Sumner, March 3, 1855[16]

Andrew and Williams seem unaware that Jesse Nelson had already initiated legal proceedings in an individual suit for his own freedom. Unwilling to wait any longer for the Virginia Supreme Court or John Cornwell to do right by him, Jesse, at twenty-six, sought the freedom to work for his own compensation. In the six years since his stay in the Yellow House, he had been hired out to work for the profit of John Cornwell.

In his case, Jesse Nelson, nominally a "man of color," sued John

Cornwell for his freedom. The optics of this case are worth noting: to all appearances, Jesse Nelson's freedom suit against John Cornwell featured a black defendant fighting for his right to the proceeds of a white man's enslaved labor.

On March 18, 1854, Caty Appleby was called, once again, to Alexandria, to the office of Judge Neale, to serve as a witness for her nephew. Caty told the story of her visit to Bruin's jail and the Yellow House a few years prior and its happy result. The Yellow House had closed in 1850, along with every slave jail in Washington. The Compromise of 1850 had ended slave trading on the "neutral ground" of Washington. That business had been flowing into Alexandria, making Joseph Bruin a very rich man.

After Caty related her testimony, Judge Neale asked her a leading question: "Is, or not, John Cornwell, the defendant in this cause related to Jesse and Albert, and if he is, what is the nature thereof?" The recorder of this testimony highlights this question, number seven, with a bracket.

Caty's answer: "He is in no manner related to them, or either of them." Now a woman in her sixties, she had testified more than a dozen times in thirty years on the subject of her mother's slaves.

The justice of the peace, Robert Hunter, confirmed that though the judge's offices were kept open all day to receive depositions on behalf of Jesse Nelson, no one had come. Jesse lost his suit.[17]

On March 6, 1855, Judge Neale promised to try to accomplish for Jesse and Albert what he had for Ludwell. "If I fail in this, I promise you, that he shall be free and so shall all of them, according to my original promise to these poor creatures."[18] Judge Neale's promise of her sons' imminent release—"It shall be <u>done</u>"—convinced Prue to leave Washington.

John Cornwell did not free Jesse or Albert Nelson until July 1856. These young men were the most valuable members of the family, as no doubt their father had intended by their careful training. They were the first to be sold and the last to see freedom.

PART THREE

BECOMING IDA MAY

◆

8

Mary Hayden Green Pike

◆

Calais, Maine, November 1854

Charles Sumner was charmed by Mary's older brother Oscar, when he met him in Washington after their manumission. Oscar, at ten years old, was "bright and intelligent, [with] the eyes of an eagle and a beautiful smile." When Sumner first met Oscar, he asked: "You are free, young man. Do you know what that means?"

Oscar replied, "I now belong to myself."

Sumner laughed. "Well! There is a definition which philosophy might borrow."

On February 13, Sumner divulged his plans for Henry and Elizabeth's children: he would launch a publicity campaign around Oscar's "bright and intelligent" little sister, Mary. He chose Mary for her light skin color and her vulnerability to trafficking in the sex trade in young enslaved girls.

Sumner sketched out a campaign around Mary's appearance: first

she would be photographed, then her daguerreotype would travel northward to be copied and displayed. The entire family would be publicly exhibited as they made their way north, first in New York and then in the State House in Boston, where Mary would be presented to the legislature. Sumner would join them in April, at the close of the senatorial session. He would present Mary at his lecture in Tremont Temple in May.

In his response of February 16, Andrew gave his support to Sumner's plan: "I feel also desirous that Members of the legislature shall have a sight of those children." He agreed with Sumner that they would add "impressiveness" to the business then under way in the Boston State House. A petition was circulating to render the Fugitive Slave Law ineffectual in the state of Massachusetts. The other high drama on the docket that spring was the removal of Justice Edward Loring from office: the judge had mishandled, in popular opinion, the trials leading to Anthony Burns's rendition.

As for Henry Williams, "He is very anxious to see his family; but, he is willing to submit to your judgment." Three days later Williams stopped by Court Street to let Andrew know that, over the weekend, he had arranged for his family's luggage to be shipped to his workplace.

Boston, 4 Court Street,
February 19, 1855

Dear Sumner,

 Seth calls in to say that, when his folks come, they may put their baggage in charge of <u>Adams Co's Express</u>.

 That will save all trouble to them, weary her person, from the care of it, and Adams & Co. will probably bring it free of expense.

 It should be directed

 "Henry Williams—

 <u>*Cornhill Coffee House*</u>

 <u>*Boston"*</u>

"Care of Adams & Co. Express"

That being the name he wears in Boston, having adopted it, when he was a fugitive.

Yours Faithfully,

J. A. Andrew[1]

The speed at which Sumner moved on his plan suggests that he intended to act first and ask permission later. That same day he sent a letter and Mary's daguerreotype to Dr. James Stone, fully expecting Stone to send the letter to the press.

Washington, Feb. 19, 1855.

Dear Doctor—I send you by the mail the daguerreotype of a child about 7 years old, who only a few months ago was a slave in Virginia, but who is now free by means sent on from Boston, which I had the happiness of being trusted with for this purpose. She is bright and intelligent— another Ida May. I think her presence among us (in Boston) will be a great deal more effective than any speech I could make.

Meanwhile I send this picture, thinking that you will be glad to exhibit among the members of the Legislature, as an illustration of Slavery. Let a hard-hearted Hunker look at it and be softened.

I send another copy in a different attitude to John A. Andrew. Her name is Mary.

Ever yours,

CHARLES SUMNER.

P.S. Such is Slavery! There it is! Should such things be allowed to continue in the City of Washington, under the shadow of the Capitol?

—Charles Sumner to Dr. James Stone, February 19, 1855[2]

Notice that Sumner did not mention Mary's color directly but instead alluded to "another Ida May." Ida May was the title charac-

ter of a sentimental antislavery novel by Mary Hayden Green Pike, which had been published under the pseudonym Mary Langdon three months previous.

Widely considered the successor to the enormously influential *Uncle Tom's Cabin*, Pike's *Ida May* was an immediate success, selling 10,500 copies on the first day, 11,500 by the end of the week, and 60,000 copies by the end of the season that Mary shared its spotlight. A celebratory review of *Ida May* published in the *Boston Telegraph* and reprinted in *Frederick Douglass's Paper* said this book was capable of providing a national "moment of clarification or illumination" and so bringing a generation of readers to antislavery: "We believe that IDA MAY is but one of a series of books which will successively electrify the reading public, and quicken the impulses of all right-thinking men and women."[3]

Ida May's release had to be delayed, twice, because the printers could not keep up with demand. After finally hitting the bookstores on Thanksgiving 1854, it outpaced every other book that Christmas—even an autobiography by circus man P. T. Barnum. The year *Ida May* sold 60,000 copies, Charles Dickens sold only 70,000 copies of *Hard Times* by the end of the run. Solomon Northup's *Twelve Years a Slave* sold approximately 27,000 copies in two years, 1853 and 1854. During his lifetime, Herman Melville sold a total of 35,048 copies of his novels.[4] The audience for sentimental antislavery novels, a genre dominated by white women authors, was unmatched in the mid-1850s.

The *New York Evening Post*'s celebrated editor William Cullen Bryant received an advance copy of *Ida May* from his friend, the publisher and marketing genius J. C. Derby (who had also published *Twelve Years a Slave*). On November 11, 1854, the *Evening Post* ran—on the front page—four columns of extracts from *Ida May* and its first review. Bryant initially made a strong claim that the author of *Ida May* was Harriet Beecher Stowe, saying, "No other living author could have written it."[5]

Days later, the publisher Phillips, Sampson, & Co. thanked the paper for the complimentary association with Stowe but affirmed that *Ida May* was "the production of an author as yet unknown to fame."[6] The *Post* retracted, but the debut made *Ida May* newsworthy, and the hunt for its author continued. They had "puffed" *Ida May* onto the bestseller list.[7]

We were remarking only a few months since that the most popular living novelists, in the strictest sense of that term, were women; that the fictions of American females had attained a wider circulation than those of either sex of any other nation. The author of Ida May *strengthens that supremacy, for it is admitted by the publishers that this is her first book, and that she is a recruit to the already strong array of talented women engaged among us in writing fiction. Why her name is longer suppressed we can only conjecture. It is probable that her relations with the South are of such a nature as to indispose her to any more personal notoriety than is inevitable.*

—New York Evening Post, *December 6, 1854*[8]

Meanwhile the author, Mary Hayden Green Pike, was at home in Calais, Maine, protected by the privacy of her pseudonym "Mary Langdon." She was busy supporting the nascent political career of her husband, state senator Frederick Augustus Pike, who supported the gradual abolition of slavery.

However, Mary Pike did not agree with her husband's political conservatism; her view was far more radical.[9] She hoped her books would do the good work that she could not. In doing so, she joined the ranks of women novelists who turned to writing to influence a political sphere that was not open to them. When Senator Sumner spoke of her book with such familiarity, she had proof that she hit her mark.

◆

Mary Hayden Green was fourteen when the seed of her politics was planted. A young agitator named Ichabod Codding came from Vermont to her small town of Calais, Maine. Sitting on the edge of an immense wood and an icy river, Calais was a small forestry town that waited for the summertime, when the St. Croix River brought people and ideas from other places.

Ichabod Codding was in his second year with the American Antislavery Society, and two years out of Middlebury College, when he arrived in Calais in the summer of 1838 to speak to those of its two thousand residents who would listen to his message.

Mary Hayden Green Pike, portrait photograph, date and photographer unknown.

Upon his arrival in Calais, no town hall, schoolhouse, or church would host his lectures. He rented a small private hall and lectured for three evenings to increasing audiences on the "sin and wrong of negro slavery." On the fourth evening, Deacon Samuel Kelley invited Codding to speak from the pulpit of the Calais Baptist Church that weekend, where Mary and her family were pew-holding members.

The following morning, a town meeting was called. Local politicians feared that Codding's uncanny gift for influence might pull their constituents to the left of the Whig Party. Local ministers feared Codding could be a revivalist in abolitionist's clothing, intent on bringing the Great Awakening back to Calais. They met at the church, a half hour before Codding was scheduled to begin, "to consider the question of allowing him to proceed."

Both sides of the question were presented. "This fellow ought to be ridden out of town on a rail," a local minister insisted.[10] Reverend

James Huckins's church was filling with antislavery fire, and Deacon Kelley had invited it in without asking permission. Huckins said Codding owed him an apology "for the farce and buffonery of the evening before, and . . . for desecrating his house." A local lawyer, "Mr. Chase," offered resolutions for the town to consider. First, "Slavery was an evil in the abstract, but that we had nothing to do with it." Secondly, "agitation disturbed the South and endangered the Union" (and, it went without saying, forestry profits). Third, the abolitionists had no right to disturb their peace or the sanctity of the Union. And finally, it was their duty to use all lawful means to stop abolitionists, those "enemies of the republic." Mr. Chase then called on Calais to close all public houses to the abolitionists, and more immediately to Codding. The townspeople should vote for peace and prosperity with their feet and stay at home, giving Codding and his ilk no countenance.

Codding had anticipated this move against him—he'd seen it before. During his very first lecture on this tour, in Brighton, he had been pulled from the podium and down the aisle to a mob waiting outside the church. Congregation members saved him, and from that he learned boldness. Now in Calais, hat in hand, the young man requested the opportunity to speak on his own behalf. Once he had the podium, he commanded the town's attention "and having got the floor, used his time to good purpose," delivering a ninety-minute lecture on slavery.[11] Chase, Huckins, and a lawyer named Bradbury tried to incite a general run out of the church, but Codding's audience remained.

The following Tuesday evening, the scene reconvened, with the same result. The debates resumed to crowded houses on Wednesday and Thursday as well, until every town member had committed, battle-hardened, to a position. His speeches were "howled down with attempts to intimidate him." On Friday, a vote was tallied for Chase's resolution to run Codding out of town: yeas, 68, nays, 85. Unhappy with the result, "a set of desperadoes called 'the Indians,' from the fact that, dressed as Indians, they committed acts they dared not commit

in their real characters," rushed the church, clearing it with rotten eggs and "shouting, yelling, howling, like so many demons from the infernal regions."

Mary Green saw her town consumed. When she was twelve, she had been baptized in the dead of winter, a hole cut in the ice for her holy immersion. Now she was baptized in fire. She sat with her family in their pew, rapt with attention and pride that Codding could deliver his lecture, unmolested, in her church.[12]

Codding's early oratory has survived only in pamphlet form, hastily recorded by those who heard him. In one early lecture, he took as his text, "Train up a child in the way he should go." When he spoke in a church, he followed the conventions of the sermon, which was to begin with exegesis, or to locate God's design through the careful exposition and practical application of a biblical passage to contemporary life.

This commandment comes home to the heart of the slave father: he looks around upon the little children that God has given him . . . Oh, how he burns with internal fire to educate their moral and intellectual nature, and fit them for usefulness here and for that state of being that shall come after. He obeys by commencing to teach his child to read; the slaveholder comes in and says, "Not a letter shall that child learn." The slave replies, "God commands me to do it." The slaveholder retorts, "I will show you to whom that child belongs; I own it as I own the pig in the sty"; and the master proves his superior authority by triumphing over the express command of Jehovah. What a principle is here! . . .

The principle, then, is settled, that chattel slavery, absolutely, so far as the slave is concerned, does overrule the direct command of God, and asserts more than God dare assert! If the principle is settled that God cannot rule over all, then it is settled that he cannot rule over any. If I say, here is a portion of the human family over which God may not reign—it is settled thus with regard to the slave, it is settled with regard to all men; and if God reigns over others, it is by express permission of the chattel

*principle. It must be seen, then, that if God has no right to rule over any,
he is no God: this would be No-godism—ATHEISM! . . .*

*For when I discover the massive moral power of these large and influ-
ential bodies pressing with ponderous weight upon the prostrate forms
and crushed hearts of my Father's children, and hear their suppressed
sighs and groans, and see them striving, and struggling, and surging
beneath the awful incubus, and all in vain, I must and will cry out,
GET OFF—IN GOD'S NAME, GET OFF!*

—*Ichabod Codding, December 6, 1850*[13]

No expository sermon is complete without its exhortation. Mary's
father, Elijah Green, left with other members of the Calais Baptist
Church to found a new congregation of like-minded members who saw
abolitionism as inseparable from faith, and slaveholders as atheists and
barbarians. According to the *Annals of Calais*, Codding left on Monday
with fifty dollars for the causes of the slave, while Huckins left his post
as minister to serve a more amenable congregation in Texas.[14]

The abolitionists won that round.

Ichabod Codding's mission to Calais was but a single, forgotten epi-
sode in a full-scale campaign; this scene was replicated in towns across
the Northern states. Where abolitionists could not show up in person,
they sent pamphlets by the hundreds. One hundred and fifty slave nar-
ratives survive, and more surely wait to be found. Dozens of petitions,
each with its own audience—Methodists, young children, Southerners,
women—can be found in archives. Whole newspapers and subscription
weeklies were dedicated to the cause. Abolitionists produced novels,
children's books, Christmas annuals, poetry collections, and short sto-
ries. Theirs was a mission conducted in words. The Pike brothers, James
Shepherd and his brother Frederick, funded a library to keep the Calais
community current on the circulating materials vital to American poli-
tics in the 1840s.

Mary Green and Frederick Pike were a like-minded match. They

were married when Mary was twenty-one. Frederick became editor of
the local paper, then mayor, then state congressman, and then represen-
tative for Maine in the U.S. Congress. Mary wrote three novels in five
years. They adopted ten-year-old Mary Sterns, Mary's second cousin,
whose father had died in a steamboat explosion. They used the pro-
ceeds from Mary Pike's first novel, *Ida May*, to build a stately home
on Main Street in Calais. Her second novel, the mixed-race romance
Caste: A Story of Republican Equality (1856), was published under the
pseudonym Sydney A. Story. This second novel, which dealt with racial
inequality and prejudice head-on, did not sell well, though Mary's hus-
band claimed its failure might be due to the change of pseudonyms.[15]
He demanded that her publisher take her third novel, *Agnes* (1859),
a historical romance that featured the racial discrimination faced by
Native Americans during the Revolutionary period. The publisher
revealed Pike's name on the title page, adding that she was the author of
Ida May, in the hope that her notoriety would help sales. It did not, and
Pike wrote only one further piece for publication, a memorial to John
Brown, then returned to her watercolors and her husband's political
career. In 1870, fire destroyed the stereotype plates for her novels, and
she chose not to take on the cost of replacement. By 1910, her obscurity
would be complete.[16]

◆

Shortly after Mary Pike's name appeared as *Ida May's* author in *Agnes*,
the abolitionists Sally Holley and Caroline F. Putnam visited her at her
home in Calais for the *Liberator*.

Calais, 30th. The authoress of Ida May, *Mrs. Pike, has just left us, after
giving us an hour's entertaining and animated conversation. She resides
in this place, and her husband, a member of the State Senate, gathered a
fine audience for Miss Holley last evening. Mrs. Cooper, with whom we*

have a delightful home, and Mrs. P[ike], with another Maine lady, spent
a winter in South Carolina, as invalids, a few years since, when Mrs.
P learned much which suggested to her the narratives of Ida May and
Caste. She has given us this afternoon many reminiscences of that South-
ern winter—some shocking atrocities which she could not shut her eyes
to. How so do many Northern ladies visiting South? Once the Mayor of
Aiken, S.C. waited on these ladies with a warrant! They were addressed,
"Ladies, you are suspected of being Abolitionists!" Their landlord soothed
the alarm of the town by favorable reports of their demeanor, and they
were suffered to remain.

—*Caroline F. Putnam, October 21, 1859*[17]

Writing *Ida May*, which takes place primarily near Aiken, South
Carolina, had helped Mary Pike process the "atrocities" and scenes that
she had witnessed as a well-to-do white visitor there. The title page of
the American editions of *Ida May* quotes John 3:11: "We speak that we
do know, and testify that we have seen." The conclusion of the verse is
implied: "and ye receive not our witness." In the preface, Pike warned
her readers that the descriptive passages in *Ida May* "will be recognized
and accepted as a true picture of that phase of social life which it repre-
sents." She was no parlor abolitionist, no mere invalid sent south for the
air; she was an undercover investigative reporter who had traveled deep
into slaveholder territory. She wrote scenes that directly confronted the
circumstances of slavery in the places where she saw it.

In the novel, five-year-old Ida May is kidnapped from her white,
middle-class family in Pennsylvania. In the first forty pages, she is
beaten, stained a light brown, and sent south to be sold into slavery. Dur-
ing the journey, she is knocked unconscious by blows and by laudanum.

Ida loses her name and identity in this bloody transformation, when
she is too young to remember herself. Traumatic amnesia keeps her
from discovering her true heritage until five years later, when her mas-
ter (and future husband), Walter Varian, reads her name on a treasured

piece of monogrammed fabric that the illiterate Ida keeps hidden on her person. This identification had escaped notice, as none of the slaves on that plantation could read, but Ida's surrogate mother in slavery, Aunt Venus, carefully saved it as a token of who Ida once was.

Pike's most complex, righteous characters in *Ida May* are black women—Venus, Chloe, and Abby—whose children were also taken from them by slaveholders. Her title character is white. The *Liberator*, in its review of *Ida May*, thought Pike's reworking of the antislavery novel's tragic heroine as a white person to be a masterstroke, as she "ingeniously" courted white sympathy with the bait of a truly white child (not a near-white child) "subjected to all the horrors of slavery."[18] Therefore it is through the clouded lens of selective solidarity that we should read this extract of Ida's darkest ordeal in the kidnapper's den, which was widely reprinted in newspapers.

In one side of the cavern a few rude stalls had been constructed, and here the three horses of the kidnappers were tied, while, on the other side, huddled together on a heap of straw, were six negro children, who had been stolen within a few months from different parts of the country, and brought here for safekeeping, until a sufficient number were collected to fill the wagon, and make it worthwhile to proceed southward with them. It was pitiable to see the condition to which these children had been reduced by their confinement in this dark place, and the discipline that Chloe had found necessary to make them docile and fit them for the condition of slavery into which they were to be sold. True, they had been fed daily with wholesome food, and taken out separately for exercise, under the care of their jailer, who knew that her masters wished to find them in good saleable condition; but being seldom washed, they were all more or less dirty and ragged, and in their faces the careless gaiety of childhood had given place to the cowering expression of abject terror. They had evidently been well "broken in," and would make no opposition to whatever fate might await them.

"*Well now, my little dears,*" *said Bill, ironically, as held the candle close to their faces, "a'n't ye tired of stayin' in this dark place? Won't ye like a little ride by way of variety?"*

The children shrank together, as if for protection, but made no reply, until one of them ventured to ask, in a timid whisper,

"Will you take us home?"

*"No, my little dears," replied Bill, "couldn't do that nohow; 't wouldn't be convenient jest now. Besides. We're goin' to do better than that for ye; we're goin' to sell ye to some nice man, that'll be kind enough to larn ye what yer ought to do, and take care o' yer; and yer can't think how much better off ye'll be than if yer was to be home, where ye'd have no good master, nor be nothin' but a poor devil of a free n**r when ye got growed up. Yer can't think how happy yer'll be. We be your real benefactors; 't a'n't many folks 't would take the pains we does, all for nothin' hardly but your good. Yer ought to be thankful to us, instead o' snivellin' that way. But folks is allers ongrateful in this world, especially n**rs," he added, rolling up his eyes, and laying his hand on the place where his heart was supposed to be, with a gesture of mock humility and resignation. Chloe laughed aloud, but Kelly, who was not in a mirthful mood, said gruffly, "Come, now, stop your foolin'. We've got some work to do tonight, and the sooner we're at it, the better."*

*"Foolin'! me foolin'!" said Bill; "I never was so serious in my life. I'm tryin' to enlighten these little heathen,—kind of a missionary preacher like, ye know,—to show 'em the blessings o' slavery, that they've been growin' up in ignorance of. I hearn' a minister preach about it once, at Baltimore, and he proved it all right out o' the Bible,—how slavery was what the Lord made the n**rs for, and how them was particular lucky as was slaves in this land o' light and liberty, where they was treated so much better 'n they would be if they was in Africa, and all that. I can't remember jest how 't was done, but I know he give it to the abolitionists powerful, for trying' to disturb 'em when they was so happy, and he proved out o' the Bible, too, how they ought to send 'em back, instead o' helping 'em away."[19]*

"*Out of the Bible!*" *replied Kelly, who had been putting the harness upon the horses, in which occupation he was now joined by his companion. "Yes, it's enough to make the devil laugh to see what some folks will try to prove out of the Bible. If there is a God, and if he made that book, as they say he did, I reckon he feels might nigh used up, when he sees some of the preachers get up in the pulpit, and twist and turn his words all sorts of ways, to prove what will be most for their own interest out of 'em. For my part, I don't believe in any such things hereafter, as they tell for; but if there is, won't some of these confounded humbugs have to take it?"*

"*P'rhaps they will,*" *said Bill, laughing; "and p'rhaps some other folks will stand a smart chance o' takin it, too.*"

"*Well,*" *replied Kelly, with a faint smile, "I believe I have a right to do as I'm a mind to, and I do it; and if I can make more money tradin' n**rs than any other way, I'll do it, just the same as the wolf eats the lamb when he's hungry; it's a law of nature, and always will be, for the strong to prey upon the weak; but I tell you what, if I did believe those things, and then shut my eyes and served the devil, I wouldn't try to cheat myself and other folks into thinking the Lord would be fool enough to believe I couldn't open my eyes if I wanted to, and so let me off because 't was a mistake.*"

Meantime, the horses were harnessed, and the two men proceeded to change their clothes, assuming suits of quakerish gray and broad palm-leaf hats. Then, sending Chloe for a basin of water, they took off the wigs that covered their heads, to which Kelly added the black eyebrows, mustache and whiskers, he had hitherto worn, and washed their faces thoroughly with soap, thus removing from the skin some dark substance that had colored it, and showing them both to be men of light complexion. Kelly especially, whose hair was nearly red, could never have been recognized as the person whom Bessy had seen carry away her beloved charge. He laughed a little as he surveyed the altered person of his comrade, who, in his turn was regarding him. "I've worn those things so long," he said,

pointing to his discarded disguise, "that I shall feel strange without 'em.
But come on; go out with the horses, and by the time you get 'em har-
nessed and come back, I shall have the little miss ready. As for the dark-
ies, they don't need any preparation."

Bill led out the horses through the hut, first flinging across their backs
some sacks containing provisions; and, as it was now so late that he was
almost sure of meeting no one, he proceeded fearlessly down the path.
Kelly returned to Ida, who still lay on the bed as they had left her, and,
taking off her outer garments, he cut her hair close to her head,—those
beautiful ringlets that had been the pride of her fond parents. He stained
her skin with a sponge, dipped in some dark liquid, until it was the color
of a dark mulatto, and then dressed her in a suit of boy's clothing which
Chloe produced at his request. Then, bringing out the negro children,
he tied their hands behind them, fastening their arms together in such
a manner that each might support his neighbor's steps while walking,
and, passing a rope between each pair, he gave one end to Chloe and the
other to Bill, who had now returned, and in this way, with the children
between them, they left the hut, Kelly following with the almost senseless
form of Ida in his arms.

—*Mary Hayden Green Pike*, Ida May:
A Story of Things Actual and Possible *(1854)*[20]

The six black children in this passage, roped together as they leave
a cave of torment, are nameless and faceless. They are utterly unrecover-
able. The ratio of black children kidnapped to white is six to one, but
the single white story is told in 453 subsequent pages.

Pike reminded readers on the following page that Southern families
kept to themselves: "adjoining plantations, and even adjoining houses,
are generally ignorant of everything that happens on a neighbor's prem-
ises, except what the white members of the family may choose to tell."
Privacy protected the slaveholder. If these anonymous children were
bought into a slaveholding family, no one would ever know that they

were stolen. They would be made invisible by sale and transport out of the community that knew them as free.

Kidnapping strikes terror in a parent's heart, and this emotional response has been encoded on the page. Like a horror movie that deploys swells of sound and darkened hallways to mount our adrenaline response, sentimental fiction like *Ida May* makes us weep for the vulnerability of our own children. The author, like her predecessor Harriet Beecher Stowe, wrote carefully calibrated scenes that intended to move her audiences to tears, and from tears to righteous indignation. Read again the children's one and only line, set apart as it is on the page, alone:

"Will you take us home?"

The page fills the reader with pathos for these children and hatred for their captor, Bill, who launches into facile racism, pro-slavery arguments, and coarse language. His response makes the blood boil. When Pike conjured this scene from her home in snowy Calais, whom did she think Bill was lecturing to, with only this cave of trembling children and partners in crime to hear him? Her growing audience, at home and abroad. Northern men and women. White Americans, to goad them to political action. Her future readers, who might not remember the tragedies borne.

Us.

9

Julian Vannerson

◆

When she visited the daguerreotypist for the first time, Mary Mildred Williams wore a plaid wrapper with a simple clip at the waist. The bodice had three folds of fabric with lace trim that layered over a skirt that fell past her knees. The skirt had a light lift from the pleats and petticoat. The plain sleeves and neckline of her day dress were augmented with lace inserts. The dress bunched uncomfortably under her arms. She had to tug at it carefully, so as not to undo the buttons up the back. She had a choker-length chain around her neck, without a pendant, and two thin bands of gold on her left hand. Her hair was natural, falling in soft ringlets from a neat part down the center. If she did not set her head just right, the curls that framed the right side of her face might fall into her eyes and ruin the exposure.

Mary was daguerreotyped at the most convenient and likely place in Washington: Vannerson's Gallery, located on the second floor of

Lane and Tucker's Building, between Four-and-a-half and Sixth streets, at what is now around 424 Pennsylvania Avenue at Seward Square.[1] Twenty-nine-year-old Julian Vannerson had just opened his solo venture blocks from the Capitol in a space with skylights made from two hundred feet of glass.[2] The skylights offered the perfect lighting for natural-looking portraits, exposing the subject softly from above and from the side—provided the subject arrived between eleven and two o'clock in the afternoon on a sunny day. Like Mary, Julian Vannerson was from Virginia. His older brother Adrian had learned photography when daguerreotypy was new, in their hometown of Richmond. It was the family business.

Vannerson's studio, situated in the heart of Capitol Hill, did fine portraiture of public men in paint, pastel, photograph, and watercolor. He invested in patents for the newest technologies and entered competitions for the most prestigious awards.

PATENT AMBROTYPES

Can only be obtained at

VANNERSON'S GALLERY

No. 424 Pennsylvania Avenue.

NO AMBROTYPE, *possessing any degree of durability, can be procured at any other establishment in this city, as Mr. Vannerson is the only artist in Washington who has secured from Mr. Cutting the right to apply his process in their production.*

Mr. Vannerson returns his thanks for the very liberal encouragement he received while conducting the "Whitehurst Gallery" for the last five years and solicits the patronage of his friends and the public at his New Gallery, where he has greater facilities than formerly for producing fine portraits, with all the latest improvements in the art of making Daguerreotypes, Ambrotypes, Photographs and Portraits in Oil Colors, on Enamelled Mill Board and Canvass, in Water Colors and Pastille.

Mr. Vannerson's work has received the highest encomiums wherever

*it has been exhibited, and taken Premiums at the World's Fair held in
London, at the Crystal Palace Exhibition in New York, at the various
Fairs of the Maryland Institute in Baltimore, and at the Exhibitions of
the Metropolitans' Mechanics' Institute, held at the Patent Office of the
United States and at the Smithsonian Institution in Washington.*

*Mr. Vannerson devotes his personal attention to all sittings, and his
Gallery, Laboratory, and Operating Rooms are all upon the second floor.*

*Small Daguerreotypes enlarged to any size, and particular care
paid to the copying of Paintings, Drawings, Statuary, and articles to
be patented.*

—*Advertisement in the antislavery newspaper,*
The National Era, *March 5, 1857*

In early 1855 Brainard & Co., a publishing house based in Boston,
began using Vannerson's studio to produce portraits for *Brainard's Portrait Gallery of Distinguished Americans.*[3] Powerful men in Washington,
including Senators William H. Seward and Stephen A. Douglas, the
antislavery representative from Ohio Solomon Foot, and Washington
mayor John W. Maury had had their daguerreotypes made for Brainard's folio by Julian Vannerson that winter. Of the nineteen portraits
drawn on stone by Leo Grozlier, the preeminent lithographic artist,
seven are based on Vannerson daguerreotypes.

Sumner appears to have called on the folio's young publisher,
Charles Henry Brainard, to arrange the photograph of Mary and her
subsequent tour of the East Coast. As a collector of fine engravings,
Sumner provisionally extended his regard for Grozlier to the Virginian Vannerson. Not one corner of Sumner's walls was free of the work
of fine engravers—depicting cathedrals, landscapes, men—a passionate
collection that took up his leisure hours. He was so pleased with Mary's
portrait that he too sat for Vannerson.

In 1855 daguerreotypy was a technology on the wane, fast becoming a luxury item, as newer, faster, and cheaper forms of photographic

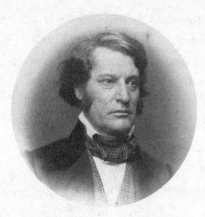

Senator Charles Sumner, portrait photograph by Julian Vannerson, for *McClees' Gallery of Photographic Portraits . . . of the Thirty-Fifth Congress* (1859).

reproduction were coming into the market. Among them was the ambrotype, a collodion positive process printed on glass, affixed with balsam, and visible against any black backing. Vannerson advertised the ambrotype as one of his specialties after obtaining the patent in 1854. After twelve years of Daguerrean supremacy in the United States, new photographic patents and technologies arrived within weeks of one another. The medium developed so quickly in the 1850s that a successful photographer's studio would offer subsequent iterations of a photographic process simultaneously, so that it could offer the newest patents, chemicals, and plates alongside the recognized brands. Vannerson would master at least five different photographic processes during his career: daguerreotype, ambrotype, tintype, stereotype, and *carte de visite*.[4] To visit this particular studio, known to photograph the Washington elite, and to choose the more costly option, the daguerreotype, was to honor the occasion of Mary's portrait as worth the expense in artistic talent, silver, gold, brocade, and brass.

This daguerreotype remained unknown for eighty years—the Massachusetts Historical Society catalogued it as "Unidentified Girl, 1855"—in part because it was so conventionally bourgeois in style.[5] The John A. Andrew papers, which were deposited in the archive by Andrew's children in 1919, added objects such as this daguerreotype in the early 1920s. A handwritten note, *"slave child in which Governor Andrew was interested,"* accompanied Mary's daguerreotype.

Mary's neutral pose could have been the result of Vannerson's con-

ventions, or a style of restraint, or perhaps his ignorance of her origins. While I cannot discern Vannerson's politics from his catalog—he photographed people on both sides of the slavery question—he chose to advertise in the local antislavery newspaper, *The National Era*.[6] He photographed members of the last Congress before the Civil War for *McClees' Gallery of Photographic Portraits of the Senators, Representatives, & Delegates of the Thirty-Fifth Congress* (1859). When the Civil War began, he joined his brother Lucien in Richmond. They bought out Jesse Whitehurst's gallery there and made photographs for their wartime hometown for a dollar a piece.

Ten years after Mary met Julian Vannerson, he would achieve lasting fame when he was called upon to make a photograph of Robert E. Lee on the day of the Confederate surrender at Appomattox. Of the many statues commissioned of Lee in the years to follow, the one most faithfully based on Vannerson's portrait stands in Montgomery, Alabama, in front of a majority black high school named Robert E. Lee.

When he met Mary, Vannerson may have assumed that he was photographing a relative, as this was precisely the sort of photograph one would have made of a senator's niece. He may have never looked at the photograph again. Though no statues exist to commemorate her, as yet, the portrait of the little girl that Vannerson made that day marked a turning point in the history of photography and persuasion.

◆

After a long wait in the lobby with her family, the receptionist ushered Mary into the sunlit rooms. The men spoke comfortably and confidentially around her. It was a blessing that the day was bright enough for Julian Vannerson to set aside the brace that he used to keep his subjects still on cloudier days. His subjects were usually taller. When photographing children, to keep them still, he rested the right arm on

a pedestal covered in itchy carpet. He set a notebook alongside Mary's arm for scale, pushed back far enough beyond the depth of field for its title card to be illegible.

The photographer moved quickly, his black hair falling forward as he brought the box camera down to focus the brass squarely at Mary's heart. He pulled the dark cloth over his head for focusing and reemerged with a satisfied look. He leaned down to check the focal length, his hands pressing into the lens tube to still a slight tremor from his decade of working with hot mercury. In the adjacent room, the plates had been buffed, iodized, and then preloaded in the yellow half-light of the darkroom. His assistant brought two wooden film loaders with two sensitized, silver-coated plates inside, and affixed them to the back of the camera box. The client, Senator Sumner, had asked to have two copies made.

Vannerson smiled at his subject as he set her shoulders, a secret grin softening his sharp goatee. Mary nodded very slightly, fastened her eyes on the lens, and held her breath. He removed the cap from the brass and pulled the metal sheet covering the plates. The moment of exposure lasted a length of time that Vannerson found by instinct rather than by pocket watch. He noted that her composure was perfect, if a little solemn for a seven-year-old. He replaced the cap, slid the sheet back into place, and walked the plates back to his darkroom. The daguerreotype would be ready within an hour.

1. THE DAGUERREOTYPE—A silver-plated sheet of copper is resilvered by electro-plating, and perfectly polished. It is then exposed in a glass box to the vapor of iodine until its surface turns to a golden yellow. Then it is exposed in another box to the fumes of the bromide of lime until it becomes a blood-red tint. Then it is exposed once more, for a few seconds, to the vapor of iodine. The plate is now sensitive to light, and is of course kept from it, until, having been placed in the darkened camera, the screen is withdrawn and the camera-picture falls upon it.

In strong light, and with the best instruments, three seconds' exposure is enough,—but the time varies with circumstances. The plate is now withdrawn and exposed to the vapor of mercury at 212 degrees. Where the daylight was strongest, the sensitive coating of the plate has undergone such a chemical change, that the mercury penetrates readily to the silver, producing a minute white granular deposit upon it, like a very thin fall of snow, drifted by the wind. The strong lights are little heaps of these granules, the middle lights thinner sheets of them; the shades are formed by the dark silver itself thinly sprinkled only, as the earth shows with a few scattered snow-flakes on its surface. The precise chemical nature of these granules we care less for than their palpable presence, which may be perfectly made out by a microscope magnifying fifty diameters or even less.

The picture thus formed would soon fade under the action of light, in consequence of further changes in the chemical elements of the film of which it consists. Some of these elements are therefore removed by washing it with a solution of hyposulphite of soda, after which it is rinsed with pure water. It is now permanent in the light, but a touch wipes off the picture as it does the bloom from a plum. To fix it, a solution of hyposulphite of soda containing chloride of gold is poured on the plate while this is held over a spirit-lamp. It is then again rinsed with pure water, and is ready for its frame.

—Oliver Wendell Holmes, June 1859[7]

Witnesses to the first photographic era did not know what profound changes would come once representation mirrored the visual field with mechanical precision. That photography changed the way people write, think, observe, and argue has become a commonplace; it is easy to forget, however, the potency that these new images must have had on the fresh eyes of an antebellum audience. At the age of seventy-five, Ralph Waldo Emerson would name photography as one of the five miracles of his lifetime in a sermon that began, "It is not possible to extricate

yourself from the questions in which your age is involved. Let the good citizen perform the duties put on him here and now."[8]

Media theorist Vilém Flusser, in *Towards a Philosophy of Photography,* argues that the invention of photography was an "apocalyptic event" as decisive in human history as the invention of writing, ushering in a revolution in human consciousness. Whole theories of mind have been ascribed to the advent of moving pictures and the cinema; to war photography, the mugshot, and the aerial photograph; to reproductions of art, art as photograph, and Photoshop; to the postcard, the rise of social media, and the selfie; to the birth of advertising, the supermodel body-image, and the paparazzi; to the ubiquity of the image, geo-tagging, and big data. This technology, which brought endless opportunities for new information and new modes of dissemination, inaugurated "a massive reorganization of knowledge and social practices" in the nineteenth century, according to theorist Jonathan Crary.[9]

The camera presupposes an observer and eyewitness: both the justice system and public opinion accept its testimony as persuasive proof. Photography offered abolitionists the crucial ability to witness the conditions of slavery. The activist and editor of the New York *Independent* during the Civil War, Theodore Tilton, wrote, "The camera has hardly begun its work as an anti-slavery agent. There are unexplored fields of abominations and cruelties which, if worked, might produce a public sentiment forever intolerant of human bondage."

But like observation itself, photography was never neutral. Anti-slavery photographs exposed a problematic tension inherent in the perceived neutrality of photography. Tilton found that pictures "appeal to a sense whose potency over the convictions is well expressed in the proverb—*'seeing is believing.'*" He felt that any viewer who could deny the injustice recorded in the photographs of "white slaves" that emerged during the Civil War, "may as well undertake to deny the existence of the sun which tells the story in black and white." These photographs were visual arguments, which Tilton described as "resistless."[10]

Sumner had two daguerreotypes made of Mary at Julian Vanner-son's studio in Washington, both expressly made to influence public sentiment. He directed his agents to distribute one of the images among the members of the Massachusetts state legislature "as an illustration of Slavery. Let a hard-hearted Hunker look at it and be softened." Sumner believed that even his hard-hearted colleagues would not be able to resist this powerful weapon aimed at the intersection of identity and sympathy.

◆

Antislavery and photography have overlapping histories; their grow-ing influence, innovative technologies, and sway over the public mind advanced apace during the 1840s and 1850s. Looking back, in his 1860 annual message to Congress, President James Buchanan blamed abo-litionist agitation for both disunion and the Republican ascendancy. "It cannot be denied," he declaimed, "that for five and twenty years the agitation at the North against slavery has been incessant." Buchan-an's culprit? The "pictorial handbills and inflammatory appeals" on the "never-ending subject" of abolition.[11]

Twenty-three years earlier, the 175 women gathered in New York City for the first Anti-Slavery Convention of American Women took up Southern abolitionist Sarah Grimké's resolution to harness the power of printed images to their cause: "*Resolved*, We regard anti-slavery prints as powerful auxiliaries in the cause of emancipation, and recommend that these 'pictorial representations' be multiplied a hundred fold; so that the speechless agony of the fettered slave may unceasingly appeal to the heart of the patriotic, the philanthropic, and the Christian."[12]

Three illustrations of suffering and appeal dominated American abolitionism in the years before photography. All three came from the eighteenth-century British abolition movement: the 1789 representation of the cross section of a slave ship, which objectifies black bodies into

commodities; the 1790s image of a undressed woman being whipped in the West Indies, which uses violence and sex in its appeal; and especially, the 1787 image of a chained, kneeling enslaved man, captioned "Am I Not a Man and a Brother?" This last icon of a strong black man pleading for aid from an implied white captor or savior first circulated as a fashionable cameo worn by the well-heeled supporters of the sugar boycotts. A female version of the supplicant slave appeared under the tagline "Am I not a Woman and a Sister?" in the May 1830 issue of the antislavery periodical *Genius of Universal Emancipation*. In 1832 William Lloyd Garrison adopted the icon with its motto as a running head for the "Ladies Department" of the *Liberator*. John A. Andrew kept a carved glass medallion of the slogan.

The daguerreotype of Mary, when considered against these predecessors, seems understated by comparison. Even so, it subtly recalls these prior antislavery illustrations. In her daguerreotype she is a supplicant, for though her hands are not chained or clasped in prayer, her plea is for white funds and votes. Though the image does not show a young woman stripped and whipped, it nevertheless offers proof of the violence and sexual exploitation in the slave system. And the image would be traded as a commodity, as Mary herself had once been, to raise funds.

The absence of visible racial cues and props in Mary's daguerreotype could be read as purposeful; it was intended to disarm audiences. The recognition that this is not a portrait of a middle-class white child but a political image of a former slave unsettles the viewer's certitude and familiarity at first sight of Mary's photograph. White viewers assumed this solemn little girl was white, which attracted their selective sympathy for her. Philosopher Emmanuel Levinas called this habit of mind "totalization," or the act of reducing our expectations for others—people with whom we have come into contact but do not know—according to racial, social, gender, and other categories. This photograph temporarily turned these assumptions on their head, by catching viewers off guard.

Early photographs, printed as they were on metal, have handily survived the century and a half that separates them from us. These photographs were not made for us, but we are still subject to their power, because we still read this portrait in the same reductive way. Infallibly, Mary's daguerreotype elicits the same surprise upon learning that this child was born a slave. Nineteenth-century racial codes and categories are still legible and still in play in America.

Photography offers a longer and more perfect transcript of the visual world than our human memories can hold. The photographic record of history can be manipulated, falsified, and omitted, but it cannot be unseen. We now expect to see an image of everything of consequence around the world, the moment after it happens. The camera, which mimicked and then surpassed the human eye in accuracy and impartiality, has taught us how to see, how to remember, and what to forget.

Today, most daguerreotypes are artifacts from a distant past, and we use photography to write history. But, in the 1850s, any photograph would have shown an image of the present time, since the technology had existed for only a dozen or so years. In 1855 a photograph indicted the viewer's present, made of a modern, contemporary world. This present-ness of photography once inspired a counter argument against gradualism, or the progressive appeal to "wait out" slavery, or to scale it down over several, educationally enriched generations. The photograph is radically immediate; it best suited William Lloyd Garrison's call for immediate emancipation.

◆

In *Camera Lucida,* Roland Barthes wrote that one could describe photography with three verbs: "to do, to undergo, to look." A portrait has three available stances—the photographer, the subject, and/or the audience—and three available actions—to take a photograph, to pose for one, and to view one. The lives of the photographer, Vannerson, and

his subject, Mary, converged for this one afternoon. What of the third group, the audience, whose job it was "to look"?

The day after the Fourth of July 1857, Charlotte Forten Grimké, a member of Salem's black abolitionist community (and sister-in-law of Angelina and Sarah Grimké), had a portrait made at Broadbent's daguerreotype studio in Philadelphia. While she was there, a friend, "Miss J," showed her a daguerreotype of a fugitive girl. That evening this antislavery woman wrote in her journal about viewing an image of a "heroic girl."

At last, at last after hiding for a whole week the sun deigns to show us his face again. Right glad are we to see him. This is truly a perfect day. Mr. C[hew] came, and insisted upon taking me to Broadbent's where I had an excellent likeness taken. Miss J was there, and showed me a daguerreotype of a young slave girl who escaped in a box. . . .

My heart was full as I gazed at it; full of admiration for the heroic girl, who risked all for freedom; full of bitter indignation that in this boasted land of liberty such a thing could occur. Were she of any other nation her heroism would receive all due honor from these Americans, but as it is, there is not even a single spot in this broad land, where her rights can be protected,—not one. Only in the dominions of a queen is she free. How long, Oh! how long will this continue!

—*Charlotte L. Forten Grimké, July 5, 1857*[13]

Grimké felt sympathy and admiration for the young woman in the daguerreotype, as well as indignation for "these Americans," with whom she did not identify either herself or the fugitive girl in the daguerreotype. She gave no indication in the journal of what the girl looked like—for her, she was a symbol of resistance. Grimké wrote of softened hearts in language that is strikingly similar to Charles Sumner's February 19 letter to Dr. Stone (page 103), but her exclamation, "How long,

Oh! How long will this continue!" did not mean the same thing as Sumner's question, "Should such things be allowed to continue . . . ?"

In January 1855, D. M. Barringer, a diplomat and a lawyer in North Carolina, wished to set his enslaved man Jerry Bethel free. In Barringer's opinion, Jerry Bethel was "one of the best colored men living." Bethel had had ample opportunity to escape, his master reported, while in New York and Europe, but Bethel desired to return to North Carolina to be "set free legally in his own State." Only the North Carolina legislature could manumit him.

To that end, Barringer "handed around" a daguerreotype of Jerry Bethel to the state assemblymen so that they might get to know him.[14] Assemblyman Zebulon B. Vance so admired the daguerreotype that he called himself "a friend of Jerry's" and recommended that the daguerreotype be sent to the state senate "with a proposition to print!" Surely, he assumed, North Carolinians who saw Jerry's portrait would make a positive assessment of his character and consider him deserving of freedom. What did being deserving of freedom look like? Jerry Bethel's daguerreotype is lost to us today, but even if we could see it, it would not answer this question.

Some members of the assembly argued against emancipating Bethel, as it would establish a precedent. Assemblyman Jordan denounced the "nuisance" of freed persons in the state, "who were not made happy by their emancipation; but were, in his opinion, more miserable than slaves." He would vote for emancipation only with "a provision to send them out of the country altogether." But Jordan and his allies did not carry the day. On January 8, 1855, the North Carolina legislature manumitted Jerry Bethel at his owner's request, 94 to 17. The daguerreotype had done its work.

10

Richard Hildreth

◆

When Mary's daguerreotype arrived in Boston on February 23, Andrew showed it to Henry Williams during his daily visit to Andrew's law offices. "Her father was very pleased at the sight of the likeness. He is very anxious to have them here—Very indeed."[1] But Andrew did not give Mary's daguerreotype to Williams, because it had work to do first.

Dr. James Stone placed his copy of the daguerreotype on view at the Boston State House, located in the heart of Beacon Hill across from Boston Common. That way, those whose interest was roused by hearing Mary's story could seek out her image.

Stone took Sumner's February 19 letter to Richard Hildreth, editor of the *Boston Telegraph* and author of his own sentimental antislavery novel, *The White Slave*. No one had written more faithfully in support of *Ida May* than Hildreth. He recognized the connection that Sum-

ner made between the heroine of that novel and the little girl in the daguerreotype, as he wrote in the paper:

ANOTHER IDA MAY.—Our readers will remember that several weeks since, some account was given of a family of white slaves in Virginia, in whom Mr. Sumner had taken much interest. Four of the six members of the family have been freed at a cost of eight hundred dollars, raised principally by John A. Andrew, Esq., of this city. This seems to be a much more judicious expenditure of money than the payment of nearly double that amount for the freedom of Anthony Burns, thereby serving the double purpose of parading the names of certain well known Fugitive Slave bill officials as subscribers to the Burns fund, and at the same time acting as a premium to slave catchers to visit our State to seize alleged fugitives for purposes of speculation.

The daguerreotype mentioned in the following letter is a portrait of one of the family referred to, a most beautiful white girl, with high forehead, straight hair, intellectual appearance, and decidedly attractive features. It may be seen for a few days at the State House, in the hands of the Clerk of the House of Representatives.

—Boston Telegraph, *February 27, 1855*[2]

This article and Sumner's letter of February 19 (page 103) were reprinted in dozens of newspapers up and down the East Coast.[3] After the story broke in Boston, Andrew wrote to Sumner that "people are constantly asking for [Mary's daguerreotype]. I must have some copies made of it when I can." He thanked Sumner for "the picture of little Mary," but "I wish I had a group of the <u>three</u>—from which to multiply copies to distribute."[4] He did not understand why Sumner had sent only the daguerreotype of the middle child, Mary, when subscribers had raised the funds to free all three. Andrew had never met nor seen the family. He still saw a child where Sumner saw an icon.

Andrew crossed Boston Common to visit the copyist Taber & Co., located at Winter and Washington streets (at what is now the Macy's department store across from Downtown Crossing). Mary's daguerreotype was copied an unknown number of times at the cost of twenty-five cents each, into smaller ninth-plate daguerreotypes. An advertisement for Taber & Co., affixed to the back of the plate, claims "600 Daily, Beware of Imitators," which suggests a hot trade in the mid-nineteenth-century equivalent of a photocopy.

Daguerreotypes were unique, but they could be rephotographed. The result was a reversed image, with some quality loss in the detail and shadow, but the subject, in this case Mary, was still clearly visible. Andrew gifted copies to influential Bostonians, subscribers to their fugitives' fund, and Massachusetts legislators, so that they could personally connect to Mary's story by holding her image in their hands. Some of these recipients penciled small notes—for example, "Mulatto raised by Charles Sumner"—and affixed them to the brocade daguerreotype case, so that future viewers would know who the child was. The prevailing idea was that her portrait, with such captions, comprised a

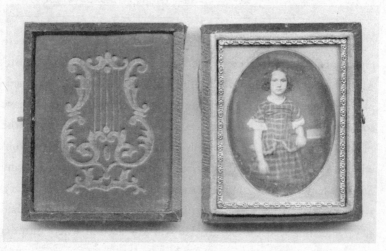

Mary Mildred Williams, copy daguerreotype, produced by Taber & Co., 1855.

self-evident argument about slavery and race, wrapped in a convenient brocade case; all that was needed was a sympathetic viewer. Objects such as Mary's portrait were assumed to evoke a script—a proper response—that could lead to antislavery conversation and conversion, doing reform work "more effectively than any speech I could make," as Sumner said.[5]

Upon receiving a copy of the daguerreotype, one correspondent, A. L. Russell, wrote Sumner, "I know that good Anti-Slavery cause is gaining daily and this beautiful girl I know will be the means, under Providence, of great good to the cause of freedom."[6]

◆

One of the copy daguerreotypes made at Taber & Co. ended up in the home of Massachusetts state senator Daniel Wells Alvord, in the northwestern mill town of Greenfield. Alvord was an acquaintance of Senator Sumner, with a daughter the same age as Mary.

Senator Alvord had brought it home so he could tell his children Caroline and Henry the story of "Little Ida May." Alvord was bringing them up alone, as their mother had died in childbirth. (He would not remarry until they were in their teens and had developed a habit of independence.)

The Alvords were a family dedicated to public service and the antislavery movement. After the Civil War began, Henry Elijah Alvord, who had called upon his father's connection with Senator Sumner in an unsuccessful attempt to land a cadetship at West Point, enlisted in the Second Massachusetts Cavalry and served with honors.[7] After the war, at twenty-one, he and his nineteen-year-old sister Caroline both moved to Fairfax County, Virginia, to work with the Freedmen's Bureau. They set off "with a noble goal" of educating the newly emancipated. On the journey south, Caroline brought Mary's daguerreotype along with her in her trunk.

Caroline taught in a Freedmen's school and boarded at the nearby Ash Grove plantation (in what is now Tysons Corner, a suburb of Washington, D.C.). The house had been built in 1740 by Lord Fairfax, owner of the vast surrounding estate, as a hunting lodge for his son. Though the estate was reduced after the Revolutionary War, the house remained in the possession of the Fairfax family. In the 1840s it was owned by the last Lord Fairfax, Henry, whose wife ran a boarding school there for young Washington women. Henry Fairfax was said to refuse to own slaves and to free any people who came into his possession.[8]

Henry Fairfax died in the Mexican War in 1847: three years later his survivors sold Ash Grove to two young men from New York City, James Sherman and Isaac Besley, who also would never own or hire slaves. They created, in effect, a small antislavery enclave in rural Virginia. During the Civil War, James's son, Franklin Sherman, served with the Tenth Michigan Cavalry in the Union Army. At one time he escaped a prisoner of war camp in his native Virginia. After his service, he returned to Ash Grove, where his parents had taken in that boarder from Massachusetts, Caroline Alvord.

Franklin and Caroline married, and using Caroline's grandfather's inheritance, they purchased the entire estate from Franklin's brothers and sisters. They raised eleven children there, including six daughters, none of whom married: all became career women (including the first female librarian at a university in North Carolina); their sons became researchers and professors and did marry. Caroline's brother Henry also married a Fairfax County local, Martha, from a nearby estate, Spring Hill, and together they explored the West.[9]

Caroline's copy of Mary's daguerreotype would stay in Tysons Corner at Ash Grove for 132 years. Tysons Corner is about thirty miles from Dumfries, where Prue was enslaved, and about thirty miles from Brentsville, where the image's subject, Mary, was likely born.

Caroline's copy of Mary's daguerreotype surfaced in July 1997 at Headley's auction in Winchester, Virginia, where a woman in Tennes-

see bought it. In 2000 it was offered for sale on eBay, where it was purchased by Joan Gage, a private collector in North Grafton, Massachusetts.[10] North Grafton is sixty-five miles from Greenfield—the copy daguerreotype had almost come full circle.

◆

To publicize Mary's story in Boston, John Andrew composed a broadsheet, "History of Ida May," which was offered for sale in portrait galleries, bookstores, and stationery shops. An editor who went by the initials S.P.H. wrote an introduction, saying that John Andrew had modestly asked to keep his own role of benefactor anonymous. For authenticity, the stationers pressed an embossed stamp into the broadsheet, which suggests that they assumed pirated copies might be made, such was Mary's popularity. Andrew writes that he hopes to secure the $300 needed to purchase Ludwell's freedom from the sales of "Little Ida May's" picture.

This sum, it is hoped, will be raised by the profits on the sale of little Ida May's picture, whose youth, beauty and innocence, rescued from all the horrible contingencies of the bond-woman's lot, have touched many hearts and moistened many eyes.

I ought to add that much the larger part of all the money raised, has been obtained by the personal exertions of Seth himself; and this is only a just recognition of his constancy and zeal for his household, and of the good impression he has been enabled to make on the many gentlemen to whom he has become known in Boston.

J. A. Andrew
BOSTON, March 3, 1855.[11]

The broadsheet, printed at J. S. Potter & Co., a printer sympathetic to the slave's cause, was wrapped around a crystalotype copy of Mary's

HISTORY OF IDA MAY.

The following letter, addressed to the writer, to whose charge has been committed the sale of the Crystalotype Pictures of little IDA MAY, the white child, recently emancipated from the infamy of slavery, through the intercession of Senator Sumner, enters sufficiently in detail, into the history of IDA and her family, to make the case, not only clear to every mind, but highly instructive, and intensely interesting. It is, therefore, submitted without further comment, except to say, that the writer could not in justice yield to the modest request of MR. ANDREW, to withhold his name from the history of the emancipation of this family, for to him, chiefly, is to be attributed the fact, that they are at this moment enjoying the blessings of Civil and Religious Liberty.

S. P. H.

MY DEAR SIR:

The child whose picture is offered, is seven years of age, was until recently, a slave in Virginia, is named Mary Botts. Her father, Seth Botts, (who works at the Cornhill Coffee House in Boston,) escaped from slavery some five years ago. He subsequently negotiated, by my aid as his friend and counsel, for the purchase of his freedom from his master, which was accomplished for the price of $600. Of this price, $500 was paid in hand on delivery of the deed of emancipation, to Senator Sumner at Washington, (through whom the money was transmitted,) and $100 by the *honorary promise* of the man himself, to be paid in two years, which promise he faithfully performed.

His escape from slavery and his purchase of himself, were both steps needful to the ultimate emancipation of his wife Elizabeth and three children, (of whom little Mary is the second child, and whose freedom, with that of Pruey Bell, the mother and Evelina, the sister of Elizabeth, is now happily accomplished, after some years of trial, negotiation, and delay

This delay was caused by the pendency of a suit in Virginia, now recently decided by the Court of Appeals, after some nine years of controversy, in which was involved the title to Pruey Bell and her descendants. It was decided in favor of the plaintiff, Mr. John Cornwall, of Georgetown, D. C., from whom the title deeds to freedom have been obtained. It is due to Mr. C. to say, that at any time heretofore he would have co-operated with the defendant in releasing Elizabeth and her children, allowing an agreed sum of $800 to be deposited in their stead; but this arrangement, though once supposed to have been made, could not be accomplished with the party defendant.

On the termination of the suit, Mr. Cornwall and his counsel, Judge Neale, of Alexandria, faithfully fulfilled *their* engagement; in due season, Elizabeth and her children were brought up to Washington, and there delivered with her papers to Mr. Sumner, who again kindly acted as the medium of communication in the work of emancipation. The oldest child, a boy named Oscar, is spoken of by Judge Neale in these words in a letter to myself. "Oscar is the *handsomest boy I ever saw in my life.*" Mr. Sumner writes of him thus. "Oscar, the boy, is bright and intelligent, with *fine* silken black hair, the eyes of an eagle, and a beautiful smile. When I told him that he was free and asked him if he knew what that meant, he said, '*I now belong to myself*'—a definition which philosophy might borrow."

Of little Mary, Mr. Sumner says: "The little girl is another Ida May; so completely white, with auburn hair, large eyes, and Caucassian features, that I could see in her nothing of African blood."

Elizabeth is so white as to pass easily enough in Virginia for a white woman; and this white blood is inherited from Pruey, her mother.

Having learned from Mr. Sumner, that Judge Neale had offered in behalf of his client, to emancipate Pruey and Evelina for $200, I at once assumed the risk, and wrote, securing their freedom, also, trusting in so clear and so good a case, that the funds would be readily contributed. And not many days elapsed, before the requisite amount was raised.

Three brothers of Elizabeth still remained. Two are now grown. One is a lad of 17 or 18 years; he is the youngest born of Pruey, whose grief, as expressed in a letter from Elizabeth to Seth, at the thought of leaving him a slave, while she was to depart in freedom, was very great. He was the Benjamin of her flock.

On learning that he also could be freed on the payment of $300, I have written to Mr. Sumner and Judge Neale, assuming the work of that enterprise, also,—it being the earnest desire of Seth that this lad, in whom he has entire confidence, that he will prove worthy of any friendship—should come to Boston, with the others of his family.

This sum, it is hoped, will be raised by the profits on the sale of little Ida May's picture, whose youth, beauty and innocence, rescued from all the horrible contingencies of the bond-woman's lot, have touched many hearts and moistened many eyes.

I ought to add that much the larger part of all the money raised, has been obtained by the personal exertions of Seth himself; and this is only a just recognition of his constancy and zeal for his household, and of the good impression he has been enabled to make on the many gentlemen to whom he has become known in Boston.

I have thus sketched an outline of this family story. You will please, according to your own taste and judgment, adopt and arrange so much of it as may help the purpose of illustrating the picture—saying as little as possible—and nothing, if possible, about your friend and humble servant,

J. A. ANDREW.

BOSTON, March 3d, 1855.

"History of Ida May," broadsheet by John Andrew, printed at J. S. Potter & Co., March 1855.
This broadsheet was accompanied by the crystalotype picture of Mary Mildred Williams.

daguerreotype made by Whipple & Black. The paper-photograph tech-
nology of the crystalotype was patented in Boston in 1850, made avail-
able to the public in late 1852, and exhibited to acclaim in 1853. The
inventor, John Adams Whipple, had been working since 1844 to over-
come the daguerreotype's irreproducible quality, and he was the first
to produce glass negatives in the United States. His crystalotype pat-
ent called for the image to be directed through the lens to a glass plate
coated with albumen (egg whites) and honey taken directly from the
comb (so as not to be clouded). This recipe binds light-sensitive chemi-
cals to a "crystal-clear" glass plate. As the photographs were captured on
transparent glass, rather than mirrored silver-plated copper, they could
be used as negatives. As negatives, one exposure could be reproduced,
and sold countless times.

Whipple, with his partner James Wallace Black, kept a studio
in busy Washington Street, at number 96, the heart of commerce in
Boston.[12] Their rooms were on the top floor, with a shop at street level
selling copies of their portraits. Upstairs, dozens of contact prints
could be seen exposing under the natural light from skylights over-
head. Charles Henry Brainard used Whipple to supply some of the
portraits in his collection of Grozlier's lithographs: the former sena-
tor from Massachusetts, Daniel Webster, and the current one, Henry
Wilson, both sat for Whipple & Black, as did Henry Wadsworth
Longfellow and Nathaniel Hawthorne. For a hundred dollars, Whip-
ple & Black offered training in the glass negative process. They taught
Oliver Wendell Holmes to make photographs. They photographed
the moon.

*Whipple has for sale crystalotype copies of the likeness of the white slave
girl, belonging to the family lately freed though the instrumentality of
Hon. Charles Sumner. The proceeds of the sale will be appropriated to
the purchase of a little boy, the youngest member of the family, now*

in bondage. The whole family will accompany Mr. Sumner to Boston this week.

<div align="right">

—Daily Atlas, *March 5, 1855*[13]

</div>

The accepted history is that reform movements began using photography strategically in the 1880s, with the advent of social documentary, when the halftone process made reproduction in newsprint possible. But abolitionists, who already recognized the power of the image as a social document and had distribution networks in place, took to photography far earlier.

For example, in April 1853, the black activist and entrepreneur William Cooper Nell set out to engage in a new "business operation," of "getting out some anti slavery portraits" on paper.

I have already <u>intimated a business operation</u> in which I am engaged = getting <u>out some anti slavery portraits</u> = <u>transferred from the Daguerreotype to the new invented Christallotype</u> [sic] = Should I secure money enough to successfully start it = good sales and profits are absolutely certain = This if my health recruits will send me to several places. This matter was embarked before the Fair but has from unavoidable causes fragged its length slowly along to the present you know having an accurate likeness of Mr. Garrison as He is = is much desired by the friends = and I hope to succeed in my effort. = You see = I have not yet abandoned— All Hope -

<div align="right">

—*William Cooper Nell, April 24, 1853*[14]

</div>

William Lloyd Garrison and the American Anti-slavery Society agreed to copy portraits suitable for mailing—investing $16.50 from their publications budget in 1856 to "William C. Nell, for portraits"— for use in propaganda and for profit.[15] Selling portraits of celebrities was good business and good fundraising. Families collected, alongside personal portraits, albums of the "visiting cards," or *cartes de visite,* of

public figures. Images printed on paper and card can be distributed as printed matter, mailed, traded, propped up on mantelpieces, tucked into albums, or used as bookmarks. Oliver Wendell Holmes called *cartes de visite* "a social currency, the sentimental greenbacks of society."[16] Sojourner Truth's *cartes de visite* were priced at one dollar, which she printed with the slogan, "I Sell the Shadow to Support the Substance."[17]

Frederick Douglass realized that the "great cheapness and universality of pictures" exerted a "powerful though silent influence" on the minds of this, and likely future, generations. "This picture-making faculty," he noted, "is flung out into the world—like all others—subject to a wild scramble between contending interests and forces. It is a mighty power—and the side to which it goes has achieved a wondrous conquest."[18]

◆

In the archives at the American Antiquarian Society in Worcester, in a copy of Richard Hildreth's *The White Slave*, tucked in the front cover where the frontispiece should be, was a crystalotype of Mary. I found it by accident, while reading the works of Hildreth in pursuit of an understanding of how antislavery fiction perpetuated selective sympathy. The previous reader of the novel, in this second edition printed in Boston in 1852, associated the white enslaved hero of Hildreth's story, Archy Moore, with Mary. For over one hundred years, this paper photograph was hidden from both ruin and preservationists alike, in this fictional narrative of "white slavery."[19]

According to an advertisement in the local paper, the "beautiful crystalotype picture of the little white slave girl—Ida May" had been available for sale at Spauldings, a bookshop in Worcester, so that seemed the likely provenance for this copy of the book and the photograph.[20] The reader had penciled a caption on the crystalotype, written across the back of the card: "White Slave liberated by Charles Sumner." A single page of the novel, nineteen, was dog-eared, where the hero

explains what it was like to be a "white slave." Although these lines offer only a facsimile of a slave's interiority, as imagined by Richard Hildreth, a white abolitionist, they suggest that a fascination with white slavery occupied a reader, one who thought Mary's picture could serve as illustration for his or her imaginings.

My mind seemed to be filled with indefinite anxieties, of which I could divine neither the causes nor the cure. There was, as it were, a heavy weight upon my bosom, an unsatisfied craving for something, I knew not what, a longing which I could do nothing to satisfy, because I could not tell its object. I would be often lost in thought, but my mind did not seem to fix itself to any certain aim, and after hours of apparently the deepest meditation, I should have been very much at a loss to tell about what I had been thinking.

But sometimes my reflections would take a more definite shape. I would begin to consider what I was and what I had to anticipate. The son of a freeman, yet born a slave! Endowed by nature with abilities, which I should never be permitted to exercise; possessed of knowledge, which already, I found it expedient to conceal! The slave of my own father, the servant of my own brother, a bounded, limited, confined, and captive creature, who did not dare to go out of sight of his master's house without a written permission to do so! Destined to be the sport, of I knew not whose caprices; forbidden in anything to act for myself, or to consult my own happiness; compelled to labor all my life at another's bidding; and liable every hour and instant, to oppressions the most outrageous, and degradations the most humiliating!

—*Richard Hildreth,* The White Slave *(1852)*[21]

Fiction and photograph converge to give a story to one and the sheen of truth to the other. How many copies of Mary's image found their way into strangers' hands? Who gazed upon her face, in admiration or disbelief?

Charles Sumner

◆

I n Washington, Senator Charles Sumner tried to keep his dealings with fugitives quiet, both for his protection and for theirs, but it did not take long for the press to catch on that he was negotiating in slaves.[1] Apparently when he was not arguing at the Capitol against slavery, Sumner was using his H Street address to liberate Washington-area slaves, one family at a time.

PURCHASE OF SLAVES.

Senator Sumner, of Mass., sometimes since purchased three slaves in Virginia, and brought them to Washington with the view of sending them North, where they would of course be free. Recently, he purchased two boys, and is said to be negotiating for others, one of whom owned in Alexandria, and worth about $1000. Several citizens of Boston, it is said, have directed Mr. S. to draw on them of the necessary funds. They

are all the relatives of a colored man named John [sic] Botts, who ran
away from his master several years ago, went to Boston, and subsequently
purchased his own freedom.

—Washington Reporter *(Pennsylvania), March 14, 1855*[2]

The editor of the pro-slavery newspaper *Washington Sentinel* rel-
ished the news that Sumner, a forty-four-year-old bachelor and "the
pride of Massachusetts," had taken an interest in three young slaves and
their mother. The *Sentinel* was committed to advancing states rights
and Southern interests by ridiculing contrary positions, so its sardonic
editor Beverley Tucker saw his opportunity to roast Sumner, and he did
so in his next issue.

Tucker's animosity toward Sumner went beyond politics. In 1853,
in the *Sentinel*'s early days of circulation, Tucker had put in a bid to
become printer for the Senate, competing against the pro-slavery editor
of the *Washington Daily Union*. Senator Sumner had written in the *Bos-
ton Commonwealth* that he would vote for neither man and asked for a
third printer to come forward as a candidate.[3] Tucker was elected to the
post, but he had a long memory for slights.

Three days after the news of "Another Ida May" broke in Boston,
the *Washington Sentinel* printed an article that gossiped about Sumner's
personal life in codes that queer him: "Senator Sumner has a weakness.
It is for young negroes."

SENATOR SUMNER—*YOUNG NEGROES AND DAGUERREOTYPES!*
The greatest philosophers, the mightiest conquerors, and the most emi-
nent statesmen are all at last but men. They have their foibles and their
vices, their special "vanities," and their particular indulgences. Some
have petted spiders, some have, grotesquely enough, fancied calves, others
wolves. Some have spent their leisure moments in killing flies, contrary to
Uncle Toby's benevolent injunction, while others have taken a malicious
delight in teazing children.

There is a grave statesman, an august Senator, who not exempt from the frailties and weaknesses that attach to man, has recently furnished to the country, particularly to the refined and enlightened and scholastic State of Massachusetts, which he in part represents, and to Boston, the "Athens of America," the evidence that he has in his composition, as well something of earth, as of heaven. Senator Sumner has a weakness. It is for young negroes. When this Senator is relieved from the fatigues of legislation, he occupies and adorns his leisure moments with the agreeable and elegant amusement of studying the features and the forms of young Ethiopians which, committed to canvass, or more faithfully represented by the process of Daguerre, he transmits to his valued friends in Massachusetts. When these pictures, sent by mail, reach their place of destination, they are shown to the polished scholars and grave legislators of that enlightened State, who are expected instantly to become convulsed with ecstasy, and absorbed with delight. We would not do injustice to the scholars and statesmen and legislators of his State, or to the refined and cultivated philanthropists of the godly city of Boston. But Senator Sumner has recently written a letter published in the Boston Telegraph, *which distinctly shows his weakness for young negroes, and his admiration for Daguerreotypes. That letter, written, no doubt, at a moment snatched from grave debate, is as follows:*

Letter from Hon. Charles Sumner . . . [Sumner's February 19 letter to Dr. Stone follows, reprinted in full; see page 103]

One remarkable thing about this picture is, that it is intended to operate on the refined Legislature of Massachusetts. This we infer from a sentence in the Senator's letter and from the following brief extract from the Boston Telegraph:

"The Daguerreotype mentioned in the following letter is a portrait of one of the family referred to, a most beautiful white girl, with high forehead, straight hair, intellectual appearance, and decidedly attractive features. It may be seen for a few days at the State House, in the hands of the Clerk of the House of Representatives."

An improvement seems to be going on in the Senator and in the grave, dignified, and enlightened legislators of the great State of scholars. They have heretofore worshipped the black, flat-nosed, thick-lipped sons and daughters of Africa. But, from the above account, it seems that they have become fascinated "with a most beautiful white girl, with high forehead, straight hair, intellectual appearance, and decidedly attractive features."

Senator Sumner, to complete the matter, ought, by all means, to have a Daguerreotype taken of the grave, solemn, enlightened, and dignified Legislature of Massachusetts, when the picture of his "Ida May" is formally presented. We can imagine the bristling hair, the compressed lips, the glaring eye balls, of the Massachusetts legislators. But we should like to see the picture. He is fond of pictures. We hope that in his leisure moments he has made arrangements to have this one taken.

—Washington Sentinel, *March 2, 1855*[4]

Mary was still in Washington when this calumny was printed; perhaps Elizabeth read it and feared for her daughter's upcoming tour of the Massachusetts legislature, they of the "glaring eye balls" and "bristling" hair. Tucker's article showed other possible responses to our poster child: amoral thoughts and perhaps disgust. Tucker seemed to think that the senator did not take into account the motives of his whole constituency.

A political cartoon produced during Sumner's second term, captioned "I'm not to blame for being white, sir!" shows him giving preferential treatment to a black girl, a rag seller, over a white girl selling firewood. Set on Boston's fashionable streets, the 1862 lithograph features two well-dressed white women under a parasol, to serve as arbitrators and audience. In the center, Sumner looks off into a middle distance, expressionless, and the two girls are represented like Topsy and Eva from *Uncle Tom's Cabin*. He hands four coins to the black girl, who smiles up at him, her palm open. Her head in profile is a racist cari-

"I'm not to blame for being white, Sir," lithograph of Charles Sumner and two children, attributed to Dominique C. Fabronius, printed by George W. Cottrell of Boston, 1862.

cature, with bare shoulders and bare feet. The printer has colored her skin so dark that her features nearly disappear into silhouette.[5]

Tucker's monstrous article had called Sumner's interest in Mary "an improvement" in abolitionism's object, as the movement had "heretofore worshipped the black, flat-nosed, thick-lipped sons and daughters of Africa." Tucker's screed could stand as a description of the black girl pictured here in this antislavery lithograph, published seven years later. White supremacy's static vision of who is beautiful, and who deserves our attention, persists. The white girl also has her hand outstretched, but it is unclear whether she reaches for coins or points at the black girl in accusation. Her shoulders are bare and colorless, and her body looks suggestively like that of a grown woman. Her slippered feet are inches from Sumner's leather shoes, squared off as in a dance. A second caption, printed beneath the headline, provides Sumner's response to her: "True, my girl, but charity ought to begin where it is most needed, and you, certainly, are the better off, having more friends and less oppressors."

Apparently, Sumner knew with startling prescience that his white audiences would connect with Mary Mildred Williams as a poster child for American slavery. His clear-mindedness, especially when it came to recognizing oppression, seems anachronistic and inconsistent with his era. By most accounts, Sumner was a total failure in the emotional work required for empathy. While his speeches read as excellent studies in human behavior and motivation, the man himself was harsh, critical, and vindictive, as his biographers have noted. President Abraham Lincoln's secretary of the treasury, Hugh McCulloch, considered Sumner unmatched as an orator and scholar, a "handsome" and "commanding presence": "a pure man, a man of unsullied and unassailable integrity. All this can be justly said of him. On the other hand, his prejudices were hastily formed and violent. His self-esteem was limitless. Impatient of contradiction, his manner to those who differed with him was arrogant and offensive. His ears were ever open to flattery, of which he was omnivorous." As for his politics, he worked at the level

of principles, not people. "For the freedom of the slaves he was an earnest worker; of their claims to all the privileges of freedom, after their emancipation, he was an able and eloquent advocate and defender; but to appeals by needy colored people to his charity, or even his sympathy, he was seemingly indifferent."[6]

He reserved his innermost confidences to his lifelong friends, Samuel Gridley Howe and Henry Wadsworth Longfellow. Although Sumner's wife, Alice Mason, was his equal in intelligence and independence, there was no love between them; their marriage in 1866 did not last a year.

Years later, writing for the *Independent,* correspondent Mary Hudson would remember Sumner as "a man solitary by the primal law of his nature, preoccupied, absorbed, aristocratic in instinct, though a leveler in ideas, never a demagogue, never a politician,—he is the born master and expounder of fundamental principles." Somehow he found in Mary the key that was needed to unlock the sympathy of voters, who were exclusively white men like himself, while reserving his own. There is a sort of genius there.

◆

The first record of Sumner in attendance at an antislavery meeting was in January 1845, when he was in his mid-thirties. There he heard William Lloyd Garrison speak for the first time, though as he told Garrison on that occasion, he had read *The Liberator* for years.

The land grab known as the "Mexican War" resulted in the annexation of new territories in the Southwest: in December 1846, Texas was admitted to the Union as a slave state, disrupting a carefully maintained balance in Congress between slave and free states. The Mexican War mobilized a generation of antislavery sympathizers to become activists, including John Andrew and Henry David Thoreau. Sumner, for his part, made his first speech against slavery in opposition to the war, argu-

ing that it was motivated by a desire to extend the reach of slavery. In 1848, the Free Soil party was formed, a third party in a two-party system. Under its slogan, "Free Soil, Free Labor, Free Men," it soon became a viable political platform dedicated to limiting slavery by focusing on keeping the new territories of the West free from the slave power.

The Compromise of 1850 was Kentucky senator Henry Clay's legislative attempt to answer the question of slavery in the west. Massachusetts senator Daniel Webster, a Whig, gave his support to the Fugitive Slave Act in his infamous "Seventh of March" speech, claiming this capitulation to Southern interests as a necessary component of the Compromise of 1850, required to stave off political and economic disunion. Abolitionist poet John Greenleaf Whittier published "Ichabod," in response to Webster: "All else is gone; from those great eyes/ The soul has fled:/ When faith is lost, when honor dies,/ The man is dead."

Sumner, by now a leader of the antislavery movement, called the Fugitive Slave Act "a hideous Heaven-defying bill . . . avowedly for the recapture of fugitive slaves, but endangering the liberty of freemen."[7] In August 1850, when it appeared the Fugitive Slave Act would become law, Sumner accepted the Free Soil nomination for U.S. Senate. That year, in direct response to Webster's capitulation, Massachusetts voters gave his Senate seat to the smart young Free Soil radical.

Upon taking his seat in the Thirty-second Congress in December 1851, Sumner began with "caution and reserve," as he wrote in a letter to Whittier. "Some of the heaviest hours of my life have been since my election," he confided in Whittier, "Would that another faithful to our cause were in my place!"[8] His situation in Washington was "*peculiar*," he wrote to his friend Samuel Gridley Howe, due to the prejudice throughout the country that he was a one-issue candidate, or as he called himself, "a fanatic." "As a first condition to my usefulness," he would need to course-correct and broaden his political scope. Proceeding under a "true policy . . . of silence," he would play a long game: "I wish that the public should become submissive to the idea that I am a

senator before they hear my voice. Unless this is so, I shall not secure a
fair hearing from the country."⁹

Sumner was true to his word: eight months passed before the coun-
try heard from him on slavery. Though he was ready to speak sooner,
he was not granted the floor. Finally, on August 26, 1852, in a three-
hour speech entitled "Freedom National; Slavery Sectional" he laid out
a national position to "oppose all sectionalism." His abolitionist argu-
ment was drawn in specifically congressional terms, calling for repeal
of the Fugitive Slave Act on constitutional grounds, and offering voters
a legislative approach to antislavery.

His proposal was not met with universal acclaim: in Boston, Gar-
rison's newspaper, the *Liberator,* rejected such legislative solutions and
found Sumner's proposal to "oppose all sectionalism" to be overly cau-
tious.¹⁰ A key tenet of Garrisonian abolitionism was sectionalism, in its
refusal to engage in politics or with slaveholders. Garrison and his fol-
lowers believed that, since the Constitution was a pro-slavery document
written by slaveholders, pro-slavery interests hopelessly, sinfully, cor-
rupted the entire United States government. Their slogan, "No Union
with Slaveholders," ran counter to the nationalizing theme of Sumner's
new platform.

But voters were moving with Sumner. The 1850s saw renewed
engagement with the political process to the benefit not only of the
antislavery movement but also of movements for women's rights and
temperance.

Sumner's first term in the Senate, 1851 to 1856, indicated the
uncertain sands of his political hour. New political parties were formed
out of the demise of Webster's Whig Party, fueling the rising threat of
the Know-Nothings, the American Party, and other nativist groups.
The Democrats split into Northern and Southern parties, each with
its own convention and platform. Admitting women into the debate
caused dissension in the antislavery ranks, fracturing the movement.
Free Soil would no longer be a viable choice when the time came for

his reelection, so his friends Andrew and Howe urged Sumner to join the new coalition, the Republican party. This chaotic political scene would propel the Republican party ascendency, and even if Sumner was a reluctant participant in party politics, he rode the rise.

◆

While Mary and her family were in Washington, in February 1855, the Senate was considering a bill to reinforce the Fugitive Slave Law. It would neutralize laws that obstructed fugitive capture and return; Vermont, Connecticut, and Michigan had passed such laws, and a fugitive protection bill was about to pass in Massachusetts. The federal bill further stated that "any suit commenced or pending in any State Court against any officer of the United States, or other person, for or on account of any act done under any law of the United States," could be removed to the jurisdiction of federal circuit courts. In other words, federally commissioned officers who rounded up fugitives would be protected from lawsuits in antislavery states by ensuring their cases would be heard by more sympathetic federal courts.

It was a grenade of a bill, and it was carefully timed. The correspondent for the New York *Evening Post* explained, "Of course, such a project, curtailing the powers of the State Courts, so odious and insulting in its intent, could not be suddenly sprung upon the Senators from the free States without provoking a long and acrimonious debate."[11] The Senate President allowed only thirteen hours of debate, before a vote would be called at midnight on Friday, February 23, 1855. The senators of Massachusetts, New York, and Connecticut claimed every hour remaining to argue that the Fugitive Slave Law was unconstitutional. They demonstrated the combined oratorical strength of a block of antislavery senators—Charles Sumner, William Seward of New York, Francis Gillette of Connecticut, and the new junior senator (and former

shoemaker) from Massachusetts, Henry Wilson. Wilson announced himself to the Senate chamber that evening as unequivocally against slavery, calling the Fugitive Slave Act "odious, inhuman, and unconstitutional." Francis Gillette, who had been elected in 1854 on the Free Soil ticket to fill a vacancy, had only ten months to make his mark. He had a speech prepared and ready for delivery in his desk. William Seward, freshly reelected by New York, was the leader of this coalition of Northern senators, and a force among them. The night was theirs.[12]

Newspapers on the East Coast published the senators' speeches in their entirety.

If any of the friends of freedom in Massachusetts are disheartened by the present aspect of the anti-Slavery cause, let them visit Washington. There is a change in the very atmosphere, which cheers and encourages the anti-Slavery heart. It is to call the attention of our friends in Massachusetts to some of these cheering facts and indications, and to bid them, thank God and take courage, that I write this hasty note.

We reached Washington on Friday evening. After tea we left our hotel to attend the President's levee, when we heard of the GREAT DEBATE in the Senate. Hurrying to the Capitol, as we ascended the stairs of the Senate gallery, we heard the familiar tones of our new Senator [Wilson] . . .

Mr. SUMNER closed the debate, at midnight, in a short speech characterized by his usual fearless denunciations of slavery and of this new aggression. He was frequently interrupted by RUSK and BUTLER, both of whom, the latter especially, were shamefully drunk. It was very, very sad to see the representative of chivalrous South Carolina disgracing his State and the Senate by his maudlin incoherencies. Mr. SUMNER pressed the point with great force that this bill was only necessary to bolster up the Fugitive Slave Bill, and that the repeal of that Act would render the passage of this, even on their own ground, unnecessary; he therefore moved to substitute for this Bill an amendment repealing the Fugitive Slave

Bill. The amendment was of course rejected and the Bill passed; and thus
closed a debate which has done for the anti-Slavery men almost as much
as the passage of the Nebraska Bill.

 It was not alone the arguments pro and con which gave to this debate
its importance; but it was the spirit of the whole scene. Slavery reads
its doom. Throughout the debate, Southern Senators were, as compared
with previous discussions, cowed—their tone is deprecating, very near
the stage which the boys call "cry-baby;" Northern Anti-Slavery Senators
were bold, confident, and defiant. . . .

 I have said that the tone of the South is despondent. The North, they
think, is at length in earnest. They have reason to be alarmed. Thirteen
Senators voted against the motion to lay on the table Mr. Chase's motion
for a select committee on the repeal of the Fugitive Bill.

 —Boston Telegraph, *February 28, 1855*[13]

Senator Gillette read from the laws governing the District of Colum-
bia, and then spent "more than an hour citing extracts in derogation of
slavery." On the Monday before last, he reported, *"a woman tied with
a rope"* was dragged by horseback "under the very shadow of the Capi-
tol." He claimed that slavery had nothing to do whatsoever with race.
"Persons are held here in slavery, at this moment, as white as the whit-
est Senator on this floor." According to one newspaper, "The strength
of his epithets, and the evident heartiness with which he applied them,
had a reviving effect on the drowsy Southern Senators (not to speak it
profanely), like a long pole in a cage of monkeys. They gathered around
him as if he were a natural curiosity, asking all sorts of derisive ques-
tions, about as germane to his remarks as his remarks were to the pre-
cise subject presented in the bill before the Senate."[14]

Senator William Dawson, a Whig from Georgia, remarked,
"These laws are as obsolete as the Blue-laws of Connecticut. Never
enforced here."

Senator James Jones, the six-foot-tall former governor of Tennessee

known as "Lean Jimmy," said, "The Senator from Connecticut has read over fifty pages which must have taken a week to prepare, and speaks of the remarks of Mr. Wade, which shows he knew what Mr. Wade was going to say. Now own up, gentlemen, you knew all about this bill and what each other was going to say on it. I do not say it in my Senatorial capacity, but personally, I verily believe you are a band of traitors."[15]

Gillette was unbowed. He was animated by talk as he sailed on with his litany of horrors, punctuated by lines of antislavery poetry and pieces of song that he sang for the chamber.

Senator Seward was in high spirits when he took the podium at eleven o'clock that night to rail against the absurdist nativism of the secret coalition known as the Know Nothings, who were at their zenith of influence in 1855. In Massachusetts, the American Party, as the outward-facing party of the secret coalition was known, had captured the governor's office, the state senate, and most of the state's house of representatives. They held most elected offices in Boston. Every one of these elected officials was a sworn member of the Order of the Star Spangled Banner, a network of secretive, ethnocentric, anti-Catholic, anti-immigrant nativist lodges. They were against the Fugitive Slave Law and the extension of slavery into the western territories, not out of love for the slave or for justice, but because it would mean reduced wages for the non-immigrant white working class.[16]

Seward condemned Know Nothing nativism: "I do most earnestly and most affectionately advise all persons hereafter to be born, that they be born in the United States; and if they can without inconvenience, to be born in the State of New York, and thus avoid a great deal of trouble for themselves and for others." The Senate chamber erupted in laughter, and he continued. "Moreover, I do most affectionately enjoin upon all such persons as are hereafter to be born, that they be born of fathers and of mothers, of grandfathers and of grandmothers of pure American blood."

The nativists fumed but did not protest, as their secret party bound them to silence in the face of Seward's mockery.

Meanwhile, Seward had bait in reserve. "Speaking from a full knowledge and conviction of the serious inconveniences which absolute and eternal slavery entails upon man and upon races of men, I do earnestly, strenuously, and affectionately conjure all people everywhere, who are hereafter to be born, to be born white." There was laughter again, though this time the hall laughed divided. Seward brought his point home. "Thus, being born in this free and happy country, and being born white, they will be born free."[17]

Senator Charles Sumner, the last of this group to speak, rose to make his own impassioned appeal. But Senator Andrew Butler would not let Sumner present his speech without debate. Butler, asking for the support of the floor, said Sumner "talks as if he was disposed to maintain the Constitution of the United States; but if I were to put him a question now, I would ask him one which he, perhaps, would not answer me honestly."

Sumner responded from the podium, "I will answer any question."

"Then I ask you honestly now, whether, all laws of Congress being put out of the question, you would recommend Massachusetts to pass a law to deliver up fugitives from Slavery."

"The Senator asks me that question, and I answer, frankly, that no temptation, no inducement, would draw me in any way to sanction the return of any man into Slavery. But then, I leave others to speak for themselves. In this respect, I speak for myself" was Sumner's reply.

The Fugitive Slave Law was the law of the land, but in his remarks, Sumner had promised to follow the higher law of his conscience. That was treason. To promote higher law ideology on this scale held up the possibility of righteous anarchy over the rule of law. "If I understand him," Butler said, "he means that, whether this law, or that law, or any other law prevails, he disregards the obligations of the Constitution of the United States."

"Not at all," Sumner responded. "That I never said. I recognize the obligations of the Constitution."

Butler addressed the chamber, "He says he recognizes the obligations of the Constitution of the United States. I see, I know he is not a tactician, and I shall not take advantage of a man who does not know half his time exactly what he is about." This comment was met with laughter. Butler turned back to Sumner: "But, sir, I will ask that gentleman one question: if it devolved upon him as a representative of Massachusetts, all Federal laws being put out of the way, would he recommend any law for the delivery of a fugitive slave under the Constitution of the United States?"

To which Sumner replied, "Never."

"I knew that. Now, sir, I have got exactly what is the truth, and what I intend shall go forth to all the Southern States." Butler took his seat.[18]

Sumner passed a note to his friend Samuel P. Chase of Ohio that whenever he tried "to utter some truth," he "was interrupted by Senators positively drunk!"[19]

At the close of his remarks, Sumner proposed an amendment to this judiciary bill to repeal the Fugitive Slave Law. This was not the first time Sumner had called for a repeal, but in this case, a repeal of the Fugitive Slave Law would make any arguments about its application moot. He called for an immediate vote, and the result was nays 29, yeas 9. Nine senators voted for the repeal of the Fugitive Slave Law, representing Maine, Vermont, Massachusetts, New York, Pennsylvania, and Ohio. As reported in the *Massachusetts Spy*, "The population of these States, with one half of Connecticut, as her representation was divided, is 9,472,318, only half a million less than one half of the free population of the country! Here is a power which the slave power may well fear. How will the South get on with New York, Pennsylvania, and Ohio against her?"[20]

A vote was called on the judiciary bill, and the result was the same. The bill passed.

◆

Sumner's position on the Fugitive Slave Law was "higher law" ideology, and Butler told the South to take notice. Higher law thinking maintains that citizens have an imperative to follow their consciences if placed in situations where to act morally would be to act illegally. The Puritan legacy of higher law provides cover for a wide range of American acts of conscience, from Thoreau's night in jail for not paying taxes to a war government, to the one hundred incidents of clinic bombings at the hands of antiabortion extremists that took place in the first twenty years of *Roe v. Wade*. When a group of constituents place themselves above the laws made by representatives, democracy is compromised. Adherence to a higher law, or personal morality, trumps their allegiance to the laws of the society and state in which they live.

A higher law stance toward the Fugitive Slave Law was particularly appealing for Americans who came to antislavery activism through religious belief. At a rally in 1854, William Lloyd Garrison burned a copy of the Constitution and the American flag. His position on human laws was that the Constitution was a pro-slavery document written by slaveholders, and that men and women of moral conscience therefore need not see themselves as bound to the laws its government produced. At a time when the privacy of home and church were sacred spaces set apart from politics, the Fugitive Slave Law legislated against providing hospitality to desperate strangers.

Many mainstream Northerners felt that the Fugitive Slave Law demanded an everyday complicity with the slave power that was not theirs to shoulder. Henry Wadsworth Longfellow put it this way in his journal: "Dine with the Club. Felt vexed at seeing plover on the table this season, and proclaimed aloud my disgust at seeing the game-laws thus violated. If anybody wants to break a law, let him break the Fugitive-slave Law. That is all it is fit for."[21]

Back home in Auburn, New York, the Seward family was operating a station on the Underground Railroad, and clandestine visitors

continued to arrive despite significant political risks to the senator. Senator Seward's wife, Frances, maintained the station. Once when he was home without her, Seward reported to her, "the underground railroad works wonderfully. Two passengers came here last night." In 1857 Seward would provide a home in Auburn for Harriet Tubman's aged parents. Frederick Douglass often thanked the Sewards publicly in his newspaper for their financial support of fugitives, knowing full well that their support did not end there.[22] If Seward ever feared the legal ramifications of his outright refusal to heed the Fugitive Slave Law, his actions did not show it.

Harriet Beecher Stowe, who said she wrote *Uncle Tom's Cabin* in response to the Fugitive Slave Law, repeatedly called on ordinary Americans to break it the first chance that they got. Her fictional politician Senator Bird explains to his wife, "It's a tiresome business, this legislating!" before adding, off-handedly, that the Fugitive Slave Law has his support.

On the present occasion, Mrs. Bird rose quickly, with very red cheeks, which quite improved her general appearance, and walked up to her husband, with quite a resolute air, and said, in a determined tone,

"Now, John, I want to know if you think such a law as that is right and Christian?"

"You won't shoot me, now, Mary, if I say I do!"

"I never could have thought it of you, John; you didn't vote for it?"

"Even so, my fair politician."

"You ought to be ashamed, John! Poor, homeless, houseless creatures! It's a shameful, wicked, abominable law, and I'll break it, for one, the first time I get a chance; and I hope I shall have a chance, I do! Things have got to a pretty pass, if a woman can't give a warm supper and a bed to poor, starving creatures, just because they are slaves, and have been abused and oppressed all their lives, poor things!"

"But, Mary, just listen to me. Your feelings are all quite right, dear, and interesting, and I love you for them; but, then, dear, we mustn't suffer our feelings to run away with our judgment; you must consider it's not a matter of private feeling,—there are great public interests involved,—there is such a state of public agitation rising, that we must put aside our private feelings."

"Now, John, I don't know anything about politics, but I can read my Bible; and there I see that I must feed the hungry, clothe the naked, and comfort the desolate; and that Bible I mean to follow."

"But in cases where your doing so would involve a great public evil—"

"Obeying God never brings on public evils. I know it can't. It's always safest, all round, to do as He bids us."

"Now, listen to me, Mary, and I can state to you a very clear argument, to show—"

"O, nonsense, John!—you can talk all night, but you wouldn't do it. I put it to you, John,—would you now turn away a poor, shivering, hungry creature from your door, because he was a runaway? Would you, now?"

—*Harriet Beecher Stowe,* Uncle Tom's Cabin *(1852)*[23]

That evening, by the plot machinations of sentimental fiction, the fugitive star of *Uncle Tom's Cabin,* Eliza Harris, arrives with her son Harry half frozen at the Bird home. Senator Bird has never tried his political theories against "the magic of the real presence of distress—the imploring human eye, the frail, trembling human hand, the despairing appeal of helpless agony." But "the letters that spell the word" *fugitive* had ceased to have any meaning for Senator Bird beyond "the image of little newspaper picture of a man with a stick and bundle."[24] Visual culture historian Marcus Wood has argued that by the 1850s, some Americans had become desensitized to the idea of the "fugitive slave," in part because of the ubiquity of wanted posters and ads for their recapture.[25]

THE FUGITIVES ARE SAFE IN A FREE LAND. Page 258.

"The Fugitives Are Safe in a Free Land," illustration by Hammatt Billings for *Uncle Tom's Cabin* by Harriet Beecher Stowe, 1852. The image shows George, Eliza, and Harry, and Mrs. Smyth.

Stowe did not remind us of it in this scene, but Eliza and Harry could both pass for white. Illustrations for the first American edition by Hammatt Billings, who also designed the masthead for the *Liberator*, and for the British edition by celebrated illustrator George Cruikshank, would render the optics of this scene more clearly, by showing a white family of fugitives. Stowe's narrator attributes Senator Bird's total reversal of personal and political opinion—and his subsequent decision to aid the fugitives, at risk to his office and reputation—to the surprising resemblance he sees between Eliza's child Harry and the Birds' late son Henry. His astonishment that a fugitive could so closely resemble his lost son causes him "intense excitement." Radicalized by relatability, he weeps, then acts on their behalf. In defiance of the law that he helped write and protect, he caves to his wife's moral authority.

When Sumner introduced Mary to the Massachusetts legislature and others in Boston, he intended for her presence to produce an instant and entire "softening" effect on hard-liners who supported the Fugitive

Slave Law, not unlike the sudden reversal of Senator Bird when he recognizes his son in the fugitive child Harry. In his February 19 letter to Dr. Stone, he had joked that "her presence among us" would be more effective than his speeches, because by her appearance, Mary would work the same "magic of real presence" that readers had seen end the argument between the fictional senator and Mrs. Bird.

The Senate session ended, and it was time to leave Washington.

PART FOUR

SENSATION

———————◆———————

"A White Slave from Virginia"

◆

On March 7, 1855, Elizabeth and her three children, Oscar, Mary, and Adelaide Rebecca, along with Prue and Evelina, headed north. According to the *New-York Daily Times,* the newly manumitted family "created quite a sensation in Washington, and were provided with a passage in the first-class cars in their journey to this City." Train cars were segregated—blacks were permitted to ride only in a small section of the smoking car. To be provided with "a passage in the first-class cars" is a meaningful detail in this context. The women traveled as white, while Oscar accompanied them in the role of servant or rode segregated in the smoking car. They traveled in the company of Charles Henry Brainard, the thirty-eight-year-old lithographic publisher and publicist from Boston. His book *Brainard's Portrait Gallery of Distinguished Americans*—primarily drawn from portraits of men who worked in Washington—was in production, and he had to deliver the

daguerreotypes to his engraver, Leo Grozlier. It may have been for this reason that Brainard was en route from Washington to Boston in early March 1855. Or perhaps he traveled with Elizabeth as a personal favor to his senator.

In reading the local press, during the weeks leading up to Mary's arrival in New York, we find much commentary on babies. That month, in New York City, P. T. Barnum launched one of his most controversial and successful ventures—the "Baby Show." Parents lined up outside his museum with their babies, hoping their little ones would be determined to be charming enough to enter the show. Barnum had put up $1,100 in prize money for the most likely baby, the most healthy baby, and babies with other merits. Would black babies be allowed to compete?

When public opinion sanctions without exception the promiscuous assemblage and close companionship of black and white, in churches, schools, theaters, courts of justice, railroad cars, Italian Opera houses, editorial sanctums, and printing offices as well as among bank directors, merchants on exchange, and in the social circle, I shall not be found backward. . . .

As society is as present constituted, however, and as it seems likely to remain during our day and generation, I regard his question as impertinent, and merely state that I shall manage the Baby Show, as I manage all other enterprises in which I engage, with a respectful deference for the social usages of the community I seek to please.

—P. T. Barnum, May 4, 1855[1]

The "one-hundred cradles" exhibition drew sixty thousand white people when it opened in June 1855. (People of color were not allowed to enter Barnum's museum until after the Civil War.) After exhibiting "one hundred of the finest white babies on this continent," Barnum stated that he would offer the same prize money for a similar exhibition of "the finest colored ones," provided an equal number were

brought around for the competition. Unsurprisingly, this did not come to pass.[2]

The circus man's distinction between white and black babies reflects the era's total segregation, a gauntlet through which Mary would have to pass for the rest of her free life in the North. Arriving in New York, she would begin to be submitted to a long series of examinations and observations intended to determine what her race would be, if legible at all. If she were found to be black, her family's mobility would be curtailed. If white, they could continue to travel first class.

◆

When meeting Mary, New Yorkers responded in ways not unlike their gawking at the curious exhibits at Barnum's museum, at such celebrities as Tom Thumb or the "Feejee mermaid." Strangers examined her for traces of the African race: in her skin, in the arrangement and size of her facial features, in the shape of her head, in the curl of her hair, and in the whites of her eyes. Her examination began at the offices of the *New-York Daily Times,* located at 138 Nassau Street.

A WHITE SLAVE FROM VIRGINIA. We received a visit yesterday from an interesting little girl,—who, less than a month since, was a slave belonging to Judge NEAL, of Alexandria, Va. Our readers will remember that we lately published a letter, addressed by Hon. CHARLES SUMNER, to some friends in Boston, accompanying a daguerreotype which that gentleman had forwarded to his friends in this city, and which he described as the portrait of a real "Ida May,"—a young female slave, so white as to defy the acutest judge to detect in her features, complexion, hair, or general appearance, the slightest trace of Negro blood. It was this child that visited our office, accompanied by CHARLES H. BRAINARD, in whose care she was placed by Mr. SUMNER, for transmission to Boston. Her history is briefly as follows: Her name is MARY MILDRED BOTTS; her father escaped

from the estate of Judge NEAL, *Alexandria, six years ago and took refuge in Boston. Two years since he purchased his freedom for $600, his wife and three children being still in bondage. The good feeling of his Boston friends induced them to subscribe for the purchase of his family, and three weeks since, through the agency of Hon.* CHARLES SUMNER, *the purchase was effected, $800 being paid for the family. . . . The child was exhibited yesterday to many prominent individuals in the City, and the general sentiment, in which we fully concur, was one of astonishment that she should ever have been held a slave. She was one of the fairest and most indisputable white children that we have ever seen.*

—The New-York Daily Times, *March 9, 1855*[3]

This journalist had one fact of Mary's enslavement incorrect. Judge Neale did not own her father. He reports a "general sentiment" of "astonishment," and in that feeling, his colleagues at the *New-York Daily Times*, "fully concur." The word "astonishment" suggests an over-powering of his senses, as if in surprise or in reaction to the sudden presence of something unaccountable and unaccounted for. Astonishment is a temporary disturbance in our categories of experience, rattling our assumptions of what is "us" and "not us."

The *Times* is further surprised that Mary was ever "held" as a slave. This shift in language, that Mary was "held" in slavery, subtly communicated a hope that she had not been born into slavery. The novel *Ida May* provides him with the fantasy of a white child who had been kidnapped into slavery, and thus was "held" wrongfully as a slave. The journalist was redirecting readers' focus away from the taboo of sexual slavery. "Prominent individuals of the city" might prefer to believe Mary was the victim of kidnapping and wrongful enslavement rather than the product of nonconsensual sex between white masters and the enslaved women Letty, Prue, and Elizabeth.

Some prominent individuals were more direct. A month earlier a

racist take on the subject had appeared in the press along with a "general laugh."

A GOOD REPARTEE.

A friend recently from Washington has related to us a little incident that transpired a short time ago in the Senate Chamber, and which made some amusement among the members.

Mr. Gillette, our Senator, sits near to Toombs of Georgia, and they frequently pass a good-humored joke. A few mornings ago, just before the Senate was called to order, while several of the members were standing near, Toombs said to Gillette: "They say, Gillette, that you abolitionists are mad with the Almighty for making the n**rs black." *"Your informant is slightly mistaken," replied Gillette; "we are only mad with you slaveholders* for making them white." *The allusion to the bleaching process that is going on among the colored population of the South was at once understand by all, and Toombs joined with much good humor in the general laugh.*

—Connecticut Courant, *February 3, 1855*[4]

◆

To shock a white audience into awareness of the pain of slavery, illustrations in popular books depicted white people enduring slave life: white bodies at auction, white bodies being whipped, and so on. This narcissistic attention to "white slavery" moved front and center in white-authored fictional works such as *Ida May*, Richard Hildreth's *The White Slave* (which depicted Archy and his wife and half-sister Cassy at the whipping post), Dion Boucicault's Broadway hit *The Octoroon*, and of course Stowe's *Uncle Tom's Cabin*, which featured several white heroines. In theaters in New York, the white child star Cordelia Howard

performed the role of Ida in dramatizations of *Ida May* and then Little Eva in *Uncle Tom's Cabin*, sometimes both on the same day.[5]

As the pro-slavery author Edward J. Stearns pointed out in 1853, in *Uncle Tom's Cabin*, "when our sympathies are to be enlisted in behalf of fugitives, [Stowe] takes care to have them not negroes, nor even mulattoes, but quadroons,—men and women all but white, and who, therefore, according to the fitness of things, ought not to be in slavery at all." Had Eliza and Harry presented as black when they appeared at Senator Bird's door, "certainly the Senator never would have helped her off. This, Mrs. Stowe very well knew, and therefore she took care to have her fugitives all but white."[6]

Mary's photograph allowed the reading public, busy consuming these stories of white trauma, to consider a white, and formerly enslaved, child. Even if readers had never seen the daguerreotype, knowing it existed gave truth to fiction.

◆

The South did not mistake this strategy. Beverley Tucker saw right through Sumner's "white slave" propaganda. His language was coarse, but the message was clear: white supremacy motivates the abolitionists' latest move toward white girls. Tucker elicited disgust in his dehumanizing descriptors for black people, and while these paragraphs are now difficult to read, they illustrate how mainstream racist ideology aligned beauty and value with Caucasian features. He makes Sumner a "ringmaster" and Mary, a romantic heroine.

SENATOR SUMNER, "IDA MAY," AND THE SOLID MEN OF BOSTON
It is no light task, quote the old adage, "to make a silk purse out of a sow's ear," but that operation is not more difficult and impossible than the process of making a hero out of a big, black, odorous buck negro—or a heroine out of a thick-lipped, goat-nosed, nappy-headed negro wench. The

Abolitionists have made many efforts to do so. They have shed oceans of crocodile tears over Fred Douglas, and shed honest blood as a sacrifice to Anthony Burns. But they were engaged in an up hill business. The dismal black could not be washed out, the thick lips could not be reduced, the flat nose could not be elevated, the nappy hair could not be straightened, and the African odor defied Eau de Cologne and otto of roses. Without the removal of these obstacles heroism was a plain impossibility. The essential element of romance was wanting, and everybody knows that heroes and heroines are romantic beings.

Here was a crisis, an emergency, that frowned its terror on the Abolitionists of Massachusetts. But there was one man who was equal to the great occasion. He saw the peril, and he determined to meet it. This man was Senator Sumner. We may imagine his anguish until he succeeded. We may fancy his eyes "in a fine frenzy rolling." We may picture to ourselves his tall, stout figure convulsed with spasms of philanthropic sympathy. We may imagine how he wrung his hands and tore his hair. But at length the mind of the statesman springs a great thought. A sudden inspiration comes to this relief, and he exclaims like the ancient mathematician, "eureka—eureka." As the apostle was moved to go to Damascus, so was Senator Sumner—the grave and the august Massachusetts Senator, moved to go to the borders of Virginia to hunt for a slave without the disgusting African marks of a flat nose, thick lips, &c. &c. The grave Senator makes his pilgrimage. He finds a girl in slavery who is nearly white. The base low marks that intervene between the unadulterated African and heroism, are absent. She is quite white. She is bought by the Senator (another person furnishing the funds) and transplanted like a tender lily to Massachusetts. But before she is sent to that solid and erudite state, a daguerreotype of her is taken, over which the august Senator presides. It is sent to Massachusetts. It is shown to the solid men of Boston and to all the grave legislators of Massachusetts. Inasmuch as we spoke of this daguerreotype and the Senator's letter, which accompanied it, we forbear at present to say more about it, and return to the original. . . .

The abolitionists have at last found out what the Southern people found out long ago—that it is sheer nonsense to undertake to invest thick-lipped Africans with romance. They have found out that to sustain, protract, and render effective their sympathy with African slaves, they must catch a white one with all the marks of the Caucasian race, and show her as a poor persecuted slave to the solid men of Boston, and the grave legislators of Massachusetts. Senator Sumner is the ringmaster, and he sequins himself most creditably.

But this girl, picked up by the grave Massachusetts Senator is so white, *that we confess, we are not without our suspicions. When carried to the office of the editor of that immaculate sheet, the New York* Times, *he thus exclaims: "She is one of the fairest and most indisputable white children that we have ever seen. 'Prominent individuals' who saw her, expressed their 'astonishment that she should ever have been held a slave.'"*

Several thoughts here suggest themselves. One is, that she is in all probability, not a bought slave, but a humbugged white girl. The second is, that, if white, as the New York Times *declares, it is very silly in the Abolitionists to undertake to illustrate African slavery by means of a white girl.*

The innocent girl finds herself with a new and romantic name. They make her swop her Virginian and her true name for the delectable appellation of—"Ida May."

She is crowned with the flowers of romance. She is made a heroine because she is white. But, to cut the matter short, we beg leave to say that we have a kindness for slaves—more kindness than all the Abolitionists put together; and we wish "Ida May" much happiness. We hope that her new masters will marry her off to one of the sons of one of the rich and solid men of Boston. No doubt Senator Sumner will give her away, and the Rev. Theodore Parker will perform the ceremony.

—Beverley Tucker, March 14, 1855[7]

The *New-York Daily Times* retorted in a short response entitled "Encouraging": "The Washington *Sentinel* has said a witty thing—we were going to quote it, but the joke reaches through a column, and we have not space to save the curiosity in. It is all about Senator Sumner's 'Ida May,' who, it shrewdly suggests must be a 'bogus' slave because the *Times* has pronounced her white."[8]

The *Times* neglected to mention Tucker's theory that "it is very silly in the Abolitionists to undertake to illustrate African slavery by means of a *white girl*." Sumner, by bringing a white child out of slavery, had intended to upend the racial construct and thereby blur the edges of slavehood. But members of his audience simply regarded her as an exception to the rule of black and white, a "bogus" representative of the class of enslaved persons.

Edward Lillie Pierce, Sumner's nineteenth-century biographer, put it best when he called Mary's daguerreotype a bait-and-switch: "many were affected by the sight of [a] slave apparently white, who were unmoved at the contemplation of negroes in bondage." Sumner's strategy generated sympathy, but at a high cost. By confirming racial difference—white slave equals white sympathy—he did not call for sympathy and, more crucially, the right to life, liberty, and the pursuit of happiness for persons of color. This equation was complicated by class and gender norms surrounding white womanhood. The near-white mothers and girls at the heart of antislavery novels trouble the social landscape only insofar as they exposed new communities of white women who needed protecting from white men. By inviting judgments about white and black "fitness" for enslavement (sexual or otherwise), mixed-race characters could either confirm a message and vision of a shared humanity or, just as easily, solidify existing racial prejudice.

The Williams Family

◆

The family traveled on to Boston by boat and rail, via the Fall River Route—the fast, luxurious, and modern way to make the journey in 1855. Brainard reserved staterooms for Prue, Evelina, Elizabeth, Oscar, Mary, and Adelaide Rebecca, and separate quarters for himself, at the rate of four dollars a person. Had the steamship company known who they were, it might have denied them staterooms, but as it was, Brainard settled their reservations, using money Henry Williams had sent by way of John Andrew. The 238-mile journey would take only 8 hours and 22 minutes, one-eighth the time it would have taken them to travel overland, which took four days and required staying three nights in uncertain lodgings. After the overnight journey, they would arrive in Boston (as the steamship company advertised) "before the first appointment of the day."

In this case, their first appointment would be reunion with husband and father Henry Williams; they were eager to be on their way. On Thursday, March 8, after "prominent members of the city" took their measure in the offices of the *New-York Daily Times,* on Nassau Street, they set out crosstown, making their way through the weekday crowd during the last hour of business on a cold day. Mary and her family boarded the steamship at Hudson River Pier 2 N.R. (North River), at Morris Street, a short walk from the Battery. (That pier no longer exists today, having been filled in and built up as Battery Park City.)

Their steamship, captained by Benjamin Brayton, was the seven-year-old *Empire State*, which had been dedicated the year Mary was born. It departed New York on Tuesday, Thursday, and Saturday afternoons. On alternate days, the *Bay State,* the company's other ship, plied the route. The Bay State Steamboat Company, run in the 1850s by William Borden, was the first in a long line to navigate the Fall River route. The *Bay State* was once the largest inland steamship in America, built and furnished at a cost of $175,000, with 420 "commodious and well-ventilated" berths in 315 feet. The newer *Empire State* was built in 1847 to the same specifications, only "still more costly and elegant" and forty feet longer. Magazines praised the ships as "chase and neat, but not gaudy." In their day these were floating palaces, with dining rooms, card salons, and dance halls fit for presidents and robber barons. According to one story, Gilded Age owner of the Bay State Steamboat Company James Fisk kept two hundred canaries in golden cages just to enliven his steamships' long corridors.[1]

The steamer pulled out of Pier 2 N.R. at four o'clock and slowly rounded Castle Garden. This being March, Castle Garden was closed for the season, though along the ramparts of the Battery, a few intrepid men and women could always be seen, as Herman Melville assured us, looking out to sunset or sea despite the hard wind. The *Empire*

State headed up the East River, treating Mary, Oscar, and Adelaide to a view of the city in silhouette against the setting sun. By dinner service, the steamer had turned east through Hell's Gate into a dark Long Island Sound.

All night the *Empire State* followed the coast of Long Island as its passengers danced, tucked themselves into their warm staterooms, or if among the black or half-price travelers, found frigid chairs tied to the lower decks. In the predawn light, the ship touched at Newport, Rhode Island, then headed north to the port town of Fall River, Massachusetts. It was a short night. Everyone, down to the last sleepy passenger, had to be packed and ready to disembark at six a.m. At the bottom of the gangplank, porters hustled them a dozen or so feet across the platform, to board waiting railcars. The Fall River train station was inside the wharf, directly adjacent to the docked steamships, an ingenious design. The steamers' arrival times were precisely synchronized with train departures on the Old Colony Railroad.

The train to Boston would take an hour and forty minutes. Later that night the Massachusetts coast would see record snow and hurricane-force winds. Nearby rail lines in Plymouth, Duxbury, and Cape Cod would become impassable beneath snowdrifts. On Saturday afternoon, stages that were due to connect to the Old Colony Railroad could not force themselves through, so passengers deserted their coaches and walked the three or four miles to Duxbury in the wind and snow, or else spent the night among strangers in the farmhouses scattered along that route.[2]

But early Friday morning was clear, and their train made the remaining fifty-three miles to Boston without incident. Mary and her family arrived in South Station at eight a.m. on March 9, 1855. Forty-four days after manumission, their free life began.

◆

Henry Williams walked down the Old Colony line platform as the engine pulled in, enveloping him in rising steam and noise. He searched every window for a familiar face, stepping aside as porters swung out from their doors, lowering the steps before the train fully slowed. The cold air dissipated any warmth from the boilers. Valets met the first-class cars with carts and heavy coats. Business commuters pressed in the direction of the exits. Baggage carts were pulled up the ramp. Henry searched this scene for his wife.

The steam and noise subsided as the platform filled with passengers wrapped in the quiet of reunion. Once the opening shouts of recognition were sounded through the window glass, the family disembarked to gather around him in a long embrace. At the train station that morning, husband and wife were restored to each other after an absence of five dangerous years. Henry met his daughter Adelaide Rebecca, now a school-aged child. His son Oscar was almost out of boyhood, a smaller version of himself.

Henry was to them like a father returned from war. He had passed through all trials. The three women too had endured. The children were growing, smart and fine. All present had once expected never to see one another again, and the joy must have come on whole, blessedly unmitigated by disappointment and loss. Their tears held equal parts relief and joy.

In that moment when Henry Williams was restored to his roles of father, husband, and son-in-law, he reattached himself to a private life that he had been denied—denied for five years by distance, and for a lifetime by slavery. He reassumed the responsibilities and endorsements of a large family. This extended family of seven was his to have and to hold. He had refused to capitulate to John Cornwell or Thomas Nelson or John C. Weedon or Charles Sumner. He had fought for the heart of his wife and fundraised for their children, whether they looked like him or not. He had taken back this dear prize for himself.

The Boston papers were on hand to witness. The *Boston Recorder* ran the headline, "A Family United."[3] The *Boston Courier*, announcing the "Arrival of Senator Sumner's Protégés," confirmed that Mary was indeed, "a very handsome child, with fair skin and regular features."[4]

◆

John Andrew, too, witnessed the reunion he had helped effect. He was proud of the role he had played in what he termed "the happy and complete re-establishment of this poor family, restored to each other." The word *re-establishment* was not wholly correct or incorrect, and he revised his thought. As enslaved people, they had had no legal claim to one another, but now Henry could take his place as head of the household without impediment. Andrew had made certain of his client's rights to the extent of the law's protections in a slaveholding society. Legally speaking, this family was complete; it would be up to them to make themselves whole.

4 Court Street
March 10,' 55

My dear Sumner,

I have just rec'd yours of the 8th,—and the "free papers."

Since the case of Ludwell is in abeyance for the present, trust be until further news from Judge Neale, I write to him by this day's mail, not only in reply to a letter rec'd this week; but, also to say that—in your absences from Washington—he need not trouble you with the subject; but may correspond with me directly, as heretofore,—I hope the money for Ludwell maybe got ~~before~~ by the time it is needed—and so no time for payment be required.

Elizabeth and the three children arrived safely and well, yesterday morning.

After all the negotiation with the two contending parties, on their

behalf, and all the anxieties, disappointments and delay, of two or three
years of effort; with the husband and father constantly calling on me,
and relying on my encouragement & aid, in raising his funds, keep-
ing up his hopes, & looking out for the protection of his family, in any
way I could.—You may be assured that I contemplated the happy and
complete re-establishment of this poor family, restored to each other, no
more as slaves, but in full freedom and peace, with more thankfulness
than I can tell.

For all your constant kindness to them while in Washington, and your
attention and aid to me, I need not say that I am heartily grateful.—

Faithfully, truly yours,

J. A. Andrew[5]

An ambrotype of Oscar and Mary would be made soon after their
arrival in Boston, at Cutting and Bowdoin studios. Mary wears the
same plaid day dress as in the daguerreotype by Vannerson, though
long sleeves have been added for the season, along with a new lace col-
lar. Her expression, however, is entirely changed: something about her
appears confident and proud, and her eyes snap.

Her brother Oscar, considerably darker-complected, wears a suit
that seems too big for him, and he seems to tower over Mary. Little is
known about him, apart from brief mentions of him as the handsome,
eagle-eyed philosopher in John Andrew's broadsheet "History of Ida
May" (page 136).

James Ambrose Cutting and David Bowdoin produced ambrotypes
together for just over a year, and the one they made of Mary and Oscar
is now in the Massachusetts Historical Society Photograph Collection,
along with the Vannerson daguerreotype. Photograph number 2.128 is
described as "a Quarter-plate ambrotype in leather case of two uniden-
tified slave children in whom, according to a note enclosed with the
case, Gov. John A. Andrew of Massachusetts 'took an interest.'"

Cutting added a layer of protective glass to the ambrotype, affixing

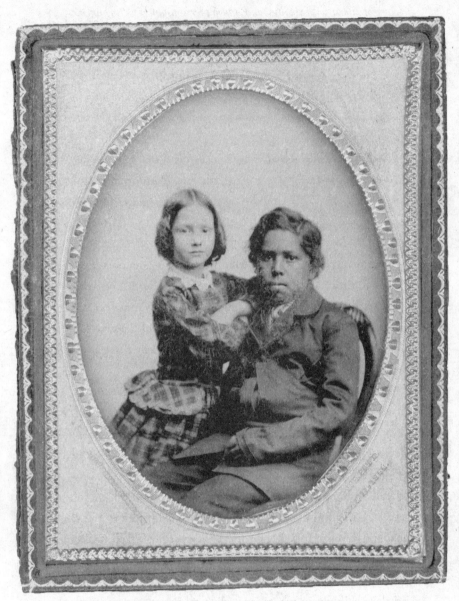

Mary Mildred and Oscar Williams, ambrotype by Cutting & Bowdoin, ca. 1855.

it to the emulsion side of the plate using balsam of fir.[6] This method
successfully sealed the images made on the glass plates of the ambro-
type, using the wet collodion process, so it would last more than a
century. For much of the 1850s, Cutting charged his fellow photog-
raphers twenty-five dollars to license his patents. Some photographers,
like Julian Vannerson, paid up, but the fee made Cutting known to
the trade as an unpopular "process-monger." Cutting would eventually
bundle his patents with those of John Whipple, who had seen more suc-
cess in keeping his "secret processes" lucrative.

The Cutting and Bowdoin ambrotype depicts Mary as a member
of a loving family. Unlike in the Vannerson daguerreotype, she is not a
poster child but a child; not an orphan but a sister; not the kidnapped
"Ida May" but a child of racially mixed parents. The perceptible differ-
ence between these two images is no wonder: one was made for private
remembrance, the other for public consumption.

This image later became a *memento mori*, or photograph of a person
who has passed. Oscar would die five years later, when he was fifteen,
of tuberculosis. The first years of the Williamses' Boston life would
be haunted by this disease, commonly known then as consumption
because it completely destroys the body, uses it up. Newcomers to city
life, living in old buildings and in close quarters through unforgiv-
ing winters, were susceptible to its grip. Even a strong young body like
Oscar's could not withstand the wasting energy of this disease.

◆

In the press, the moniker "Ida May," and the fictional backstory that
went with it, stuck to Mary. "Little Ida May" became the predominant
way she was referred to, though her given name Mary Mildred Botts
occasionally appeared in papers, such as in the *Courier*. The *Messenger*
went so far as to say that "the girl's name was changed to 'Ida May' by

Mr. Sumner; and by that name she will, in future be known."[7] Masters took liberties with slaves' names, and at least one journalist seems to have thought Sumner owned her. Other newspapers called her "Ida May II," as though she were a sequel.[8] This renaming could be innocuous, like a stage name, or it could be symptomatic of a deeper issue: when people's names are changed, neutralized, or erased, they are lost to history. Further, a name change removes the protections of a large loving family.

In the novel, Ida May was a white child "kidnapped" into slavery. Mary's nickname, "Little Ida May," attached that fictional story to her. Sumner wanted Mary's race to read as "white," not "made white," so for that reason, he captioned her image with a story about the kidnapping of a white girl, Ida May. It was as if Ida May, last seen in the papers beaten senseless by her kidnappers, had been spectacularly resurrected by Charles Sumner (and fund-raising) three months later. Abolitionists commonly promoted sensational stories of "mistaken" enslavement, to demonstrate how the Fugitive Slave Act might encourage the kidnapping of free people into slavery.

Ida May was published to great fanfare in 1854; Solomon Northup had published his true slave narrative of mistaken captivity, *Twelve Years a Slave*, a year earlier. Then in the spring of 1855, Northup took to the antislavery circuit to lecture on his experiences in Louisiana, and on at least two occasions, Mary stood by his side as "Little Ida May." They were a notable pair: a grown man and father, hardened by years of labor, and a little girl with strawberry hair. [9] They had one thing in common: the American public felt their enslavements to be unfair. It was a seductive argument. Kidnapping was a simple injustice rather than a systemic one, and thus easier to solve.

Solomon Northup's narrative proved that free persons could be sold into slavery without recourse, because of the color of their skin. In a contemporary slave narrative, *Running a Thousand Miles for Freedom*,

William Craft made this reminder: "slavery in America is not at all con-
fined to persons of any particular complexion." His wife, Ellen Craft,
the daughter of a slave and her master, "passes" for a white invalid man
in the narrative. But Craft wanted to extend the threat of kidnapping
to include all children, to engage all readers. He warned white parents,
"it is almost impossible for a white child, after having been kidnapped
and sold into or reduced to slavery, in part of the country where it is not
known (as often is the case), ever to recover its freedom."[10]

But unlike "Little Ida May," Mary Mildred Williams was not kid-
napped. She had been born into slavery—and into a loving family. She
never lost either her identity or her mother. Her father had been work-
ing and waiting for her. By conflating Mary's true story with Ida May's
fictional one, Sumner whitewashed her story, painting over genera-
tions of sexual exploitation with a single kidnapping. In the spotlight,
Mary was isolated from her entire family. Her robust family support
was inconvenient to the telling of Ida May's orphan tale. And by rais-
ing awareness for those few children kidnapped into slavery, Sumner
eclipsed the multitudes who were taken from their parents as a matter
of business. The *Liberator* exclaimed in its first issue, "There were kid-
napped in the past year . . . MORE THAN FIFTY THOUSAND INFANTS, the
offspring of slave parents!!!"[11]

◆

While the public thought Mary Mildred Botts had been renamed "Ida
May" by her famous patron, in her private life Mary took her father's
name, becoming Mary Mildred Williams. Henry Williams had left the
surname Botts in Virginia and changed his name upon his arrival in
Boston. Now his wife and three children followed suit.

Our name attaches us to our family, and families were separated
by slavery. Most people assumed Mary's father was her mother's mas-

ter, J. C. Weedon, because of the pale color of her skin. Therefore, it is doubly important that we use the name Mary Mildred Williams, her father's chosen name for her—and not her father's master's family name, Botts—to refer to Mary in future.[12]

The small note affixed to the copy of the daguerreotype of Mary kept by Caroline Alvord Sherman reads "Mulatto raised by Charles Sumner," although anyone familiar with Senator Sumner would hardly expect him to raise a ward. In the novel *Ida May*, Ida's parents are thought to be dead. No wonder then, that good people came forward to adopt Mary, to take up the parental role that her slave masters must have defiled. William Knight of Medway, Massachusetts, having read Sumner's letter about Mary in the papers, sent the senator an offer to adopt "Little Ida May" and raise her with his own sons.

Medway, February 28, 1855

Hon. Charles Sumner

Dear Sir, I noticed in the paper last evening a letter to Dr. Stone in which you say you have a little "Ida May" redeemed from slavery; if she has no home or there is none provided for her, we would be happy to take her, and give her all the privileges we give our own children.

We have only two little boys, and the idea of having an active, intelligent little girl would be very pleasing.

Most respectfully yours,
Wm Knight[13]

Knight's note recognizes that should Mary already have a home, he will honor that claim. He offers white privilege by name: "all the privileges that we give our own children." Elizabeth and Henry Williams faced a difficult choice, presented to them many times over the course of Mary's fame: to give her up to white society.

◆

Did Mary ever read *Ida May*, or have it read to her? When she was a child, the announcers who introduced her as "Little Ida May" would no doubt have sketched the novel for the audience. Despite its antislavery fervor, the novel was available for purchase in Washington, and Elizabeth could have procured a copy, resplendent in its cobalt blue binding. Whether or not seven-year-old Mary read the novel, its message was clear: some children were not meant for slavery. She was one of them.

Frederick Bailey, the slavery name of Frederick Douglass, was also seven years of age when he learned he was a slave. He had witnessed, first hand, that enslavement promises violence. As the man remembered the inquisitive child, Douglass recalled how his aunt Esther's torture initiated a productive line of inquiry.

The heart-rending incidents, related in the foregoing chapter, led me, thus early, to inquire into the nature and history of slavery. Why am I a slave? Why are some people slaves, and others masters? Was there ever a time this was not so? How did the relation commence? These were the perplexing questions which began now to claim my thoughts, and to exercise the weak powers of my mind, for I was still but a child, and knew less than children of the same age in the free states. As my questions concerning these things were only put to children a little older, and little better informed than myself, I was not rapid in reaching a solid footing. By some means I learned from these inquiries that "God, up in the sky," made every body; and that he made white people to be masters and mistresses, and black people to be slaves. This did not satisfy me, nor lessen my interest in the subject. . . .

Then, too, I found that there were puzzling exceptions to this theory of slavery on both sides, and in the middle. I knew of blacks who were not slaves; I knew of whites who were not slaveholders; and I knew of persons who were nearly white, who were slaves. Color, therefore, was a very unsatisfactory basis for slavery.

Once, however, engaged in the inquiry, I was not very long in finding

out the true solution of the matter. It was not color, *but* crime, *not* God,
but man, *that afforded the true explanation of the existence of slavery;
nor was I long in finding out another important truth, viz: what man
can make, man can unmake. The appalling darkness faded away, and I
was master of the subject.*

—*Frederick Douglass,* My Bondage and My Freedom [14]

Young Frederick walks us through the steps he made away from
ignorance once Esther's whipping has made slavery visible to him. The
scales fall from his eyes; he remembers this moment as a transformative
conversion experience that has left him "master of the subject." Doug-
lass earns his mastery through contemplation of visible evidence, and
like all uncovered truths, it appears self-evident. Mary found herself to
be of these "puzzling exceptions." What solutions did she learn from
becoming "Ida May"?

<div style="text-align: center">

14

</div>

"Features, Skin, and Hair"

<div style="text-align: center">

◆

</div>

O n her second day in Boston, Saturday, March 10, "Little Ida May" was expected to appear at the Boston State House, where, along- side Solomon Northup, she would be presented to the Massachusetts legislature and members of the press. Northup's story preceded him, as Mary's daguerreotype preceded her. A few weeks earlier John Andrew had written Sumner, "I feel also desirous that Members of the legislature shall have a sight of those children," for "their presence may add impres- siveness" to the issues under consideration.[1] Dr. Stone had organized Northup and Mary's visit—it would be a spectacular sideshow on a day when the State House would have the public's full attention.

That Saturday the state legislature would consider two petitions, both Vigilance Committee efforts. The first was a petition for state action to curtail the Fugitive Slave Law. The second was a bill calling for the removal of Justice Edward G. Loring as Suffolk County probate

judge. A year earlier, Loring had adjudicated the Anthony Burns trial, returning Burns to slavery, in compliance with the Fugitive Slave Act and in the face of vocal public opposition. On the day Mary and Northup appeared, the Committee on Federal Relations would hear new information in the controversial Loring case.[2]

Earlier in the week, at the State House, the Reverends Thomas Wentworth Higginson, Theodore Parker, and Wendell Phillips had been indicted by the U.S. Circuit Court for obstruction of justice. Parker and Phillips were called to court for their rousing speeches on behalf of Burns at Faneuil Hall on the eve of his sentencing. Higginson and his compatriots had broken down the courthouse doorway in an attempt to free Burns during his hearing before Justice Loring; a guard lost his life in the melée that followed. The day after Higginson's court appearance, Anthony Burns was returned to Boston, a man freed by fund-raising.

With this much antislavery news happening in the space of a week, it is notable that Northup and Mary's visit was so widely covered in the press. The *Worcester Spy* reported that "Solomon Northup, of N. York, who spent twelve years as a slave on the Red River, and Ida May, the little redeemed slave, from Washington, were in the Hall of the House on Saturday, for a short time, and excited much sympathy and interest. The little girl has no feature which indicates any negro origin.—Her eyes sparkled just like those of any other little girl when she saw the big cod-fish hanging in the hall."[3] The *Boston Courier* noticed that "she is a good looking child, with a pale face a very little freckled, chestnut colored hair, and has no characteristics of the negro race in her features."[4] In contrast, the correspondent for the *St. Albans Messenger*, from Vermont, maintained a healthy incredulity to the proposition that the members of the Massachusetts legislature would welcome Mary's presence in these proceedings.

Hon. Charles Sumner, an abolitionist and Senator from Massachusetts,
has created no little sensation in this city, with his "white slave girl,"

whom he bought and brought from Virginia. He has been dubbed a slaveholder by some of his enemies, inasmuch as he purchased the girl's freedom with his own funds, and upon his own responsibility. The girl, although a mulatto, has quite a fair, white complexion, and will easily pass for "white folks." Her family still remains in bondage; so, in order to more effectually enlist sympathy, Mr. Sumner had several copies of a daguerreotype taken of her, and circulated among his abolition friends, with a view of raising funds sufficient to buy the rest of the family. . . . She was taken to the State House soon after her arrival here, and was much caressed and flattered by members of the Legislature; which circumstance was a little singular, considering that they were Know Nothings, and she slightly tinctured with "foreign extraction."

—*"Boston Correspondence," St. Albans Messenger, March 22, 1855*[5]

Her staged appearance at the State House was "a little singular," contended the *St. Albans* reporter, considering that the majority of elected officials in Massachusetts in 1855 were members of the white supremacist American Party, otherwise known as the Know Nothings. These ethnocentrists were unlikely to "caress" and "flatter" a child of indeterminate race.

William Cooper Nell, acting as a correspondent for *Frederick Douglass's Paper,* reported on Mary's appearance with likeminded cynicism about the Know Nothing response. He began, as most contemporary reports of Mary did, by confirming that her racial features were white: "She is perfectly white." Then, as he was speaking to the black abolitionist community reading *Frederick Douglass's Paper*, he shifted his tone: her whiteness, not her slave-ness, produced excitement in white, nativist audiences. Black Bostonians were not surprised by her color, because, "white fugitives" were a daily appearance in their community.

BOSTON, March 12, 1855.
Anthony Burns arrived in this city on Wednesday afternoon. In the eve-

ning there was a grand reception meeting at the Tremont Temple. About two thousand persons were present. Burns was loudly cheered when he went in, and took his seat; after which, three cheers were called for and given . . . The meeting was an enthusiastic one, and the sentiments of the speeches were pretty generally approved of and loudly cheered by the audience. Rev. Dr. Kirk was the chief speaker of the evening. He made one remark which, we confess, we did not understand; he said, "a black man is a man, every inch of him. Under the skin, all is human.*" We wonder if the learned Doctor means that the skin, hair and nails of the black man are not human? Perhaps he means if a black man was skinned and scalped, and his toe and fingernails taken off, then the rest of him would be human. Now, we like the Doctor's speech very much, but we are inclined to think that the Doctor, in this instance, was a little ambiguous. We shall be glad to report progress in this matter at an early day, as we hear that Dr. Rock is to lecture soon on the varieties of the human species, and review Mr. Pettit's speech in Congress on the inferiority of the African race; and I hope to be able to learn more particularly what is meant by "all under the skin is human." Burns spoke very well; he has, however, a little too much of the slaveholder's religion, which cripples him. We think however, that he will soon get over that, if he remains in New England . . .*

Solomon Northrop [sic], of your State, who was sold into slavery, and kept there for twelve-long years, is now in Boston; he will hold a meeting here this week, and tell his sorrowful story.

Honorable Charles Sumner, the pride of Massachusetts, has arrived home, and brings with him "Little Ida May." She is perfectly white, and on that account produces intense excitement. We see daily white fugitives, and the cupidity of a slaveholder would suffer him to keep anyone, even his mother, in slavery. When white men learn this, and that their own liberties are in danger, then they will see the reasonableness of an unconditional emancipation. S. Northrop and "Ida" visited both branches of the Legislature on Saturday.

The kidnappers are again among us. "A short, chunky Irishman" is the hunter. A warrant has been issued but the probabilities are, that the fugitive is now safe.

—W. C. Nell, Frederick Douglass's Paper, *March 16, 1855*[6]

Frederick Douglass's Paper had positively reviewed *Ida May*, at length, earlier that year, observing that the novel had the power to electrify audiences. But when regarding Ida May's avatar apparent, three months later, Nell explained that black abolitionists, like himself, were not all that impressed by "little Ida May." Black communities in Boston could hardly be surprised by anything a slaveholder might do. The greedy slaveholder might even keep his children's mother enslaved, his children, or as the article exaggerates—his own mother—in slavery. Would this new example of the "cupidity" of one group of white men persuade another group of white men to see the reasonableness of abolition?

This notice in *Frederick Douglass's Paper* discussed two figures who appeared along with Mary: Solomon Northup and Anthony Burns. The day before, William Cooper Nell had written to his friend Amy Kirby Post, "the past week has been prolific with anti slavery interest . . . —Return of Anthony Burns—arrival of the Little White Slave Ida May and also of Solomon Northrup."[7] Nell unerringly framed "the Little White Slave Ida May" with these two black men in relief.[8] They arrived on the Boston antislavery scene with one message in common: the white American public felt their enslavements to be unfair applications of the Fugitive Slave Law.

◆

White Americans of this time cast a practiced eye on the children of mixed parentage to assess them for blackness. Mary's skin operated as a living document, a history of slavery, that American audiences appar-

ently knew how to read. Consider, for example, the similarity between initial descriptions of Mary. The *Boston Telegraph* reported that in her daguerreotype Mary seemed to be "a most *beautiful* white girl, with high *forehead*, straight *hair*, intellectual appearance, and decidedly attractive *features*.'"[9] A *Boston Courier* reporter, who met her at the State House, reported that she was a "*good-looking* child, with a pale *face* a very little freckled, chestnut colored *hair*, and has no striking characteristics of the negro race in her *features*."[10] These italicized words highlight the formulaic procedure of assessing for whiteness. With the word "features," these writers refer to Caucasian face shapes (nose, lips, and eye shape) as "regular," or ascribing to a norm. There is a script they follow: in the places on Mary's body that they look, in the words that they use to describe what they see, and in the affirmation of her qualities (assumed to be white qualities) of intelligence and beauty. The procedure is the same from city to city. Features, skin, and hair are the markers that divide races.

If bought and brought home, a photograph of Mary's features, hair, and skin could be examined privately at leisure. We study Mary's face for the markers of race and identity, as though we remember all the steps in that absurd, complicated dance.

Contemporary popular culture reaffirmed the script for making phenotypic, or race-type, examinations. In the examination scene in *Ida May,* Walter Varian, Ida May's future husband, scrutinizes her body shortly after his uncle has purchased her. At this point in the story, Ida is ten years old, and she has been enslaved for five years. Walter looks her over carefully and concludes, "I have no doubt she is of white parentage." Walter walks his uncle through the evidence. "You notice that though she is not very fair, her *skin* has the clear darkness of a *brunette*, and not the yellowish tinge which marks the lighter shades of the negro race. Her *features*, her whole form and mien, show that she is wholly of the Anglo-Saxon lineage."[11]

Walter trusts himself to discern the truth of Ida's white heritage,

despite the fact that Ida has been enslaved for half of her childhood. Her "Anglo-Saxon lineage" is confirmed through a pseudo-scientific analysis of her "form and mien." Walter's facility in reading the sign-posts of race shows that he is not "astonished" to find out that this slave girl is a white girl, he is convinced of it, and furthermore, he knows that his analysis of her features has the power to make her free. Walter, who came of age and was educated in the North, is clearly practiced and confident in this specialized kind of looking. He has feelings for Ida almost immediately, despite their difference in age. Mostly, he is relieved to not have fallen in love with a slave.

Not every man in the novel has Walter's response. Every time Ida is sold, her price is assessed according to a routinized expectation that her future utility included sex. Her kidnappers sell her to James Bell at a bargain due to her emaciated, feverish, and mentally broken condition, saying, "I tell you, it goes to my heart to have to part with her this way, for she'll sell for a thousand dollars, as a fancy girl, in ten years." Five years later, when Ida's health and beauty are recovered, Mrs. James Bell designs that Ida be sold to avoid the ignominy of a tempted husband. At the moment of her purchase by Charles Maynard, her future guardian, the narrator comments that Mr. Maynard, who "was acquainted with the market value of such articles," hurried the proceedings to avoid conversation with the slave-driver, "whose coarse jokes and allusions to what Ida would soon be worth as a 'fancy girl,' aroused disgust and anger."

Phenotypic examination held legal weight both in fictional marriage plots and in actual court cases. Take, for example, the trial of Salome Muller, from a kidnapping story out of New Orleans, recounted in a review of *Ida May*.[12]

There was no trace of African descent in any feature of the face of Salome Muller. She had long, straight black hair, hazel eyes, thin lips and a Roman nose. The complexion of her face and neck was as dark as that

of the darkest brunette. *It appears however, that, during the twenty-five
years of her servitude, she had been exposed to the sun's rays in the hot
climate of Louisiana, with head and neck unsheltered, as is the custom of
the female slaves, laboring in the cotton or the sugar field. The parts of her
person which had been shielded from the sun were comparatively white.*

— Boston Atlas, *quoted in* Liberator, *December 1854*[13]

Salome undressed before the court into her childhood whiteness.
She shed the clothes and color of slavery, and claimed to be an orphaned
German immigrant mistakenly enslaved from 1818 until a friend rec-
ognized her in 1843. When she successfully sued for her freedom the
following year, the abolitionist press saw her case as shaking the racial
foundation of slavery. Southerners thought the same case confirmed
their social system, since Louisiana courts had chivalrously rescued one
white woman from mistaken bondage.

In the 1859 hit *The Octoroon, or Life in Louisiana,* New York audi-
ences were called upon to examine the body of the title character, the
beautiful ingénue Zoe, to determine the constraints race might place on
her mobility through marriage. Although exposing her race to George
Peyton has the potential to end their relationship, Zoe walks her lover
and her audience through an examination of her body.

Zoe. *And what shall I say? I—my mother was—no, no—not her! Why
 should I refer the blame to her? George, do you see that hand you
 hold? Look at these fingers; do you see the* nails *are of a bluish tinge?*
George. *Yes, near the quick there is a faint blue mark.*
Zoe. *Look in my* eyes; *is not the same color in the white?*
George. *It is their beauty.*
Zoe. *Could you see the roots of my* hair *you would see the same dark,
 fatal mark. Do you know what that is?*
George. *No.*

> Zoe. *That—that is the ineffaceable curse of Cain. Of the blood that*
> *feeds my heart, one drop in eight is black—bright red as the rest*
> *may be, that one drop poisons all the flood; those seven bright drops*
> *give me love like yours—hope like yours—ambition like yours—life*
> *hung with passions like dewdrops on the morning flowers; but the*
> *one thing—forbidden by the laws—I'm an Octoroon!*
> —*Dion Boucicault*, The Octoroon, or Life in Louisiana *(1859)* [14]

Zoe's three marks of race have nothing at all to do with skin: the quick of the nail, the roots of the hair, and the whites of the eyes. The marriage plots between Walter and Ida and between Zoe and George showed how this mode of looking, the phenotypic gaze, was animated by desire and rarely indifference. Zoe chose not "to refer the blame" on her racially mixed and sexually enslaved mother; she also does not assume "blame" herself. The Peyton men were to blame.

These words and gestures are remarkably consistent across texts; they focus on the examination of nails, eyes, and hair. In *The Octoroon*, on Salome Muller's bared shoulders, in Ida May's "clear darkness," and in Mary's "slightest trace" of "Negro blood," the markers for race are nearly invisible and often misleading.

Dramatically, Zoe's self-examination walks her audience through the pretended scrutiny of an actress's body, though they already know the outcome. In New York performances of *The Octoroon* at the Winter Garden Theater, the playwright's second wife—the Irish star Agnes Robertson—famously played Zoe.

Recently, historian Carol Wilson has concluded that Salome Muller was in fact Sally Miller, a shrewd woman who, like Mary, was born into slavery. Mistaken by a passerby for a German doppelgänger, Sally saw her chance at liberation and took it.

The *New-York Daily Times* claimed that Mary was "so white as to defy the acutest judge to detect in her features, complexion, hair, or

general appearance, the slightest trace of Negro blood." If racial markers could not provide proof of free status, or correctly identify a girl as African or German, or as lawfully marriageable or no, then how precarious, how absurd it was to have race be the sole basis for an entire system of exploitative labor.

Thomas Wentworth Higginson

◆

Worcester, Massachusetts, March 27, 1855

I n late March, Mary traveled to Worcester, Massachusetts, to appear with Solomon Northup at the Non-Resistant Convention, a radical pacifist movement best understood as an experiment in Christian perfectionism. Non-Resistants believed that if humanity freed itself from violence and coercion in its earthly institutions, they could bring about the second coming of heaven on earth. No resistance meant no violence, not even in self-defense. No warfare, no military, no prisons, no death penalty, and no profit by institutions supported by coercion, including capitalism and colonialism. The logical conclusion of radical pacifism is anarchy: Non-Resistants did not acknowledge human governments, as they were invariably framed by violence, and each individual conscience was held to a higher law. Non-Resistants were deeply committed to ending slavery and worked toward peaceful, immediate emancipation through moral suasion, or as William Lloyd Garrison put

it, through "appeal to the reason and conscience of slaveholders." Words and vigilance would be their weapons.

Gradually, even the most radical peace activists—including Garrison himself—began to accommodate violence in the service of freedom. Slave insurrection, for example, was seen as a necessary use of force. Passive nonresistance did not apply to the fugitive, the oppressed, or the enslaved: one must be free from coercion to choose to act peaceably.[1] It was in this context that Solomon Northup was invited to lecture at the close of the convention on Saturday, to "share his story of agony" as a "faithful prototype of 'Uncle Tom.'"[2] Northup's talk was advertised as a tale of violence overcome. "He was carried to New Orleans, sold to a planter on the Red River, and was beaten, outraged and abused, till life became a daily agony. Let him have a full house." This event in Worcester would be one of the last Non-Resistant Conventions, and those in attendance held an assortment of positions on the subject of violence in the service of abolition.

A reform convention could also be a cold winter evening's entertainment. Having moved to Worcester in 1852, the Reverend Thomas Wentworth Higginson described it as "a seething center of all the reforms."[3] For the women of Worcester, the wives of fortunes in iron and steel, attendance at these regular events was expected. Mrs. Hannah Marsh Inman wrote in her daily diary about chores ("Washing Day again"); her toothaches (she had eight teeth pulled on March 16); the price of yarn (50 cents); and her activism. "February 9. Sewing, Joanna washing. Storm. Evening attended an AntiSlavery lecture delivered by Frederick Douglas, very good indeed." She circulated in antislavery discussion groups, reading clubs, benefit concerts, and sewing circles, on a tight rotation, without much comment beyond which neighbors she saw there. "March 2, 1855: Making soap. PM went to the funeral of Doct. Basset, after to the AntiSlavery sewing circle, a goodly number out." She read *Ida May* on December 31, 1854, and made no comment upon it, though a title mention was rare. In Worcester, being a fru-

gal middle-class radical abolitionist appears to have been as ordinary as baking.

[March] 23 Doing a little of all sorts. PM went out shopping, made two calls, came home very tired indeed.

24 A large baking and company to dinner. Evening attended the Nonresistant Convention, an address by Adin Ballue, very good indeed.

25 Attended through the day and evening very much interested in the discussions. They had for speakers William L. Garrison, Henry C. Wright, Steven S. Foster and wife, Mr. Higginson, and some others.

26 Very dull this morning. A call from Simeon. PM one from Miss Kennedy.

27 Ironing and boiling dinner. PM Lucy Bacon came to make a visit. Evening all went to the Soiree at the Hall. Little Ida May the white slave was there from Boston. Went and had two teeth filled.

28 Baking all the forenoon. PM went out to make calls, a call from Mrs. Cutting. Eve at home.

29 Went with Lucy to spend the day with Mrs. Phettiplace. Evening at home.

30 Company to spend the day. Mrs. Moesly here to tea. Evening all went to lecture. Sick all day and not very happy.

31 Saturday has come again with all its cares and toil. PM went out shopping with Lucy. At 4 o'clock she left for home. Evening attended Solomon Northrop's lecture. Thus endeth another day of my short life.

—Hannah Marsh Inman, diary entry for March 23, 1955 [4]

On the evening of Tuesday, March 27, the Non-Resistant Convention opened with "The Soiree of the Free Church," and according to the newspaper, it was a party that was "numerously attended, and passed off in a very pleasant manner." Mrs. Inman, like all her wide circle, braved record snow to attend. At the height of the evening, an announcer called for girls under ten years of age to join him on stage. There was

a delay, as the Mrs. Inmans in the audience considered the propriety of such an exhibition. The crowd pulled children up to the stage, as parents reluctantly gave them up up in the spirit of the evening. To the five local girls, the organizer surreptitiously added Mary. Once the girls were on the platform behind him, he gestured toward them and asked the audience, which of them was the redeemed slave child that the press called "Little Ida May"? Could they determine which girl was born to slavery by the color of her skin alone?

THE WHITE SLAVE.—The Soiree of the Free Church, which took place at Horticultural Hall, last evening, was numerously attended, and passed off in a very pleasant manner. Little Mary Botts, the white slave child was present, and excited all the sympathies of those who saw her. She, in company with five other little girls, taken promiscuously from the meeting, was placed upon the platform, and she was the last child amongst them, indicated by the persons present, as the slave child. She has auburn hair, blue eyes, and a skin as fair as any Circassian. She will remain, today, at the house of A. P. Ware, 23 Crown Street.

<div align="right">

—Worcester Spy, *March 29, 1855*[5]

</div>

Imagine the excruciating embarrassment felt by these six girls on stage and their mortified parents as the crowd threw out suggestions. Last one to the left! That one there, beside you! One girl's eyes grew wide in disbelief as the audience pointed out her "yellowish tinge." Another cried for her mother. Yet another giggled at the absurd turn the evening had taken, but her laugh became edged with hysteria as the audience closed in for a better look. Men peeked under bonnets to see the color of a girl's hair at the roots. They pulled hands down closer to the footlights to see if a bluish tint could be found in the bed of small fingernails. One girl stood still as a trapped creature when the crowd came to a consensus around her suspected blackness, much to her father's dismay.[6]

Mary would be available for visitors to call on in person at Mr. A. P. Ware's house for the rest of the convention. Mrs. Ware, well known to the convention set, took Mary home.

◆

The Reverend Thomas Wentworth Higginson, the pastor of the Worcester Free Church, was in the audience that night, though he was not a pacifist. He was a radical Republican, and an activist for antislavery and women's rights, from his Harvard days through the end of the Civil War. He proudly wore a scar across his chin from leading the fight at the courthouse in Boston to free Anthony Burns. He thought the use of Mary as entertainment and spectacle to be distasteful and told others so. If the people wanted spectacle and exotic Circassian beauties, they could attend P. J. Barnum's lecture, "The Art of Making Money" at city hall the following night.

Higginson had been interested in Mary since early March, and he owned a copy of Andrew's broadsheet, "History of Ida May" (page 136).[7] He might have picked it up at his stationer, Spauldings, in Worcester, which had advertised it, or when he was called to testify at Boston State House earlier that month, the day before Mary was there. As soon as he had a free moment, he went to Ware's house to see Mary in person. They chatted, a church leader who loved children but had none, and a child who must have become accustomed to attention. He wondered at her precociousness and delighted in her laughter. Later that afternoon, he called again, and it was the same—the world disappeared, and there were only these two.

His wife, Mary Channing's, degenerative illness had made his dreams of a family diminish. She did not allow him to lie with her, though he was her husband. Some days she did not leave her room. Higginson could hardly offer little Mary a suitable home, in the absence of

a mother's care. He knew she had parents—she spoke of them. But he dreamed that Mary might fill the void in his own family.

Higginson told Mary it would please him very much if she would have a picture made with him.[8] After a few turns around a daguerreotypist's gallery, they were invited to sit before the camera in a glass-paneled room at the top of the stairs. Higginson arranged his coat, reached down for Mary, and bounced her upon his knee. She struck her pose, seated still on his lap, practiced now in the art of picture taking, while Higginson did not stop smiling.

He took Mary back to Boston himself so he might meet her parents. While riding the train with her sitting next to him, he wished there could be no end to the clicking rails and the happy chatter. Just before Framingham, they passed a white lake, covered in snow, with a gray sky above. The lake was home to a community of swans clustered upon the ice. White upon white.

They arrived in Boston too soon, pulling into the station in the early afternoon, a three-hour journey passing by in the blink of an eye. Bundled up against a cold wind that threatened to unseat them from their cab, the two headed across Copley Square toward Boylston Street. They pulled into the close side streets of Beacon Hill and stopped in front of Mary's door. Her father, Henry Williams, came bounding out to receive them. Her mother and grandmother were not at home. Higginson started at the sight of Mary's brown father, and her brother Oscar standing behind him. The word used to describe white and black people who mixed without reserve was *promiscuous*.

Higginson explained to Henry Williams that he did not think it right for a young girl to be paraded about in the manner devised for Mary. She was a child, not an exhibit. Her sensibilities would surely see some effects from this publicity, and she ought to be given the shelter and anonymity of a loving home. Fifty years later, in his 1904 memoir, Higginson would remember the frustration he felt with John Andrew

and others, who "exhibited" her to the public as Ida May, "as a curiosity." This injudicious practice should have been "stopped."

Mary's appearance with Senator Sumner at Tremont Temple that weekend could be her last for some time. Neither man knew what would happen should Sumner's speech be successful. Would Sumner ask to keep Mary by his side?

Sumner had arrived in Boston just after Mary and her family, on Sunday, March 11. He lived nearby at 20 Hancock Street. During the intersession months, he planned to resume his life of conversation with dear friends—Samuel Gridley Howe, Henry Wadsworth Longfellow, the naturalist Louis Agassiz—at supper clubs. He had returned to his habit of taking the daily papers in the Athenaeum's reading rooms. Given their proximity in the small neighborhood of Beacon Hill, Charles Sumner and Henry Williams must have met in person after their years of correspondence.

Sumner fundraised for the Williams family while in Boston. Longfellow, Sumner's closest friend, gave six dollars "For Ida May, slave" on March 24, as marked in his account books under "Giving in 1855." Perhaps Mary and her siblings visited Longfellow's Cambridge mansion, the Craigie House, and met the poet and his wife, Fanny, in a house filled with children about the same ages as Oscar, Mary, and Adelaide.[9]

One thing was certain: interest in Mary would wane, and when it did, her family would be waiting to retrieve her.

Higginson offered the Williams family some help in this regard. He explained that he had been, until recently, the pastor of a congregation at Newburyport, a seaside town about thirty-five miles north of Boston. When summer came, perhaps Williams would allow his daughter to travel there? To go to the shore would hide Mary from the limelight, so that it would find another. Newburyport was a town friendly to abolition, it was the birthplace of William Lloyd Garrison, and where John Greenleaf Whittier's family called home.

Higginson's friend Caroline "Carrie" Cushing Andrews, along with her sister Jane, had agreed to enroll Mary in the Sunday school they ran in the summer months at Newburyport. During the school year, Carrie Andrews worked at a school in Perth Amboy, New Jersey, where she lived and taught in a small colony of abolitionists founded by her neighbors Sarah and Angelina Grimké, and Theodore Weld. Her work was in the education of freed people. Mary would be in good hands, and she could study and prepare for the coming school term along with children her own age. All three Williams children could enter school the following year, since integrated public schools had recently opened in Boston. The timing was good.

The Williams family could finish touring Mary with the senator before embarking on a new partnership with this new benefactor. Williams and Higginson had more than Mary in common. They had both dropped in on Henry David Thoreau at his home in Concord in 1850, unannounced. Carrie Andrews had long been Thoreau's friend and correspondent. They shared a love of Thoreau for the liberation he offered to each.[10] And both men would attend Sumner's upcoming lecture at Tremont Temple and subsequent events. They could discuss Higginson's offer then, when Elizabeth and Prue would also be available to meet him.

In the days that followed, Higginson measured his mixed impressions of the Williams family against the happiness of his friendship with Mary.

It happened during these anxious days that Sumner bought a Negro family and gave them their freedom. One of the children was white, and Mr. Higginson conceived of the plan of adopting her and thus filling the vacancy in his own family. He wrote: "I have made a new acquaintance, most fascinating to me—the dear little white slave girl whom Mr. Sumner purchased—'Ida May' they call her—but her real name is Mary Mildred something. Fancy a slender little girl of seven . . . with reddish

hair, brown eyes, delicate features and skin so delicate as to be a good deal freckled. She came up to be shown at a public meeting here, and it was love at first sight between us, she was like an own child to me, and when in Boston this morning I restored her to her tall mulatto father and her handsome little dark brother and sister, it gave me a strange bewildered feeling. They were owned in Alexandria; the mother and grandmother are described as almost white. I am going to see them. There is a photograph of the little girl, but not nearly so good as a daguerreotype which was taken here, of her sitting in my lap—her face is lovely in the picture, but mine (my wife declares) is spoiled by happiness.*"*

—*Mary Potter Thatcher Higginson,*
Thomas Wentworth Higginson: The Story of his Life [11]

16

"The Anti-slavery Enterprise"

———— ◆ ————

In the fall of 1854, Dr. James Stone had organized the "Independent Lectures on Slavery" to build on the antislavery sentiment in Boston following Anthony Burns's rendition. The fifty thousand Bostonians who had taken to the streets to witness one man's extradition could stand to learn more about the three million living in slavery. Reformer Caroline Healey Dall, in her column for the *National Anti-Slavery Standard*, said that when she moved home to Boston in 1855, she found that the mood had shifted. "Whole families who would not speak upon the subject when I left New England, now entered upon it of their own accord." However, these new converts were at best, uninformed, or at worst, "self-deluded" apologists for slavery.[1] Meanwhile, she found the hardline "rebellious few were more bitter than ever before."

The lectures took place in the renovated Tremont Temple, which had seating in the thousands. Tickets cost fifty cents a couple, and Ticknor's and Jewett's bookstore offered for sale subscriptions for the entire lecture series.

The organizing committee invited abolitionism's brightest stars and also, with magnanimous intent, voices from the proslavery opposition. Few supporters of slavery honored the committee with a response, and fewer still made an appearance. Senator Sam Houston, who delivered his address on February 22, was the exception. In January Sumner and Houston had met in the Senate chamber, and shared a few words about the upcoming lectures. In a letter to Samuel G. Howe marked "confidential," Sumner asked if it would be possible to plant questioners in the audience when Houston represented the proslavery argument.

Senate Chamber
24th Jan. '55

Dear Howe,

Houston told me today that he wished to give me his platform. "I have but two planks" said he.—"The Constitution & the Union." To which I replied—"Those are mine precisely; but we differ on the meaning in the Constitution." He says that his whole lecture will be contained in those two points.

I think the General shews [sic] some sensitiveness, with regard to his address. Many here regard the whole thing as an important political step, calculated to affect his Presidential prospects.

I have promised the General a kind & cordial reception. This he will have surely. But I think that some person in the audience might properly address him, in the course of his remarks, some pertinent inquiries. You know that he is accustomed to such interruptions. For instance, ask him—Does he recognize ppty [property] in man? Where does the Constitution recognize ppty in man? Has not the South been the aggressor?

In what has the North been the aggressor? Such questions as these would
bring him to precise points. Think of them; but say nothing of me.

Ever Yrs, C. S.

—*Charles Sumner to Samuel Gridley Howe, January 24, 1855*[2]

Illness prevented Sumner from making the first speech in the series, on November 23, 1854—the week *Ida May* was released. He suffered from what the press diagnosed as both rheumatism and a cold, but he called his complaint "his disability." "Had it not interfered with public engagements, I should have stuck to my bed for a few days & nothing would have been known of it out of my mother's house. I do not like being gazetted as a sick man."[3] Instead, he would end the series as its fourteenth lecturer, on March 29, after he returned from Washington at the close of the senatorial session. He still was not well. "He was looking so pale and ill that it made one's heart ache to see him," reported Caroline Healey Dall.

On the afternoon before his scheduled lecture, a line was already forming outside the Tremont Temple. "Between two and three hundred people applied to Mr. Hayes, Superintendent of the Tremont Temple, on Thursday afternoon and evening, in hopes to obtain tickets to the course of 'Lectures on Slavery,' by paying four dollars therefore. Nearly all were disappointed."[4] Hayes was a former policeman who had quit to protest the police role in slave catching. On the second evening, Sumner would praise him from the stage as "Mr. Hayes, who resigned his place in the police of Boston rather than be instrumental in the return of a fugitive slave," and again, Mr. Hayes, who "for himself, he could imagine no place, no salary, no consideration which he would not gladly forego rather than become in any way an agent in enslaving his fellow men."[5]

The lecture committee found only nineteen tickets returned by their subscribers, even though a premium of a dollar above the pur-

chase price had been advertised for any subscriber who wished to sell. Hayes redistributed those nineteen tickets at sixteen times their price. Many people remained outside the rest of the evening, in the hopes that five dollars might get them in. An additional date, March 30, was added to accommodate the disappointed crowd, with tickets on sale at the bookseller. About six thousand people attended the lectures.[6] "On the whole," it was reported, "this may be the most successful course of popular lectures ever established in Boston."[7]

◆

A few blocks away at his Boston home on Hancock Street, Sumner took the sold out series as an occasion to declare victory. He had in hand a letter from John Andrew, sent that very day with the happy report that the Henry Williams case was complete. The broadsheet "History of Ida May" (page 136) had sold well, and the funds needed to free Ludwell had been secured. The manumission of the entire family would be complete within the year. He must congratulate Williams when he saw him later that evening.

MR. SUMNER'S LECTURE

There was a crowded audience last night at the Tremont Temple to hear Charles Sumner lecture on 'the Necessity, the Practicability, and the Dignity of the Anti-Slavery Enterprise.' The Governor of the Commonwealth, and many other distinguished citizens occupied the platform, on which also sat the liberated slaves, Anthony Burns and Ida May . . .

The practicability of the anti-slavery enterprise, Mr. Sumner said, was certain, because it was right. *What ever it was right to do could be done. What was proposed to be done? Simply this. To secure to the slaves the marriage relation, to give them the right to learn to read and write, to give them an equivalent for their labor. Would any man say that these things could not be done? It was a libel on human nature and on the*

American people to maintain that they were impracticable. Yet do these
things, give the slave his wife and children, so that they shall be his and
not another's, give him the right to education, give him remuneration for
his labor, and slavery is at an end.

—Boston Evening Telegraph, *March 30, 1855*[8]

In the crowded hall, Mary would have had to listen carefully to Mr. Sumner to follow his speech. He was facing away from her on the stage; the lecture was complex. She watched the audience to determine their response as Sumner described her father's path out of slavery. Sumner laid out three keys that would unlock freedom: marriage rights, literacy, and wages. Sumner and Andrew's legal efforts had secured Henry and Elizabeth Williams's marriage. The family had been taught to read and write, and their children expected to have an education in Boston's schools. Williams now worked for wages, enough to buy them freedom and comfort. For this family, "slavery was at an end" in the very practicable way that Sumner set forth in Boston that night.

Sumner's practical three-part proposal was better received than the one Ralph Waldo Emerson had proposed, earlier in the lecture series, when he called on the antislavery families of New England to forgo their cigars and carriages and instead buy and free one enslaved family each.

◆

Sumner opened his lecture by recalling to the audience the early days of the antislavery movement, when it was still a radical fringe group. Two decades earlier, a mob had broken up the meeting of twenty or so members of the Boston Female Anti-Slavery Society on Washington Street. But on this day, thousands had gathered without fear of interruption.

In the autumn of 1835, on the 21st Oct an association of ladies, known
as the Boston Female Anti-Slavery Society, was summoned to meet in

*an upper story of No. 44 Washington St.—in this good city of Boston
& it was announced that several addresses were to be delivered on the
occasion. The ~~hall~~ room was small & the company expected was not
large. Sometime before the appointed hour ~~of meeting~~, the door was sur-
rounded by a loud & tumultuous crowd, who saluted the members, as
they came, with all manner of vileness, & afterwards, during the prayers
with which the proceedings commenced, actually hurled missiles at the
lady presiding, &, finally by force & clamor, which were unchecked by
the Mayor, dispersed the assembly. Intruders insolently seized the ~~trunk
of~~ papers of the Society, & hurled them out of the windows into the street
where they were madly destroyed. The simple sign on the building, bear-
ing the words "Anti-Slavery Rooms" was next wrenched from its place
& torn to splinters. The fury of the crowd, which now blocked the street
with ~~I understand to be thousands~~ its uncounted numbers, next directed
itself upon Wm. Lloyd Garrison,—known as the editor of the Liberator
& ~~determined Abolitionist~~ the originator of the Anti-Slavery Enterprise
of [the] day—ruthlessly seized this ~~this~~ peaceable citizen, & with a hal-
tar [sic] about his neck, amidst ~~clamorous~~ savage threats, dragged him
through the streets, until at last, guilty ~~of~~ only of loving liberty, if not
[. . .], too well, he was lodged in the common jail for protection against
an infuriate multitude . . .*

*Since then a ~~great unprecedented~~ change has taken place. Instead of
that small company of women, counted by tens, we have now this mighty
assembly, counted by thousands; instead of that humble apartment, the
mere appendage of a printing office, where, as in the manger itself, Truth
was ~~sheltered~~ cradled, we have now this beautiful hall, ample in its pro-
portions & adorned by art; instead of a profane & clamorous mob, beat-
ing at our gates, hurling our papers out of the windows into the street
& tearing the sign with the name "Anti-Slavery" into splinters—even
as the insane ~~people~~ populace of Paris once tore the body of the regicide
Ravaillac—we ~~now have~~ now have peace & harmony at our unguarded
doors, ruffled only by a generous contest to participate in this occasion;*

*& instead of a hostile press, denouncing our attempts (as "rascally" &
intolerable) appealing directly to mob rule & even declaring that such
meetings should be prevented by the strong arm of the law, we find now
kindly notices, encouraging words & a generous God-speed.*

*Here is a great fact, worth of notice & memory; for it attests the first
stage of victory. Slavery, in all its many-sided wrong still continues, but
here in Boston freedom of discussion is secured . . . It is the inauguration
of Freedom. From this time forward her voice of warning & command
cannot be silenced . . . On this I now take my stand. In undertaking to
give expression to the thoughts suggested by the occasion, I am not insen-
sible to the responsibility which I assume. Fully to herald our great cause
would task an angel's tongue. I can speak only in the plain words of an
honest heart . . .*

—*Charles Sumner, March 29 and 30, 1855*[9]

Sumner carefully wrote and memorized his speeches, and once per-
fected, he would give the same presentation many times. Later in his
career, he would skimp on such preparations, moving more of his atten-
tion to the printing of his lectures. But he would deliver this speech to
packed houses across Massachusetts and New York during the entire
month of April. According to an early reviewer, "His lecture was emi-
nently a *lecture*. It was neither a senatorial speech or a stump speech, but
it was justly adapted to the calmer and more promiscuous audience of
the lyceum and the lecture room."[10] It was about an hour and forty-five
minutes long and was said to improve with repetition.

On the morning of March 30, the day when he would deliver it
for the second time, Sumner wrote to Samuel J. May, an agent of the
American Anti-Slavery Society in Syracuse, New York, to discuss his
lecture schedule. "I am to speak in New Haven on April 11th, and every
evening now till then," Sumner wrote, referring to stops in Roxbury,
Worcester, Providence, New Haven, Albany, and Rochester. He was
expected in Albany on April 12 and in Rochester on the thirteenth,

but other than those "fixed" days, "you can change the appointments according to your desire." His only request was that he not have a night off while on the road: "I desire to work every night and should be glad to have an engagement." He had two openings on his calendar, on April 21 and 23, that might be booked "say at Troy and Poughkeepsie?" For his appearances in Boston, he received one hundred dollars per appearance; at other towns in Massachusetts, he was paid fifty. "I do not desire to speculate for fees," he added, noting that he would accept whatever a local lecture committee could pay.[11]

The *National Anti-Slavery Standard* reported at the beginning of April, "he has yielded to these importunities and consented to devote his whole energies to this form of labor from the present time until the 10th of May."[12] His tour would close in New York City, coinciding with the American Anti-Slavery Society's anniversary week celebrations on May 9, at the Metropolitan Theater, on Broadway above Bleecker. Samuel May's New York Anti-Slavery Society published his April schedule as:

> Albany . . . Thursday, April 12th
>
> Rochester . . . Friday, 13th
>
> Canandaigua . . . Saturday, 14th
>
> Auburn . . . Monday, 16th
>
> Skaneateles . . . Tuesday, 17th
>
> Syracuse . . . Wednesday, 18th
>
> Utica . . . Thursday, 19th
>
> Fulton . . . Friday, 20th

Everywhere Sumner spoke, locals asked him to deliver the lecture on more nights and in additional towns. That spring he reached nearly a hundred thousand spectators and countless others in print. As his fame spread, his rhetoric intensified. The speech solidified his position as a leader in the antislavery movement.

"Well, Mr. Sumner has given us a true, old-fashioned anti-slavery discourse," said Garrison, after the first night.[13]

◆

Although Mary was present on the stage on the opening night, March 29, Sumner did not refer to her directly. Later in the speech, he argued that chattel slavery depended upon an untenable distinction between the races. Had Mary's family known this was his intent in inviting her to the stage? In their forty days together, Sumner had meditated on Mary's story, come to know her background, and made a lecture from her history. He asked his audience to imagine slavery as a white experience.

And, first, of the ~~great question~~ alleged distinction of race. This assumes two different forms, one founded on a prophetic malediction in the Old Testament, & the other on the professed observation of science. Its importance is apparent in the obvious fact that, unless such difference be clearly established, every argument by which our own freedom is vindicated— every applause awarded to the successful rebellion of our fathers—every condemnation directed against the enslavement of our white fellow citizens, by Algerine corsairs, will plead trumpet-tongued against the deep condemnation of Slavery, whether white or black.

—Charles Sumner, March 29 and 30, 1855[14]

The presence of "Little Ida May," there for all to see, proved that "clear" and "unmistakable" distinctions between the races did not exist, and racial difference was an unmanageable and inadequate criterion for slavery. Therefore, if the American public was to be comfortable with the institution of slavery, it must also be prepared to countenance white slavery, whether Algerian or homegrown. Given the inherent instability of categories of race, Sumner rejected the ideology of racial inferiority, a mainstay of proslavery rhetoric.

Midway through the speech, Sumner pivoted. Speaking for the abolitionist community, he said he did not intend "to change human nature."

But descending from these summits of principle let me shew [sic] precisely what we aim to accomplish. In stating our object its practicability will be apparent. It does not assume in any way to change human nature, or to place any individual in a sphere to which he is not adapted. It does not suppose *assert that a race degraded for generations under the iron heel of Slavery can be lifted at once into all the privileges of an American citizen. But it does confidently assume that every* individual *man, without distinction of color, is entitled to life, liberty & the pursuit of happiness; & it does with equal confidence assert that* all *every individual, who bear the human form,* can *should at once be recognized as man.*

When the speech was readied for print, Sumner revised the line to read: "While discountenancing all prejudice of color and every establishment of caste, the Anti-Slavery Enterprise at least so far as I may speak for it—does not undertake to change human nature, or to force any individual into relations of life for which he is not morally, intellectually and socially adapted."[15]

The phrase "relations of life" disassociated the antislavery enterprise from advocating for a wide range of other social rights for African Americans, such as rights to interracial marriage, to vote, and to own property. Sumner denounced prejudice and caste, but overall he left room for fellow whites to maintain social hierarchies based on race. He did not address the question of the social and intellectual equality of black people, particularly of those who had been "degraded" by slavery for generations. A pernicious thought poisoned the well. Sumner attacked slavery, but he tolerated segregation.

On April 13 Frederick Douglass heard the speech at home in Roch-

ester. He reread the transcripts to be sure of what he had heard before writing to Sumner.

Rochester, April 24, 1855

To Hon. Chas. Sumner

My dear Sir:

There were two points in your address, which grated a little on my ear at the moment, and which I would have called to your attention immediately after its delivery in Rochester had opportunity permitted. The first claimed that Mr. Garrison originated the present Anti-Slavery movement—a claim which I do not regard as well grounded, and I think I have succeeded in showing this in a lecture recently delivered in Rochester and in several other places during the past winter. Mr. Garrison found the Anti-Slavery movement already in existence when he stepped to the side of Benjamin Lundy in Baltimore. The second point was your very guarded disclaimer touching the social elevation of the colored race. It seemed to me that considering the obstinate and persecuting character of American prejudice against color, and the readiness with which those who entertain it avail themselves of every implication in its favor, your remark on that point was unfortunate.

I may be a little sensitive on the subject of our social position. I think I have become more so of late, because I have detected, in some of my old comrades, something like a falling away from their first love, touching the recognition of the entire manhood and social equality of the colored people. I do not mean by this, that every colored man, without regard to his character or attainments, shall be recognized as socially equal to white people who are in these respects superior to him; but I do mean to say that the simple fact of color should not be the criterion by which to ascertain or to fix the social station of any. Let every man, without regard to color, go wherever his character and abilities naturally carry him. And further, let there be no public opinion ready to repel any who are in these respects fit for high social position.

For my own individual part as a colored man, I have little of which to complain. I have found myself socially higher than I am placed politically. The most debased white man in New York is my superior at the ballot box, but not so in a social point of view. In the one case color is the standard of fitness or unfitness; in the other, character.

I thank you heartily, my dear Sir, for honoring me with the opportunity of dropping these suggestions for your perusal.

With the spirit and manner of your noble address, I was not only pleased but profoundly gratified, and I thank God that talents and acquirements so high as yours, are devoted to the service of my crushed and bleeding race.

Believe me, my dear Sir,
Your faithful and grateful friend,
Frederick Douglass[16]

Douglass was correct in dating Garrison's initiation in antislavery work to the 1820s, in Benjamin Lundy's Baltimore printing office. Douglass and Garrison's relationship was strained over a difference in ideology and method, and the competition between them for subscribers of their respective antislavery newspapers did not hasten reconciliation.[17]

Douglass wrote to Sumner with sensitivity and tact. He had achieved his social position in a climate of near constant battle against prejudice.[18] He had to fight for his seat on the train. He would have to fight for his sons' right to fight for the Union. He had to fight to speak in his own voice, to philosophize, to weigh new views on the subject in his mind, without being called to censure as an imposter to his race. "It was said to me," Douglass wrote in *My Bondage and My Freedom*, that (for credibility's sake) it would be "better have a *little* plantation manner of speech than not; 'tis not best that you seem too learned." He noted that his white compeers in the movement were uncertain allies in the fight for human equality.

Mary's popularity as an antislavery icon was a symptom of the lapse

that Douglass named as "a falling away from . . . the recognition of the entire manhood and social equality of the colored people." He never completely dispelled the rumor that he was not born a slave or raised in illiteracy; Mary too was subject to that suspicion due to her appearance. It seemed that American audiences categorized the enslaved millions as not deserving of the sustained attention paid these exceptional ex-slaves. In a speech, "Life Pictures," that he gave years later, Douglass reconsidered the process that had made him an icon, a representative of his race. "All subjective ideas become more distinct, palpable, and strong, by the habit of rendering them objective." He added this warning: our faculty for making examples out of individuals was a "power that can be potent in the hands of the bigot and fanatic, or in the hands of the liberal and enlightened."[19]

Historian Benjamin Quarles, in his groundbreaking 1969 study of black abolitionism, wrote that by 1860, Charles Sumner was second to none in the esteem of black Americans.[20] But Sumner's bias found its way into public statements. Despite Douglass's private suggestion that he desist, Sumner continued to give the lecture as written, race disclaimers and all.

Receiving no direct response from Sumner, Douglass published his thoughts in an editorial in his newspaper. What did Sumner mean when he said he would not change human nature, or place any individual in a sphere to which he was not adapted? Was that sphere the bedroom?

But it is possible that Mr. Sumner only means here to say that intermarriage of individuals of the two races is not contemplated by the Anti-Slavery Enterprise, for which he is authorized to speak; and if he does, it may still be doubted if such a disclaimer was necessary. By whom is the charge of amalgamation brought? Who but the people of the South are raising the cry of amalgamation as unnatural and monstrous? And yet who but they are blotting out the distinction between white and black? . . .

Mr. S seldom walks the broad avenues of Washington, that he does

not meet the mulatto daughters of Southern members of Congress, and
the best blood of old Virginia courses in the veins.

—Frederick Douglass's Paper, *June 1, 1855*[21]

Douglass's editorial reminds us, once again, that Mary's presence on the platform was pedestrian. If anything, her appearance pointed to a lack of consistency in white support. William Cooper Nell had made more or less the same criticism in his report to Douglass's paper, a few months prior. White audiences should not feel such "intense excitement" about "the Little White Slave Ida May" and Anthony Burns. "White fugitives" were not new; the only new aspect was the interest white audiences paid them. In the newspapers of black abolitionists, there is evidence of pushback against the whitening of the antislavery argument, as represented by Mary as "Ida May."

◆

A month after her appearance at Sumner's lecture, Mary appeared, as "Ida May II," at Dr. John Sweat Rock's speech on race. Community leader Dr. Rock was an abolitionist and surgeon, who in 1861, would also become the first black lawyer to be admitted to the bar of the U.S. Supreme Court.

LECTURE TONIGHT BY A COLORED PHYSICIAN. Dr. J. S. Rock, a truly talented colored man, and "uncommon good speaker," will repeat his lecture on "the races and slavery," at Cochituate Hall this (Friday) evening, at 7 o'clock. Go and hear him. Anthony Burns and Ida May II., a white slave child, will be present.

—Boston Evening Transcript, *May 4, 1855*[22]

In this 1855 speech, Dr. Rock used Mary's presence at the event to make the same point as Sumner: to prove that classification by race

was an untenable, irrational construct.[23] He challenged the connection between race and slavery with humor and force. Though making the same argument as Sumner, Rock did not equivocate on the issue of equality. "It is utterly impossible to classify mankind into races," he said, and when we attempt a racial standard, "we shut out all white men from the Caucasian race whose features are not regular according to the standard, and we shut out all black men from the African race, whose features are not irregular according to the standard.—White men who have irregular features we make Africans, and black men who have regular features we make Caucasians." The only conclusion to be drawn from racial classification is this: "In undertaking to prove too much they prove nothing."[24]

Before the month was out, "Little Ida May" receded from public view. There are no further mentions in the press of Mary's appearances as "Ida May II."

◆

On the opening day of the Anti-Slavery Anniversary Week celebrations in New York City, there was a torrential downpour. "Had the weather been favorable, it is a safe thing to affirm that the house could not have held the audience that resorted to it."[25] And as the *National Anti-Slavery Standard* went on to report, the doors were "held open for all and the world to come in" all day. During the week before this annual gathering of the antislavery faithful, there had been "vile and malignant" anti-abolitionist demonstrations and press, but this did not muster a counter protest on the day of the anniversary celebrations. "The sternest denunciations of Union and of the Church failed to arouse a single sibilant remonstrance."

The abolitionist movement felt renewed. Mainstream crowds listened to radicals advocate zealous positions without protest or censure. Swelled numbers gathered to hear William Lloyd Garrison, Wendell

Phillips, Theodore Parker, and others. "It certainly meant something more than met the eye, when two Senators of a Sovereign State"— Henry Wilson and Charles Sumner—"in the same week, stood before immense audiences in the chief city in the land, and exposed the dangers of Freedom and debunked the abominations of Slavery." This was Sumner's first lecture in New York, and it was sold out. He was invited to reappear a second night, downtown at Niblo's Theater, and then a third night, in Brooklyn. All three events sold out.

Sumner commanded the antislavery arena, but he worried that this springtime growth would be checked. "We seem to approach success," Sumner wrote antislavery jurist William Jay, "but I shall not be disappointed if we are again baffled." From his vantage point, a triumph so quick in coming could not effect deep change, for "our cause is so great that it can triumph only slowly."[26]

PART FIVE

PRIVATE PASSAGES

◆

17

Private Life

◆

Henry Williams returned to Concord, bringing with him a small statuette of Little Eva and Uncle Tom, the stars of *Uncle Tom's Cabin*. It was October 1855, and these objects, known as "Tomitudes," were in every shop in North Boston. That month also marked the five-year anniversary of Henry's flight from Virginia.

He was making an errand of gratitude and reflection. He could take the train now, surely, but Concord historians insist that he walked. This time Henry Williams approached the Thoreau home in the broad light of day and entered by the front door. Sophia and Henry David Thoreau were surprised to see him. Four years after they had sent him by train to Canada, he was standing upon their doorstep. He had much to tell them about his manumission and his reunion with his family, and they gathered to listen.

Williams gave Thoreau the statue of Tom and Eva, not to remember

the novel by, but to remember him by. It had been made in Staffordshire, England, he showed Thoreau, while he himself was from Stafford County, Virginia. Williams had met Thoreau on his previous flight to Concord, before his wife and children were reunited with him, and before the world had met Uncle Tom and Little Eva. And just as the figurine depicts Eva standing on the knee of a grinning Tom, now Henry beams when he is with his daughter Mary.

George Tolman, a later resident of Thoreau's home and custodian of his effects there, would say of the figurine that "the negro spent his last penny for the gift for his friend," but that seems a demeaning, false assumption, made for effect.[1] Williams could handle money. But "Thoreau was deeply appreciative of the gratitude and always treasured the gift and its association," Tolman recalled, and he would keep the statuette for the rest of his life. It remains treasured beyond its worth today. "Tom and Eva" is a highlight of the Thoreau collection at the Concord Museum.

What Thoreau biographer Annie Russell Marble called a "crude and striking piece of china," I regard as a proxy portrait of Henry Williams and Mary Mildred Williams. The child is as white as the man is black, and both wear snappy clothing. Eva stands upon Tom's thigh, his hand around her hip. He wears a wreath of red flowers she has made him, and their redness is only a gradient lighter than her reddish hair. Her face is sweetly serious, while his wears a smile. Fiction and truth converged

Uncle Tom and Eva, glazed ceramic figurine, gifted to Henry David Thoreau by Henry Williams in October 1855.

here, as the real-life father and daughter assumed a curious symmetry with a pair in American literature, like a transparency laid across a map. The press thought *Ida May* had been written by Harriet Beecher Stowe, in the two years after *Uncle Tom's Cabin*. The tragic heroines of these two novels, Ida May and Eva St. Clair, were so similar as to be acted by the same young starlet on the same day. The press called Mary "Ida May II." Her father gave Henry David Thoreau a statuette of Little Eva and Uncle Tom. Of these congruencies, which are merely associative, and which hold meaning?

No doubt Thoreau cleared obstacles on the day he and Williams had spent together four years earlier. Modest in his aid, Thoreau was humble even in his private journal. We cannot know how much practical support Thoreau or others in Concord gave Williams, because Thoreau did not write of it. Records note only fifty cents donated by Ralph Waldo Emerson. When Williams returned to Boston, after his brief sojourn in Canada, he found people who could help him to achieve his manumission and reunite with his wife and children. Something he remembered in Thoreau's solicitous kindness—perhaps a word of encouragement, enlightenment, or introduction—required this memento of thanks.

◆

As Henry made his trip to Concord, Mary's private life began. There is no evidence of a specific decision by the men responsible for her fame to end her public appearances. More likely all parties took a summer holiday and, upon their return, found interest in Mary dissipated.

During the summer of 1855, Sumner went west, touring eleven free states and three slave states. Leaving directly after his New York appearances, he passed through Pennsylvania, Ohio, and Indiana. He stopped in Kentucky, visiting Henry Clay's family in Madison County, as well as Lexington, Paris, and Frankfort, towns "where I have seen much to admire, & much which I can never forget—the magnificent woodland pastures & the cattle—& the slaves. I was present at the sale of a slave

on the court-house steps!" He tossed a silver coin to a grinning boy while his master looked on. He visited Mammoth Cave, then journeyed down the Cumberland River to St. Louis. A steamboat up the Mississippi took him as far as St. Paul. He was badly bruised in a carriage accident near Davenport, Iowa. He saw Chicago, Detroit, Madison, and Milwaukee, and back in Iowa on July 10, he visited the offices of the *Dubuque Tribune* for an interview. He toured the Great Lakes by boat. He hiked the White Mountains of New Hampshire. He apparently was in no hurry to return to his senatorial labors in Washington. "It seems to me that nothing but my interest in the Slavery Question would keep me there another session," he wrote.[2]

Mary, for her part, spent the summer of 1855 in Newburyport, which had the desired effect of ending her public career. She traveled to Newburyport with Carrie Andrews, without her parents or siblings.

Mr. Higginson was much moved at the situation of this lovely child. He wished me to take her home with me and keep her for a while in my vacation, at Newburyport. While I was there he wrote me the most explicit directions in regard to her care and enjoyment, I thought he hoped at one time to adopt her, as after I had returned to my school, and given her back to her parents, he wrote sorrowfully to me, "My dream of Mildred is ended. I was not worthy of it."

—*Caroline Andrews Leighton to Mary Potter Thacher Higginson*[3]

When Mary returned to her parents in the fall, her family was the same, but she was changed. For two months or more, she had led the life of a white child, the kind of life she might expect if she were adopted. Did her revelations about white society change her manner?

Higginson visited Mary when he was in Boston, and with each visit came a renewed entreaty to her parents to let him take Mary to another

life. He had attempted such an adoption years before, when a fugitive woman, who presented white, arrived with her two children in Worcester. She had been sent by Samuel J. May, and "we had them in our care all winter."[4]

She escaped 4 months ago from North Carolina, disguised in deep mourning, bringing her child three years old, also white. She has also a baby born since her arrival; they are her master's [half-brother's] children, poor creature; and she is coming here for safety. She has always been petted and waited on, and can do nothing except sew; but we shall probably get her into some family where she can do housework: and perhaps the elder child will be adopted, if she is willing.

—Thomas Wentworth Higginson, quoted by
Mary Potter Thacher Higginson[5]

For the better part of a year, Higginson helped the woman from North Carolina make a full transition into white society through marriage to a white tradesman from Boston, who knew the woman's story but married her anyway. Apparently, she was unwilling to give up her children to adoption. "She disappeared into the mass of white population, where we were content to leave her untraced."[6]

Higginson's visits to the Williams family continued, his aid unrelenting. "When I was in Boston, I went to see my darling little Mildred Williams Ida May," wrote Higginson, giving her two names, side by side. "They, you know, are free. She is as gentle and refined as ever with her delicate skin and golden hair." He concluded, "She may be adopted by a member of Congress."[7] He could not adopt Mary himself, so he recruited another family.

A year passed. Mary was not adopted by the "member of Congress" as Higginson had arranged. A new benefactor was in the picture, a woman, who had offered to adopt Mary. Higginson also had a new

family in mind, one that could offer advantages. He wrote "to Madam,"
to confirm her good intent. He does not give her name or address.

<p align="right">*March 23, 1857*</p>

Dear Madam,

*I take the liberty of writing to you, in regard to a little girl in whom
I am deeply interested, Mary Mildred Williams.*

*She was here when she first come from Washington, & won all our
hearts. Since then I have not seen her till lately, owing chiefly to absence
from this country. But I have just visited her again, in hopes of fulfilling
a plan I have long had, to procure her adoption into some other family.*

*I would gladly have taken her myself, (having no children,) had my
wife's health and other circumstances permitted. I have now, however,
made arrangements for her adoption into an excellent family, where she
would have every advantage of education and careful training,—when,
on calling on Mrs. Williams, I found that you had formed a similar plan.*

*Of course, you have the first claim, especially as the child has already
staid with you, and become attached to you. But as I understand that
they have not heard from you for some time, I am anxious to know
whether you still desire to take her?*

*I should deem it a favor, if you would inform me in regard to the mat-
ter, as early as convenient, in order that I may carry out my own plan (to
which the family seem willing to consent) unless yours is fulfilled.*

<p align="right">*Very respectfully yours,*
T. W. Higginson[8]</p>

Mary had stayed with "Madam" before. "Madam" was a stranger to
Higginson but not to Mary, who was "attached" to her, even though she
had not been in touch, "for some time." She was likely a fellow reformer.

Higginson had known Mary for two years, almost to the day, when
he wrote this letter. He assumed that "the family seem willing to con-
sent" to his plan of adoption, but he could be mistaken. The urgency

with which he pursued his plan may have to do with his concerns that her associations in black Boston would reveal her origins. As a racially mixed child, adoption away from her father and brother would have removed her contextual markers of blackness and permitted her to pass into white society. In the era of *Dred Scott*, adoption would have meant that Mary had the rights of a U.S. citizen, the privileges afforded upper-class whites, and the future expected for an educated white woman. But did her parents consent to Higginson's plan? Would Elizabeth and Henry allow for the removal, by "social promotion," of one of their fair daughters? Elizabeth held her child close that winter.

18

"The Crime Against Kansas"

◆

O ut west, proslavery and antislavery factions erupted in violence as "Bleeding Kansas" reached a point of no return in May 1856. The Kansas-Nebraska Act of 1854 had established "popular sovereignty" as the determining factor behind whether the former Indian Territory known as Kansas would be incorporated as a slave or free state. Proslavery settlers, their numbers swelled by "border ruffians" from Missouri, had elected a legislature that wrote a proslavery constitution for Kansas, with a statute that called for five years imprisonment of any man who "questioned" the rights of slaveholders. In defiance of this statute, and to tip the balance of popular sovereignty, the New England Emigrant Aid Society recruited nearly nine thousand antislavery voters and their families to move to Kansas. Then in a decisive blow to the cause of liberty, President Franklin Pierce came out in open support for the proslavery constitution. He asked Congress to incorporate Kansas as a

slave state and sent federal troops in support. Violence escalated. Eight hundred proslavery men sacked the antislavery settlement at Lawrence. The territory was no longer safe for antislavery.

Thomas Wentworth Higginson left Massachusetts to bring "supplies" to the settlers: 92 pistols and 5,900 rounds of ammunition.[1] Members of his Worcester congregation had emigrated to Kansas, and he went there in support. In the communities of Lawrence and Topeka, Higginson would be known as "the Reverend General." He would hold services at the "Church Militant," a makeshift structure of packing crates covered in buffalo skins.

In Washington, on May 19, Charles Sumner delivered a vitriolic five-hour speech to a packed, hot Senate chamber. The hopes of the Free Soil movement were being trounced in Kansas, and Sumner's diatribe flew in the face of convention and decorum. In "The Crime Against Kansas," he verbally assaulted politicians he felt to be responsible for the bloodshed in "Bloody Kansas": President Franklin Pierce, for his collusion with a proslavery territorial government; and Senator Stephen Douglas of Illinois, for the Kansas-Nebraska Act, the policy of popular sovereignty and the lawless behavior of "border ruffians" in attacking the "peaceful settlers" of Kansas. Sumner called Douglas "the squire of Slavery, its very Sancho Panza, ready to do all its humiliating offices."

Senator Andrew Butler of South Carolina was another especial target. The previous February, Butler had relentlessly interrupted Sumner's midnight appeal, and despite Butler's alleged drunkenness on that occasion, he had cornered Sumner into admitting a treasonous policy of disregard for the Fugitive Slave Law. In response to the fighting in Kansas, Butler had called for the disarmament of the people of Kansas, which Sumner called the "Remedy of Folly." In the most famous lines of his 118-page speech, Sumner viciously maligned Butler and his state.

The Senator from South Carolina has read many books of chivalry, and believes himself a chivalrous knight, with sentiments of honor and cour-

age. Of course he has chosen a mistress, to whom he has made his vows, and who, though ugly to others, is always lovely to him; though polluted in the sight of the world, is chaste in his sight—I mean, the harlot, Slavery. For her, his tongue is always profuse in words . . . The frenzy of Don Quixote, in behalf of his wench Dulcinea del Toboso, is all sur-passed. The asserted rights of slavery, which shock equality of all kinds, are cloaked by a fantastic claim of equality. If the slave States cannot enjoy . . . the full power in the national Territories to compel fellow-men to unpaid toil, to separate husband and wife, and to sell little children at the auction block—then sir, the chivalric Senator will conduct the State of South Carolina out of the Union! Heroic Knight! Exalted Senator! A second Moses come for second exodus! . . .

Has he read the history of 'the State' which he represents? He can-not surely have forgotten its shameful imbecility from slavery, confessed throughout the Revolution, followed by its more shameful assumptions for slavery since . . . Instead of moving, with backward treading steps to cover its nakedness, [Senator Butler] rushes forward, in the very ecstasy of madness, to expose it, by provoking a comparison with Kansas . . .

Were the whole history of South Carolina blotted out of existence . . . civilization might lose—I do not say how little, but surely less than it has already gained by the example of Kansas, in its valiant struggle against oppression, and in the development of a new science of emigration. Already, in Lawrence alone, there are newspapers and schools, including a high school; and throughout this infant Territory there is more of mature scholarship, in proportion to its inhabitants, than in all South Carolina.
 —*Charles Sumner, May 19, 1856*[2]

Disunion was not to be feared but welcomed as an occasion for these imbeciles devoted to owning slaves to depart. After Sumner delivered the first half of his speech on Monday, he was chastised for his offen-sive language and personal attacks. During the second half, proslavery senators made a show of nonattention. They talked audibly, laughed

and stood about in groups, despite calls to order. Stephen Douglas was writing letters, with not one eye on Sumner.

Then, after completing the second half of the speech on Tuesday, Sumner faced open rancor. A livid Douglas rose to ridicule him. For weeks, Douglas said, he and his colleagues had been hearing rumors that the Senator had a new speech "written, printed, committed to memory, practiced every night before the glass with a negro boy to hold the candle and watch the gestures, and annoying the boards in the adjoining rooms until they were forced to quit the House!" The Senate chamber erupted in laughter. According to Douglas, Sumner's speech was no extemporaneous attack on Butler, nor an appeal to end the bloodshed in Kansas, but an array of "libels" and "gross insults" that were "conned over, written with cool, deliberate malignity, repeated from night to night in order to catch the appropriate grace." Sumner's carefully prepared speaking style that had been lauded as graceful in Boston was labeled premeditated and cruel in Washington.[3] Douglas recalled that Sumner and the rest of the "Black Republicans" had openly promised to defy the Fugitive Slave Law, citing a higher power that put them above the Constitution they were sworn to protect.

"I am in doubt as to what can be his object," Douglas said. "He has not hesitated to charge three fourths of the Senate with fraud, with swindling, with crime, with infamy, at least one hundred times over in his speech. Is it his object to provoke some of us to kick him as we would a dog in the street, that he may get sympathy upon the just chastisement?" Did Douglas incite violence with this comment?

"You arrange it on the opposite side of the House to set your hounds after me," Douglas continued, "and then complain when I cuff them over the head, and send them back yelping. I never made an assault on any Senator; I have only repelled attacks. The attack of the Senator from Massachusetts now is not on me alone. Even the courteous and the accomplished Senator from South Carolina [Mr. Butler] could not be passed by in his absence." Did Douglas defend his remarks with a threat?

In response, Sumner called Douglas "offensive" and "noisome."

When the Senate adjourned that day, a House Republican, John Bingham of Ohio, caught up to Senator Henry Wilson and warned him, "You had better go down with Mr. Sumner; I think there will be an assault upon him."

"Do you think so?" Wilson asked.

"I have heard remarks made," Bingham replied. " . . . I think an assault will be made." Wilson took the warning seriously, but for his own reasons, he did not share this information with his colleague from Massachusetts. Instead, Wilson simply said to Sumner, "I am going home with you to-day—several of us are going home with you."

No, Sumner would not have an escort. "None of that, Wilson."

Wilson rallied Anson Burlingame, from the Massachusetts fifth district, and Schuyler Colfax of Indiana to protect Sumner. "Walk down with us," he urged these men, "for it is possible there may be some demonstration against him."[4]

While Wilson was making arrangements with Burlingame, Sumner "shot off just as I should any other day," slipping out from Wilson's accompaniment by means of a side door.

On the street, Sumner overtook William Seward; they had plans for dinner. They walked together as far as the omnibuses, which Seward proposed they take to dinner together. But Sumner had to stop by the printer's office to review the proofs of "The Crime Against Kansas," so he walked home from there alone and unmolested. He dressed and kept his dinner appointment.

◆

Two days later, on May 22, 1856, Representative Preston Brooks of South Carolina, Butler's second cousin, went after Sumner in the Senate chamber, seeking retribution for the speech. The Senate adjourned at twelve forty-five that afternoon, and when the last woman had left

the chamber audience nearly an hour later, Sumner could still be found at his desk, signing the first edition of "The Crime Against Kansas." Brooks approached Sumner and made this pronouncement:

"Mr. Sumner, I have read your Speech with care and as much impartiality as was possible and I feel it is my duty to tell you that you have libeled my State and slandered a relative who is aged and absent and I am come to punish you for it."

Sumner did not recognize Brooks, having never met him before. He was rising in greeting when the first blow struck him on top of his head. Trapped by his desk, Sumner suffered a dozen strikes of Brooks's gold-tipped cane on his head, face, and hands. Blinded by blood, he roared, and applying all his strength, he wrested his desk from the iron fasteners that had bolted it to the floor. He staggered down the aisle, hands outstretched in defense, but the blows kept coming.

The younger Brooks required a cane for his limp, ever since taking a bullet in his thigh in a duel. He later said that he chose to use a cane to punish Sumner rather than a whip, which could have been wrested from his hand. Sumner was the stronger man, Brooks told his brother, though they were both six feet tall. He wished "expressly" to avoid taking Sumner's life, but he carried a pistol just in case.

As you will learn by Telegraph that I have given Senator Sumner a caning and lest Mother should feel unnecessary alarm I write to give a more detailed statement of the occurrence. Sumner made a violent speech in which he insulted South Carolina and Judge Butler grossly. The Judge was & is absent and his friends all concurred in the opinion that the Judge would be compelled to flog him. This Butler is unable to do as Sumner is a very powerful man and weighs 30 pounds more than myself. Under the circumstances I felt it to be my duty to relieve Butler & avenge the insult to my State. I waited an hour and a half in the grounds on the day before yesterday for S when he escaped me by taking a carriage. Did the same thing yesterday with the same result.

I then went to the Senate and waited until it adjourned. There were
some ladies in the Hall and I had to wait a full hour until they left. I then
went to S's seat and said, "Mr. Sumner, I have read your Speech with
care and as much impartiality as was possible and I feel it my duty to tell
you that you have libeled my State and slandered a relative who is aged
and absent and I am come to punish you for it." At the concluding words
I struck him with my cane and gave him about 30 first rate stripes with
a gutta percha cane which had been given me a few months before by a
friend from N. Carolina named Vick. Every lick went where I intended.
For about the first five or six licks he offered to make fight but I plied him
so rapidly that he did not touch me. Towards the last he bellowed like
a calf. I wore my cane out completely but saved the Head which is gold.
The fragments of the stick are begged for as sacred relics. Every Southern
man is delighted and the Abolitionists are like a hive of disturbed bees. I
expected to be attacked this morning but no one came near me. They are
making all sorts of threats. It would not take much to have the throats
of every Abolitionist cut. I have been arrested of course & there is now a
resolution before the House the object of which is to result in my expul-
sion. This they can't do. It requires two-thirds to do it and they can't get a
half. Every Southern man sustains me. The debate is now very animated
on the subject. Don't be alarmed it will all work right. The only danger
I am in is from assassination, but this you must not intimate to Mother.

Love to all. I am glad you have all paid our Brother James a visit.

Your affectionate brother

—Preston Brooks to James Hampden Brooks, May 23, 1856[5]

The sound of Sumner's desk overturning had caught the attention
of the chamber. New York congressmen Ambrose Murray and Edwin
Morgan had been talking to *New-York Daily Times* reporter James Q.
Simonton at the south entrance of the Senate chamber when they heard
"a noise, thumps, pounding and a rustling disturbance"—the sound of

blows. They rushed from the gallery to Sumner's aid, calling for help, "crying for those who were around to take him off."[6] They were stopped by a representative from South Carolina, Laurence M. Keitt, who held his cane over his head and his hand on his holstered pistol. Accounts were conflicting, but Keitt may have been yelling, "Let them alone! God-damn, let them alone!" Senator John Crittenden from Kentucky, the only man close enough to Brooks to interfere, tried to call him off, once Brooks was beating a senseless man. "Don't kill him," Crittenden said.

"I did not intend to kill him, but I did intend to whip him" was the response.[7] Brooks exerted his full power—he could not have hit Sumner with any greater force or rapidity. The gutta-percha cane had splintered on the fourth blow. Then Brooks beat Sumner with the broken piece, about eight inches long. "Oh Lord!" Sumner cried, "Oh! Oh!" He was like a person in convulsions, "his arms were thrown around as if unconsciously. There was no resistance, as I should judge," said Senator L. F. S. Foster of Connecticut.[8] "Every effort Mr. Sumner made was merely spasmodic, and I do not believe he was conscious from the first blow," said Edwin Morgan.[9] Sumner took out another desk as he fell.

Brooks pulled Sumner from the floor by the sleeve, as memorialized in illustrations of the event, and raised Sumner's head so he could continue to beat it, intending to deliver "about 30 first-rate stripes." Sumner fell unconscious to the sound of one of his fellow senators calling, "Give the damned Abolitionist hell!" and "It is all fair." There were twenty or twenty-five men in the room, "standing around," said Ambrose Murray.[10]

"Mr. Murray and myself arrived there at the same instant of time." Morgan remembered. "I was nearer Mr. Sumner, and he was nearest Mr. Brooks. We started from the same point, but went different routes; he caught the arm of Brooks, and I the falling body of Sumner." Murray caught Brooks by the right arm and drew him back, turning him to face the exit, away from Sumner. Brooks stopped and dropped his grip, satisfied.

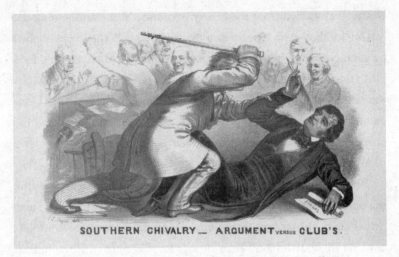

SOUTHERN CHIVALRY — ARGUMENT versus CLUB'S.

"Southern Chivalry—Argument Versus Clubs," lithograph by John L. Magee showing
Preston Brooks's 1856 attack on Charles Sumner.

At the same moment, Edwin Morgan caught Sumner as he slid senseless into the center aisle. With his head cradled on Morgan's knee, his blood pooled on the Senate floor. Morgan begged for someone to call a surgeon. Someone already had. Morgan's coat was soaked with blood.

Brooks walked out with Keitt into the sunny afternoon unchallenged, his duty discharged. He would later pay a fine of three hundred dollars for assault and battery. Brooks and Keitt both resigned their congressional seats in July, but both were reinstated by popular vote in the next election.

◆

Sumner came to. Many hands helped him to his feet. He mumbled that he would need his hat. "I think I can walk." He told the page to collect the documents on his desk. He was escorted to a sofa. The doctor arrived. Dr. Cornelius Boyle found that Sumner's skull was exposed by the gashes across his head. He was still bleeding profusely. Dr. Boyle

stitched up Sumner's wounds, on a sofa in an anteroom to the Senate chamber. Sumner's suit jacket, stiff with blood, was carefully pulled off to relieve the swelling across his shoulders and forearms.

Someone caught Henry Wilson, as he was heading down the street for home, and told him of the assault. His fears realized, he ran back to the Senate chamber and found Sumner in the anteroom having his head wounds dressed. He helped Sumner into a carriage. As his friends undressed him and settled him into his room, Sumner was speaking. Wilson remembered him saying defiantly, "When I recover I will meet them again, and put it to them again." Dr. Boyle remembered a more incredulous Sumner saying: "I could not believe that a thing like this was possible."

◆

The following day Wilson told of Sumner's assault to a convened Senate, and he called for decisive action protecting its members from assault "for words spoken in debate." William Seward introduced a resolution that the president of the Senate appoint a committee of five to investigate the circumstances behind the "violent assault upon the person of the Hon. Charles Sumner." Committeemen were selected from both the House and Senate immediately, by ballot. The chairman, Representative Lewis Campbell of Ohio, wrote to inform Preston Brooks of the formation of this committee and to make a request for witnesses. Brooks responded, "I know of no witness to the affair but Hon. Mr. Winslow, of North Carolina."[11]

Committee member Alexander C. M. Pennington of New Jersey had visited Sumner's rooms that morning and found him in too critical a condition to attend the committee to testify. Sumner could not be moved, but Dr. Boyle thought the committee might come to him. "And the committee thereupon proceeded to the lodgings of Mr. Sumner;

Mr. [Lewis] Campbell having first invited Mr. Brooks to proceed with them, and Mr. Brooks having declined."[12]

Question. *What do you know of the facts connected with the assault alleged to have been made upon you in the Senate Chamber by Hon. Mr. Brooks of South Carolina, on Thursday, May 22, 1856?*

Answer. *Instead of leaving the Chamber with the rest on the adjournment, I continued in my seat, occupied with my pen. While thus intent, in order to be in season for the mail, which was soon to close, I was approached by several persons who desired to speak with me; but I answered them promptly and briefly, excusing myself for the reason that I was much engaged. When the last of these left me, I drew my arm-chair close to my desk, and, with my legs under the desk, continued writing . . .*

While thus intent, with my head bent over my writing, I was addressed by a person who had approached the front of my desk, so entirely unobserved that I was not aware of his presence until I heard my name pronounced. As I looked up, with pen in hand, I saw a tall man, whose countenance was not familiar, standing directly over me, and, at the same moment, caught these words: "I have read your speech twice over carefully. It is a libel on South Carolina and Mr. Butler, who is a relative of mine——." While these words were still passing from his lips, he commenced a succession of blows with a heavy cane on my bare head, by the first of which I was stunned so as to lose sight. I no longer saw my assailant, nor any other person or object in the room. What I did afterwards was done almost unconsciously acting under the instincts of self-defense. With head already bent down, I rose from my seat, wrenching up my desk, which was screwed to the floor, and then pressed forward, while my assailant continued his blows. I have no other consciousness until I found myself ten feet forward, in front of my desk, lying on the floor of the Senate, with my bleeding head supported on the knee of a gentleman, . . . Mr. Morgan, of New York. Other persons there were about me, offering me friendly assistance; but I did not recognize any of

them. Others were at a distance, looking on, and offering no assistance,
of whom I recognized only Mr. Douglas, of Illinois, Mr. Toombs, of
Georgia, and I thought also my assailant, standing between them. . . .

I desire to add that, besides the words which I have given as uttered
by my assailant, I have an indistinct recollection of the words "old man";
but these are so enveloped in the mist which ensued from the first blow,
that I am not sure whether they were uttered or not. . . .

Question, *Did you at any time between the delivery of your speech*
referred to, and the time when you were attacked, receive any intimation
in writing, or otherwise, that Mr. Brooks intended to attack you?

Answer. *Never, directly or indirectly; nor had I the most remote sus-*
picion of any attack, nor was I in any way prepared for an attack. . . . I
was, in fact, entirely defenseless at the time, except so far as my natural
strength went. . . . Nor did I ever wear arms in my life. I have always
lived in a civilized community where wearing arms has not been con-
sidered necessary.

—*Charles Sumner, testimony, May 26, 1856*[13]

Senator Butler explained that when the "Crime Against Kansas"
speech hit the papers, Preston Brooks was chided everywhere he went.
"He could not go into a parlor, or drawing-room, or to a dinner party,
where he did not find an implied reproach. . . . It was hard for any man,
much less for a man of his temperament to bear this."[14] Brooks had
looked for an opportunity to confront Sumner each day that week. He
decided not to formally challenge him to a duel, as was custom, feeling
that Sumner was unlikely to accept. More likely Sumner would coun-
ter with legal charges. Butler was not able, due to his age and a recent
stroke, to perform this office on behalf of South Carolina. Brooks would
later say, "I felt it to be my duty to relieve Butler and avenge the insult to
my State." In South Carolina, it was customary to flog a rival who made
a public insult. Brooks performed his duty thoroughly.[15]

On the Thursday following his attack, Brooks wrote to the presi-

242 *Jessie Morgan-Owens*

dent of the Senate, "I had reason to believe that the Senator from Massachusetts did not acknowledge that personal responsibility for wrongs in personal deportment which would have saved me the painful necessity of the collision which I sought; and in my judgment, therefore, I had no alternative but to act as I did." He apologized, not for the "collision" but for where it took place.[16] He did not wish to be considered in breach of the privileges or dignity of the Senate.

Immediately after the attack, Southern congressmen had collected pieces of the cane that littered the sticky floor of the Senate chamber and took them home to be made into commemorative rings. The gold head of the cane was saved for Brooks. He would receive a hero's welcome in much of the South, while the North vilified him. For the one hundred canes gifted to Brooks, South Carolina's avenger, there were one hundred effigies of him burned in answer.

In the North, this shocking act irrevocably charged the tone of the antislavery debate. The press moved away from sympathetic appeals, such as those represented by the image of young Mary, to talk of war. Southerners who thought Brooks manly and his action justifiable considered Sumner feminine, ridiculous, and undefended. Northerners who saw Sumner as a "restrained, manly intellectual" considered Brooks "an uncontrolled brute." As abolitionist historian Manisha Sinha has explained, reactions to the caning represented, with respect to "manliness," a clash of distinct civilizations within one nation. Massachusetts and South Carolina harbored two distinct social codes, two codes of gender performance, two visions of progress, and two approaches toward injury and honor.[17]

Reverend Henry Ward Beecher announced, "The symbol of the North is the pen; the symbol of the South is the bludgeon."

"Blow must be given back for blow!" wrote the editor of the *Pittsburgh Gazette*.[18]

William Cullen Bryant called on his fellow abolitionists to join the fight: "Violence is the order of the day; the North is to be pushed to the

wall by it, and this plot will succeed if the people of the free states are as apathetic as the slaveholders are insolent."[19]

Harriet Beecher Stowe was "so indignant at the outrage" that in her new novel, "instead of carrying out some of her characters and making them like Little Eva, charming and tender, she introduced this spirit of revenge under the name of the negro Dred."[20] The South had escalated the debate to blows, not against the slave but against the senator, and in the face of this new aggression, abolitionism now called for violence, not sympathy.

In every city Sumner had visited the previous year in peace, "indignation meetings" cropped up. Four thousand gathered in New York's Broadway Tabernacle, and five thousand in Boston's Faneuil Hall. He was reelected in 1856, even though he could not return to his Senate seat for fifty months.

◆

The bloody climate required a new icon, and his name was John Brown. In Kansas on May 24, 1856, two nights after Brooks caned Sumner, Brown, five of his sons, and two other men rode out to Pottawatomie County to attack slaveholders directly. They pulled five men from their cabins, settlers who were known to support slavery, and hacked them to death with broadswords.

Brown had the support of Thomas Wentworth Higginson, the most radical member of the "Secret Six," a group of abolitionists whose provided Brown with funds, strategy, and philosophy.[21] Brown also had the support of Henry David Thoreau, who knew him from the preparation time Brown spent in Concord. Brown had the support of Frederick Douglass, who felt that the time for pacifism had passed. On October 16, 1859, Brown and twenty-one men attacked the arsenal at Harpers Ferry, Virginia, with the intent of instigating a slave insurrection. Brown was captured and charged with murder, conspiracy, and treason.

After the raid on Harpers Ferry, Douglass had to leave the country for a time to secure his own safety. Thoreau volunteered to speak in Douglass's stead, making a plea for Brown's life.

A man of rare common sense and directness of speech, as of action; a transcendentalist above all, a man of ideas and principles, that was what distinguished him. Not yielding to a whim or transient impulse, but carrying out the purpose of a life. I noticed that he did not overstate anything, but spoke within bounds. . . .

If [David] Walker may be considered the representative of the South, I wish I could say that Brown was the representative of the North. He was a superior man. He did not value his bodily life in comparison with ideal things. He did not recognize unjust human laws, but resisted them as he was bid. For once we are lifted out of the trivialness and dust of politics into the region of truth and manhood. No man in America has ever stood up so persistently and effectively for the dignity of human nature, knowing himself for a man, and the equal of any and all governments. In that sense he was the most American of us all. . . .

I do not believe in erecting statues to those who still live in our hearts, whose bones have not yet crumbled in the earth around us, but I would rather see the statue of Captain Brown in the Massachusetts State-House yard, than that of any other man whom I know. I rejoice that I live in this age, that I am his contemporary.

—Henry David Thoreau, October 30, 1859[22]

Brown was found guilty on all three charges and hanged on December 2, 1859. Having died for the Union cause by striking its first blow, transcendentalists made him a martyr.

19

Frederick Douglass

◆

The 1860 Federal census records "Mary M." as age twelve, Oscar as fifteen, and Adelaide R. as ten. Oscar would not live to see the end of the year. Their Boston neighbors are tradespeople: a baker, a pattern maker, and two "piano forte workers." The census noted the value of Henry Williams's personal estate was $600. The Williamses had the means to reside in a single-family residence and take in another family as boarders. Fugitives from Virginia—Nathaniel and Fanny Booth—and their infant daughter, Ida, are recorded as living with the Williams family in 1860.

The census noted that all three children attended school the previous year. The next year Mary attended the progressive Everett School for girls, which opened in 1860 in Boston's South End, on Northampton Street. The opening speech, dedicated by the former governor for

whom the school was named, noted that to educate girls in a first-class school such as this one was a political act: "Give [girls] for two or three generations equal advantages of mental culture, and the lords of creation will have to carry more guns than they do at present, to keep her out of the enjoyment of anything which sound reasoning and fair experiment shall show to be of her rights."[1] Edward Everett had taken an early step toward education access when, as president of Harvard in 1848, he stated publicly that black applicants for admission to Harvard would be judged by the same criteria as white applicants, without prejudice to race.

In 1849 Robert Morris, the young black attorney and antisegregation activist, asked Charles Sumner to be his co-counsel when *Sarah Roberts v. City of Boston*, a case fighting segregation in Boston's public schools, reached the Massachusetts Supreme Court. Few black men had passed the bar, and no black attorney had yet argued before the state's highest court. Sumner took the case without payment.

In *Roberts v. Boston*, Benjamin Roberts, the father of five-year-old Sarah Roberts, had tried to take his daughter to their neighborhood public school, and she was physically denied entry. To attend one of the two schools in Boston designated for children of color, Sarah would have had to walk 2,100 feet, past elementary schools intended for white students. Her father sued the city of Boston for damages. Sarah Roberts's 2,100-foot walk to school might be considered trivial, Sumner argued, but like the small tax on tea that began a revolution, trivial matters serve as symptoms of our deepest injustices.

Appearing before Judge Lemuel Shaw of the Supreme Judicial Court of Massachusetts that December, Morris and Sumner argued that the Boston School Committee's racial segregation policy was unconstitutional. The Declaration of Independence and the Massachusetts constitution both affirmed that "all men are created equal," and

Sumner argued that the state's educational resources should provide for all the children of Boston. He recalled his personal experience of sitting companionably "on the same benches with colored persons, listening, like myself, to the learned lectures" while at law school in Paris. Boston should not make caste distinctions.

We abjure nobility of all kinds; but here is a nobility of the skin. We abjure all hereditary distinctions; but here is a hereditary distinction, founded not on the merit of the ancestor, but on his color. We abjure all privileges derived from birth; but here is a privilege which depends solely on the accident, whether an ancestor is black or white. We abjure all inequality before the law; but here is an inequality which touches not an individual but a race. We revolt at the relation of caste; but here is a caste which is established under a Constitution, declaring that all men are born equal.

Charles Sumner, Sarah Roberts v. City of Boston,
December 4, 1849[2]

The court found against Sarah Roberts. Chief Justice Shaw claimed that racial prejudice could not be legislated, as it was born of society and not of the law. Robert Morris, with Benjamin Roberts and Charles Sumner, then took their case to the Massachusetts legislature. William Cooper Nell supported them by leading a petition and letter writing campaign. Massachusetts banned segregated schools in 1855, the first state to do so (though the schools continue to be separated in practice). But the Roberts case cast a dark shadow. Southern supreme courts took up Shaw's ruling as a precedent in support of segregation, and the U.S. Supreme Court cited it in its infamous ruling in *Plessy v. Ferguson,* which made "separate but equal" the law of the land.[3]

The *Liberator* positioned Mary Mildred Williams as a poster child

for the last time in an 1861 article that crowed about how successful Boston's integrated Everett School had become.

COLORED YOUTH IN BOSTON SCHOOLS

Six years have elapsed since the Legislature abrogated the last distinction which this State has made in the education of her children—the separate colored school; and though Boston was the last to come under the sway of this advancing idea, she seems destined to be the first to bestow an appreciative need upon the deserving colored child. . . . In the Everett School, there are some six or eight of these children. A recent gathering in the hall of the school-house showed, on one side of the room, a white slave girl ransomed a few years since, through the effort of a Massachusetts Senator, and on the other, a sable daughter of one of the isles of the Southern Ocean, while between were youth of almost every nation and clime—Celt and Teuton, African and Asiatic—in happy emulation with the children of our more favored Anglo-Saxon race. That they were taught without prejudice, each stimulated by a proper competition with the other, and all cordially welcomed to the advantages of our inestimable system, it is not necessary that I should here assert.

Liberator, *December 13, 1861*

Six years after her brief moment in abolition's gaze, after her "ransoming" by Senator Sumner, Mary's color and personal history still elicited notice. She was marked as a representative of her race in a group of children, singled out by this school official from the "six or eight" children of color to anchor his imaginary global lineup of races. Mary marked the white extreme in this diversity spectrum, to the side of immigrants and at the farthest distance from her Caribbean classmate. The "white slave girl," along with her immigrant, African, and Asian classmates, is held apart from "our more favored Anglo-Saxon race" in this address by the founder of her school, Charles Wesley

Slack, also the author of the bill that (nominally) ended school segregation in Boston.

Her token presence in a schoolroom still held enough social currency to make a political point. It is unclear whether her sister Adelaide Rebecca joined this tableau. Mary had made some progress toward anonymity; her name was not given or needed in the *Liberator*'s article to tell her story.

◆

"Colored Youth in Boston Schools" appeared on the bottom of the front page of the *Liberator* on December 13, 1861. Above it was a glowing review of Frederick Douglass's lecture on photography's power, "Pictures and Progress," which he had delivered the previous week at Tremont Temple.

If ever a man, standing before a great audience of refined and cultivated people, has the right to their indulgence, surely he whose early years were spent in slavery, whose spelling book was the soft sand at his feet, and who took his degree of the sign-boards over the doors, might claim such indulgence; and yet, as Frederick Douglass stood there, his form dilating with conscious power, his eye flashing, and his whole face glowing with enthusiasm, while his clear silver tones rang like a trumpet, all who saw and heard him must have felt that he was not an object of indulgence, but of admiration. His very presence gives the lie to the oft-repeated assertion that the negro is incapable of elevation, and only fit for a menial condition.

But it is not in a lecture such as this that Frederick Douglass shows his greatest power—that he is really himself. At the close of the meeting at Tremont Temple, he went directly to Rev. Mr. Grimes's church . . . Here the exuberance of his nature found expression in the glowing imagery of

his imaginative race: his wit and drollery were inimitable; and his rol-
licking good humor, blended with a vein of pathos, took all hearts captive.

The Liberator, *December 13, 1861*

The lecture was part of the Parker Fraternity lecture series. "Men from the highest seats of learning, philosophy and statesmanship"—including Douglass, Ralph Waldo Emerson, Henry Ward Beecher, Wendell Phillips, Thomas Wentworth Higginson, and Charles Sumner—had been invited to speak in memory of Theodore Parker, who had died of tuberculosis in Florence, Italy, in May 1860.[4] Sumner said in his speech that although he was inclined "naturally to some topic of literature—of history—of science—of art—to something at least which makes for Peace," he could not take such liberties in wartime, as "the voice refuses such a theme." Sumner chose the topic of war. But Douglass did not: "it may seem almost an impertinence to ask your attention on a lecture on pictures," he told the audience, but "the all engrossing character of the war" makes its own apology for "this seeming transgression."[5]

In this lecture and in the three subsequent lectures he gave on the same theme during the war, Douglass explored photography's potential to influence public opinion. "The world is flooded in pictures," he said; Louis-Jacques-Mandé Daguerre, the inventor of the daguerreotype, has turned "the planet into a picture gallery." Parked at every crossroads in the United States, Douglass reported, was the "inevitable Daguerre-ian Gallery" on wheels where "the farmer boy gets an iron shoe for his horse, and metallic picture for himself at the same time, and at the same price."[6] In the nation's love affair with pictures, Douglass argued, could be found a latent democratic power: this cheap, ubiquitous technique of image-making could propagate messages that were equally legible to the whole of society. Douglass's theory of images rested on the assump-tions that sentiment had the power to effect political change, and that photography opened new ways to appeal to it. One of racism's patholo-

gies was a diseased visuality—an inability to see past race. What if the pictures we made and saw told a different story?

"Pictures, like songs, should be left to make their own way in the world," he told his audiences, because they are "equally social forces—the one reaching and swaying the heart by the eye, and the other by the ear." He would go on to become the most-photographed man in America in the nineteenth century.[7] He tried to make an impression on American culture of what it meant to be a black man.[8]

◆

No one in the nineteenth century made a more lucid assessment of photography's service to ideology than Frederick Douglass; but his contemporary audience, expecting another of Douglass's recriminations of slavery, seems to have been unwilling to applaud Douglass's "latitude of range." According to one local correspondent, Douglass's lecture "came near being a total failure; the Speaker only saved himself by switching off suddenly from his subject and pitching in on the great question of the day," that is, the war to end slavery.[9] After his lecture at Tremont Temple, Douglass repaired to Reverend Grimes's Twelfth Baptist Church for what appears to have been an after-party. His reviewer for the *Liberator* followed him there. The *Liberator* review noted Douglass's code switching: in the room filled to capacity with members of Boston's black abolitionist community, Douglass was "really himself."

On December 3, 1861, President Lincoln made the same mistake on the same day. His first annual message to Congress was also panned for omitting to mention slavery.[10]

Exactly a year earlier, on December 3, 1860, Douglass had spoken in Tremont Temple at a John Brown commemorative event, honoring him on the anniversary of his execution, when an anti-abolitionist riot

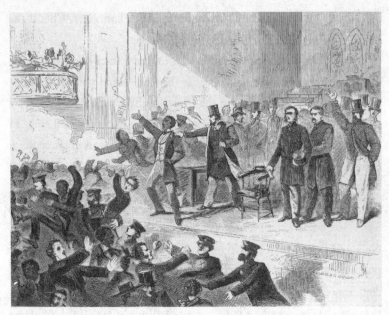

"Expulsion of Negroes and Abolitionists from Tremont Temple, Boston, Massachusetts, on December 3, 1860,"
engraving by Winslow Homer, illustration for *Harper's Weekly*, December 15, 1860.

erupted. Winslow Homer's 1860 illustration of that event for *Harper's Weekly* depicts a man who could be Douglass suspended triumphantly mid-oration, his arms outstretched above a melée of limbs. Douglass was pulled from the podium by the hair and subjected to the verbal abuse of an antiabolitionist mob shouting "Put him out! Down him! Put a rope around his neck!"

On December 3, 1861, Douglass took the podium at Tremont Temple again, to "impertinently" speak of pictures and progress. He could not know if his audience's response would be a welcome or another nightmare. He concluded his speech on pictures with this moral: "where there is no criticism, there is no progress."

On December 31, 1862, once more in the Tremont Temple, Douglass waited for midnight—with Reverend Grimes and William Wells Brown and much of black Boston—to see the jubilee promised by the Emancipation Proclamation. On New Year's Day, during that first

"watch night" of equal parts disbelief and hope, word arrived over the telegraph wires that President Lincoln had signed the document. Chaos of a happy sort erupted in the hall.

That night Douglass took the podium to lead the congregation in singing "Blow Ye the Trumpet, Blow." He would later describe the scene as "wild and grand. Joy and gladness exhausted all forms of expression, from shouts of praise to joy and tears." At midnight, the party had to vacate Tremont Temple, so Reverend Grimes opened his church for a continued celebration, which lasted until dawn, as it has every year since. It was, Douglass remembered, "a worthy celebration of the first step on the part of the nation in its departure from the thralldom of the ages."[11]

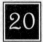

Prudence Bell

The words spoken to the crowd assembled at Tremont Temple on the historic morning of January 1, 1863, were recorded by Edward Mitchell Bannister, the secretary of the Union Progressive Association, a group founded by William Cooper Nell for social uplift and political organizing.

Bannister, a freeborn activist, was deeply connected with the work of antislavery in Boston. He and his wife Christianna Carteaux boarded with Lewis Hayden, the ardent abolitionist whose home was a fortified safe house for fugitives. He aspired to be a painter but had found no established white artists in Boston to take him on in a studio apprenticeship. Nor had he found patronage for travel abroad to the schools of Europe. He taught himself how to paint, by seeing paintings, and how to make photographs at a studio in New York. He started out painting portraits, later making his mark as a landscape painter. He ran an ad

for "E. M. Bannister Portrait Painter" in the *Liberator*, on October 21, 1864. He rented space in the Studio Building on Tremont Street, two doors down from that of the sculptor Edmonia Lewis.[1]

Few of Bannister's portraits remain today. But according to art historian Juanita Marie Holland, his only extant work from 1864 is a memorial portrait of Prudence Nelson Bell. Her daughters, Elizabeth and Evelina, commissioned the painting after Prue died on November 29, 1864.

I wrote to Evelina's grandson, Charles Johnson, Jr., to request details about the painting, which was displayed in their home in New Jersey for many years, before they moved to Connecticut in 1981. Charles had already died, but his widow, Arlette, responded to my request. She told me that Prue's descendants had passed down a story about this sitting:

Bannister arrived at Prue's home to find her laid out in a coffin, under dim window light. Working quickly and quietly in the solemn

Prudence Nelson Bell (oil painting), posthumous portrait by Edward Mitchell Bannister, 1864.

company, he painted Prue as if he had known her in her prime. Evelina had arranged her mother in her favorite lace bonnet. Banister placed her before a dark, neutral background with a nondescript green hill or upholstered chair behind her. As he worked, the portrait would not come together—the eyes were not right. Bannister was not to blame, given that they were dimmed by death. One story had it that Ludwell was called in to sit for Bannister, given that his eyes were so like his mother's. On the other hand, Arlette Johnson wrote to me, "I heard that . . . her eyes [were] painted from her daughter's," referring to Evelina.[2]

In person, the portrait has a hurried quality.[3] Only her face is rendered in any detail. Her straight, strong nose is framed by a single strong crease. Circles shadow her eyes, but the rest of her face is clear and bright. Given her age, her dark hair should have been gray or white, but Bannister made her youthful. The bow of her white bonnet has a greenish tinge. In the background is a neon green mound.

Prue had died quickly of pneumonia, in only six days, when she was seventy-three years old. According to the register *Deaths in Boston*, she died at 1 Livingston Street in Rockland, which would have been near her son Ludwell in East Abingdon, southeast of Boston. Floating above the name "Prudence Bell" there is a small designation, "col[d]." Likely Evelina Bell gave the details of her mother's death to the city. She omitted the name "Nelson" from her mother's tombstone as well as her death record.

Under the column designated for occupations, the clerk wrote, "wife of Thomas."

◆

Ludwell Bell Nelson had moved to Abington in Plymouth County shortly after his manumission, where he worked as a boot cutter, then as a boot stitcher. His brother Jesse Bell Nelson joined him in the shoe industry, moving to Abington after his manumission on July 3, 1856.

Jesse died of typhoid fever, just nine months into his free life, on March 24, 1857.

On January 8, 1863, Ludwell married a white woman, nineteen-year-old Isabella Pike of Weymouth, Massachusetts, and they lived as a white family. Like most white men of his era, he enrolled in the militia in 1859. I do not know if he saw service. Demand for boots soared during the war.

After his mother's death, Ludwell's record disappears, as does the record of his oldest sibling, Albert Bell Nelson. Albert had remained in Washington for three months after their manumission in July 1856. He was married, and a "Mr. White" owned his wife and child. He hoped to see them freed, with John A. Andrew's assistance, as his sister had been. His wife's owner had offered to sell her and the child to Albert, in exchange for $1.75 per day in labor, should Albert choose to remain in Washington for several more years. He did not. He left Washington for Boston on the morning of September 24, 1856, taking the six o'clock train.[4] There is no further trace of Albert or any record of the redemption of his wife and child.

According to an oral history recorded by Evelina's daughter, Addie Johnson Trusty, Ludwell and Albert moved to New Jersey and joined white society as a doctor and a journalist, respectively.[5] Trusty also noted that Prudence Bell had been "an active fugitive slave assistant" in Weymouth until the end of her life.

◆

In May 1866 Evelina Bell married Robert Johnson, a notable member of Boston's free black community, twenty-five years her senior. He had been a fugitive from Richmond, Virginia, arriving in Boston in 1829 at age eighteen. Johnson served as a deacon at Reverend Grimes's Twelfth Baptist Church, and family lore remembers that his home—at 16 Belnap Street (now 69 Joy Street)—had a trapdoor that had once been

used to secret William Lloyd Garrison from a mob. Though his occupation was recorded as "laborer," he owned a small clothing recycling business at 5 Brattle Street, where Evelina's skill as a seamstress would have been of benefit. Their marriage certificate lists Thomas Nelson as the bride's father, Prue Bell as her mother, and Washington, D.C., as her birthplace.

They had two children: Charles William Johnson, born in 1868, and Adelaide, born at home the following year. Addie's birth record lists her as colored. Addie did not have children, but Charles had a large family. Prudence Bell's living descendants can be found among those who count Charles William Johnson as their ancestor. Robert and Evelina Johnson's beautiful brick townhome on Joy Street was one block away from the white side of Beacon Hill, and one block from Charles Sumner's Boston residence on Hancock Street.

Evelina's husband, Robert, already had four grown sons, all soldiers: Henry West, Frederick, William, and Robert Jr. In January 1863, less than two weeks after the Emancipation Proclamation, Sumner introduced a bill "to enlist 300,000 colored troops." (Sumner spent much of the war in Boston, where he "took his seat with the air of a prince of blood at the table, close at hand to the Chief Magistrate," Governor John Andrew.[6]) The bill was defeated, but Massachusetts's wartime governor John A. Andrew had already taken up the cause at home. On November 27, 1862, Governor Andrew shared the Thanksgiving meal at the home of his friend, the black abolitionist Lewis Hayden, who convinced him to seek permission from President Lincoln to form a permanent regiment for colored troops.[7] Secretary of war Edwin M. Stanton authorized Andrew to form a regiment of free colored volunteers, the 54th Massachusetts. Two of Frederick Douglass's sons, Lewis and Charles, immediately signed up.[8]

On February 16, 1863, Deacon Robert Johnson and his sons joined the Douglass men in calling for a muster at the African Meeting House, to recruit their peers to enlist. By June, Robert Jr. and Henry West

Johnson had joined Company F of the 54th Massachusetts. They had six months of service together before Robert Jr., now a sergeant, was captured at Botany Bay, South Carolina.[9] Sergeant Robert Johnson, Jr. survived the filth of close confinement in Charleston Jail with fifty of his regiment. He wrote to the *Liberator* that he saw there "a disposition to release all free men, and as we come under that head, we hope a movement in that direction will soon be made."[10] The prisoners were permitted to come to the yard once a day for water and given one pint of meal each day for food. Every night for over a year, the men of the 54th Massachusetts sang songs in support of the Union for the benefit of their fellow prisoners. A song that Robert Johnson, Jr. wrote, to the tune of "When the Cruel War Is Over," was a special favorite. The first verse gives us a sense of the conditions he faced.

I.

When I enlisted in the army,
Then I thought 't was grand,
Marching through the Streets of Boston
Behind a regimental band.
When at Wagner, I was captured
Then my courage failed;
Now I'm dirty, hungry, naked
Here in Charleston Jail.
CHORUS
Weeping, sad and lonely,
Oh, how bad I feel!
Down in South Carolina,
Praying for a good, square meal.

—*Robert Johnson, Jr.*[11]

Sergeant Robert Johnson, Jr. died of starvation shortly after his transport to Florence prison in Anderson County, a place far worse

than the town jail: "Corpses lay by the roadside waiting for the dead-cart, their glassy eyes turned to heaven, the flies swarming in their mouths, their big toes tied together with a cotton string, and their skeleton arms folded on their breasts." Thirty-nine men of the 54th Massachusetts were held at "Florence Stockade" for two months and nineteen days that winter, during which time a third of them died.[12]

◆

"I did not seek the command of colored troops, but it sought me," Thomas Wentworth Higginson wrote in the introduction to his camp diary, published in 1870 as *Army Life in a Black Regiment*.[13] General Rufus Saxton had invited him to command the first regiment of freed slaves mustered into the Union Army, the First South Carolina Volunteers, later known as the 33rd U.S. Colored Troops. Harriet Tubman would serve with these men.

Higginson did not say yes right away, but agreed to take the post after he traveled to Beaufort, South Carolina, to meet the men he would command. "I had been an abolitionist too long, and had loved and known John Brown too well, not to feel a thrill of joy at last on finding myself in the position where he only wished to be," Higginson recalled. John Brown had given his life for the dream of a mighty force that would rise up from the ranks of slaves, and now, Higginson found himself as its commander. The regiment that he met three days before Thanksgiving 1862 was "as thoroughly black as the most faith-

Thomas Wentworth Higginson as a colonel of the First South Carolina Volunteers, carte de visite. Photograph taken by James Wallace Black, 1863, for *Portraits of American Abolitionists*.

ful philanthropist could desire; there did not seem to be so much as a mulatto among them."[14]

He felt a burden to prove these soldiers to be the equals of those born to freedom, and he had every intention of putting them through the same the drill and discipline that their white compatriots in Massachusetts underwent. "Fortunately, I felt perfect confidence in their ability to be so trained."[15] He quickly noted how readily these men took to drill, and how free of complaint was their labor.

The first three days passed like three years, his time "devoted almost wholly to tightening reins" before the Thanksgiving holiday, which finally permitted him the time to take it all in. Watching his men through the windows of the broken Smith plantation, he wrote rapidly, in an eager effort to retain all he could of his profound transformation.[16]

Already I am growing used to the experience, at first so novel, of living among five hundred men, and scarce a white face to be seen,—of seeing them go through their daily processes, eating, frolicking, talking, just as if they were white. Each day at dress-parade, I stand with the customary folding of the arms before a regimental line of countenances so black that I can hardly tell whether the men stand steadily or not; black is every hand which moves in ready cadence as I vociferate, "Battalion! Shoulder Arms!" nor is it till the line of white officers moves forward, as parade is dismissed, that I am reminded that my own face is not the color of coal.
—*Thomas Wentworth Higginson, November 27, 1862*[17]

Two weeks later Higginson found his company to be made up of mysterious "grown-up children."[18] Nature, he complained, had "concealed all this wealth of mother-wit" under visages that appeared to him hopelessly inscrutable. Cato, an older soldier, looked by day in the cotton fields "as a being the light of whose brain had utterly gone out," but to Higginson's surprise, he could tell a campfire yarn fit for Ulysses.[19] Though his life depended upon theirs, he never wavered in infantiliz-

ing his troops in word and action. He walked in the darkness of his own bias, even if he had answered the call several times over to fight for justice.

While Higginson labored through his prejudice, a soldier named Henry Williams (a man much younger than Mary's father, born into slavery in Beaufort), the first sergeant of Company K under Colonel Higginson's command, led an expedition to Pocotaligo, South Carolina. On November 23, 1862, Company K traveled deep into rebel territory, raided the Heyward plantation, and freed twenty-seven people.

◆

The Union occupation of Prince William County, Virginia, was complete by 1862. On October 6, 1863, Capt. Joseph Keith Newell of the 10th Regiment of the Massachusetts Volunteers wrote that General McClellan had sent him from nearby Manassas, along with a detail, to dismantle and retrieve bricks found in Brentsville's courthouse and jail.[20] When he arrived at Brentsville, Captain Newell found that the clerk of the county, Phillip D. Lipscomb (who had once hired Ludwell Bell Nelson) had "carelessly left all the county records and papers, when he stepped out," that is, escaped the occupying Union Army, "and at this date they were in bad condition. The floors of four rooms were covered, fully two feet deep, with the papers and documents, some of great antiquity." The clerk of Prince William County had left Virginia's archive to rot: "Marriage certificates of parties whose grandchildren, if they had any, have long since joined them in the tomb, and the millions of papers that would accumulate in such a place, in two centuries of time." Newell's men dug up (and pocketed) priceless documents: military orders from the third year of the American Revolution, signed by John Jay; a certificate of membership in the Cincinnatus Society signed by "H. Knox, the secretary, and George Washington, President." Wartime Brentsville was now ungovernable and outside history.

Captain Newell ended his account with a note of derision: "When next they begin to govern Prince William County, it is thought they will have to commence their county records where the war left off, and it is hoped they will appoint a county clerk who will take better care of his papers in future."

Lost deep in those two feet of rotting papers were documents that might have answered a hundred questions that arose in the writing of this book. Were Prue and her family held at the Brentsville Jail while *Cornwell v. Weedon* progressed through the courts? Why did Powell's Run fall off the county lists in 1837—did it burn down, or was it dismantled for new development? When did Gus Cornwell, Conney's only son, die? What truly happened to John's father, Juber? Perhaps the original of Conney Cornwell's will, written by Nelson's hand, the cause of so much strife, lay there buried in that historical mulch, along with that of her husband, Jesse Cornwell.[21]

Captain Thomas Nelson's sons with Eliza Jane—ages sixteen to thirty-one when the Civil War broke out—all served in the Confederate Army. Their sixth child, Horatio Nelson, died a week after his twentieth birthday, after four years of service in the Confederate war against the North. Their eldest, Edwin Nelson, served first as deputy sheriff for the county and then was mustered as lieutenant into the 15th Virginia Cavalry. He fought in the front lines, in nearby Manassas and in Maryland.

While home on furlough, on June 21, 1863, Lieutenant Edwin Nelson was visiting his wife (and cousin), Bettie Weedon, when he was captured. He then underwent a harrowing twenty-two-month tour of Union prisons. He was initially taken to Point Lookout prison in Maryland, then was transferred to the Old Capital prison at Washington, then to the Philadelphia prison, and to the Officers prison on Johnson's Island on Lake Erie. His family greeted his survival as a miracle, given the conditions he witnessed and the contagion he escaped. Bettie Weedon was his wife for fifty years.[22]

After the war, Edwin Nelson became the clerk of Prince William County, a post he held for forty years. He built a sturdy side-passage house with a stone basement that still stands across the lawn from his workplace, the rebuilt Brentsville courthouse and jail. He performed the task of housing the county records with the fastidiousness that Captain Newell missed in his wartime predecessor. Edwin Nelson put to right the records that, had they been intact, would have allowed this story of his father's perfidy and adultery to be more easily told.

◆

The Massachusetts state census taken May 1, 1865, in Lexington, Middlesex County, records 495 families, residing in 455 dwellings. To indicate the color of Lexington's 2,215 white residents, the census-taker made no mark in column 6, "Color—White, Black, Mulatto, or Indian."[23] The Williams family appeared on page eighteen. Henry and Elizabeth Williams were both listed as forty-six, which is incorrect, with Mary, seventeen, and Adelaide Rebecca, fifteen. All four members of the family are listed with an "M" for mulatto, with Henry Williams listed as "laborer." They maintained a single-family residence.

Besides the four Williamses, also living in Lexington were a young childless couple, Josephine and James Jackson from Louisiana and North Carolina, both listed as "mulattos," and Henry Clay, a nineteen-year-old black man, who came from North Carolina in the company of a soldier he had served in the war. Fourteen-year-old Annie Lawrence, who was living as a maid at Dr. Dio Lewis's girls academy, was close in age to Mary and Rebecca. She was also of white complexion; she had been owned by her father in Virginia, and her mother was still enslaved. Annie was redeemed by abolitionists. When she died of consumption two years later, her sister Mary Lawrence took her place, and she was adopted by the Lewis family. When Dr. Dio Lewis first asked his student body to vote on whether or not these "colored girls" should be

allowed to attend his progressive private school, ten students voted no. When he asked again, a few years later, on behalf of his "colored daughter" Mary Lawrence, who was of white complexion, she was permitted to stay and study at the school.[24]

Why did Henry and Elizabeth choose to move to Lexington during the Civil War? It could be for the air. So many members of the family had been taken from them already, whether slowly by tuberculosis (which caused Oscar's death in 1860), or quickly by typhoid fever or pneumonia (which took Prue and Jesse). According to contemporary medicine, the countryside offered the possibility of recovery, and they had the means to set up a home there. Around this time, Cornhill Coffeehouse changed owners. Henry Williams lost or left his position as a waiter, and he found work in Lexington.

More inexplicable was Henry and Elizabeth's choice to leave Lexington separately. Sometime between 1865 and 1870, Elizabeth moved to Hyde Park, where she appeared on the 1870 census, with Mary, twenty-one, and Adelaide Rebecca, nineteen. They resided at 63 Summit Street, a property that Elizabeth purchased (worth $3,000 in 1870) in Hyde Park, a town south of Roxbury. The house was new construction, a two-story home of eight rooms with windows framed by shutters, set back from a quiet suburban street, with a large sloping yard at the back. Elizabeth, Mary, and Adelaide Rebecca lived there as white women, without Henry Williams.

We know Elizabeth did not remarry because she did not change her name. Both Henry and Elizabeth marked "married" on subsequent documents. They never again appeared to share an address. Henry Williams worked as a waiter in Cambridge. His common name can be found in listings for the city directory as a waiter at Memorial Hall house in 1880 and in 1887 as a waiter at the University Press. The prosaic possibility—the end of their relationship—is within the range of this scant evidence.

Without their father's presence, two sisters of marriageable age

could more easily pass into white society. Without Henry, Elizabeth was considered white, and that was how she would be known for the rest of her life. Whether or not her parents intended for her to have a white future, within the year Adelaide Rebecca had moved back across the color line when she married black coachman William Taylor in 1871. The young couple set up house in her aunt Evelina's home at 69 Joy Street, where Adelaide Rebecca helped out with the little ones, her namesake cousin, Addie, and her nephew Charles. The sisters, Evelina and Elizabeth, now lived in two camps, one on each side of the color line. When living alone these women were considered white, but when living with black husbands, they were considered black. What emotional cost did these fluctuating identities demand of a marriage?

Adelaide Rebecca Williams Taylor died at her aunt's home, two years after her marriage, of tuberculosis. She was twenty-three. She was listed on her death certificate, dated July 24, 1873, as "colored." She did not leave children.

◆

Evelina Bell Johnson chose to identify with the black community until the end of her life. The 1880 federal census-taker was unsure as to how to record her race; her entry shows another marking, "[Un? Mul?]," overlaid by "B," for black. Evelina listed her birthplace in one place as Maryland, and in another, as Washington, D.C. Her origins appear to be willfully obscured. As Robert Johnson's widow after tuberculosis took his life on December 8, 1880, Evelina remained in the house on Joy Street for the next twenty years. She attended a black church, lived in a black neighborhood, and raised her two children there. She took Bell as her maiden name, leaving off Nelson. Upon her death, at her home on Joy Street on February 1, 1901, the city registrar for deaths listed Evelina Johnson as "col," for "colored."

In Hyde Park, Elizabeth and Mary Williams became Episcopalian

and lived in a white suburban district. They took in two white orphans, Ella L. Bradley, as boarder, and Agnes Gagin, as servant, to help around the house, to assist them through illness, and to raise as their wards.

Elizabeth Williams died on March 5, 1892. Her death certificate gives her maiden name as Nelson and confirms her parents' identities as Thomas Nelson and Prudence Bell. It lists her as white. She was buried at Mount Hope, as was her husband, Henry Williams, who died on January 19, 1898. In the space for Henry's parents, the death registrar wrote "unknown."

◆

Mary Williams was the only member of her immediate family to survive into the twentieth century. She never married and did not have children. In April 1882, at thirty-three or four, she got a job as a clerk in the registry of deeds, and it paid well at $780 a year.[25] She lived near home in Mattapan when she was hired, but some time after the position began, she found an apartment closer to her work, living at 755 Tremont Street in 1888. She maintained her position there for at least twenty years, a face in the secretarial pool.

At the turn of the century, Higginson remembered seeing Mary at work. He wrote in his memoir *Part of a Man's Life,* "Another slave child, habitually passing for white, was known to the public as 'Ida May,' and was exhibited to audiences as a curiosity by Governor Andrew and others, until that injudicious practice was stopped. She, too, was under my care for a time, went to school, became a clerk in a public office, and I willingly lost sight of her," he claimed, so that she could "disappear" more easily "in the white ranks."[26]

By 1905, when Higginson wrote this comment, Mary had been considered "white" for many years, but it is unlikely that her employer knew her full history. Mary's liminal identity as a potentially black or potentially white woman remained as salient as ever in the Jim Crow

era. In her youth, in the days before Emancipation and Reconstruction, at least four well-to-do white families had tried to adopt her and effect the very transformation that white society made a crime in her adulthood.[27] White benefactors, like Higginson, who were once eager to welcome the child Mary as one of their own, now brought the danger of exposure with their greetings.

As Allyson Hobbs writes in *A Chosen Exile*, passing is a collaborative act—a collusion between family members, benefactors, and the passer, must substantiate the lie—and it exacts an emotional toll. Seth Botts's name change to Henry Williams protected Mary with the anonymity of a common name like Williams, as did the press's habit of calling her "Ida May." It is a historical truth that if Mary identified with the whiteness she was born to, she lived a legal lie, in the context of hypodescent. Much of identity is other-created, meaning that it plays into perceptions that others hold for us and keeps up appearances in society. "Passing" requires that we think of Mary as pulling one over on her fellow workers, her peers, and her potential partners. To "pass" is to suppress difference in exchange for the privileges afforded the dominant, or mainstream, identity. This book features dozens of Americans who would have identified themselves as white without hesitation, and their society (then, as now) afforded them wide latitude to make that choice and to proceed with nuanced intention. Mary's mother, uncle, and sister moved back and forth across the color line as their hearts bade them, through marriage. What of women who did not marry?

Home was a rented apartment at 106 Chestnut Street—a few blocks down Beacon Hill from where her family first landed in Boston, blocks from the State House where she had been exhibited, blocks from what had been her aunt Evelina's house, and around the corner from what today would be the bar in *Cheers*. The steep steps at 106 Chestnut Street are beautifully adorned with flowers, now a townhouse in a tony district.

At Chestnut Street, Mary Williams lived with Mary Maynard, an

Irish-American woman who worked for the government as an assistant probation officer at the Boston Municipal Court. Their immediate neighbors were a bohemian mix of editors, artists, a stockbroker, and a masseuse, many of whom, like Maynard, were the first generation of their families in the United States. Every weekday Mary and Mary walked the few blocks along the Boston Common to their work near the State House. In 1908 Mary Maynard was among the Boston probation officers commended by the *Chicago Tribune* for their humane treatment of female prisoners.[28]

The 1900 census listed Mary Mildred Williams, fifty-one, as white and the head of the household.[29] The census-taker recorded Mary Maynard, forty-five, as her "female partner," not as her "boarder." Today that designation "partner" is used for couples. The 1900 census was the first year "partner" could be used, with the following instructions: "If two or more persons share a common abode as partners, write 'head' for one and 'partner' for the other or others." Fin-de-siècle Beacon Hill was home to a gay society, and theirs may have been a "Boston Marriage."

By the turn of the century, Mary's unsought fame was dispelled. Her stage name's novel, *Ida May*, was out of print. Her once large and cherished family was reduced to only her niece, Addy, and nephew, Charles. In middle age, her income and housing secure, Mary Mildred Williams was free to choose, and she chose independence.

EPILOGUE

◆

I keep a stash of old photographs that my mother and I collected at flea markets for about a quarter apiece. (One lucky person once found a daguerreotype of Frederick Douglass this way, in a shoebox of abolitionist memorabilia for sale for cheap at a gun show in Dayton, Ohio. They sold it to the Chicago Institute of Art for $185,000.) I brought a handful of tintypes and studio portraits to class at the Bard Early College where I teach in New Orleans, to use as props for a set of writing exercises to illustrate how slippery historical narrative can be: *Write what you think you know about this photograph. Write what you can plausibly say about this photograph.* I would ask students to trade narratives and to pass off the new story as history in a short presentation. All the stories were fictional, of course. I did not know even the most basic information about any of the people in my old photograph collection, so the students' stories might as well speak in response to the photographic silence.

One day before we started, a student, Victoria Suazo, stopped us, saying she did not like old pictures because of the way the eyes haunt you from beyond. Other students nodded their agreement. It is often said of New Orleans that the dead are kept close. Maybe because we bury our dead aboveground, we easily and often access the spiritual realm in conversation. There is no shame here in conforming to superstition. Suazo asked us to reconsider: How do we know the stories we were making up on the spot weren't the stories that they wanted us to tell, whispered into our intuitions from beyond? Or what if these photographed dead would haunt us once we spoke the wrong story about their lives?

All narrative summons characters out of thin air. Photography compels narrative. Since these characters were once human and deserving of dignity, if they were summoned, they deserved to have their stories told accurately. What is the danger of writing fiction in the absence of facts? What of these subjects' privacy? Since the class did not have the time or the leads to research the images, we shelved the exercise.

◆

I made a pilgrimage to Prudence Bell's grave. It is in the Mount Pleasant Cemetery in Rockland, tucked away in a working-class neighborhood, about an hour and a half south of Boston. The older parts of the cemetery were haphazard and disordered, not in the customary rows. The graves stretched to woods that bordered on two sides, and across the road to a gated section on what appeared to be private land, bordered by Trump signs. There was no map or caretaker to consult.

Here is what I could decipher from the faded inscription on her headstone:

Prudence Bell

died

November 29, 1864
Aged 73 years

Dear Mother they have laid thee to rest
[At? In?] life's trials [boldly? sadly?] passed
The preparation of the blest
Shall [purpose . . .] [sustain] at last

The grass and soil have worn away the inscription from the bottom up, making it difficult to read. Prue's grave does not record a born day, since she may not have known it. Her children's graves do.

Jesse Nelson has the first tombstone on the row, as he was the first in death. Both headstones show a carving of an acorn, a symbol of humble beginnings and rebirth. Someone in the past applied concrete to secure the tombstone, to keep it from falling over. Now the last two lines of Jesse's inscription are partially covered by concrete.

The Mount Pleasant gravesite of Prudence Bell and family.

Jesse Nelson

Born in Dumfries, VA

b. February 18, 1828

Died at East Abington

of typhoid fever after an

illness of nine days.

Mar. 24, 1857;

aged 29 years and 1 mo

———————

"I asked Jesus for help"

We sadly lay our brother to rest

In manhood's early d[—]

Our earthly friend [———

———] pray are you[1]

Between Prue and her son Jesse Nelson in the family row, there is a small headstone, a miniature in the same style, for Prue's grandson, William Ludwell Nelson. Ludwell and Isabella had had a son who died at eight weeks on June 27, 1864. The second half of 1864 was a hard year for this family. They buried William, a cherished baby boy for a grandmother who had also lost Oscar. Five months later Prue followed, her rebuilt family undone by disease. Mary witnessed these deaths when she was seventeen. Her mother and her aunt Evelina oversaw their burials. Unfathomable was the heartbreak of losing the fellowship of family so hard won.

For Ludwell, these losses—brother, nephew, son, mother—would have compounded his grief. According to the oral history by Evelina's daughter Adelaide Johnson Trusty, which I mentioned in the previous chapter, Ludwell resettled in white society in New Jersey and became a doctor. But at Mount Pleasant Cemetery, I tripped over a fallen headstone that was partially obscured beneath a mound of turf and an anthill, a few steps removed from Prudence. It read:

Ludwell B. Nelson
Died
May 26, 1866
aged 33 years and 10 mos

No further inscription is visible.

◆

Six days after I finished the manuscript for this book and submitted it to my editor, Mary Mildred Williams's death certificate arrived in the mail. Mary Williams is a common name, and I had been disappointed many times before, but this document proved to be the correct one.[2] The death certificate provided several key pieces of information: She lived the last ten years of her life in New York, and her burial took place in Boston at Forest Hills in June 1921. Like Prue, she was seventy-three when she died. Mary M. Williams was recorded, at her death, to be white.

According to the front desk clerks at Forest Hills cemetery, Mary purchased a plot in 1894, plot 4330, when she was only forty-six. She disinterred and moved her mother's remains there, two years after Elizabeth had been laid to rest, and also her brother Oscar, dead thirty years. This new cemetery was integrated, so mother and son could be buried together.

A third body was laid to rest there, too, in 1918: Ella L. Bradley. According to the 1880 census, Ella was twenty when she came to live with Elizabeth and Mary as their boarder, forming a bond between the young women that apparently lasted until death.

When her time came, Mary would be laid to rest together with them. At her death, Mary's body was shipped from New York to Boston, at an expense great enough to signify intent. She wanted her family to rest together, and she chose a cemetery that felt like a city park, near

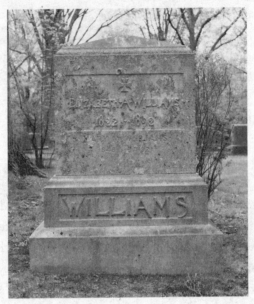

The Forest Hills gravesite of Mary M. Williams, Elizabeth Williams, Oscar Williams, and Ella L. Bradley.

the Hyde Park neighborhood where her mother had spent the end of her life. The plot Mary chose was set back from the path and placed her among upper-middle-class families.

Mary wanted her mother to be remembered there. In this history about a person who left no words, the archive offered this last utterance.

◆

At the end of her life, Mary had a diagnosis of chronic nephritis, a kidney disease. She lived her last years at St. Luke's Home for Aged Women, a seven-story building facing the Cathedral of St. John the Divine, which was built concurrently with its neighbor, Columbia University, at the corner of Broadway and West 114th Street. (The university eventually subsumed the building.) Founded downtown as St. Luke's Home for Indigent Christian Females in 1852 by the Episcopa-

lian diocese of New York City, St. Luke's cared for "the elderly gentle-women in the Church who had no other care."

In Mary's time, the home had eighty-seven residents age sixty or above, many of whom did not pay board. There were private rooms, a library and a chapel, a solarium on the roof, craft and music classes, a choir, and full-time care for the bedridden occupants of the sixth floor. To qualify for entrance, Mary would have had to be a communicant in a parish in the Diocese and City of New York for three to five years prior to entry. Her death certificate indicates she resided in New York for approximately ten years, so most likely Mary moved to Manhattan in 1911 at sixty-three, then a couple years later entered into St. Luke's through her parish, where she lived until her death. Unfortunately, St. Luke's yearbooks for 1912 to 1920 appear to have been lost.

◆

The headstone is nearly six feet tall, with "ELIZABETH A. WILLIAMS 1822–1892" carved across the top portion in relief, and at the bottom, the family name Williams, in a gorgeous font reminiscent of wood. There is an Anglican cross above Elizabeth's name. Below her mother's dates, "MARY M. WILLIAMS 1847–1921" appears in a simple sans-serif font, added in the twentieth century.

The reverse side, partially hidden by a flowering bush, reads:

OSCAR

BELOVED SON OF HENRY & ELIZABETH A. WILLIAMS

1845–1860

There is a space below Oscar's inscription, followed by a fourth commemoration near the base:

ELLA L. BRADLEY

DIED NOVEMBER 11, 1918

The same cemetery holds the remains of William Cooper Nell and William Lloyd Garrison and now, Mary Mildred Williams, recovered to America's historical narrative. But as an unknowable research subject, she offers up more questions. Was anyone there, at the gravesite, when Mary was interred? What was the relationship between Mary and Ella Bradley? Did Ella have descendants? What became of Henry Williams, and why was he not moved here too? Justice requires that we recover more unrecorded stories, lives, and experiences like those in this book; each one is potentially precious and meaningful to conversations today.

Monuments such as this one should remind us of the sustaining power of family, of the strength of mothers and grandmothers, and of the bravery of those who choose to be fathers. Mary's story suggests to us a new kind of monument to the past, inclusive of all children, who like Oscar may leave behind only a single sentence of redemption: *I now belong to myself.*

Datebooks, notes, and newspaper articles help us take the measure of men like Charles Sumner and John Andrew and Henry David Thoreau. But Mary Williams lived a private life, marked not by words but by gestures of the family loyalty that she learned from her grandmother Prue. May Mary Mildred Williams's monument be a testament to the abiding value of this experience and what it can teach us about what it means to be human.

Mary's silence remains, even now, a cipher of nuance and depth. Hers is the silence of the private woman, the silence of old photographs, the silence of the beloved, the silence of the caregiver, the silence of the oppressed, the silence of those who find a way through oppression, and the silence wrapped in the archive, ready to be given the honor of a hearing.

ACKNOWLEDGMENTS

—————————◆—————————

While I was writing my dissertation on the literature of abolition and the new technology of photography, the National Endowment for the Humanities was funding a wide-scale digitization of archival documents of nearly every kind in hundreds of archives. Software known as OCR, or optical character recognition, made it possible for reams of newspapers and other documents to become text-searchable. I gained access to one of these databases, American Historical Newspapers, and typed in "daguerreotype" and "slavery."

Thus did I first learn of Mary in 2006, in much the same way the reading public of 1855 learned of her, that is, by reading Sumner's February 19th letter reprinted in the *Boston Telegraph*, which contained these key words, and conjuring in my imagination the little girl he described. That letter was full of leads: Who was "Ida May"? What speech would Sumner have made in 1855? Who was Dr. Stone? Where was the daguerreotype he mentioned, and why was it so compelling? And the question at the heart of it all: who was Mary?

The day I found the letter, I wrote in my notes, *I wonder if the daguerreotype is still extant, and if so, if I could see it.* I did not see it until

two years later. I was a graduate fellow at the Humanities Initiative at New York University, and every so often the university press would drop off its new titles at our scholars lounge. Late one afternoon I was alone in the office when I flipped through Mary Niall Mitchell's *Raising Freedom's Child: Black Children and Visions of the Future After Slavery*, and on page 73, I saw a face that felt instantly familiar. The caption read: "Unidentified girl (probably Mary Botts), daguerreotype, Julian Vannerson, Ca. 1855. Photo I.256 Massachusetts Historical Society." Mitchell's footnote mentioned the same February 19 letter I had already found in the newspaper. It was a dead end, but not a disappointment: the daguerreotype had been found, so it stood to reason that more of her story might also be recovered. I was awarded three substantial grants: from the National Endowment for the Humanities at the American Antiquarian Society, from the Suzy Newhouse Center at Wellesley College, and from the Humanities Research Start-Up Fund at Nanyang Technological University in Singapore (where I taught from 2009 to 2012), allowing me to dedicate significant time to archival research.

If the actor left a written record, I read it. Reading biographies, I learned that Higginson and Sumner's early editors considered Mary's family and their manumission to be a small footnote in these men's life stories. Frederick Douglass, Thomas Wentworth Higginson, and Charles Sumner were exceptionally prolific, so I spent many of these early days of my research reading their words at Houghton Library, Harvard, the Library of Congress, the Massachusetts Historical Society, the American Antiquarian Society, the New-York Historical Society, the Gilder Lehrman Collection, the Morgan Library, and in printed material.

The novel *Ida May* was not in print when I began this project, but it was digitized in 2006 by the Antislavery Literature Project. It made clear the reason Sumner chose this novel, but little was known about its author, beyond her birthplace, Calais, Maine, and her husband, Frederick Pike. I learned about Mary Hayden Green Pike's life from a thesis

written by a master's student at the University of Maine in 1944, which I requested be copied and sent to me. (It has since been placed online.) I purchased a first edition of *Ida May* online for a negligible sum.

Using my grant from the NEH and the American Antiquarian Society, I was able to read all the newspaper reviews of that novel from November 1854 to January 1855 to see how audiences responded to the original *Ida May*, before they met Mary as "Little Ida May." I found so much out about *Ida May* that I brought out a new edition of the novel with Broadview Press. A selection of these reviews can be found in the appendix of that book. I prefer the American Antiquarian Society for this kind of research, because it holds extensive newspaper holdings and because it extends the access for researchers working online in its Readex databases to the hostel next door. I could spend my nights reading newspapers from 1855 while eating chocolate and popcorn. (Thank you AAS!) During March 1855, many reviews of "Ida May" became about Mary, so this search offered material about both the fictional *Ida May* and Mary, or "Little Ida May."

None of this research yielded any information about the family's time in bondage. For that I turned to a generous community of genealogists and their tools: census records, birth, death, and marriage certificates, wills, land deeds, tax payments, gravesites, and military records. The Cornwell family has a listserv on Rootsweb.com, a community hosted by Ancestry.com, where several researchers, led by Cindy McCatchern and her father Ron Cornwell, posted transcripts of documents they had located about Jesse and Constance Cornwell. I corresponded with Cindy, and she shared with me what they had found so far. Their story stopped with the Virginia Supreme Court finding in John Cornell's favor. Ron Cornwell wrote of Prue and her children, "We have no record, at this time, of what actually became of them." (Dear Cindy, enjoy, with my gratitude!) Henry and Elizabeth Williams had no grandchildren, and my subject Mary had no descendants. The widow of Evelina's grandson, Mrs. Arlette Johnson,

corresponded with me to share what she had heard about the painting of Prue made by Edward Mitchell Bannister. I thank the Museum of African American History in Boston for granting me access to this striking painting.

Though the years Caty and Kitty Cornwell spent in court left their family in tatters, their litigiousness brought Prue's family into the historical record. John's suit against J. C. Weedon in 1847 brought all of the Cornwells' earlier cases, wills, and arbitration agreements into the files held by the Fredericksburg Circuit Court. Although it took the better part of a year to read and organize the information in these Xeroxed handwritten documents, the depositions made in those cases offered a remarkably detailed picture of their lives, a fortuitous coincidence given their position in the history of Prince William County as illiterate women without means, their illegitimate mixed-race son, and their female slaves. Late in my research, the website "O Say Can You See," launched to share Washington, D.C., cases of interest, brought me Jesse Nelson's suit against John Cornwell, which told the story of his stay at the Yellow House.

◆

While in Singapore, I taught a class on antislavery and archival research that was entirely based on digital archives. I shared my own archive project with the twelve advanced students who took that class and they still offer me sustaining suggestions and their enthusiasm.

I am now the happy dean of several graduating classes of brilliant students at Bard Early College, who have taught me a tremendous amount about identity, justice, beauty, and liberation. My colleagues at BECNO know how many trials were borne in the writing of this book, and I appreciate their patience with me as I learned things the hard way. Thanks also to my colleagues at the Institute for Writing and Thinking at Bard College for their generative practices—not just for teachers!

And I wish to thank Donna Uzelac, for reminding me to make this book a reality while holding down a heart-demanding job.

When it came time to find an agent, I took a chance and shot for the stars. Thank you Jay Mandel for catching this project, and Sam Anderson for introducing us. At Norton, my gratitude also goes out to Mary's champion, Jill Bialosky; my patient teacher, Drew Weitman; my careful copyeditor, Janet Biehl; and the book's designers.

I wish to name the several groups of readers who shepherded this project into its present form.

Mary was a child of mixed race, whose family ought to have a place in American history, and whose childhood was marked by race in ways that I, as a woman raised white, cannot fully, viscerally understand. For this, I was particularly thankful for opportunities to share research with scholars of color, who gave open-handed feedback on this project. It is crucial to recognize where your knowledge simply cannot extend, and where the only remedy will be found in other people. I wish to thank my team of "beta readers," especially Lenora Warren, Nikki Greene, Aundrea Gregg, and Denise Frazier, for your generosity in the work of communicating across difference at the beginning and end of the project.

This book began as so many do, as a small part of one chapter in a dissertation, and for recognizing that germ of an idea as the center of another book, I wish to thank my nurturing and kind advisors: Nancy Ruttenberg, Virginia Jackson, Bryan Waterman, Liz McHenry, and Ulrich Baer. My close-knit graduate student cohort at NYU produced several social justice activists, writers, artists, and professors, and I am fiercely proud to stand in our circle of cronies. The C19 community, the Newhouse Center at Wellesley College, and the American Antiquarian Society hosted invaluable lunchtime conversations centered on Mary, a child they had never heard of, and that I hope they will never forget.

When I moved back to New Orleans, I took up writing outside academia again, a habit I had left when I left in 2000. I am deeply grateful

to my new and old friends who recalled me to my style and broadened my idea of an audience. May every writer be reborn into a writing group like No Name.

Somehow, I won the lifelong friendship (and reading notes) of two extraordinary thinkers, Maeve Adams and Raphaëlle Guidée, who continue to startle me with their insight and empathy. (My thanks, too, for their equally brilliant partners.)

My family will be reading this book for the first time in print. So first of all, I thank you for your patience!

My father Rick Morgan and stepmother Kathy Morgan have been proud and vocal supporters of my return to history. They, too, have been making forays into history, digging through archives in Louisiana and Nova Scotia to learn what they can about our long past in this place. I appreciate their clear-eyed searches.

In reparation for our ancestors' part in Louisiana's history of exploitation, known and unknown, I plan to donate 25 percent of the proceeds of this book, and any future earnings from the telling of Mary's story, to organizations that serve communities of color, and those that work toward liberation in our present moment.

I wish to thank Missy Cotita, my mother, for reminding me over and over again that this was a story about family. (Mom, I hope you find this story as compelling as I have. I wrote much of it in your cabin!) I name my own grandmother Ruth Liuzza as my inspiration for Prue, for her grace under pressure or change. My sister Katie Shipley, my brother Andy Morgan and sister-in-law Quinn St. Amand, and my stepfather Tim Cotita all show their support through curiosity; they empower me with their words, laughter, and good food for the good fight.

None of this work would have been possible without the willingness of my partner in life and art, James Owens, to go further and to keep looking for a better world. Our son was not yet born when the book began, and somehow, he is now almost seven—Mary's age when she entered the limelight. Please forgive the times when you had to

share me with the past, Nathaniel, and know always that my world revolves in love around you.

◆

I hope the publication of this book calls forth new material; if it does, please find me online at www.morgan-owens.com or @marymildredwilliams. I will be posting artifacts and new information as it comes to light.

NOTES

PROLOGUE: BOSTON, MAY 29, 1855

1. Charles Sumner, "The Anti-slavery Enterprise: Its Necessity, Practicability, and Dignity, With Glimpses of the Special Duties of the North," delivered March 29 and 30, 1855, Manuscript Collection, New-York Historical Society. See the digital version at https://www.nyhistory.org/slaverycollections/collections/sumner/index.html.
2. *Boston slave riot, and trial of Anthony Burns* . . . (Boston: Fetridge & Co., 1854), at Library of Congress, https://www.loc.gov/item/04033077/. For more on Burns, see Virginia Hamilton, *Anthony Burns* (New York: Knopf, 1988), and Albert J. von Frank, *The Trials of Anthony Burns* (Cambridge, Mass.: Harvard University Press, 1998).
3. Sumner to Stone, February 19, 1855, as published in the *Boston Telegraph*, February 27, 1855.
4. In 1855 the newspapers that reprinted Sumner's letter could not reproduce Mary's daguerreotype alongside it, since that technology would not be invented for another thirty years. *Frank Leslie's Illustrated Newspaper,* which appeared in 1855, offered photorealistic engravings based on photographs. In 1880 the *New York Daily Graphic* was the first newspaper to print photographs as halftones. By 1897 high-quality halftones had replaced engravings in most papers.
5. Historian Mary Niall Mitchell, who found Mary's daguerreotype in the MHS archives, underlined this point in her report: "Before I identified Mary's portrait, it had been in the collections of the MHS since the 1920s, and in the Andrew family's possession

since 1855." Mary Niall Mitchell, "The Real Ida May: A Fugitive Tale in the Archives," *Massachusetts Historical Review* 15 (2013): 59.

6. Sumner, "The Anti-slavery Enterprise."
7. "Redeemed Slaves in the House," *Worcester Daily Spy*, March 12, 1855.

1. CONSTANCE CORNWELL, PRINCE WILLIAM COUNTY, VIRGINIA, 1805

1. *Kitty Cornwell v. Thomas Nelson*, 1844, deposition of John Webster.
2. Material about the Cornwell family can be located at the Ruth E. Lloyd Information Center (hereafter RELIC) at the Prince William County Library. A local historian, Ron Turner, transcribed many of these documents and published them at http://www.pwcvirginia.com/pwcvabookspublishedworks.htm. Cornwell family genealogists, foremost Cindy McCatchern, have transcribed and posted material on the Cornwell family message board and listserv, CORNWELL-L, hosted by RootsWeb.com and Ancestry.com.
3. Jesse Cornwell, Last Will and Testament, December 25, 1804, admitted to the Court of Chancery of Prince William County, Virginia, August 1813.
4. *Grand Jury v. Lidia Cornwell*, February 26, 1760, Prince William County Order Book 1759–61, p. 45. Thanks to Ron Cornwell for this source.
5. From Balls Ford, Sudley Road crosses under I-66 and enters the Manassas National Battlefield Park.
6. Advertisement in *Republican Journal* at RELIC; ordinary license found by Cindy McCatchern and Ron Cornwell.
7. Her sister-in-law noted, "Constance Cornwell, with the aid of her children and slaves, paid the debts of Jesse Cornwell." *Cornwell v. Nelson*, 1844, deposition of Jesse Brockley.
8. It was due annually to the landlords Robert and Mary Hedges, Deed dated April 13, 1789, RELIC. These hundred acres of tobacco farmland were located along the Felkins Branch of Cedar Run, near what would become Brentsville. For more information on the rights of widowed women and *feme sole*, see Julie Richter, "Women in Colonial Virginia," in *Encyclopedia Virginia* (Virginia Foundation for the Humanities, 2013).
9. Antimiscegenation laws, on the books until *Loving v. Virginia* in 1967, enforced racial segregation by making relationships between races a felony. In the context of white supremacy, a lynch mob often enforced this offense extralegally. For more context on such relationships, see Martha Hodes, *White Women, Black Men* (New Haven, CT: Yale University Press, 1997).
10. Children of all interracial unions were considered illegitimate in Virginia until 1885.
11. This neighbor, Samuel Jackson, may have been Prudence's father.
12. The deed for this property shows John and Sarah Lynn as the prior owners.
13. Ten years later Juba might have been freed. Cornwell family genealogist Elaine Crockett contends that Juba (also listed as Juber) was sold to the overseer Jonathan Leathers, who worked for a prosperous landowner, Francis Taylor. Taylor or Leathers subsequently sold Juba to Benjamin Berry, Taylor's elderly relative. Juba was with Berry

when Berry died at ninety-six in Henderson County, Kentucky, in 1820. According to the 1820 Henderson County deed book, the heirs of Benjamin Berry, in the division of their father's property, "agreed among ourselves that Negroe Juber as he had been a faithful servant . . . be free." See "[CORNWELL] Slave Jubar, Father of John Cornwell, Mulatto," posted August 10, 2010, http://boards.rootsweb.com/surnames .cornwell/3026/mb.ashx.

14. Eli also purchased this land from the Lynn family. Eli, who had served as a witness to the deed for Conney's purchase of her place at Powell's Run, may have brokered both deals.

15. *Cornwell v. Nelson*, 1844, deposition of Dumfries constable John Tansill.

16. *Cornwell v. Nelson*, 1844, deposition of William King. William King was not on Caty's side in the ongoing property suits between Caty and her sisters, so this information may not be reliable. Eli Petty's release does not appear in archived documents.

17. Personal property taxes, 1830–39. William King is not listed with his family after 1833, i.e., "Kitty Cornwell and son J.W. King; 2 wm + 6 + 2h."

18. Evelina Bell Johnson, oral history, in Adelaide M. Cromwell, *The Other Brahmins: Boston's Black Upper Class, 1750–1950* (Fayetteville: University of Arkansas Press, 1994), pp. 221–24. I have not found any other records of James Bell.

19. *Cornwell v. Nelson*, 1844, deposition of Catherine Appleby.

20. The estate sale was called by auctioneer Francis Wood. The coffin was made by Benjamin Cole.

21. The appraisers were the constable John Tansill, the auctioneer Francis Wood, and a neighbor, James Arnold.

22. Henry Bibb, *Life and Adventures* (New York: Published by the Author, 1850), pp. 101–2.

23. In August 1848, the clerk of court John Williams was called upon to certify that this catalog was a true transcript of the original held in the records of the County Court of Prince William. While in possession of this document, perhaps it was John Williams who transcribed its contents, then inscribed a hash-mark at Prudence's entry, to highlight her as different from the other listed items. He may have intended to distinguish the property in question in the lawsuit, *Weedon v. Cornwell*, brought by John Cornwell twenty years later. Someone has studied these documents for mention of Prue before me. This person entered the archive of the Circuit Court of Fredericksburg, Virginia, with a pencil. Roguishly, he or she drew a wavering line alongside a handful of court documents that all happen to account for Prue. There were other enslaved men and women on the place, left unnoticed. It is always the same sort of line; if annotations can have "handwriting," they would be in the same hand. This person left no words or other marginalia by which I compare it. Maybe it was Clerk John Williams in 1848, but otherwise I have no idea who this mysterious researcher might have been.

24. *Cornwell v. Nelson*, 1844, deposition of Jesse Brockley (Nancy's son).

25. Once cleared of furniture and Constance Cornwell's personal effects, the farm was rented for $20 for two years to a local farmer, Thomas Gooding. Then Caty rented Powell's Run for three years, from 1831 to 1833, paying Nelson $30 for the right to work her mother's land. She purchased the land outright on June 1, 1833, for $100,

which Nelson carefully recorded for the estate. In 1810 the purchase price for Powell's Run was $250—the value of a carriage and pair—and now, twenty years later, it was worth 60 percent less, adjusted for inflation. The house at Powell's Run fell off her property tax lists in 1837, either sold or absorbed into Caty's farm. By 1840 the little town of Dumfries, where they lived, had fallen into decay. Many of its people had moved when Brentsville became the county seat in 1822. Quantico Creek had silted in, due to extensive tobacco farming, and Dumfries, without a navigable port, became difficult to get to.

26. *Cornwell v. Nelson,* 1844, deposition of John Webster.

27. *Cornwell v. Nelson* 1844, deposition of John Tansill.

28. *Cornwell v. Nelson,* 1844, deposition of John Tansill.

29. Much of this story of Conney and her daughters can be found in the 180 pages of handwritten depositions and documents held in the Circuit Court of Fredericksburg, Virginia.

30. *Kitty Cornwell v. John Appleby and Caty Petty,* May 17, 1825.

31. *Kitty Cornwell v. John Appleby and Caty Petty,* May 17, 1825, bill of sale for Betsey.

32. *Cornwell v. Nelson,* June 7, 1844.

33. *Cornwell v. Nelson,* June 7, 1844.

34. *Cornwell v. Nelson,* June 7, 1844, deposition of Isaac Davis, Brentsville resident. Davis stated, "I told her I understand that Frank had gone with a gang of Negros of Major [word illegible] and Mr. Grimsby, by way of Grahams in Prince William." Kitty was not forthcoming. And according to multiple accounts, she never did disclose what happened to Frank. The depositions around his sudden departure are inconclusive. Davis told the court that "this was the substance of the conversation we had about Frank, tho' more words were used by her, but I've stated the Substance of all that was spoken about him and the conversation was turned by her talking about a slave called Bet of the same estate."

2. PRUDENCE NELSON BELL, NELSON'S PLANTATION AND MILL, 1826

1. During this time Betsey and her daughters became the property in question in a lawsuit between Kitty and Caty, so they were also required by law to live with the administrator of the estate, Thomas Nelson, until the suit was settled. This legal maneuver brought Mahala back to her mother, Betsey, after years of separation—she had been working at Kitty's house—though that peace would be short-lived. The constable, John Tansill, brought Captain Nelson under indictment "for suffering Betsey to run at large," that is, to live independently with her family. Nelson was compelled to "hire" them back to Caty to quash the indictment. The fact that Betsey lived alone could indicate Prue's living arrangements as well. *Cornwell v. Nelson,* 1844, deposition of John Tansill.

2. For a comprehensive view of the legal codes governing free blacks in Virginia, see John Henderson Russell, *The Free Negro in Virginia, 1619–1865* (Baltimore: Johns Hopkins University Press, 1913). For North Carolina, see "Slaves and Free Persons of Color. An

Act Concerning Slaves and Free Persons of Color," *Documenting the American South*, 1826 c21 s1, http://docsouth.unc.edu/nc/slavesfree/slavesfree.html. For Maryland, see "Passed 3d of Jan. 1807. No free negro shall emigrate to this state, &c.," *Session Laws of 1806*, vol. 608, p. 234, msa.maryland.gov. These laws had the additional effect of curtailing runaways holding forged free papers.

3. *Kitty Cornwell v. John Catesby Weedon,* deposition of Kitty King, Alexandria, Va., May 14, 1849.

4. *Cornwell v. Weedon,* deposition of Kitty King.

5. This word *mulatto/a* is offensive and not an appropriate term for persons of mixed race. I will use it in this book only when it appears in quotations. Unfortunately, the word was used liberally by my white sources.

6. *Cornwell v. Weedon*, deposition of Catherine Appleby, July 18–19, 1848.

7. The Beverley/Chapman's Mill is now a historic site undergoing preservation efforts: www.chapmansmill.org.

8. *Kitty Cornwell v. Thomas Nelson*, 1844, affidavit of Seymour H. Storke, submittted October 11, 1839.

9. Walter Johnson, "The Slave Trader, the White Slave, and the Politics of Racial Determination in the 1850s," *Journal of American History* 87, no. 1 (2000). See also Edward E. Baptist, *The Half Has Never Been Told: Slavery and the Making of American Capitalism* (New York: Basic Books, 2014), p 240.

10. *Kitty Cornwell v. Thomas Nelson*, 1844, affidavit of John Cooper, submitted November 1839.

11. *Cornwell v. Nelson*, 1844, deposition of John Tansill.

12. Adelaide Payne is listed on *United States Census of 1850* as a "mulatto" woman of thirty years of age, born in Virginia, living in the wealthy DeKrafft household. She could not read.

3. JESSE AND ALBERT NELSON, WASHINGTON, 1847

1. *Jesse Nelson v. John Cornwell*, deposition of Catherine Appleby, March 18, 1854, in *O Say Can You See: Early Washington, D.C., Law & Family*, http://earlywashingtondc.org/doc/oscys.case.0267.008#.

2. Louis Berger Group, *Archaeology of the Bruin Slave Jail (Site 44AX0172)*, prepared for Columbia Equity Trust, Inc., https://bit.ly/2Npu3hu. See also the Virginia Foundation for the Humanities, African American Historic Sites Database at: http://www.aahistoricsitesva.org/items/show/67.

3. Mary Kay Ricks, *Escape on the "Pearl": The Heroic Bid for Freedom on the Underground Railroad* (New York: HarperPerennial, 2008), pp. 127–30.

4. "Williams' Private Jail (Slave Pen)," Histories of the National Mall, Library of Congress http://mallhistory.org/items/show/45; and Theresa L. Kraus, "Was FAA HQ the Site of a Notorious Slave Pen?" https://www.faa.gov/about/history/milestones.

5. As one foreign observer noted in 1853: "Mrs. J wished to have a negro boy as a servant, and inquired if she could have such a one from this place. 'No! Children were

not allowed to go out from here. They were kept here for a short time to fatten, and after that were sent to the slave market down South, to be sold.'" Frederika Bremer, *The Homes of the New World: Impressions of America*, trans. Mary Howitt (New York: Harper & Bros., 1853), p. 1:492.

6. Solomon Northup, *Twelve Years a Slave* (Auburn, N.Y.: Derby & Miller, 1853), pp. 38–43.

7. I have found counterevidence scattered through the Prince William County register that John returned to Prince William County in the early 1840s. For example, from 1844: "John Cornwell, free negro, hired out for delinquent taxes, 1843." Free blacks in Virginia paid taxes on income and a $1.50 poll tax, though they could not vote. If he was forced to labor in Prince William County, he could not also have maintained a position in Georgetown from 1840 to 1847. Possibly he made the mistake of returning to Prince William County in 1843 and found himself locked up in Brentsville and forced to labor. He might have served his time and returned to his position and family in Georgetown.

8. Billy King remembers, "He left the state of Virginia in the year 1828. I did not know where he went to and did not hear of him until the year 1841 when my family was at the house of John Cornwell in George Town."

9. *Cornwell v. Weedon*, Judge Neale to Judge Scott, amended suit, September 5, 1849.

10. *Cornwell v. Weedon*, John C. Weedon's demurrer to the bill of complaint brought against him by John Cornwell, October 18, 1848.

11. Given that her family thought that she was seventy-three when she died in 1864, I have used that date throughout to determine Prue's age, including my estimate that she was eighteen (and not ten or twelve) when Constance purchased her.

12. *Cornwell v. Weedon*, depositions taken at Brentsville for J. C. Weedon's defense, October 5 and 6, 1848.

13. *Cornwell v. Weedon,* deposition of Kitty King, taken at the office of Christopher Neale, Alexandria, Va., September 14, 1849.

4. HENRY WILLIAMS, BOSTON, 1850

1. Mary Niall Mitchell used the U.S. census slave schedules to locate Seth's father. She believes he was a man named James Tolson, who in 1840 held "18 enslaved people in his household, eight of them under the age of ten, and only six of the total employed in agriculture." By 1850, perhaps with Seth's departure, the number was reduced to seventeen enslaved people. In 1860 the name appears in the census records as Folson, of "Stafford Store, Stafford County, Va." In 1860 Folson hired out slaves to Prince William County, an arrangement that may have afforded Elizabeth and Seth the chance to meet. Examining Andrew's handwriting in his letter to Charles Sumner of January 22, 1855, concerning Seth's manumission, it remains inconclusive if this man was named Tolson or Folson. See Mitchell, "The Real Ida May: A Fugitive Tale in the Archives," *Massachusetts Historical Review* 15 (2013): 61.

2. Folson is quoted in Andrew to Sumner, January 13, 1852, letter accompanying Seth

Botts's deed of emancipation, John A. Andrew Papers, Massachusetts Historical Society.

3. Eric Foner, *Gateway to Freedom: The Hidden History of the Underground Railroad* (New York: Norton, 2015). William Still, *The Underground Railroad* (Philadelphia: Porter & Coates, 1872), is the most faithful account of its activities through Philadelphia.

4. As reported in the *Liberator*.

5. The historical geography of the North Slope and Beacon Hill was identified in support of the Museum of African American History on Joy Street. See Kathryn Grover and Janine V. da Silva, *The Historic Resource Study: Boston African American National Historic Site*, December 31, 2002, https://www.nps.gov/subjects/ugrr/discover_history/upload/BOAFSRS.pdf.

6. Congregation of Belknap Street Church, manifesto, October 25, 1850, as reported in *Liberator*, November 1, 1850.

7. Fugitive Slave Act, at Avalon Project, Yale Law School, avalon.law.yale.edu/19th_century/fugitive.asp.

8. Gary L. Collison, *Shadrach Minkins: From Fugitive Slave to Citizen* (Cambridge, Mass.: Harvard University Press, 1997).

9. Quoted in Higginson, *Cheerful Yesterdays*, p. 136.

10. The nearby Boston Athenaeum has in its archives twenty years of Cornhill Coffeehouse menus.

11. For Thoreau's role in the Vigilance Committee and his services to fugitives sent to Concord, see Sandra Harbert Petrulionis, *To Set This World Right: The Antislavery Movement in Thoreau's Concord* (Ithaca, N.Y.: Cornell University Press, 2006), pp. 92–93. There is also a self-published one-act play about this encounter: *Minot's Cat and the Fugitive Slave* by Dan Sklar.

12. John A. Andrew to Charles Sumner, January 22, 1852, Charles Sumner Papers, Houghton Library, Harvard University.

13. Henry David Thoreau, entry for October 1, 1851, in *The Writings: Journal*, vol. 3, *September 16, 1851–April 30, 1852*, ed. Bradford Torrey (Boston: Houghton Mifflin, 1906), p. 38.

5. JOHN ALBION ANDREW, BOSTON, 1852

1. Henry Greenleaf Pearson, *The Life of John A. Andrew: Governor of Massachusetts*, 2 vols. (Boston: Houghton Mifflin, 1904). Andrew makes a charming appearance in Edward Waldo Emerson, *The Early Years of the Saturday Club, 1855–1870* (Boston: Houghton Mifflin, 1918).

2. Cyrus Woodman to E. Bond, in Brunswick *Telegraph*, July 22, 1887, quoted in Pearson, *Life of Andrew*, p. 20.

3. Quoted in Emerson, *Saturday Club*, p. 357.

4. Thomas Wentworth Higginson, *Cheerful Yesterdays* (Boston: Houghton Mifflin, 1898), p. 146.

5. *Liberator*, November 1, 1850.

6. The Massachusetts Historical Society has one box of records from 1846 to 1882 of the Boston Anti-Man-Hunting League.

7. John A. Andrew to Charles Sumner, January 22, 1852, Charles Sumner Papers, Houghton Library, Harvard University.

8. In a letter published in the *Front Royal Gazette* of October 24, 1855, Clark admonished Burns for disregarding his biblical duty to obey. By a trick of history, Clark knew both Henry Williams, when he was Seth Botts, and Anthony Burns. He baptized Burns, and now that Burns had gained his freedom and a vocation as a minister, Clark, citing Ephesians, suggested that Burns take up his ministry between Pittsburgh and Cincinnati, "where you will have frequent opportunities to turn the tide of the stampedes from Virginia and Kentucky, and bring the apostolic batteries to bear against the fugitives; and so by 'doing good' in that way, you may measurably make amends for the expenditure of $30,000 by the Government in your arrest, trial, and restoration to your legal owner." Broadside made to circulate John Clark's letter, *Front Royal Gazette*, October 24, 1855, Duke University Library.

6. ELIZABETH WILLIAMS, PRINCE WILLIAM COUNTY, 1852

1. J. C. Weedon vs J. C. Goods & P. D. Lipscomb Slave Contract, January 1, 1852, Prince William County Clerk's Loose Papers.

2. His source may be Elizabeth. Andrew mentioned that Henry and his wife, Elizabeth, corresponded during their separation, but I have found no trace of it.

3. John A. Andrew to Charles Sumner, August 3, 1852, Charles Sumner Papers, Houghton Library, Harvard University. The remaining letters cited in this chapter are held in the same collection.

4. Andrew to Sumner, February 2, 1855.

5. Andrew to Sumner, February 2, 1855.

6. Andrew to Sumner, January 22, 1855.

7. Andrew to Sumner, January 24, 1855.

8. Christopher Neale to Charles Sumner, January 27, 1855.

7. EVELINA BELL, WASHINGTON, FEBRUARY 1855

1. Beverly Wilson Palmer edited and indexed Sumner's papers. His scrapbooks are now held at Harvard's Houghton Library. Only those that were preserved by his recipients remain. Palmer, *Guide and Index to the Papers of Charles Sumner* (University of Michigan, Chadwyck-Healey, 1988).

2. I have pieced together this conversation from Sumner's papers at Houghton Library for January and February 1855, Andrew's archive at the Massachusetts Historical Society for the same period, and a letter between Andrew and Neale archived at the Morgan Library.

3. Christopher Neale, February 14, 1855, in reply to Sumner, February 11, 1855 (not held).

4. John A. Andrew to Charles Sumner, January 24, 1855. Charles Sumner Papers, Houghton Library, Harvard University. Unless otherwise indicated, all the remaining letters in this chapter are held in the same collection.

5. Andrew to Sumner, January 31 and February 2, 1855.

6. Neale to Sumner, February 14, 1855.

7. *Williams v. Ash*, 42 U. S. 1 (1843).

8. Andrew to Sumner, February 2, 1855.

9. Neale to Sumner, February 14, 1855.

10. Andrew to Sumner, January 31,1855.

11. Andrew to Sumner, February 2, 1855.

12. Neale to Sumner, February 21, 1855.

13. Andrew to Sumner, February 2, 1855.

14. Andrew to Sumner, February 16, 1855.

15. E. S. Streeter, *The Stranger's Guide, or The Daguerreotype of Washington DC* (Washington, D.C.: C. Alexander, 1850), pp. 12–13.

16. Andrew to Sumner, March 3, 1855.

17. "Jesse Nelson v. John Cornwell," in *O Say Can You See: Early Washington, D.C., Law & Family*, ed. William G. Thomas III et al. (Lincoln: University of Nebraska), online at http://earlywashingtondc.org/doc/oscys.case.0267.008.

18. Neale to Sumner, March 6, 1855, John A. Andrew Papers, Massachusetts Historical Society.

8. MARY HAYDEN GREEN PIKE, CALAIS, MAINE, NOVEMBER 1854

1. John Andrew to Charles Sumner, February 19, 1855, Charles Sumner Papers, Houghton Library, Harvard University.

2. The letter was published in *Boston Telegraph*, February 27, 1855.

3. *Boston Telegraph*, November 24, 1854.

4. *Hard Times* was produced to increase sales of the periodical; see "Discovering Dickens: A Community Reading Project," *Victorian Reading Project*, http://dickens.stanford.edu/dickens/archive/hard/historical_context.html. On sales of *Twelve Years a Slave* and other slave narratives, see Philip Gould, "The Rise, Development, and Circulation of the Slave Narrative," in *The Cambridge Companion to the African American Slave Narrative*, ed. Audrey Fisch (New York: Cambridge University Press, 2007). *Moby-Dick* (1851) sold 3,215 copies, http://www.melville.org/earnings.htm.

5. William Cullen Bryant, "New Novel by Mrs. Stowe," *Evening Post*, November 11, 1854.

6. *Evening Post*, November 17, 1854.

7. For a detailed study of the publicity campaign behind *Ida May*'s success, see Donald E. Liedel, "The Puffing of *Ida May*: Publishers Exploit the Antislavery Novel," *Journal of Popular Culture* 3, no. 2 (1969).

8. "Who Wrote Ida May?" *New York Evening Post*, December 6, 1854. Someone has bracketed, in pen, this very passage in a giant folio of the year of 1854 *Evening Post*.

9. In 1853, while Pike was beginning to write *Ida May*, her brother-in-law James Shep-

herd Pike, a vehement opponent of the institution of slavery, was nonetheless writing such antiblack and racist columns for the *New York Tribune* that he was quickly censored by editor Horace Greeley. For more on the Pike family and their politics, see Jessie Morgan-Owens, introduction to Mary Hayden Green Pike, *Ida May*, ed. Jessie Morgan-Owens (Peterborough, Ont.: Broadview Press, 2017); and Robert Franklin Durden, *James Shepherd Pike: Republicanism and the American Negro, 1850–1882* (Durham, N.C.: Duke University Press, 1957).

10. Austin Willey, *The History of the Antislavery Cause in State and Nation* (Portland, ME, 1886), p. 115.

11. D. W. Bartlett, *Modern Agitators, or Pen Portraits of Living American Reformers* (Auburn, NY: Miller, Orton, & Mulligan, 1855), p. 216, http://name.umdl.umich .edu/ABT6622.0001.001

12. Rachel Reed Griffin, *The Life and Writings of Mary Hayden Green Pike*, MA thesis, University of Maine, 1944.

13. Ichabod Codding, sermon based on Proverbs 22:6, "Train up a child . . . ," delivered December 6, 1850, Joliet, IL.

14. Rev. I. C. Knowlton, *The Annals of Calais, Maine, and St. Stephen, New Brunswick . . .* (Calais, ME: J. A. Sears, printer, 1875), p. 138.

15. Frederick Pike accused Phillips, Sampson, & Co., of a "mercantile blunder" when it published *Caste* under a new pseudonym, with no indication that this was the second novel by the best-selling author of *Ida May*. Pike to Moses Dresser Phillips, June 21, 1857, manuscript collection, Boston Public Library.

16. I partnered with Broadview Press to publish an updated version of *Ida May* in May 2017.

17. Caroline F. Putnam, *Liberator*, October 21, 1859.

18. *Liberator*, "Ida May, The Kidnapped White Slave," November 17, 1854.

19. The Baltimore Conference of the Methodist Church was split on the subject of slavery.

20. Mary Hayden Green Pike, *Ida May* (1854), chap. 3.

9. JULIAN VANNERSON, WASHINGTON, FEBRUARY 1855

1. Someone has scratched the word *Richmond* into the frame of the daguerreotype, which offers contradictory evidence that Mary was photographed before leaving Virginia, at the Vannerson family studios in Richmond. I have found no evidence that Mary ever visited Richmond. Given that Sumner and Brainard used the studio in Washington, this seems like the most likely place for her photograph to have been made. *Richmond* was likely added later.

2. Contemporary advertisements and *Craig's Daguerreian Registry: American Photographers 1839–1860*, https://bit.ly/2vmneXu.

3. The Boston Athenaeum has a copy of *Brainard's Portraits*, which includes engravings of both Charles Sumner and John A. Andrew.

4. Since 1999, in my professional life as a magazine photographer, I have had to contend with three different ways of shooting, processing, and printing pictures: slide film,

medium format film, and digital technologies of increasing capability. The only thing that stays the same is the sun.

5. Mary's daguerreotypes, lost for many years, were found by Mary Niall Mitchell in the John A. Andrew Papers at the Massachusetts Historical Society in 2010. I wrote my article "Another Ida May: Photographic Writing in the American Abolition Campaign" between 2006 and 2009, before I had reference to these images, so I too was unable to see the image Sumner describes.

6. Roy Meredith, *The Faces of Robert E. Lee* (New York: Charles Scribner's Sons, 1947).

7. Oliver Wendell Holmes, "The Stereoscope and Stereograph," *Atlantic*, June 1859.

8. Ralph Waldo Emerson, "The Fortune of the Republic," in *The Complete Works of Ralph Waldo Emerson* (New York: Houghton Mifflin, 1904), p. 11:539.

9. This historical construction and transformations of vision during this period cannot be overestimated. See Jonathan Crary, *Techniques of the Observer: On Vision and Modernity in the Nineteenth Century* (Cambridge, MA: MIT Press, 1992), p. 3; and Vilém Flusser, *Towards a Philosophy of Photography* (1983), trans. Anthony Matthews (London: Reaktion Books, 2000).

10. "The White Slaves," *Independent . . . Devoted to the Consideration of Politics, Social and Economic Tendencies, . . .* February 4, 1864, p. 4.

11. James Buchanan, Fourth Annual Message to Congress on the State of the Union, December 3, 1860, American Presidency Project, http://www.presidency.ucsb.edu/ws/index.php?pid=29501.

12. Sarah Grimké, quoted in "Proceedings of the Anti-Slavery Convention of American Women," *Liberator*, June 16, 1837.

13. Charlotte L. Forten Grimké, entry for July 5, 1857, *The Journals of Charlotte Forten Grimké*, ed. Brenda Stephenson (New York: Oxford University Press, 1988), p. 235.

14. "An Act to Emancipate Jerry, a slave," ratified in Mecklenburg County, North Carolina, January 8, 1855, *Public and Private Laws of North Carolina 1854–55*, chap. 109, pp. 89–90. Reported in the *National Era,* January 18, 1855.

10. RICHARD HILDRETH, BOSTON, MARCH 1855

1. John A. Andrew to Charles Sumner, February 23, 1855, Charles Sumner Papers, Houghton Library, Harvard University.

2. Richard Hildreth, "Another Ida May," *Boston Telegraph*, February 27, 1855.

3. Hildreth's article about Sumner's February 19 letter was reprinted in the *Albany Evening Journal* on February 28, the *New-York Daily Times* on March 1, the *Washington Sentinel* on March 2, *Frederick Douglass's Paper* in Rochester on March 9, the *National Anti-slavery Standard* in New York on March 17, the *Anti-Slavery Bugle* in New Lisbon, Ohio, on March 24, the *Liberator* on March 30, 1855, and doubtless elsewhere.

4. Andrew to Sumner, February 23, 1855.

5. The images of Mary were what literary historian Robin Bernstein has called "scriptive things"—objects that compel their owners to perform a certain repertoire of actions.

Robin Bernstein, *Racial Innocence: Performing American Childhood from Slavery to Civil Rights* (New York: NYU Press, 2011).

6. A. L. Russell to Charles Sumner, March 13, 1855, Charles Sumner Papers, also quoted in Mitchell, "The Real Ida May: A Fugitive Tale in the Archives," *Massachusetts Historical Review* 15 (2013): 73.

7. Henry E. Alvord to Charles Sumner, July 9, 1861, Houghton Library, Harvard University. In this letter Henry Alvord, enrolled at Norwich University, requests Sumner's endorsement for West Point. He tells Sumner he has been following a motto Sumner had given to his older cousin, when Sumner visited the Alvord home in Greenfield in 1851: "*Study! Study!! Study!!! And don't marry till you're thirty!*"

8. "Ash Grove," *Fairfax Herald*, October 4, 1907.

9. Henry married Martha Scott Swink when he was twenty-two.

10. Harvard women's historian Nancy Cott attended my talk about Mary at Wellesley College. She later sent me a link to Joan Gage's website, where I found her article about the copy daguerreotype of Mary. Joan Gage, "A White Slave Girl 'Mulatto Raised by Charles Sumner,'" *Rolling Crone*, March 12, 2011, http://arollingcrone.blogspot .com/2011/03/white-slave-girl-mulatto-raised-by.html. Gage's article was also published in *Daguerreian Annual* (2011). In May 2013, I met with Joan Gage to view the daguerreotype. I was in residence at the American Antiquarian Society, near her home in North Grafton. Our meeting was heightened by coincidence, for this was the second time photography had brought Joan and me together. Joan, her husband Nicolas Gage, and her daughter Eleni Gage are all writers, and in 2008 my photography team Morgan & Owens shared a byline with Eleni Gage in the magazine *Travel + Leisure*. We photographed a story Eleni was writing about her father's home in Epiros, Greece. We met Eleni for lunch at the Aristo Mountain Lodge, perched high above the Vikos Gorge. Over tapenade and toast, we hammered out a plan for capturing the remaining items on the shoot list. Her mother, Joan, came along for that trip. Five years later, at the Armsby Abbey in Worcester, Joan pulled her copy of Mary's daguerreotype from her bag and handed it to me. I treasured the opportunity to hold her daguerreotype in my hands, in a tavern lit by the street-side window, rather than in the bright, silent archive.

11. American Broadsides and Ephemera collection, American Antiquarian Society, digitized by Readex. Andrew had to write to Sumner for a description of Oscar. He had not yet met Elizabeth or the children when he composed this clear recitation of their story. I first downloaded this broadsheet on Thanksgiving break 2007. I also had not yet seen their photograph, and I didn't know what Mary and Oscar looked like either. It would be four months before I saw Mary and six months before I traveled to Greece and met the Gages. I wrote in my notebook in November 2007, "I have not been able to find anything about this missing photograph. I don't know why I continue to assume it's out there."

12. Sally Pierce et al., *Whipple and Black: Commercial Photographers in Boston* (Boston: Boston Athenaeum, 1987), p. 19.

13. "Affairs in and Outside the City," *Daily Atlas* (Boston), March 5, 1855. Notice that

Ludwell is here referred to as a "little boy," whereas in the broadsheet he is seventeen or eighteen years old. Born in 1833, Ludwell was twenty-two in 1855.

14. William Cooper Nell to Amy Kirby Post, April 24, 1853, in William Cooper Nell, *Selected Writings 1832–1874*, ed. Dorothy Porter Wesley and Constance Porter Uzelac (Baltimore: Black Classic Press, 2002).

15. *American Anti-slavery Cash Book for 1852–1863*, in Sydney Howard Gay Papers, New York Public Library.

16. Oliver Wendell Holmes quoted in Robert Taft, *Photography and the American Scene: A Social History, 1839–1889* (New York: Macmillan, 1938), p. 143. Taft reports that around 1860, "the introduction of the card photograph and the album effected a revolution in the photographic business; any tendency toward a revival of daguerreotypes was completely obliterated by the new fashion."

17. See, for example, Sojourner Truth's *cartes de visite* from 1864 held by the Library of Congress.

18. Douglass delivered "Lecture on Pictures" at Boston's Tremont Temple on December 3, 1861. It was published as "Pictures and Progress: An Address Delivered in Boston, Massachusetts, on 3 December 1861," in *The Frederick Douglass Papers: Series One, Speeches, Debates, and Interviews*, vol. 3, *1855–1863*, ed. John Blassingame (New Haven, Conn.: Yale University Press, 1979), pp. 452–73.

19. On May 22, 2013, while in residence in the archives at the American Antiquarian Society, I called up the nineteenth-century editions of Hildreth's books from the stacks. I had already read all the extant copies of his newspaper, the *Boston Telegraph*. Archivist Ashley Cataldo set the small books on the velvet, along with a pair of foam risers for support. I opened the first copy, and tucked in the front cover, where the frontispiece should be, was the crystalotype of Mary. I had no expectation of finding her photograph. To the other researchers' surprise, I stood up and knocked my wooden chair back with a dull thud onto the carpet. The catalog made no reference to images; no one knew it was there. Until now, I had assumed no crystalotypes of Mary survived. I alerted Lauren Hewes, the curator of graphic arts, to the discovery. She confirmed that the archive has more than five thousand paper and card photographs in its care, and now here was its first crystalotype.

20. "Pictures of Ida May," *Worcester Spy*, March 29, 1855.

21. Richard Hildreth, *The White Slave; or, Memoirs of a Fugitive* (Boston: Tappan & Whittemore, 1852), p. 19.

11. CHARLES SUMNER, WASHINGTON, MARCH 1855

1. "Eventually the Senator was requested to purchase the uncles and aunts of the Botts children and draw on Boston for the amount needed, whatever it might be. This he did after much negotiation, it being known in each case, however, that his object in buying these people was to give them their freedom and send them North. While these negotiations were pending, Mr. Sumner tried to keep the matter as quiet as possible

in Washington, for obvious reasons; but it got into the papers, and excited some comment." Arnold Burges Johnson, "Charles Sumner.—III," *Cosmopolitan* 4 (1888), p. 147.

2. *Washington Reporter* (Pennsylvania), March 14, 1855.

3. Sumner to James M. Stone, editor of the *Boston Commonwealth,* December 23, 1853, in Sumner, *Selected Letters,* ed. Beverly Wilson Palmer (Boston: Northeastern University Press, 1990), pp. 1:397–98.

4. Beverley Tucker, "Senator Sumner—Young Negroes and Daguerreotypes!" *Washington Sentinel,* March 2, 1855.

5. The lithograph is unsigned. The Library of Congress uses two contemporary pieces of similar draftsmanship to name Dominique C. Fabronius as its likely illustrator. The printer was George W. Cottrell of Boston.

6. Hugh McCulloch, *Men and Measures of Half a Century: Sketches and Comments* (New York: Scribner's, 1889).

7. Sumner to William Bates and James W. Stone, August 12, 1850, in Sumner, *Selected Letters,* 1:308.

8. Sumner to John Greenleaf Whittier, May 4, 1851, in Sumner, *Selected Letters,* 1:333.

9. Sumner to Howe, April 5, 1852, in Sumner, *Selected Letters* 1:356.

10. Sumner to George Sumner, June 17 and 24, 1851, in Sumner, *Selected Letters,* 1:336, note 3. He refers to the *Liberator* of May 23, 1851.

11. "Important Debate in the Senate, Washington February 23, 1855," reprinted in the *National Anti-Slavery Standard,* March 3, 1855.

12. The transcript of the debate can be found in *Congressional Globe,* 33rd Congress, 2nd Session, pp. 211–46.

13. Unsigned letter dated February 26, *Boston Telegraph,* February 28, 1855.

14. As reported in the *Antislavery Standard,* February 1855.

15. As reported in the *Massachusetts Spy,* March 7, 1855.

16. Steven Taylor, "Progressive Nativism: The Know-Nothing Party in Massachusetts," *Historical Journal of Massachusetts* 28, no. 2 (Summer 2000): 167–84.

17. As reported in the *Massachusetts Spy,* March 14, 1855.

18. *Congressional Globe,* p. 246. Also reported in *Worcester Spy,* March 21, 1855.

19. Sumner to Chase, March 2, 1855, note passed in the Senate Chamber, Boston Public Library.

20. "F.W.B.," *Massachusetts Spy,* March 7, 1855.

21. Henry Wadsworth Longfellow, journal entry for April 29, 1858, in *Life of Henry Wadsworth Longfellow, with Extracts from His Journals and Correspondence,* ed. Samuel Longfellow (Boston: Houghton Mifflin, 1891), p. 355.

22. Walter Stahr, *Seward: Lincoln's Indispensable Man* (New York: Simon & Schuster, 2013); and Doris Kearns Goodwin, *Team of Rivals: The Political Genius of Abraham Lincoln* (New York: Simon & Schuster, 2005).

23. Harriet Beecher Stowe, *Uncle Tom's Cabin* (Boston: Jewett, 1852), chap. 9.

24. Harriet Beecher Stowe, *The Annotated Uncle Tom's Cabin* (New York: Norton, 2007), p. 97.

25. Marcus Wood, *Blind Memory: Visual Representations of Slavery in England and America* (New York: Routledge, 2000), pp. 87–99. For context on the illustrations, see Jo-Ann Morgan, *Uncle Tom's Cabin as Visual Culture* (New York: Routledge, 2009).

12. "A WHITE SLAVE FROM VIRGINIA," NEW YORK, MARCH 1855

1. P. T. Barnum to editor of *New York Tribune*, May 4, 1855, Lost Museum Archive, https://lostmuseum.cuny.edu/archive/letters-about-the-baby-shows-to-the-new-york.

2. Barnum to *Tribune*, May 4, 1855.

3. "A White Slave from Virginia," *New-York Daily Times*, March 9, 1855, reprinted in *Frederick Douglass's Paper*, March 16, 1855.

4. "A Good Repartee," *Connecticut Courant*, February 3, 1855.

5. Announcements for Purdy's National Theater, *New York Times*, August 28 and 30, 1856, in *Uncle Tom's Cabin & American Culture: A Multi-Media Archive*, University of Virginia.

6. Edward J. Stearns, *Notes on Uncle Tom's Cabin* . . . (Philadelphia: Lippincott, Grambo & Co., 1853), p. 145.

7. Beverley Tucker, "Senator Sumner, 'Ida May,' and the Solid Men of Boston," *Washington Sentinel*, March 14, 1855.

8. "Encouraging," *New-York Daily Times*, March 16, 1855.

13. THE WILLIAMS FAMILY, BOSTON, MARCH 7, 1855

1. George Foster, *Splendor Sailed the Sound: The New Haven Railroad and the Fall River Line* (San Mateo, Calif.: Potentials Group, 1989), p. 9.

2. "The Late Storm and Its Effects," *Boston Courier*, March 15, 1855.

3. "A Family United," *Boston Recorder*, March 15, 1855.

4. "Arrival of Senator Sumner's Protégés," *Boston Courier*, March 12, 1855.

5. This letter gives the impression that Prue and Evelina did not travel with Elizabeth and children but came to Boston separately. John Andrew to Charles Sumner, March 10, 1855, Charles Sumner Papers, Houghton Library, Harvard University.

6. James A. Cutting, *Improvements in the Preparation of Collodion for Photographic Pictures*, U.S. Patent 11213, July 4, 1854; U.S. Patent 11266, July 11, 1854; U.S. Patent 11267, July 11, 1854.

7. "Boston Correspondence," *St. Albans Messenger*, March 22, 1855.

8. *Boston Evening Transcript*, May 4, 1855.

9. In the summer of 2014, Melissa Howell, the great-great-great-grandaughter of Solomon Northup, reached out to me to determine if a photograph of Mary Williams and Solomon Northup had been found. So far there are no extant photographs of Northup. In November 2014, with a group of students, I joined her family in Marksville, Louisiana, on their first visit to Louisiana, to celebrate the opening of the Solomon Northup Trail and experience firsthand sites Northup described in such detail in *Twelve Years a*

Slave. The organizers attempted to bring together descendants from both sides for reconciliation, but the Epps family did not attend. As teenagers, Melissa Howell and her cousins learned that they were descendants of a famous and formerly enslaved person; two generations of the descendants of Solomon's son, Alonzo Northup, had lived apart from the larger family, as white people.

10. William Craft, *Running a Thousand Miles for Freedom* (London: William Tweedie, 1860), pp. 1–3.
11. William Lloyd Garrison, "Today," *Liberator*, January 1, 1831.
12. My use of the name Mary Mildred Williams goes against the scant scholarship extant about Mary Mildred Botts, including my own prior article and papers, but I hope this book will correct the record.
13. William Knight to Charles Sumner, February 28, 1855, John A. Andrew Papers, Massachusetts Historical Society.
14. Douglass, *My Bondage,* chap. 6.

14. "FEATURES, SKIN, AND HAIR," BOSTON, MARCH 1855

1. John A. Andrew to Charles Sumner, February 16, 1855, Charles Sumner Papers, Houghton Library, Harvard University.
2. The bill to remove Loring passed the state legislature, though Governor Henry Gardner would block his removal. It would take two further bills and the election of a Republican governor before Loring lost his judgeship.
3. "Redeemed Slaves in the House," *Worcester Daily Spy*, March 12, 1855. The last two sentences in the article mark the only place in the archives where a journalist has recorded Mary's response to her experience. I was so intrigued by this lone indication that Mary was an observing subject that I took an afternoon off to visit the Boston State House, to see the codfish for myself. I found it much smaller than expected. It is made of gold.
4. Notice in *Boston Courier,* reprinted in *Portland Advertiser,* March 20, 1855.
5. "Boston Correspondence," *St. Albans Messenger,* March 22, 1855.
6. W. C. Nell, "From our Boston Correspondent," *Frederick Douglass's Paper,* March 16, 1855.
7. William Cooper Nell to Amy Kirby Post, March 11, 1855, in William Cooper Nell, *Selected Writings 1832-1874,* ed. Dorothy Porter Wesley and Constance Porter Uzelac (Baltimore: Black Classic Press, 2002), entry #303.
8. Cindy Weinstein notices that this framing of Mary and Solomon "brings together the story of a real black adult male and a fictional white young girl, but also links the protagonist of a slave narrative and the heroine of a sentimental novel." Weinstein, *Family, Kinship, and Sympathy in Nineteenth-Century American Literature* (New York: Cambridge University Press, 2006), pp. 95–125.
9. *Boston Telegraph,* February 27, 1855, emphasis added.
10. "Local and Other Items," *Portland Advertiser,* March 20, 1855, emphasis added.
11. Mary Hayden Green Pike, *Ida May,* ed. Jessie Morgan-Owens (Peterborough, Ont.: Broadview Press, 2017), p. 93, emphasis added.

12. Carol Wilson, *The Two Lives of Sally Miller: A Case of Mistaken Racial Identity in Antebellum New Orleans* (New Brunswick, N.J.: Rutgers University Press, 2007).

13. *Boston Atlas,* quoted in *Liberator,* December 1854, emphasis added.

14. Dion Boucicault, *The Octoroon, or Life in Louisiana* (1859), in *Early American Drama,* ed. Jeffrey H. Richards (New York: Penguin Classics, 1997), p. 467, emphasis added.

15. THOMAS WENTWORTH HIGGINSON, WORCESTER, MASSACHUSETTS, MARCH 27, 1855

1. Lewis Perry, *Radical Abolitionism: Anarchy and the Government of God in Antislavery Thought* (Knoxville: University of Tennessee Press, 1973). For tenets of pacifism across abolitionism, see Manisha Sinha, *The Slave's Cause: A History of Abolition* (New Haven, Conn.: Yale University Press, 2017).

2. *Worcester Spy,* March 31, 1855.

3. Thomas Wentworth Higginson, *Cheerful Yesterdays* (Boston: Houghton Mifflin, 1898), p. 131.

4. Hannah Marsh Inman, diary entry for March 23, 1955, Manuscript Collection, Worcester Historical Museum. Transcription by Holly V. Izard for the Worcester Women's History Project.

5. "The White Slave," *Worcester Spy,* March 29, 1855.

6. In 1856 in Brooklyn, Reverend Henry Ward Beecher staged mock auctions of white enslaved women and girls for his congregation at Plymouth Church. These hysterical events theatrically raised funds to emancipate and support these young women and their families. He continued this practice until the end of the Civil War.

7. Higginson's copy is in the archive of his correspondence at Houghton Library at Harvard.

8. This daguerreotype of Thomas Wentworth Higginson, laughing as Mary sat upon his knee, has not yet turned up in the archives.

9. In 1855, at forty-seven, Longfellow had retired from teaching at Harvard, thanks to his royalties. Years earlier, at Sumner's request, Longfellow wrote seven poems for the Anti-Slavery tract society to distribute. He composed his *Poems on Slavery* at sea, on a stormy return voyage from Europe in 1842. Jill Lepore says of these poems: "Longfellow had no appetite for combat and no interest in attacking slaveholders (that was for Sumner to do); instead, he wrote, mournful—modern readers would say mawkishly—about the plight of slaves." Lepore, "Longfellow's Ride," *The Story of America: Essays on Origins* (Princeton, N.J.: Princeton University Press, 2012), p. 226. One poem, "The Quadroon Girl," dwells on betrayal at a Louisiana plantation, when a father sells his enslaved daughter into the sex trade.

10. Brenda Wineapple, *White Heat: The Friendship of Emily Dickinson and Thomas Wentworth Higginson* (New York: Knopf Doubleday, 2008), pp. 95–96.

11. Higginson quoted in Mary Potter Thatcher Higginson, *Thomas Wentworth Higginson: The Story of his Life* (Boston: Houghton Mifflin, 1914), p. 153.

16. "THE ANTI-SLAVERY ENTERPRISE," BOSTON, MARCH 29, 1855

1. Caroline Healey Dall to editor of *National Anti-Slavery Standard,* April 19, 1855.

2. Charles Sumner to Samuel Gridley Howe, January 24, 1855, in Sumner, *Selected Letters,* ed. Beverly Wilson Palmer (Boston: Northeastern University Press, 1990).

3. Charles Sumner to Julius Rockwell, November 26, 1854, in Sumner, *Selected Letters.*

4. "Disappointment," *Boston Evening Transcript,* March 29, 1855.

5. Charles Sumner, "The Anti-slavery Enterprise: Its Necessity, Practicability, and Dignity, With Glimpses of the Special Duties of the North," delivered March 30, 1855, Manuscript Collection, New-York Historical Society. See the digital version at https://www.nyhistory.org/slaverycollections/collections/sumner/index.html.

6. "Mr. Sumner's Anti-Slavery Lecture," *Boston Evening Transcript,* March 31, 1855.

7. "Disappointment," *Boston Evening Transcript,* March 29, 1855.

8. "Mr. Sumner's Lecture," *Boston Evening Telegraph,* March 30, 1855.

9. Sumner, "The Anti-slavery Enterprise."

10. "Mr. Sumner's Lecture," *Boston Evening Telegraph,* March 30, 1855.

11. Charles Sumner to Samuel J. May, March 30, 1855, Boston Public Library.

12. *National Anti-Slavery Standard,* May 1855.

13. According to Reverend Convers Francis, quoted in Sumner, *Memoir and Letters of Charles Sumner,* ed. Edward Lillie Pierce (Boston: Roberts Brothers, 1893), p. 3:416.

14. Charles Sumner, "The Anti-slavery Enterprise: Its Necessity, Practicability, and Dignity, With Glimpses of the Special Duties of the North," delivered March 30, 1855, Manuscript Collection, New-York Historical Society.

15. Charles Sumner, *Recent Speeches and Addresses* (Boston: Higgins & Bradley, 1856), p. 493.

16. Frederick Douglass to Charles Sumner, April 24, 1855, in Frederick Douglass, *Selected Speeches and Writings,* ed. Philip S. Foner (Chicago: Lawrence Hill Books, 1999), p. 33.

17. Frederick Douglass, *My Bondage and My Freedom* (1855), chap. 23. In this chapter, he explains what it was like to be a black man among white abolitionists.

18. One hundred years later Dr. Martin Luther King, Jr., made the same case: "I have a dream that my four little children will one day live in a nation where they will not be judged by the color of their skin, but by the content of their character."

19. "Life Pictures," Frederick Douglass Papers, Library of Congress.

20. Benjamin Quarles, *Black Abolitionists* (New York: Oxford University Press, 1969).

21. *Frederick Douglass's Paper,* June 1, 1855.

22. "Lecture Tonight by a Colored Physician," *Boston Evening Transcript,* May 4, 1855.

23. "Dr. Rock's Lecture at the Music Hall," *Frederick Douglass's Paper,* April 20, 1855. A summary is available in the University of Detroit Mercy Black Abolitionist Archives, digital collections, at https://www.udmercy.edu/academics/special/black-abolitionist.php.

24. John S. Rock, speech at Music Hall, Boston, April 5, 1855, as in *Frederick Douglass's Paper,* April 20, 1855.

25. *National Anti-slavery Standard,* May 19, 1855.

26. Charles Sumner to William Jay, October 7, 1855, in Sumner, *Memoir and Letters*, p. 3:420.

17. PRIVATE LIFE, BOSTON, OCTOBER 1855

1. Annie Russell Marble, *Thoreau: His Home, Friends, and Books* (New York: AMS Press, 1902), p. 199. George Tolman, "the custodian of the treasure-house" and former resident of the Thoreau house, became the secretary of the Concord Antiquarian Society when Thoreau's home became a museum.
2. Sumner to William Schouler, June 14, 1855; Sumner to Frances Seward, May 21, 1855, in Sumner, *Selected Letters*.
3. Caroline Andrews Leighton quoted in Mary Thacher Higginson, *Thomas Wentworth Higginson: A Story of His Life* (Boston: Houghton Mifflin, 1914), p. 154.
4. Higginson, *Cheerful Yesterdays*, p. 146.
5. Higginson, quoted in Mary Potter Thacher Higginson, *Story of His Life*, p. 152.
6. Higginson, *Cheerful Yesterdays*, p. 147.
7. Higginson quoted in Mary Potter Thacher Higginson, *Thomas Wentworth Higginson: A Story of His Life* (Boston: Houghton Mifflin, 1914), pp. 153–54. The recipient of this letter is unknown. I believe this member of Congress could be Daniel Alvord, which would explain the care his daughter Caroline Alvord Sherman placed in the copy daguerreotype image of her erstwhile sister.
8. Higginson to unknown recipient, "Dear Madam," March 23, 1857, in "Higginson, Adoption of Mary Mildred Williams," A-110, M133 #13, Alma Lutz collection of documents by and about abolitionists and women's rights activists, 1775-1943, Schlesinger Library on the History of Women in America, Radcliffe Institute for Advanced Study, Harvard University. Along with archivists at the Schlesinger library, we have examined the original letter for identifying marks and found none. I have called "Madam" a reformer because Alma Lutz collected documents about women's rights activists; however, this item could have been preserved because of Higginson's activism, not that of his unknown recipient.

18. "THE CRIME AGAINST KANSAS," WASHINGTON, MAY 1856

1. Brenda Wineapple, *White Heat: The Friendship of Emily Dickinson and Thomas Wentworth Higginson* (New York: Alfred A. Knopf, 2008), pp. 87–88.
2. Charles Sumner, "The Crime Against Kansas," speech delivered in the Senate, May 19, 1856.
3. Stephen Douglas, "Kansas Affairs," *Congressional Globe*, 34th Congress, 1st session, May 20, 1856, pp. 544–46.
4. Henry Wilson, in *Congressional Globe*, 34th Congress, 1st session, pp. 1357–58.
5. Preston Brooks to James Hampden Brooks, May 23, 1856, in Preston S. Brooks Letters, #1842-z, Southern Historical Collection, Wilson Library, University of North Carolina at Chapel Hill.

6. Edwin Morgan, in *Congressional Globe*, House of Representatives, 34th Congress, 2nd session, May 27, 1856, p. 1357.

7. According to James A. Pearce, in *Congressional Globe*, House committee report on Sumner's assault, 34th Congress, 1st session, 1355.

8. Hon. L. F. S. Foster, in *Congressional Globe*, p. 1356.

9. Edwin Morgan, *Congressional Globe*, p. 1357.

10. Ambrose Murray, in *Congressional Globe*, p. 1357.

11. Preston Brooks, letter, *Congressional Globe*, p. 1353.

12. Dr. Cornelius Boyle, in *Congressional Globe*, p. 1353.

13. Charles Sumner, testimony to the House committee on the assault, May 26, 1856, *Congressional Globe*, pp. 1353–54.

14. In *The Caning: The Assault that Drove America to Civil War* (Yardley, PA: Westholme, 2013), Stephen Puleo locates the responses to Sumner's speech along a "reaction continuum": "Un-American" (Senator Lewis Cass of Michigan); "Language intemperate and bitter," "offensive" to hear from "a man of character" (former Massachusetts governor Edward Everett); "Majestic, elegant, and crushing" (*New York Times*); "a brave and noble speech you made, never to die out of the memories of men" and "the greatest voice on the greatest subject that has ever been uttered" (Henry Wadsworth Longfellow); elevating "the range and scope of senatorial debate" and that "no man now living, within the last five years had rendered the American people a greater service to won for himself a nobler fame" (*New York Tribune*). See also Sumner, *Memoir and Letters of Charles Sumner*, ed. Edward Lillie Pierce (Boston: Roberts Brothers, 1893), p. 3:457.

15. For more on Brooks and codes of chivalry, see Puleo, *Caning*, and David Herbert Donald, *Charles Sumner and the Coming of the Civil War* (New York: Alfred A. Knopf, 1960), chap. 11.

16. P. S. Brooks to J. D. Bright, president of the Senate, in *Congressional Globe*, p. 1347.

17. Manisha Sinha, "The Caning of Charles Sumner: Slavery, Race, and Ideology in the Age of the Civil War," *Journal of the Early Republic* 23, no. 2 (2003), pp. 233–62.

18. Puleo, *Caning*, p. 133.

19. New York *Evening Post*, May 23, 1855.

20. As recalled by Stowe's publisher, Moses D. Phillips, in J. C. Derby, *Fifty Years Among Authors, Books and Publishers* (Hartford, Conn.: Winter & Hatch, 1886), p. 521.

21. David S. Reynolds, *John Brown: The Man who Killed Slavery, Sparked the Civil War, Seeded Civil Rights* (New York: Vintage, 2006).

22. Henry David Thoreau, "A Plea for Captain John Brown," speech delivered in Concord, October 30, 1859.

19. FREDERICK DOUGLASS, BOSTON, 1860

1. Edward Everett, "The Common Schools of Boston," dedication of the Everett School-House, *New York Times*, September 19, 1860. Everett closed this speech with a recommendation that women not be afforded the right to vote.

2. Charles Sumner, "Argument for the Constitutionality of Separate Colored Schools," in *Sarah Roberts v. City of Boston*, December 4, 1849.

3. For a study on the Roberts Case, see Stephen and Paul Kendrick, *Sarah's Long Walk: The Free Blacks of Boston and How Their Struggle for Equality Changed America* (Boston: Beacon Press, 2004).

4. See Frederick Douglass, "Pictures and Progress," in *The Frederick Douglass Papers*, vol. 3, *1855–1863*, ed. John Blassingame (New Haven, Conn.: Yale University Press, 1979), Blassingame's introduction, p. 452.

5. In addition to memorializing Theodore Parker, these lectures also responded to Lincoln's inaugural address. Douglass critiqued Lincoln's decision not to arm black troops. See Laura Wexler, "'A More Perfect Likeness': Frederick Douglass and the Image of the Nation," in *Pictures and Progress: Early Photography and the Making of African American Identity*, ed. Maurice O. Wallace and Shawn Michelle Smith (Durham, NC: Duke University Press, 2012).

6. Douglass, "Pictures and Progress" (1864), p. 9, Frederick Douglass Papers, Library of Congress.

7. Zoe Trodd, *Picturing Frederick Douglass* (New York: Norton, 2015); and private conversation with author.

8. For more on Douglass's theory of images, see Ginger Hill, "'Rightly Viewed': Theorizations of Self in Frederick Douglass's Lectures on Pictures," in *Pictures and Progress: Early Photography*, ed. Wallace and Smith, pp. 41–82.

9. Douglass would revise his message about pictures between 1861 and 1864, when he gave four lectures on photography. The manuscripts are housed in the "Speech, Article, and Book File," in the Frederick Douglass Papers at the Library of Congress: "Lecture on Pictures [title varies]" (Box 22, reel 14), "Pictures and Progress" (box 28, reel 18). He delivered the first lecture, "Life Pictures," in Syracuse, New York, on November 14, 1861. He delivered the second, "Age of Pictures," at the Parker Fraternity series in Boston. He delivered the third, "Lecture on Pictures," at Boston's Tremont Temple on December 3, 1861; it is published as "Pictures and Progress" in *The Frederick Douglass Papers*, vol. 3, *1855–1863*, ed. John Blassingame (New Haven, Conn.: Yale University Press, 1979). The fourth lecture was a revised, undated version of "Pictures and Progress," delivered four years later. See also David Blight, *Frederick Douglass' Civil War: Keeping Faith in Jubilee* (Baton Rouge: Louisiana State University Press, 1991), p. 13.

10. Blassingame, introduction to "Pictures and Progress," p. 452. For Lincoln, see the *National Anti-Slavery Standard*, December 7, 1861.

11. Douglass, *Life and Times of Frederick Douglass, Written by Himself* (1893), Library of America edition, p. 792.

20. PRUDENCE BELL, PLYMOUTH COUNTY, MASSACHUSETTS, 1864

1. See the catalog of the retrospective of Edward Mitchell Bannister's work curated by Juanita Marie Holland for Kenkeleba House gallery in 1992. See also Marilyn Rich-

ardson, "Taken From Life: Edward M. Bannister, Edmonia Lewis and the Memorialization of the 54th Massachusetts Regiment," in *Hope and Glory: Essays on the Legacy of the 54th Massachusetts Regiment* (Amherst: University of Massachusetts Press, 2001), pp. 94–115. Bannister belonged to the Crispus Attucks Choir and the Histrionic Club, and he served as an officer or delegate in several black abolitionist groups, including the Colored Citizens of Boston, the Union Progressive Association, and the New England Colored Convention.

2. Arlette Johnson to author, May 2, 2016.

3. The Johnsons donated the painting to Boston's Museum of African American History, which holds the painting off-site at a storage facility. When I visited in May 2017, I crossed the main atrium of the Fortress, passing beneath dozens of containers of Boston's treasures hydraulically suspended stories overhead. Then I was ushered into a small, brightly lit room, where I saw, sitting on an easel, the painting of Prue Bell.

4. J. E. Weiss to C. H. Brainard, September 24, 1856, John A. Andrew Papers, Massachusetts Historical Society.

5. Adelaide M. Cromwell, "An Old Boston Negro Family's Adjustment Through the Years," in *The Other Brahmins: Boston's Black Upper Class, 1750-1950* (Fayetteville: University of Arkansas Press, 1994), pp. 221–24.

6. James K. Hosmer recalled his visit to Governor Andrew's war cabinet, September 1862, in Edward Waldo Emerson, *The Early Years of the Saturday Club, 1855–1870* (Boston: Houghton Mifflin, 1918).

7. See Joel Strangis, *Lewis Hayden and the War Against Slavery* (North Haven, Conn.: Linnet Books, 1999) p. 119.

8. Luis F. Emilio, *A Brave Black Regiment: The History of the Fifty-Fourth Regiment of Massachusetts Volunteer Infantry 1863–1865* (1894; reprint New York: Arno Press, 1969).

9. All four of Robert Johnson's sons served in the 54th. Henry Johnson would become the first commander of Post 134 of the Grand Army of the Republic and lead the fight for equal pay for colored troops.

10. Kathryn Grover and Janine V. da Silva, *The Historic Resource Study: Boston African American National Historic Site* (December 31, 2002), https://www.nps.gov/subjects/ugrr/discover_history/upload/BOAFSRS.pdf.

11. The song was published in the *New York Times*, May 10, 1891. See *Brave Black Regiment*, p. 494.

12. "Sumter Watchman," October 1864, *Brave Black Regiment*, p. 501.

13. Thomas Wentworth Higginson, *Army Life in a Black Regiment* (Boston: Fields, Osgood, 1870), p. 3.

14. Higginson, *Army Life*, pp. 4, 7.

15. Higginson, *Army Life*, p. 3.

16. "Five Generations on Smith's plantation in Beaufort, South Carolina," a famous photograph of a black family taken by Timothy O'Sullivan in 1862, was made at this plantation. Library of Congress Prints and Photographs Division. http://www.loc.gov/pictures/item/98504449.

17. Higginson, *Army Life*, p. 9.

18. Higginson, *Army Life,* p. 17.

19. Higginson, *Army Life,* p. 13.

20. Joseph Keith Newell, ed., *"Ours": Annals of 10th Regiment, Massachusetts Volunteers in the Rebellion* (Springfield, Mass.: C. A. Nichols & Co., 1875).

21. In an accidental boon to this history, John Cornwell's case was transferred to Spotsylvania County, and from there, it was heard at the Virginia Supreme Court, whose clerk carefully hand-copied and marked up the documents I have accessed.

22. *Manassas Democrat,* February 16, 1911.

23. According to a local historian, the 1855 census listed no people of color living in Lexington, and in 1860, only one. This increase, by seven, was attributed to emancipation. There was a small, active black community in nearby Concord. Richard Kollen, *Lexington: From Liberty's Birthplace to Progressive Suburb* (Mount Pleasant, SC: Arcadia, 2001).

24. For the Annie and Mary Lawrence story, see Mary F. Eastman and Helen Cecelia Clarke Lewis, *The Biography of Dio Lewis* (Fowler & Wells, 1891) chap. 11.

25. *Documents of the City of Boston 1888*, vol. 3 (Boston: Rockwell & Churchill, 1889), p. 79.

26. Thomas Wentworth Higginson, *Part of a Man's Life* (Boston: Houghton Mifflin, 1905), p. 122.

27. Higginson, "Madam," the Knight family from Medford, and a man named Silas Ketchum who wrote Sumner to inquire about a child like Mary in 1856. Charles Sumner to Silas Ketchum, December 16, 1856, quoted in Mitchell, "The Real Ida May: A Fugitive Tale in the Archives," *Massachusetts Historical Review* 15 (2013): 87n77.

28. Maynard retired after twenty years of service in May 1917. In the 1910 census, she was living at another address, as another woman's boarder.

29. In 1900 the census taker was responsible for taking down the race of the person whose record he was making.

EPILOGUE: HYDE PARK, MASSACHUSETTS, 2017

1. Jesse Nelson's death record states that he was thirty years and one month old at time of death. There may have been some uncertainty around Jesse's birthdate, a common problem arising from enslavement. Given that his family, present for his death, gave his age, and the hospital recorded the date of death, I have used February 18, 1848, as his likely birthdate for this book. See *Massachusetts Vital Records, 1840–1911,* and entry for "Nelson, Jesse," *Vital Records of Abington, Massachusetts to the Year 1850* (New England Historic Genealogical Society), p. 148.

2. A group of students at the University of Massachusetts at Lowell, for a class project, created a family tree for Nathaniel Booth and his wife Fanny, who boarded with the Williams family in the 1860. These student researchers added a Williams family tree on Ancestry.com that included Mary's birth and death date. I followed this date through the records to the New York Department of Records and Information.

ILLUSTRATION CREDITS

———————◆———————

INDEX

◆

Note: Material in illustrations is indicated in *italics*.
Endnotes are indicated by n or nn after the page number.

GIRL IN BLACK
AND WHITE

Jessie Morgan-Owens

GIRL IN BLACK AND WHITE

Jessie Morgan-Owens

DISCUSSION QUESTIONS

1. *Girl in Black and White* uses a photograph of Mary Mildred Williams as a jumping off point for the story of how Williams became the face of American slavery for a brief period of time. What makes photography such a powerful medium?

2. Constance Cornwell's will stated that her grandson would inherit her current slaves as well as "the increase of the females forever" (p. 19). What were the ramifications of this line in Constance's will, especially as it relates to Mary Williams?

3. Mary's father, Henry Williams, eventually makes his way north to Boston and finds work as a waiter at the Cornhill Coffeehouse. How does Williams's escape put into motion many of the events in the story of Mary Williams? How does place play a role in this history?

4. What do you think were Senator Charles Sumner's motivations in helping Mary and her family in their fight for freedom? In what ways was he taking on their cause out of a sense of morality and in what ways was he hoping to leverage his actions into political capital?

5. Several people in the book, including Mary, are noted as being of mixed race. As the author states, "Mary's skin color indicted at least four generations of white American rapists, men who used their status in the master class to coerce enslaved women into bearing their children" (p. 6). What does this tell us about the history of sexual violence as it relates to slavery? How does the physical appearance of "white" slaves challenge beliefs about race and class?

6. Sumner paraded Mary about to sold-out abolitionist lecture series and would argue that her existence was evidence that slavery was not bound by race. White audiences were more emotionally affected by Mary's story than by the suffering of black enslaved people. How did Sumner use the idea that sympathy works through resemblance to his advantage? What does Mary Williams and her story tell us about the complicated racial politics of the abolition movement?

7. Mary was touted as being a real-life "Ida May," the main character in an anti-slavery novel about a white child who is kidnapped and sold into slavery. How did Mary, as "Little Ida May" come to life, spark fear in the white American public?

8. The author explains that Mary's photograph was one of the first images of photographic propaganda and "one of the first portraits made solely to prove a political point" (p. 5). How have iconic images throughout history been used to advance political ideas?

9. As quickly as Mary became a national sensation, her story lost steam among Americans. Why did people so fervently embrace Mary only to seemingly forget her? Why was Mary, and what her light skin represented, deemed to be taboo?

10. Morgan-Owens's research helped bring Mary and her story back from relative obscurity. Is it necessary that stories like Mary's be uncovered?

11. Mary was the only member of her family to survive into the twentieth century and was listed as "white" in the 1900 census. How did the rise of Jim Crow during this time period curtail Mary's identity, either as a black woman or as a white woman?

12. Racism continues to threaten and weaken our communities. How does the story of Mary Williams relate to the racial divisions we are experiencing currently?

13. Mary's own thoughts regarding her experiences were never recorded; in fact, the majority of the women in this story are voiceless in the annals of history. Based on what you have learned in

this book, are you able to hypothesize what Mary might have thought about being the face that transformed the abolition movement?

14. Morgan-Owens chose to reproduce her research in the form of extracts that appear throughout the book. What effect do these passages have on you as a reader of history?

15. Do you agree with the statement in the epigraph by Frederick Douglass that "where there is no criticism there is no progress" (p. vii)? How is this book a work of criticism?

The author's teaching guide for *Girl in Black and White*, with class plans, slide deck, and document-based prompts, can be found on her website at www.morgan-owens.com.

SELECTED NORTON BOOKS WITH
READING GROUP GUIDES AVAILABLE

For a complete list of Norton's works with reading group guides,
please go to wwnorton.com/reading-guides.

Diana Abu-Jaber	*Life Without a Recipe*
Diane Ackerman	*The Zookeeper's Wife*
Michelle Adelman	*Piece of Mind*
Molly Antopol	*The UnAmericans*
Andrea Barrett	*Archangel*
Rowan Hisayo Buchanan	*Harmless Like You**
Ada Calhoun	*Wedding Toasts I'll Never Give**
Bonnie Jo Campbell	*Mothers, Tell Your Daughters*
	Once Upon a River
Lan Samantha Chang	*Inheritance*
Ann Cherian	*A Good Indian Wife*
Evgenia Citkowitz	*The Shades**
Amanda Coe	*The Love She Left Behind*
Michael Cox	*The Meaning of Night*
Jeremy Dauber	*Jewish Comedy**
Jared Diamond	*Guns, Germs, and Steel*
Caitlin Doughty	*From Here to Eternity**
Andre Dubus III	*House of Sand and Fog*
	Townie: A Memoir
Anne Enright	*The Forgotten Waltz*
	The Green Road
Amanda Filipacchi	*The Unfortunate Importance of Beauty*
Beth Ann Fennelly	*Heating & Cooling**
Betty Friedan	*The Feminine Mystique**
Maureen Gibbon	*Paris Red*
Stephen Greenblatt	*The Swerve**
Lawrence Hill	*The Illegal*
	Someone Knows My Name
Ann Hood	*The Book That Matters Most*
	The Obituary Writer
Dara Horn	*A Guide for the Perplexed*
Blair Hurley	*The Devoted**

Meghan Kenny	*The Driest Season**
Nicole Krauss	*The History of Love*
Don Lee	*The Collective**
Amy Liptrot	*The Outrun: A Memoir*
Donna M. Lucey	*Sargent's Women**
Bernard MacLaverty	*Midwinter Break**
Maaza Mengiste	*Beneath the Lion's Gaze*
Claire Messud	*The Burning Girl*
	When the World Was Steady
Liz Moore	*Heft*
	The Unseen World
Neel Mukherjee	*The Lives of Others*
	*A State of Freedom**
Janice P. Nimura	*Daughters of the Samurai**
Rachel Pearson	*No Apparent Distress**
Richard Powers	*Orfeo*
Kirstin Valdez Quade	*Night at the Fiestas*
Jean Rhys	*Wide Sargasso Sea*
Mary Roach	*Packing for Mars**
Somini Sengupta	*The End of Karma**
Akhil Sharma	*Family Life*
	*A Life of Adventure and Delight**
Joan Silber	*Fools**
Johanna Skibsrud	*Quartet for the End of Time*
Mark Slouka	*Brewster*
Kate Southwood	*Evensong*
Manil Suri	*The City of Devi*
	The Age of Shiva
Madeleine Thien	*Do Not Say We Have Nothing*
	Dogs at the Perimeter
Vu Tran	*Dragonfish*
Rose Tremain	*The American Lover*
	The Gustav Sonata
Brady Udall	*The Lonely Polygamist*
Brad Watson	*Miss Jane*
Constance Fenimore Woolson	*Miss Grief and Other Stories**

*Available only on the Norton website